Black Cultural Production
after Civil Rights

Black Cultural Production after Civil Rights

Edited by Robert J. Patterson

UNIVERSITY OF ILLINOIS PRESS
Urbana, Chicago, and Springfield

Library of Congress Cataloging-in-Publication Data
Names: Patterson, Robert J., 1980– editor.
Title: Black cultural production after civil rights / edited by
 Robert J. Patterson.
Description: [Urbana, Ill.]: [University of Illinois Press], [2019] |
 Includes bibliographical references and index. |
Identifiers: LCCN 2019007394 (print) | LCCN 2019013708
 (ebook) | ISBN 9780252051630 (ebook) | ISBN
 9780252042775 (cloth : alk. paper) | ISBN 9780252084607
 (pbk. : alk. paper)
Subjects: LCSH: African American arts—20th century. | African
 American arts—Political aspects—History—20th century.
 | American literature—African American authors—History
 and criticism. | African Americans in motion pictures. |
 African American artists. | African Americans—Intellectual
 life—20th century. | Politics and culture—United States—
 History—20th century.
Classification: LCC NX512.3.A35 (ebook) | LCC NX512.3.A35
 B596 2019 (print) | DDC 700.89/960730904—dc23
LC record available at https://lccn.loc.gov/2019007394

Black Lives Matter

Contents

Acknowledgments

Black Cultural Production after Civil Rights brings together a range of scholars whose vast expertise, conscientiousness, and research made this volume possible. Within African American Studies, edited volumes have played an indispensable role in disseminating knowledge, cultivating interdisciplinary modes of inquiry and methods of analysis, and advancing the missions of Black Studies. The commitment of Madhu, Lisa, Monica, Courtney, Nadine, Samantha, Jermaine, Terrion, Kinohi, and Soyica made it possible for us to advance and add to important arguments, perspectives, and voices to the field. I appreciate the care with which they all approached their individual essays, as well as the seriousness with which they engaged each other's chapters. The explicit inter-chapter conversations undoubtedly have enriched the volume's intertextuality. I welcome the opportunity to work with them on future projects.

A range of cultural modes of expressivity find themselves in this volume, and their very existence also made the examinations that *Black Cultural Production* undertakes possible. While I will not attempt to name every artist and artistic production this volume analyzes, I will offer sincere gratitude to the artistic production and artists alike. This volume centralizes artistic production from the 1970s and accentuates how it helps us to better understand black freedom dreams, black freedom movements, and black freedom strategies. That we continue to think about, write about, and dream about the significance of this

historical period attests to our deep appreciation for the work it has done, continues to do, and will do.

For the past three years, my research assistant, Sebastien Pierre-Louis, has provided a variety of support on different projects. For *Black Cultural Production*, Sebastien once again contributed essential assistance that facilitated the completion of this project. Each chapter appreciates his attention to detail. As an undergraduate in the McDonough School of Business at Georgetown University, Sebastien probably knows more now about the *Chicago Manual of Style* than he cares to know! Nonetheless, I appreciate his thoroughness and commitment to this project. I also thank the Department of African American Studies for the support it provided. Finally, I appreciate the Competitive Grant-in-Aid that Georgetown University's Main Campus Research committee awarded this project to aid in its publication.

The editorial staff at the University of Illinois Press continues to expand its list in African American Studies, and I thank Dawn Durante for her leadership in and commitment to this effort. Since Dawn and I first discussed this volume, she has remained enthusiastic, engaged, insightful, and unwavering. I value the feedback she provided for the chapters; along with that of the two anonymous readers, her suggestions enhanced the book's execution. Many thanks, too, to Alison Syring, an editorial assistant whose conscientiousness and efficiency ensured the successful production of this project.

This volume reminds us that the whole remains greater than the sum of its parts. Community matters, as does black life. *Black Cultural Production* evidences both, and for that fact I express gratitude.

Dreams Reimagined

Political Possibilities and the Black Cultural Imagination

ROBERT J. PATTERSON

The 1970s Contextualized

When DuBois identified "the problem of the twentieth century" as the color line, "the relation of the darker to the lighter races of men in Asia and Africa, in America and the islands of the sea," at the turn of the twentieth century, he hardly could have imagined then that his declaration would hold true during the second decade of the twenty-first century.[1] Although DuBois would later question the United States' commitments toward democracy and equality, and ultimately renounce his U.S. citizenship, his death in 1961 preceded the pinnacle legislative achievements of the modern civil rights movement. Had Du-Bois, for example, witnessed the Civil Rights Act of 1964 and the Voting Rights Act of 1965, he might have reconsidered the possibilities for racial equality as approaching and imagined the ebbing of the color line. Even if he had lived through the 1960s, his enthusiasm would have lived ephemerally as his previous disillusionment became more entrenched. Indeed, the 1953 *Brown v. the Board of Education of Topeka, Kansas* ruling had overturned legal segregation, second-class citizenship, and the white supremacist enhancing policies and laws that the 1896 *Plessy v. Ferguson* ruling had authorized, codified, and reinforced. It paved the way for the civil rights acts of the 1960s. Yet, the 1970s ushered in an anti–civil rights backlash that, when coupled with an increasing tide of conservatism, impeded the enforcement of civil rights legislation.

The Civil Rights Acts of 1964 and 1968, the Economic Opportunity Act of 1964, the Voting Rights Act of 1965, and the Fair Housing Act of 1968 promised the possibility for a more inclusive, democratic nation. The expectation for fair access to housing, voting, and employment opportunities gave African Americans hope that they might now transfer intergenerational wealth instead of poverty. While the Youngers in Lorraine Hansberry's groundbreaking *A Raisin in the Sun* (1959) experienced residential discrimination in *urban* Chicago as a consequence of de facto segregation, post–civil rights era African Americans now had juridical support for integrated institutions across the nation. Yet the Youngers's example resonates because it reveals how de facto segregation becomes more possible in light of de jure segregation, and because it foreshadows the intractability and long-term consequences of both.[2] The post–civil rights era retrenchment of de facto segregation revealed how white supremacy and antiblack racism were interconnected, intertwined, interrelated, and deeply embedded in America's values and institutions. Neither legislative acts nor a naive belief in the general goodness of the American people could undo their historical and emotional sentience.

Post–civil rights era assaults on legal remedies to black inequality thus all but ensured the limited development of sustainable institutional and infrastructural changes to translate so-called *equal opportunities* into *equal outcomes*. Black people theoretically had the same *access* as whites to previously denied opportunities, yet black people's previous exclusion diminished the degree to which taking advantage of the new opportunities would equalize their chances for equality; the juridical changes alone could not account for the *cumulative* effects the historical disadvantages had produced. This disparity, rooted in the legacies of historical discrimination and compounded by new manifestations of Jim Crow and its legacies, perpetuates the material disparities between white and black people in the post–civil rights era. While Michelle Alexander rightfully notes how mass incarceration and the prison industrial complex extend Jim Crow's reach, the new Jim Crow possesses many additional manifestations, too, in the post–civil rights era.[3]

The 1970s thus clarified what civil rights activists such as Bayard Rustin and Ella Baker had known already; neither the *mere* removal of legal obstructions to equality of access nor laissez-faire enforcement could reverse the cumulative effects of antiblack racism and discrimination to right the wrongs of the past and set conditions under which African Americans would prosper. Instead, the clear need arose for a post–civil rights era package deal, a shift from "single-issue demands of the movement's classical phase" to focus more broadly on equity and equality by way of affirmative actions.[4] As Dr. King once put it, "A society

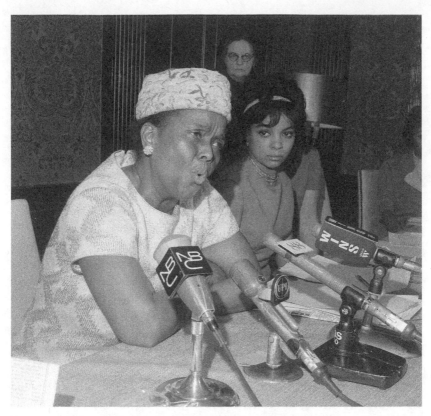

Figure 0.1. Ella Baker, official of the Southern Conference Educational Fund, speaks at the Jeannette Rankin news conference on January 3, 1968. To the right of Baker is actress Ruby Dee (AP Photo/Jack Harris).

that has done something special against the Negro for hundreds of years must now do something special for the Negro."[5] King and others agreed the government needed to help level the playing field to achieve the aims of the civil rights movement. Yet the emerging ideas of post-racialism, color-blindness, and race neutrality undermined the intent of the legislative gains of the civil rights movement and further retrenched black inequality. As importantly, even seemingly "neutral" mechanisms for evaluation remained pervious to cumulative histories of antiblackness; using credit scores to make mortgage rate determinations and SAT scores for college admissions criteria, for example, ignored how the intergenerational transfer of wealth for whites and poverty for blacks indisputably racialized the "neutral" determinants and perpetuated inequality. Putatively race-neutral policies did, and still do, mask the ways that institutional racism

operates, how white privilege thwarts the possibility of translating an equality of access into an equality of outcome, and lay bare one of the new civil rights crises that the post–civil rights era ushers in.

As concepts such as meritocracy became increasingly refracted through the myth of scarcity, affirmative action programs, which had the potential to translate the equality of opportunity into the equality of outcome, lost traction. By casting beneficiaries of affirmative action programs as "unqualified" and "undeserving," anti–affirmative action proponents racialized the myth of scarcity to characterize black people as stealing (from) a finite set of resources. The myth of scarcity insists that there are limited resources available (access to *quality* health care, public schools, employment opportunities, and safe neighborhoods), that individuals must therefore compete for those limited resources, and that those who work hard and have the right credentials *earn* and *deserve* access based (primarily) on their own hard work. By conjoining anti–affirmative action discourses with the myth of scarcity, affirmative action opponents also saw the racialization of the welfare state and the rise of neoliberalism as additional means by which to advance their agendas.[6] This framing helped to exhaust already scant governmental and social support for these programs. Anti–affirmative action proponents manipulated King's rhetoric to champion color-blind (and race-neutral) policies, effectually reinforcing the racism and stratification against which he vehemently fought.

In this context, artists, critics, activists, and cultural producers alike found themselves wondering how American society could achieve its ideal of equality for black citizens in the absence of Jim Crow laws. What circumstances, if any, could eradicate racial animus, or had James Baldwin correctly understood white racism as fundamentally American and inevitably intractable?[7] If equality was not possible through legal means, what extralegal or nonlegal means could help black people to achieve freedom? On the one hand, it is dispositive that the modern civil rights movement transformed the American fabric by removing Jim Crow segregation and thus allowing African Americans access to more opportunities within American institutions. The influx of African Americans on the campuses of predominantly white colleges and universities, the dramatic increase in registered voters in southern states in particular, and the proliferation of black mayors and other elected officials throughout the nation demonstrate the material changes that the civil rights movement engendered.[8] On the other hand, the post–civil rights era's broader cultural tendency has been to view these and similar advances as evidence par excellence that the civil rights movement afforded black people equality. Subsequent failures by black individuals and communities thus became understood as deficiencies in black

people's efforts as post–civil rights era American discourses increasingly have ignored civil rights historians' admonitions to consider the modern civil rights movement as a part of a broader (and ongoing) movement.[9] The increasing legal threats toward civil rights that continue to emerge in the post–civil rights era, as well as the need for equality of outcomes, foreground the ongoing nature of civil rights attainment, agitation, and activism.

Black Cultural Production, after Civil Rights

Black Cultural Production after Civil Rights grapples with the unfinished business of the civil rights movement by considering how post–civil rights era black cultural production rethinks black freedom in light of the civil rights movement's aftermath. Similar to previous decades, the 1970s witnessed material and symbolic advances and gains (progression), even as it also wove substantive and substantial setbacks (regression) into the American fabric. The volume analyzes the 1970s and its cultural production to consider how the progression-regression paradox that has defined black experience throughout history takes on *new forms* in the 1970s. While 1970s cultural production remains at the forefront of the analyses, the volume's historical teleology moves from the post-Emancipation period to the post-Obama age. It closely examines historical events and actors, political figures, cultural artifacts, changing political ideologies, and expanding black cultural aesthetics that constitute the 1970s progression-regression paradoxes. It does so to contextualize the particular and varied set of concerns about freedom, slavery's legacies, gender equality, and black sexual politics, to name some issues, that cultural producers examined in light of the modern civil rights movement. Following Cornel West's analysis of the 1960s, this volume similarly thinks of the 1970s as "a historical construct or heuristic rubric that renders noteworthy historical processes and events intelligible," and examines how African American literature, cinematic production, and visual culture, for example, shape these conversations. Black cultural production does not simply reflect historical circumstances, nor do historical circumstances primarily shape black cultural production.[10] Instead, cultural production and politics work dialogically, and the essays in this volume unearth how both help us to understand the past and the present and to imagine the future.

Whereas prior to the civil rights movement an emphasis on "legal" issues dominated conversations about black disenfranchisement, the post–civil rights era magnified the limits of privileging equality under the law. Gene Jarrett rightfully contends "racial representation in African American literary history has consistently endeavored to overthrow racial injustice," and many critics apply

this proposition across black cultural modes of expressivity. This volume focuses on the nontraditional insights black cultural production provides on how to best "overthrow racial injustice."[11] While black cultural production serves as an important site of political critique and reconsideration, it also importantly carves out a space for what I am calling *political imaginative possibility*. The phrase political imaginative possibility aims to capture how black cultural production identifies sociopolitical shortcomings, intraracial antagonisms, and/or philosophical and/or ideological blind spots *and* provides a *radical* solution that pushes conventional ways of thinking about the matter. *Black Cultural Production* details how cultural productions often imagine how to make our world anew, and implicitly and explicitly provide strategies to attain this goal. It acknowledges the role black art historically has had in expanding black freedom, and de-privileges social scientific solutions to black disenfranchisement in the cultural and public imaginaries.

The solutions black cultural production offers often require us to invoke our imaginations and think outside of the norms that the existing sociopolitical order disciplines us to call upon when we imagine or think about black freedom. Black freedom, in many ways, remains a radical idea, and black cultural production turns attention to how radicality does not always completely reject a problematic idea, practice, or policy. In Ellisonian fashion, black cultural production underscores the merits of slipping the yoke and changing the joke.[12] One of the difficulties nevertheless of thinking about the political possibilities that black cultural production offers lies in the fact that the artistic production offers not so neat, and, often times, paradoxical formulations, that force the consumers to rethink the very ideas—freedom, enfranchisement, civil rights, community, agency—that undergird their notions of what it means to "overthrow injustice." This consideration of black cultural production foregrounds a matrix of intersections: where the sociological meets the artistic; the artistic meets the aesthetic; the aesthetic meets the political. Although African American cultural producers concern themselves with the material lives of black people, the protocols of realism that often circumscribe their work do not bind their art nor do the artists reduce their work to sociological realism. The shifts in cultural production aesthetics during the 1970s allowed African American cultural producers to experiment with contemporary artistic forms, including postmodernism and the black aesthetic, that expanded the boundaries of the tradition in which they produced, the nature of black cultural production itself, and ideas about blackness.

Black Cultural Production thus insists that black cultural production during the 1970s anchors the philosophical, aesthetic, and political debates that animate

contemporary debates in African American studies and insists that, despite abject social and political conditions, black cultural production keeps imagining how black people thrive, care, and forge communities. In *In the Wake: On Blackness and Being*, Christina Sharpe examines how contemporary racial logics find roots in chattel slavery to show "how slavery's violences emerge within the contemporary conditions of spatial, legal, psychic, material, and other dimensions of Black non/being as well as in black modes of resistance."[13] She further uses the word wake-work "to imagine new ways to live in the wake of slavery, in slavery's afterlives, to survive (and more) the afterlife of property."[14] By drawing upon a range of texts across cultural modes of expressivity, *Black Cultural Production* contextualizes the significant historical, cultural, political, and/or social events that shaped the cultural production and maintains a keen eye toward how the logics of slavery and Jim Crow animate contemporary politics. That is, it demonstrates the specific ways—materially, ideologically, aesthetically, and discursively—that the cultural production itself performs wake-work as the art imagines ways to circumvent black abjection and social death.

Black Cultural Production's essays therefore engage the particularities of the 1970s progression-regression paradox, by which unprecedented civil rights gains coexist with novel impediments to collectivist black liberation projects: among these, the rise of neoliberalism and a powerful conservative backlash, the pathologization and criminalization of poverty, and the growth of the prison-industrial complex. Within this cultural milieu, black writers, artists, historians, and critics have taken renewed interest in the historical roots of black un-freedom. As important, black cultural production engaged in this process to highlight how freedom and thriving might be achieved, and the cultural production provides a space to imagine possibilities for black thriving that have yet to be imagined or otherwise realized. They are concerned with, as are the essays in this volume, the possibilities for acknowledging a history of oppression, while moving beyond that history—and exploring if the ability to move beyond it is possible.

Literary Activisms: Black Cultural Production and Its Political Influence(s)

African American literary and cultural production, since its inception, has debated black artists' roles, and the roles of black arts, in African American life, culture, and politics. The ongoing presence of black sociopolitical disenfranchisement in American society *prior to* the civil rights movement accentuated demands that black cultural production intentionally and self-consciously fight

oppression and "expos[e] the white-supremacist, discriminatory, prejudicial, and inequitable degradation of African Americans on the basis of race."[15] The persistent presence of Jim Crow segregation *prior* to the civil rights movement draws attention to two related and important *shifts* that happen in the post–Jim Crow era; first, the word "prior" avoids overestimating the degree to which the modern civil rights movement reshaped the sociopolitical fabric of the United States. Second, it acknowledges how the social upheaval of the 1960s impacted artistic production by demanding (and allowing for) new modes of expression that had sometimes circumscribed aesthetic expectations for black art (realism in particular).

This claim thus rejects part of the premise that animates Kenneth Warren's *What Was African American Literature*, which makes astute claims yet relies too much upon an understanding of African American literary and cultural production as primarily reactionary. It also notably miscalculates the impact that the eradication of Jim Crow has had on black sociality and political life. Warren asserts: "my argument is that African American literature is not a transhistorical entity within which the kinds of changes described here have occurred but that African American literature itself constitutes a representational and rhetorical strategy within the domain of a literary practice responsive to conditions that, by and large, no longer obtain."[16] Warren's harshest critics would agree that African American literature is historically grounded and contextualized (not transhistorical). They also would concur that even though African American literature examines black life, literature remains bound to the limits of representation, and that representation, at best, only approximates black life (the debates about realism, though, might engender more skepticism here than on the previous claim). Critics' biggest dissent nonetheless emerges not in the idea that representational and aesthetic practices change in light of the end of Jim Crow; instead, they rightfully take exception to the innuendo that *literature* itself ends precisely because Jim Crow ends—as if Jim Crow really has ended. Against such a view, this volume insists the "post" in post–Jim Crow signals the *potential* "end of one manifestation of Jim Crow" and not the "end of" Jim Crow per se. This difference is significant. In this respect, *Black Cultural Production* adds to the scholarly project that *Contemporary African American Literature: The Living Canon* inaugurates when it rejects the claims that Warren offers, yet participates in the debates about black identity, aesthetics, and civil rights that Warren generates.[17]

The post–Jim Crow era, where legal, formal, and explicit forms of discrimination in the public sphere are eradicated, reconfigured how Jim Crow and its legacies later manifested themselves in American culture, law, and public

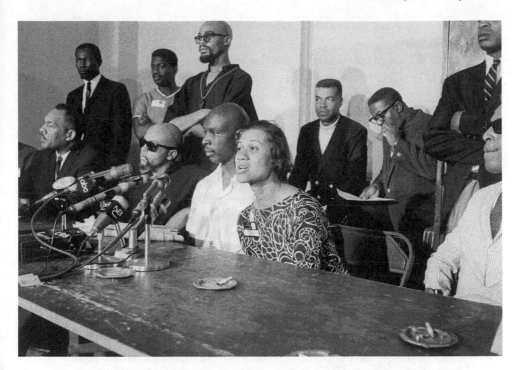

Figure 0.2. Gloria Richardson Standridge, a civil rights leader from Cambridge, Maryland., speaks at a news conference in the Episcopal Diocese headquarters in Newark, New Jersey, just before interruption by Black Power adherents who objected to the presence of white newsmen, July 22, 1967. At left is Jim Tayari, vice chairman of US, a more militant civil rights group from the west coast, and in white shirt is Omar Ahmed, chairman of the East River CORE chapter in New York City (AP Photo/John Duricka).

policy. With their skepticism toward the limitations of legal equality confirmed, artists and texts thus continued to envision new ways to imagine freedom in light of these reconfigured forms. The civil rights movement thus made palpable the progression-regression paradox of black life and politics, and this "post-integration" blues that it generates emerges in black cultural production. This phrase captures a vexed feeling about "how integration has affected black subjects because it amplifies both the immense gains achieved by the civil rights movement, and the cultural, political, and psychological fallout from these benefits."[18] In terms of black artistic production, artists who employ a post-integration blues aesthetic foreground how the post–civil rights moment also works to "create avenues for imagining blackness that refuse to be contained by the mutually exclusive poles of assimilation and separatism."[19] They also think more expansively about where the civil rights movement falls short in imagin-

ing black freedom dreams and proffer ways to think beyond the limitations of legal equality.

The politics of the civil rights movement's integrationist agenda, as well as those of the black nationalist's separatist one, continue to inform black artistic production in the post–civil rights era. Both movements think of blackness in particular ways, and artists in the 1970s call into question the efficacy of both ways (and not simply the black nationalist way, for example) to identify the limitations of each and provide new ways of conceptualizing blackness. The movements themselves and the distance from them that the 1970s provide equip artists with a critical lens to develop their political imaginative possibility. In Gershun Avilez's theorization of post–civil rights art, politics, and culture, he argues that artists employ an aesthetic radicalism, which he posits "describes how artists incorporated nationalism and created opportunities for experimenting with form as well as extending the reach of political rhetoric."[20] The desire for new aesthetics with greater political import extended beyond the nationalist (and assimilationist) paradigm(s) and a decisive turn against realism and realist aesthetics informs post–civil rights era black cultural production as well.

In *Abstractionist Aesthetics*, Philip Brian Harper argues that African American cultural production has found itself in a double bind wherein the expectations for social critique have circumscribed both African American cultural production and consumers' expectations to a realist mode. If racial realism, as Gene Jarrett specifies in *Dean and Truants*, "pertains to a long history in which authors have sought to re-create a lived or living world according to prevailing ideologies of race or racial difference,"[21] abstractionist aesthetics draw attention to the constructed-ness of the realist representation. Insofar as abstractionism "entails the resolute awareness that even the most realistic representation is precisely a *representation*," its aesthetic "crucially recognizes that any artwork whatsoever is definitionally *abstract* in relation to the world in which it emerges, regardless of whether or not it features nonreferentiality typically understood to constitute aesthetic abstraction per se."[22] Harper's argument thus joins a cadre of scholars whose explications of African American expressive culture decenter realism, emphasize the aesthetic and artistic elements of cultural production, and foreground the newly emphasized nonrealist aesthetics' potential for political transformation.

Black Cultural Production importantly brings into conversation a range of formative black cultural products—some of which received mainstream attention, scholarly and otherwise, some of which did not—to examine how the texts influenced and continue to shape ideas about blackness, black aesthetics, and black subjectivities. It situates black expressive culture as a critical and cru-

cial site for thinking about black politics and foregrounds black art's ongoing role in shaping black subjectivity and the black imagination. Black arts have functioned as a form of activism during political upheavals, and the return to black art's political influence in this post-Obama political moment allows us to understand how politics shape artistic creation and how artistic creation might shape black politics. In other words, contemporary contexts help us to uncover new meanings in texts, and the black cultural imagination remains a prime site for extracting new ways of thinking about politics, political activity, and subjectivities.

Conversations about blackness and black identity in the 1970s often held the black arts and Black Power movements as immediate interlocutors even when the artistic production does not name them explicitly. This context nonetheless calls to mind a series of texts about this period that *Black Cultural Production* thinks with and against. Eddie Glaude's *Is It Nation Time? Contemporary Essays on Black Power and Nationalism*, for example, provides a capacious analysis of what Glaude estimates to be "the ambiguous legacy of the black power movement" to correct the lack of serious scholarly engagement paid to the movement.[23] Like *Nation Time*, this volume considers the black arts and Black Power movements as formidable moments in black cultural politics and aesthetics, yet it does not devote its primary attention to them. An additional important interlocutor emerges in Lisa Gail Collins's and Margo Natalie Crawford's *New Thoughts on the Black Arts Movement*. As Collins and Crawford contextualize in the volume's introduction, the Kerner Commission Report (1968) had demonstrated long-term effects of discrimination and segregation and proposed that a national response be created to alleviate racial inequality and stratification. Collins and Crawford juxtapose the Kerner Commission Report's publication with the rise of Black Power to demonstrate how the political context and political movement emerge in the cultural production.[24] Although *Black Cultural Production* does not call forth the Kerner Commission Report explicitly, it does invoke its arguments when it insists that the need for equal outcomes persisted and that the government had a responsibility toward facilitating this process. *New Thoughts* examines how social and political contexts inform cultural production from the black arts movement, and *Black Cultural Production* analyzes how the cultural production helps us to understand this movement and other ones, too.

Black cultural production proliferated, despite attempts to thwart black political thriving and the imaginative possibilities it offers, and the 1970s often imagined an impending sociopolitical transformation. *In Black Post-Blackness*, Margo Natalie Crawford theorizes an aesthetics of anticipation, which she perceptively notes differentiates itself from waiting in its "activity." Crawford

explains: "The productive force of anticipation is its difference from waiting. Anticipation is much more active than waiting. Anticipation, like invisibility (as in Ralph Ellison's *Invisible Man*), gives one a 'different sense of time'; it makes one's present deeply tied to the future."[25] The 1970s witnessed a host of *first* achievements that arguably anticipated shifts in black cultural production that have occurred in the last five decades, and that staged a fluid relationship between the past, present, and future. Multiple cultural modes of expressivity often set the stage on which future black aesthetics and politics call forth political imaginative possibilities. To admit this truth is to recognize the 1970s as a paradigmatic archive for black cultural production.

The CBS cinematic adaptation of Ernest Gaines's *The Autobiography of Miss Jane Pittman*, for example, did more than popularize an important literary text that chronicled black leadership and civil rights struggles and triumphs from slavery to the modern civil rights movement. To the broader viewing public, the television series, by way of the then emerging actress Cicely Tyson, also cultivated the black viewing public's increased interest in more nuanced and complex engagements with black history and black life. In some respects, it reflects and anticipates a turn to slavery that the 1970s witnessed, and that the twenty-first century has re-witnessed. Similarly, the serializing of Alex Haley's *Roots* in a television miniseries becomes more legible when we accept *The Autobiography of Miss Jane Pittman's* cinematic success as a crucial indication of the black viewing public's cultural desires. This argument underscores a relationship between the broader historiographical interest in rewriting dominant narratives that had rendered black life, choice, and innovation subordinate, incomplete, or otherwise absent. While some may now lambast the aesthetic, political, and gender politics of Blaxploitation films, it remains important to hold that critique in tension with the progression-regression paradox, and to consider the productive possibilities that the cultural production engendered. We cannot, as it were, throw the baby out with the bath water. This logic, too, holds true, when we accept that *The Jeffersons* often reinforced the logics of black heteropatriarchy and capitalism, both of which undermine black thriving. At the same time, the show still calls forth innovative ways that the 1970s thought about black capitalism as a way to subvert (if not overthrow) racial injustice.

Black music similarly offered explicit critiques of the status quo as well as generated and participated in new aesthetic forms that ultimately expanded the boundaries of what constituted black music and blackness. Whereas black music undoubtedly protested a lack of civil rights, as the now late Queen of Soul Aretha Franklin's signature song, "Respect," is often thought to do, black music also protested America's involvement in the Vietnam War (Edwin Starr's

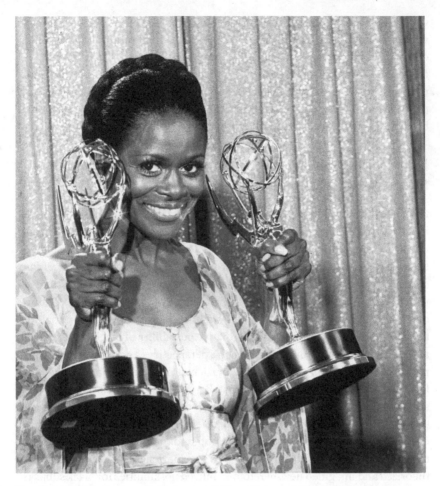

Figure 0.3. Cicely Tyson poses with her Emmy statuettes at the annual Emmy Awards presentation in Los Angeles, California, May 28, 1974. Tyson won for her role in *The Autobiography of Miss Jane Pittman* for actress of the year, special, and best lead actress in a television drama for a special program (AP Photo).

"War"). Yet the emergence of funk music during this era extended the general critique of culture and cultural movements that developed in popular music and also provided an imaginative space for black culture and politics to make themselves anew. Funk, as Brian Ward explains, "put a premium on personal expressivity, embraced a sort of manic hedonism, and reified the cool arts of dressing up and getting down in distinctively black ways. This was both great fun and a cultural response to the absence of any viable mass struggle for inte-

gration into an equalitarian, pluralistic America. Once more, black Americans were dancing to keep from crying."[26] While some might interpret Ward's claim of distinctively black ways as a nod toward racial essentialism, this analysis offers a more capacious understanding of the phrase as gesturing toward multiple distinct ways of defining blackness; in other words, the funk genre itself produced an aesthetic change that expanded the boundaries of what constituted blackness and black cultural production.

Black Feminism, Black Women's Literary and Cultural Renaissance

A volume that examines and theorizes black cultural production during the 1970s must acknowledge the multiple significances of the Black Women's Literary and Cultural Renaissance (as it is so often described) not only because of the sheer volume of literary production, but also because of its discursive *inspiriting influences*.[27] The literary renaissance inspired a broader cultural renaissance in which the guiding and still developing principles of black feminism continuously shaped black art (literature, plays, films, poetry, manifestoes) that unabashedly revealed the political imaginative possibility of black women, black art, and black politics from black women's perspectives and experiences. These points of view also foregrounded the particular challenges that black women faced and experienced in a racist, sexist, heterosexist, and classist society. By situating these stories within the context of black heteropatriarchy, these cultural producers broke with the nationalist aesthetic, and the silence of intraracial oppression and violence that contributed to their oppression.[28] Although they wrote from real, substantive, and lived experience, they simultaneously theorized and imagined new, heretofore unlived possibilities for black subjects.

In 1990, Patricia Hill Collins published the groundbreaking *Black Feminist Thought*, where she rejected the extant notions that insisted "subordinate groups identify with the powerful and have no valid independent interpretation of their own oppression" and that "the oppressed are less human than their rulers, and are therefore less capable of interpreting their own experiences."[29] To the contrary, Collins insists that black women have a standpoint, or a group knowledge/consciousness based on a common experience of oppression. She further claims that while these standpoints may vary, they do in fact provide independent interpretations of oppression and evidence black women's capacities to interpret their own experiences. Although Collins speaks broadly about black women's experiences, she intentionally resists characterizing black women monolithically and avoids the traps of essentialism. In a wide-ranging text that consid-

ers black popular culture, representations of black women, and the challenges of and possibilities for black relationships, *Black Feminist Thought* becomes a paradigmatic text in black feminism and draws upon and expands many of the conversations central to black feminism that emerged during the 1970s.

One of the most significant ideological and discursive transformations that the 1970s witnesses then is the growth of black feminism, and how black feminist thinking (re)shapes conversations about black life and politics. Across black cultural production, black feminism's earliest notions of intersectionality articulate political imaginative possibilities for black life that reject traditional, hierarchical gender roles and contravene the *traditional* logics of black nationalism and black aesthetics.[30] As Toni Cade (Bambara) puts it in her groundbreaking *The Black Woman*, "the usual notion of sexual differentiation in roles is an obstacle to political consciousness, that way those terms are generally defined and acted upon in this part of the world is a hindrance to full development."[31] As Bambara clarifies throughout "On the Issue of Roles," strict adherence to patriarchy (both white and black-hetero) thwarted the development of a radical, liberating political paradigm because the hierarchy upon which the roles were built necessarily differentiates and devalues black women. If her precursor and interlocutor Frances Beale had previously articulated how black women—vis-à-vis "double jeopardy"—had experienced a particular set of interlocking gender and racial oppressions that also had insidious economic repercussions for black women, Cade (Bambara) extended the argument to contend that black people also reject the very roles that would thwart their collective development.[32] Bambara's collection, similar to the other 1970s *first* texts that Angelyn Mitchell and Danille Taylor identify in their introduction to *The Cambridge Companion to African American Women's Literature*, "helped to establish the terms for both African American literary analyses and for black feminist criticism, highlighting the urgencies, issues, and concerns of African American women writers."[33] These texts influenced black cultural production more broadly, and the issues and concerns provided the necessary material from which black women cultural producers revealed their political imaginative possibilities.

When Kimberlé Crenshaw introduced the term "intersectionality" in the 1990s, she expanded upon the work black feminists before her had done to theorize how black women's race, gender, class, and sexuality, for example, produced a specific set of sociopolitical disadvantages that required specialized solutions. In the 1960s, for example, in "Double Jeopardy," Frances Beale rejected the masculinist politics of black liberation movements that accepted the normativity of sexism (and capitalism) in calling for civil rights for black men. Beale admonishes "those who are exerting their 'manhood' by telling black

women to step back into a domestic, submissive role are assuming a counter-revolutionary position. Black women likewise have been abused by the system, and we must begin talking about the elimination of all kinds of oppression."[34] Rejecting hierarchies of oppression that pit black men's interest against black women's, Beale continues an important conversation that demands the elimination of oppression for all people, including (and especially) black women. Undoubtedly, Bambara's text converges with Beale.

The conversation that Beale puts forth during the 1960s provides an important genealogy for locating Crenshaw's work, but so does Deborah King's "Multiple Jeopardy." Importantly, King's thinking rejects the notion that one form of oppression *merely* adds to another to instead argue for the multiplicative or exponential ways that different forms of oppression compound disadvantages. As King explains, "Most applications of the concepts of double and triple jeopardy have been overly simplistic in assuming that the relationships among the various discriminations are additive. . . . The simple incremental process does not represent the nature of black women's oppression, but rather, I would contend, leads to nonproductive assertions that one factor can and should supplant the other. . . . The modifier 'multiple' refers not only to several, simultaneous oppressions, but to the multiplicative relationships among them as well."[35] By emphasizing the multiplicative aspects of oppression and its resulting inequality, King calls forth the need for more complex and nuanced solutions to black women's specific experiences of many oppressions.

While black feminist thinking often challenged the sexism—and investments in capitalism—in black freedom struggles, and foregrounded the intersections of black women's multiple identities, its earliest instantiations at times reinforced heteronormativity. Barbara Smith's "Toward a Black Feminist Criticism," for example, considered what it would mean to read Morrison's *Sula* as a lesbian novel as a way to disrupt heteronormativity's vice grip on analyses of the text and to destigmatize lesbianism within black feminist criticism; put another way, Smith proposed that critics' resistance to reading the text as such might also illuminate a broader cultural homophobia.[36] In some ways, Smith inaugurates a conversation that Cheryl Clarke extends in "Lesbianism: An Act of Resistance," where she argues that "the lesbian has decolonized her body. She has rejected a life of servitude implicit in Western, heterosexual relationships and has accepted the potential of mutuality in a lesbian relationship—roles notwithstanding."[37] Clarke turns attention to how nonheteronormativity might in fact turn black oppression on its head, contravening contemporary discussions that foregrounded the need for heteronormativity as central to black people's abilities to succeed in the post–civil rights era.

Clarke and Smith emerge as important interlocutors in black feminist thinking lineages because they participate in an important conversation that calls into question the usefulness of respectability politics as a strategy for black people to use to fight oppression. Situated within the broader context of racial uplift ideologies that focused on black people espousing "normative" practices, for example, not having children out of wedlock, to prove their worthiness of citizenship rights, respectability politics have continued to shape intraracial and interracial ideas about black people's sexual and gender practices. In *Beyond Respectability*, Brittney C. Cooper recognizes the deep affective ties that black communities have had toward respectability politics and challenges them to look at the ways that black women intellectuals have cast doubt on respectability politics as a way to reimagine black liberation and gender relationships. By turning attention to those black women "who did not subscribe to respectability politics as a wholesale ideology for racial progress," Cooper's genealogy of black women's thinking about, attitudes toward, and practice/rejection of respectability politics constructs a broader history of black feminism's engagement with and challenging of respectability politics.[38] Cooper also allows us to contextualize the more pronounced critiques of respectability politics that emerge in light of the expansion of black feminist networks—through its institutionalization in academia, and its organization during black freedom struggles of the 1960s. These contexts inform its emergence in black cultural production and how black cultural production shaped black feminist thinking.

Black feminist cultural production thus became to black feminism what the black arts movement had become to Black Power: a mutually constitutive artistic-political and political-artistic movement that illuminated and challenged the ideological and pragmatic shortcomings of dominant discourses and practices, while articulating alternative, innovative possibilities for black life, art, and politics. Whereas the Black Power and arts movements focused on racialized manhood, black feminism extended this premise to focus on racialized womanhood without ever relegating or neglecting its relationship to racialized manhood and other intersecting identities. Black feminism, as Terrion Williamson explains, denotes "a sustained sociopolitical commitment to centering the lives of black women and girls while actively struggling against racism, sexism, heterosexism, classism and other intersecting modalities of oppression that affect those who do not identify as either black or female."[39] Inasmuch as black feminism foregrounded black women's subjectivity in its thinking about gender, race, and politics, it kept black men's subjectivities in mind, too, as they related to black women, other black men, and society more generally. Black feminism desired more so to expand the capaciousness of com-

munity than it did to invert gender (and sexual dominant) hierarchies; that is, its conceptualization of a thriving community meant that black women and men had to interact and collaborate outside of the social norms, which insisted on the elevation of men at the expense of women. It would perhaps then be more accurate to say that black nationalism neglected to consider black women outside stereotypical dominant roles than it had ignored them altogether. The similar elision of blackness in white feminist theorizations also compelled the formation of black feminism, even as we acknowledge that black feminism did not emerge solely as a reactionary enterprise.

Toni Morrison's *The Bluest Eye* (1970), *Sula* (1973), *Song of Solomon* (1977); Gayl Jones' *Corregidora* (1975); Alice Walker's *The Third Life of Grange Copeland* (1973) and *Meridian* (1976); and Michele Wallace's *Black Macho* (1980) represent a small cadre of black women's cultural productions that are, in the words of L. H. Stallings, "countering the dispossession and displacement that happens though the privatization and politicization of love and intimacy via monogamy and marriage."[40] Collectively, these representations include: women-led households that succeed; black men–led households that threaten women's survival; single-women households that thrive; and bisexual and lesbian relationships between women. Together, these texts further call into question the efficacy of what Candace Jenkins theorizes as the "salvific wish" and foregrounds instead what Susana Morris theorizes as a "community of support."[41] Together, Stallings, Morris, and Jenkins provide theoretical examinations of black women's writing that demonstrate how the artists' political imaginative possibilities reject "the endangered" or "pathological" family discourses so central to post–civil rights era analyses of black life, black family, black culture, and black politics.

By rejecting the masculinist ideologies that privilege patriarchy and men (the salvific wish) in a text such as Morrison's *Sula*, for example, black cultural producers suggest that (black) men become necessary for communal thriving *only* in a society that exploits and devalues women. As Jenkins explains, "That period, beginning in the latter half of the 1960s and continuing through the 1970s, would be more focused on black patriarchal power than any previous period in the twentieth century. . . . the thinly veiled misogyny of suggestions that black women, occasionally in collusion with or as proxies for white racism, stand in the way of (black) patriarchy's success."[42] This point intimates then the multitudinous ways that society operates on the exploitation of black women, but naturalizes that process by attributing it to family structure and gender conformities (or lack thereof). The cultural production, by contrast, highlights the State's s role, through industrialization and suburbanization, for example, in reproducing inequality for black families, in general, and black women in

particular.[43] Throughout the chapters in this volume, the authors expand upon black feminist thinking, both complementing and supplementing the claims the introduction lays out.

The Plan for This Volume

The literary, cinematic, poetic, visual, and dramatic constitute the primary cultural forms of expressivity that this volume engages, yet it keeps in mind the broader cultural shifts these artists generated. Through historically grounded and sociopolitically contextualized arguments, the essays consider how the cultural production conformed to, broke away from, and created additional paradigms for black cultural production. The 1970s figure centrally, yet to understand this period, what influences it, and how it influences, this volume necessarily looks backward and forward, emphasizing the fluidity of temporal boundaries. By collapsing a rigid temporality between the past, present, and future, *Black Cultural Production* begins by examining the persistence of slavery in African American cultural production because, as the earlier discussion of Sharpe suggests, there is a fluid relationship between slavery, the present, and the future. To imagine black freedom, we must interrogate slavery.

Within the field of African American studies, slavery remains an indistinguishable part of contemporary black life and American race relations, even as scholars debate to what degree. Because slavery becomes so prominent across black cultural modes of expressivity in the post–civil rights era, the volume's first three chapters consider a host of issues that remain important to the study of slavery, including how the Black Power movement invoked this historical moment, how cinematic approaches to slavery have evolved throughout the late twentieth century, and how gender and sexuality shaped racial representations of slavery. By establishing the significance of slavery as an overarching narrative arc for understanding blackness and contemporary debates about it, the volume turns attention to post–civil rights representations of blackness in literature and visual culture to consider how black cultural producers use the slave past to understand the contemporary moment and to imagine the future. Chapters 4 through 8 then explicitly turn attention to the interrelationship between black art, black feminism, and black culture, demonstrating the dialogic that formed among the texts and continues to resonate. The ability of black literature to enjoy large circulation depended, too, on the ability of it to get published, so Chapter 9's examination of black publishing venues and the role Black Power thinking played in those publication choices contextualize how the trends the first eight chapters identify become entrenched in black cultural spaces. Chapter 10, while

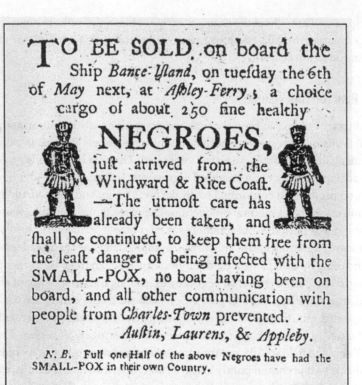

Figure 0.4. This is an undated image showing a circa 1780 newspaper advertisement by the slave-trading dealership of Austin, Laurens and Appleby announcing the arrival of African slaves to the American colonies at Ashley Ferry outside of Charleston, South Carolina (AP Photo).

considering again the significance of race and gender in black theatrical production, purposefully follows Chapter 9 because this chapter draws attention to the role theater had in creating spaces and communities of black viewing/reading publics. And it is these publics in which the texts circulated and through whom they performed their activism and engendered more expansive notions of black subjectivities, black life, and black politics.

African American cultural modes of expressivity's preoccupation with American chattel slavery and its legacies since the 1970s attests to how this era of American history continues to shape and reshape American life, culture, and politics. Indeed, the obsession with slavery demonstrates the degree to which all are, in the words of Christina Sharpe, post-slavery subjects, "fully consti-

tuted by the discursive codes of slavery and post-slavery" even as "post-slavery subjectivity is largely borne and readable on the (New World) *black* subject."[44] The advent of now canonical texts about slavery in the 1970s (for example, Jones's *Corregidora*, Reed's *Flight to Canada*, and Butler's *Kindred)* provided fecund space for scholars to theorize the genre of the neo-slave and emancipatory slave narratives, and the cultural, political, and psychological work these narratives performed in black and/or American culture.[45] Beyond remembering slavery, filling in potential historical gaps, imagining the unimaginable, and speaking the unspeakable, these narratives recast slavery and its legacies as historically contingent and contemporarily relevant to the making of black politics, political desire, and black subjectivities. As Aida Levy-Hussen astutely puts it, "contemporary narratives of slavery dramatize African Americans' enduring attachments to an unresolved history of racial trauma that appears at once a site of unresolved suffering and an object of reparative desire."[46] Yet, the "hermeneutics of therapeutic reading" that intend to fulfill our reparative desire and resolve our suffering become undone by the impossibility of repair.

At this point in the twenty-first century, the lauded neo-slave narratives have themselves begun to transition, and twenty-first-century examinations of slavery, as Toni Morrison's *A Mercy* evidences, turn into what Margo Natalie Crawford argues are post–neo slave narratives; that is, they mark "a move from the literary imagination that fills in the gaps (what historians cannot know) to the refusal to fill in the gaps but to linger in the unknown."[47] This push to linger in the unknown calls forth the unknowability of the slave past and its legacies, despite the desire to know *more about* both. It also gestures toward the fact that making sense of the afterlives of slavery may require becoming comfortable with slavery's (and antiblackness) incomprehensibility. This claim seems to embody the condition of blackness in the post–civil rights era and underwrites the complex vision of the cultural producers' various political imaginative possibilities. Put another way, it captures a double bind between the desire to know, understand, and move forward on the one hand, and the impossibility of knowing, understanding, and moving forward on the other. With slavery's return to representational priority (and not the return to slavery), this volume opens.

Madhu Dubey's Chapter 1 argues that the black arts movement produced a Black Power literature of slavery that used the aesthetic call for experimental forms to examine slavery and its legacies. By examining texts that include Ronald Fair's *Many Thousand Gone*, Amiri Baraka's *Slave Ship*, and Blyden Jackson's *Operation Burning Candle*, Dubey demonstrates how "in literary works informed by Black Power, psychopolitical breakthrough demands formal techniques violating realist conventions, such as flattened allegorical modes of characteriza-

tion and plot structures marked by temporal simultaneity that culminate in cata-
clysmic change." Dubey insists that in this less-studied Black Power literature
of slavery, artists demand that we pay as much attention to slavery's psychic
and psychological legacies as we do to its material ones. She illuminates how
black aesthetics shape black politics and black politics shape black aesthetics
as she disrupts the tendency to think of "literature about slavery" beginning
primarily in the mid-1970s.

Lisa Woolfork's Chapter 2 analyzes the proliferation of narratives about slav-
ery during the second half of the 1970s in order to reveal how "[t]hey narratively
reanimated the slave past, textually reinhabited it, and imaginatively pulled
forward elements of its overlooked significance." By foregrounding the trope
of "generations" in Lucille Clifton's *Generations*, Alex Haley's *Roots*, Ishmael
Reed's *Flight to Canada*, and *Octavia* Butler's *Kindred*, Woolfork argues that the texts
examine slavery in order to show its material and discursive presences in the
post–civil rights era. Using the trope of generations, Woolfork pays particular
attention to how slavery informs contemporary discussions of black familial life.
Exploring the formal and thematic devices authors employ to disrupt temporal
distinctions between the past, present, and future, Woolfork reveals how the
texts conjoin claims about slavery's enduring aftermath with the possibilities
for black futurity. Woolfork foregrounds the role that African American literary
production specifically has had in influencing the broader cultural imagination's
engagement with slavery's afterlives by foregrounding black interior lives.

In Chapter 3, Monica Ndounou turns attention to how the 1970s onslaught of
films about slavery fit within a broader cultural imperative to capture slavery's
complexities and atrocities by foregrounding the perspectives of black people.
Her examination of films, which includes *Mandingo*, *Sankofa*, the *Roots* remake,
and *The Birth of a Nation* (Nate Parker's), analyzes the significance of narrating
slavery from black people's points of view. By drawing parallels between the
racial politics of the 1970s and the contemporary moment, she also suggests
the resurgence of films about slavery in the twenty-first century speaks to the
unfinished legacies of slavery and Jim Crow. Ndounou "examine[s] the format,
economic data, narrative focus, casting, reception and genre of a sampling of
films" to disrupt the white savior perspective that too often dominated films
about slavery and to illuminate the interiority of black life and subjectivity that
post–civil rights era black cultural production aims to capture.

Courtney R. Baker's Chapter 4 elucidates how visual culture more gener-
ally became an important site for black people to think about race, rights, and
enfranchisement during the post–civil rights era. The eradication of Jim Crow
upended the spatial logics of segregation and allowed black bodies to enter pre-

viously prohibited spaces. Accordingly, Baker argues, "With this more elastic notion of space, African-American visual culture was able to address itself to the decolonization of memory, the body, gender, sexuality, ritual, the future, and representation itself to envision not only new spaces but also the new Black subject who would inhabit these spaces." Her investigation of Blaxploitation films, Pam Grier's women-in-prison films, television shows, and art work such as Betye Saar's *Liberation of Aunt Jemima* produced during the 1970s, for example, emphasizes that the end of segregation provided access to material opportunities that in turn expanded the psychic boundaries of blackness. These new notions of blackness, as she explains, existed alongside notions of heteronormativity and traditional gender roles that constricted the more elastic notions of race.

Nadine Knight's Chapter 5 returns to the Black Women's Literary and Cultural Renaissance to demonstrate how anti–Vietnam War protest remains an important yet understudied movement in this cultural production. Knight uncovers how the growing anti–Vietnam War tide in the Black Power movement spurs a broader inter- and intraracial critique of racial, gender, and sexual politics by black women cultural producers. In light of the deferred freedom dreams of the 1960s, Knight asserts that "the question of rage, and how it was best expressed, guided black women of the 1970s as they critiqued the black/white struggle, celebrated the freedom of disruptive rhetoric, and reimagined the deployment of militancy and violence within black families and communities." Through her analysis of texts, which includes Toni Cade Bambara's *The Black Woman*, Toni Morrison's *Sula*, Nikki Giovanni's *Creation*, and June Jordan's *His Own Where*, Knight usefully foregrounds black women's roles in the anti-Vietnam protest to demonstrate how they invoked it, in conjunction with discourses about violence and militancy, to (re)shape conversations about leadership and human rights in the post–civil rights era.

Samantha Pinto's Chapter 6 examines the interrelationship between aesthetics and politics and how the movement away from literary realism marked a concurrent shift away from racial and gendered essentialism. These trends afforded black women writers in general, as Kennedy's *A Funny House for the Negro* and Ross's *Oreo* evidence more specifically, the opportunity to "locate possibility— both painful and pleasurable—in the consumption of popular performances of sexuality, gender, and race that they draw on to constitute an emergent black feminist literacy that does not rely solely on literary realism." Using the term *literacy* to hone our attention on black women's roles as both cultural producers *and consumers*, Pinto demonstrates how the under-studied area of black women's cultural consumption also expands notions of what constitutes black women's subjectivities and artistic modes of expression.

Jermaine Singleton's Chapter 7 investigates Gayl Jones's *Corregidora* and draws upon theories of mourning and melancholia to tease out how post-slavery subjects negotiate slavery's traumatic legacies. By focusing primarily on *Corregidora*, Singleton foregrounds Jones's significance in the Black Women's Literary Renaissance and examines the text as a case study to understand how it (and others) shifted conversation in Black Studies about racialization. Singleton posits that "Jones's novel embeds and utilizes the productive tensions between past and present, African American resistance and healing, and blackness as a public and private claim to destabilize foundational tenets and cultural reverberations of racial ideology." Singleton also foregrounds how and why discussions about race accentuate gender and sexuality more prominently in the post–civil rights era.

Terrion Williamson's Chapter 8 analyzes the trope of the angry black woman to call attention to the many ways that this image circulates in American culture and to reveal how it functions to undermine black women's rightful and understandable feelings of anger. As Williamson explains, "I am not concerned with black women's anger *per se* but with the trope of the angry black woman—which I see not so much as a misrepresentation of black women as a misappropriation of black women's anger—as it is mobilized within cultural discourse." By contextualizing the rise of this trope alongside black women's increasingly vociferous critiques of racialized sexism in black cultural venues, including *The Black Scholar* and Cade's *The Black Woman*, Williamson demonstrates how black cultural production used the trope of the angry black woman to expand ways of understanding and imagining black women (Michele Wallace's *Black Macho*), despite efforts to use the image to discipline black women into black heteropatriarchal scripts (the infamous Moynihan report).

Kinohi Nishikawa's Chapter 9 argues that the increase in black-owned publishing venues during the 1960s and 1970s allowed black writers not to appeal to white-owned presses and white-dominated literary audiences. The proliferation of writing by African Americans and the growth in black publishing venues shape the values and preferences of a newly emerging class of black readers. These newly formed literary publics centered black interests, aesthetics, and politics. As Nishikawa contends, "As distinct from the general reading public or the concept of the public sphere, a literary public is one that values the specific qualities of imaginative writing to constitute and engage a social body." Nishikawa details the significant role black presses had in generating conversations about race, politics, and aesthetics in post–civil rights era black communities and considers how the philosophies of the black freedom struggles in general, and Black Power in particular, influence publishing institutions.

Soyica Colbert's Chapter 10 examines Ntozake Shange's *for colored girls* to illuminate the play's pioneering role in engendering needed conversations about domestic violence in black intimate spaces. By analyzing Shange's choreopoem and Tyler Perry's cinematic adaptation, Colbert considers how "[t]he ongoingness of Shange's work perpetuates its ability to confront, depict, and produce strategies and techniques to heal from violence particularized by the intersectional position of being a woman of color." By situating the choreopoem within the emerging conversations about black bodily agency and intimate partner violence, Colbert demonstrates how Shange's aesthetic choices and thematic content coalesce to articulate a politics of black womanhood that foregrounds the ability to exert control over black women's bodies and sexuality as central to their efforts for equality.

Collectively, the chapters in *Black Cultural Production* specify and contextualize the significant historical (civil rights movement and subsequent anti–civil rights backlash movements), cultural (black feminism and the black arts movement), and/or political (Black Power movement and anti-Vietnam movements) events that shaped—and were shaped by—cultural productions during the 1970s. It argues that African American cultural production continues to influence, determine, and engage in social critique and transformation and remains an imperative, essential site for the (re)making of black politics. By foregrounding the political imaginative possibilities that the cultural productions make possible, the essays locate black art and aesthetics as equally important vectors in remaking the sociocultural fabric. In the essays' examinations of significant "topics/issues in African American cultural studies of the 1970s," including slavery, civil rights, cinema and visual culture, black popular culture, black cultural institutions, black theater, and black women's cultural production during this cultural renaissance, the volume's historiography of black cultural productions theorizes black cultural production's intertextuality and interdisciplinarity.

Notes

1. W. E. B. DuBois, *The Souls of Black Folk* (Boston: Beacon Press, 2011), 5.

2. The fact that Hansberry's father had settled the case against residential segregation in 1940 and the fact that Hansberry writes this play in 1959 and bases it on this experience reinforces the point here about de jure and de facto segregation's embeddedness.

3. See Michelle Alexander, *The New Jim Crow: Mass Incarceration in the Age of Color Blindness* (New York: The New Press, 2012).

4. Bayard Rustin, "From Protest to Politics: The Future of the Civil Rights Movement" [1965], in *Time on Two Crosses* (San Francisco: Cleif Press, 2003), 112.

5. King, *Where Do We Go from Here: Chaos or Community?* (Boston: Beacon Press, 2010), 159.

6. For a keen discussion about the rise of neoliberalism, see Jodi Melamed, "The Spirit of Neoliberalism: From Racial Liberalism to Neoliberal Multiculturalism," *Social Text* 29.4 (2006): 1–24; and Grace Hong, *Death beyond Disavowal: The Impossible Politics of Difference* (Minneapolis: University of Minnesota Press, 2015). For a discussion about the welfare state's racialization, see Yascha Mounk, *The Age of Responsibility: Luck, Choice and the Welfare State* (Cambridge: Harvard University Press, 2017).

7. James Baldwin, *Notes of a Native Son* (Boston: Beacon Press, 2002).

8. See Manning Marable, *Race, Reform, and Rebellion: The Second Reconstruction and beyond in Black America, 1945–2006* (Jackson: The University Press of Mississippi, 2007) and Ronald Walters and Robert Smith, *African American Leadership* (Albany: State University of New York Press, 1999).

9. See Jacquelyn Dowd Hall, "The Long Civil Rights Movement and Political Uses of the Past," *Journal of American History* 91.4 (2005): 1233–1263.

10. Cornel West, "The Paradox of the African American Rebellion," in *Is It Nation Time? Contemporary Essays on Black Power and Nationalism.* Ed. Eddie S. Glaude Jr. (Chicago: University of Chicago Press, 2002), 22.

11. Gene Jarrett, *Representing the Race: A New Political History of African American Literature* (New York: New York University Press, 2011), 6.

12. Ralph Ellison, "Change the Joke and Slip the Yoke," *Partisan Review* 25.2 (1958): 212–222.

13. Christina Sharpe, *In the Wake: On Blackness and Being* (Durham: Duke University Press, 2016), 14.

14. Ibid., 18.

15. Jarrett, *Representing the Race*, 6.

16. Kenneth Warren, *What Was African American Literature?* (Cambridge: Harvard University Press, 2010), 9.

17. In the introduction, King and Turner note that they reject the terms that Warren lays out and then discuss the many ways the volume's essays respond directly and indirectly to Warren's claims. See pages 1–13 in *Contemporary African American Literature: The Living Canon*. Eds. Lovalerie King and Shirley Moody-Turner (Bloomington: Indiana University Press, 2013).

18. Alexander G. Weheliye, "Post-Integration Blues: Black Geeks and Afro-Diasporic Humanism," in *Contemporary African American Literature*, 213.

19. Ibid., 214.

20. Gershun Avilez, *Radical Aesthetics and Modern Black Nationalism* (Urbana: University of Illinois Press, 2016), 4,

21. Gene Jarrett, *Deans and Truants: Race and Realism in African American Literature* (Philadelphia: University of Pennsylvania Press, 2006), 8.

22. Philip Brian Harper, *Abstractionist Aesthetics: Artistic Form and Social Critique in African American Culture* (New York: New York University Press, 2015), 2.

23. Eddie Glaude Jr., "Introduction Revisited," in *Is It Nation Time?* 1.

24. See pages 2–8 in particular, "Introduction: Power to the People! The Art of Black Power." Eds. Lisa G. Collins and Margo Natalie Crawford (New Brunswick: Rutgers University Press, 2006).

25. Margo Natalie Crawford, *Black Post-Blackness: The Black Arts Movement and Twenty-First Century Aesthetics* (Urbana: University of Illinois Press, 2017), 30.

26. Brian Ward, *Just My Soul Responding: Rhythm and Blues, Black Consciousness, and Race Relations* (Los Angeles: University of California Press, 1998), 354.

27. In *Inspiriting Influences*, Awkward compellingly argues that black women's writing possesses an intertextuality, cultivated by black women's writing communities. I extend the premise here to think about how black women's cultural production more generally was in conversation by echoing similar themes, even when they sometimes diverged in argument. See Michael Awkward, *Inspiriting Influences: Tradition, Revision, and Afro-American Women's Novels* (New York: Columbia University Press, 1991).

28. See Madhu Dubey, *Black Women Novelists and the Nationalist Aesthetic* (Bloomington: Indiana University Press, 1989) and David Ikard, *Breaking the Silence: Toward a Black Male Feminism* (Baton Rouge: Louisiana State University Press, 2007).

29. Patricia Hill Collins, *Black Feminist Thought: Knowledge, Consciousness, and the Politics of Empowerment* (New York: Routledge, 2000), 24.

30. Of the voluminous texts that represent this claim, representative samples include: Alice Walker, "In Search of Our Mother's Gardens," (402–409); Barbara Smith, "Toward a Black Feminist Criticism," (410–427); and Deborah McDowell, "New Directions for Black Feminist Criticism" (428–441) in *Within the Circle: An Anthology of African American Literary Criticism: From the Harlem Renaissance to the Present* ed. Angelyn Mitchell (Durham: Duke University Press, 1994). Michele Wallace, "A Black Feminist's Search for Sisterhood," *Village Voice*, July 28, 1975, 7.

31. Toni Cade Bambara, *The Black Woman: An Anthology* (New York: Pocket Books), 123–124.

32. See Frances Beale, "Double Jeopardy: To Be Black and Female," in *Words of Fire: An Anthology of African-American Feminist Thought*. Eds. Beverly Guy-Sheftall and Johnetta Cole (New York: The New Press, 1995), 146–157.

33. Angelyn Mitchell and Danille Taylor, *The Cambridge Companion to African American Women's Literature* (New York: Cambridge University Press, 1999), 4.

34. Beale, "Double Jeopardy," 148.

35. Deborah King, "Multiple Jeopardy, Multiple Consciousness: The Context of Black Feminist Consciousness," in Guy-Sheftall, *Words of Fire*, 297.

36. Smith, "Toward a Black Feminist Criticism," in *Within the Circle*.

37. Cheryl Clarke, "Lesbianism: An Act of Resistance," in Guy-Sheftall, *Words of Fire*, 242.

38. Brittney Cooper, *Beyond Respectability: The Intellectual Thought of Race Women* (Urbana: University of Illinois Press, 2017), 25.

39. Terrion Williamson, *Scandalize My Name: Black Feminist Practice and the Making of Social Life* (New York: Fordham University Press, 2017), 7.

40. L. H. Stallings, *Funk the Erotic: Transaesthetics and Black Sexual Cultures* (Urbana: University of Illinois Press, 2015), 125.

41. Jenkins defines the salvific wish: "These nineteenth-century gestures toward communal uplift through the adoption of bourgeois values are the beginnings of the pattern of black female and middle-class desire." As she elaborates, "according to the salvific wish, black women (and, to a much lesser extent, black men) could pay with their bodies, or rather with the concealment and restraint of those bodies, for the ultimate 'safety' of the black community as a whole." (13–14). See Candace Jenkins, *Private Lives, Proper Relations: Regulating Black Intimacy* (Minneapolis: University of Minnesota Press, 2007). Morris defines "an ethic of community support and accountability" as "an ethos of family that emphasizes mutually observed affection, affirmation, loyalty, and respect without the repressive aspects of respectability politics" (10). Although it is not, as Morris notes, "a political strategy in the way that respectability politics has been," this "diverse range of cultural practices" also has political implications. Susana Morris, *Close Kin, Distant Relatives: The Paradox of Respectability in Black Women's Literature* (Charlottesville: University of Virginia Press, 2014).

42. Jenkins, *Private Lives*, 89.

43. Roderick Ferguson fleshes out this issue further in *Aberrations in Black: A Queer Color of Critique* (Minneapolis: University of Minnesota Press, 2003), where he demonstrates how, since the turn of the twentieth century, the state has increasingly displaced responsibilities that it had heretofore held onto black families in general and the black husband in particular.

44. Christina Sharpe, *Monstrous Intimacies: Making Post-Slavery Subjects* (Durham: Duke University Press, 2010), 3.

45. Arlene Keizer, *Black Subjects: Identity Formation in the Contemporary Narrative of Slavery* (Ithaca: Cornell University Press, 2004); Angelyn Mitchell, *The Freedom to Remember: Narrative, Slavery, and Gender in Contemporary Black Women's Fiction* (New Brunswick: Rutgers University Press, 2002); Ashraf Rushdy, *Neo-Slave Narratives: Studies in the Social Logic of a Literary Form* (New York: Oxford University Press, 1999); and Bernard Bell, *The Afro-American Novel and Its Traditions* (Amherst: University of Massachusetts Press, 1989).

46. Aida Levy-Hussen, *How to Read African American Literature* (New York: New York University Press, 2016), 2.

47. Margo Natalie Crawford, "The Inside-Turned-Out Architecture of the Post-Neo-Slave Narrative," in *The Psychic Hold of Slavery: Legacies of Slavery in American Expressive Culture*. Eds. Soyica D. Colbert, Robert J. Patterson, and Aida Levy-Hussen (New Brunswick: Rutgers University Press, 2016), 70.

Freedom Now

Black Power and the
Literature of Slavery

MADHU DUBEY

The outpouring of literature about slavery since the 1970s is now a widely recognized phenomenon of African American literary history and culture. In the extensive critical scholarship on this literature, a canon of sorts has emerged, taking as its point of departure novels published in the mid- to late-1970s, such as Gayl Jones's *Corregidora* (1975), Ishmael Reed's *Flight to Canada* (1976), and Octavia Butler's *Kindred* (1979). Extending to works published from the 1980s into the twenty-first century, this canon notably includes Toni Morrison's *Beloved* (1987), Charles Johnson's *Middle Passage* (1990), and Edward Jones's *The Known World* (2003). That these texts form our contemporary canon of literature about slavery makes perfect sense, given that they are marked by rich formal experimentation that lends complexity to their explorations of the inheritance of slavery. Scholars agree that the preoccupation with slavery since the 1970s—in African American literature but also in the wider realms of American literature and culture, as the chapters in this volume evidence—constitutes a retrospective attempt to take stock of the shifting significance of race in the post–civil rights decades. But what is missing from our canon of literature about slavery is an earlier and fairly cohesive body of works produced during the peak years of racial turbulence, works that may be loosely characterized as Black Power literature of slavery.[1]

Published or performed from the late-1960s through the mid-1970s, these predominantly male-authored works include novels and plays such as Ron-

ald Fair's *Many Thousand Gone* (1965), Amiri Baraka's *Slave Ship* (1967), Harold Courlander's *The African* (1967), Joseph Walker's *Ododo* (1968), John Oliver Killens's *Slaves* (1969), Loften Mitchell's *Tell Pharaoh* (1970), John Williams's *Captain Blackman* (1972), and Blyden Jackson's *Operation Burning Candle* (1973). Spanning dramatic and fictional genres from ritual theater, musical epic, and historical pageant to fugitive slave narrative, speculative history, and political thriller, these works engage what was widely seen as a moment of racial crisis by way of formal innovations directly sparked by Black Power discourses on slavery. It is not surprising that the Black Power movement proved so generative for experimental literature about slavery, considering its call for "new forms" of freedom capable of disrupting a centuries-old history of racial oppression.[2] Black Power discourse invokes slavery to name a paralyzing burden of psychological dependency that persists into the present, and it positions itself, in contradistinction to the civil rights movement, as the emancipatory force that can break this continuum by means of thoroughgoing psychological transformation. In literary works informed by Black Power, psycho-political breakthrough demands formal techniques violating realist conventions, such as flattened allegorical modes of characterization and plot structures marked by temporal simultaneity that culminate in cataclysmic change. However, this literature also exposes fault lines in Black Power accounts of historical change, in particular its masculinist and absolutist notions of political agency, which would be more deeply probed in the subsequent canon of literary works about slavery.

Slavery is crucial to the task of historical revision urged by a broad spectrum of 1960s militants ranging from the Black Panthers to cultural nationalists. Its most vital function is to lay bare the "foul annals of American history" by dismantling its founding myths, its periodizing logic, and its presumed teleology.[3] Calling for a "new evaluation" of U.S. history, Eldridge Cleaver invokes slavery to discredit America's idealized self-image as a nation founded on the principle of freedom. Cleaver extensively quotes Frederick Douglass to show that the contradiction inherent in American national identity was best understood by its "most alienated" citizens, the enslaved. Douglass's "scorching indictment" of slavery "can still, years later, arouse an audience of black Americans" because the legacy of slavery endures into the present, belying the widespread belief that the arc of U.S. history ultimately bends toward "freedom and justice for all."[4] Disputing this belief entails a reconsideration of the Civil War period as a crux moment of historical transition. The Emancipation Proclamation, Stokely Carmichael and Charles Hamilton note in *Black Power*, failed to bring about substantive freedom, as the formerly enslaved were systematically disenfranchised following the failure of Reconstruction. Literary texts informed by

Black Power echo this view of postbellum history as an extension of slavery by another name: to quote the choric voice in Joseph Walker's play *Ododo*: "We've never left slavery/ Reconstruction is yet to be."[5] The racial strife of the 1960s accordingly resumes the unfinished business of the Civil War.

Carmichael and Hamilton reserve their sharpest critique for the idea that the civil rights movement marked the end of the struggle for freedom dating back to slavery. Black Power discourse fashions itself as the vanguard of real change, and it shores up this account of its own historic significance by relegating the civil rights struggle to a past on the verge of becoming obsolete (see the discussion of Black Power in Chapter 9 of this volume). The civil rights movement represents "the language of yesterday," assert Carmichael and Hamilton, specifying that its idiom of patience is utterly "irrelevant" in the face of growing black militancy.[6] Such accounts were meant to dispel the widespread perception of the peak years of the civil rights movement, 1955–1965, as the "decade of progress." In fact, claims Nathan Wright, the misuse and overuse of the term 'progress' is what precipitated "the crisis which bred Black Power."[7] While Carmichael and Hamilton consign the civil rights movement to an unspecified "yesterday," other advocates of Black Power go further, identifying it with the past of slavery. The civil rights movement could not bring about real freedom because it was held captive to "the slave mentality of looking to others for direction and support," in Nathan Wright's view.[8] Militant writings of this time reference slavery to disparage various aspects of the civil rights movement, such as its nonviolent and gradualist approach, its integrationist goals, and the idealistic faith in American commitment to racial equality that was implicit in its tactics of moral persuasion. In the words of Amiri Baraka, writing as LeRoi Jones in 1967, "The civilrighter is usually an american, otherwise he would know, if he is colored, that that concept is meaningless fantasy. Slaves have no civil rights."[9]

Disenchantment with civil rights ideals permeates Black Power literature of slavery. Calling out America as a "Paper Nation," Walker's *Ododo* profanes sacrosanct documents such as the Constitution and the Civil Rights Act by urging the audience to use them as toilet paper.[10] In Blyden Jackson's political thriller *Operation Burning Candle*, the militant Aaron justifies his plot to assassinate Southern congressmen by pointing to the futility of the civil rights movement, which perpetuated a subservient mentality rooted in slavery. Ronald Fair's *Many Thousand Gone* plays a quirky variation on this motif of debunking civil rights models of progress. Fair sketches a scenario in which slavery has continued into the mid–twentieth century in Jacob County, Mississippi, unbeknown to the rest of the nation or to the federal government. Taking a civil rights

approach, members of the older generation write a letter to the U.S. President, beseeching him to help deliver them into freedom. The president responds by sending federal marshals who are easily outwitted and thrown into jail by the county sheriff. It is not federal intervention but violent rebellion that eventually brings about freedom: the enslaved burn down the town and, in the bitterly funny final twist of the plot, it is they who liberate the ineffectual federal marshals from jail.

Keeping faith with the aims of Black Power, Fair and other writers disavow the civil rights movement in order to nullify progressive narratives of U.S. racial history. Slavery is instrumental to this purpose, of not only exposing the "bold whitewash of history," in John Williams's phrase, but also constituting the present as a moment of racial confrontation rather than reconciliation.[11] At once historical and urgently presentist, these works promote a truth-telling approach to the past even as they dispense with the conventions of formal realism. Insistent repetition of refrains, such as "Let the record be read and read well" in Loften Mitchell's drama *Tell Pharaoh* and "Let me tell you about slavery and all the truth it made me see" in *Ododo*, attest to their corrective historical mission and fit within a larger movement toward revisionist historiography that emerges in this period (see Woolfork, Chapter 2 in this volume).[12] Mitchell's text, which reads in parts like a history lesson, dramatizes "untold" truths about brutal exploitation and violent rebellion that controvert plantation romances about the "good old days" of slavery.[13] The need for such corrective history lessons is thematized in John Williams's *Captain Blackman* when the eponymous protagonist teaches a seminar on U.S. military history to black soldiers. Covering a long historical stretch from the American War of Independence to the Vietnam War, this seminar highlights the U.S. military's consistent mistreatment of its black troops, prompting the recognition that every war supposedly inspired by idealistic principles such as democracy or freedom was at bottom a race war fought to defend white supremacy. Knowing "the national truth" therefore means understanding the pervasiveness of racism throughout American history—in Blackman's view, "This was real Black Power."[14] To disabuse his students of their misguided patriotism, Blackman gives them a long view of U.S. history, demonstrating, by dint of sheer repetition, the antiprogressive bent of a history in which the drive for freedom and equality was thwarted again and again.

In Williams's novel, and even more so in the theatrical works of this time, the interpretive prism of slavery sharpens the impression of historical stasis. The repetitions and conflations used to emplot American history in these works render the past as coeval with the present. The choric voice in *Ododo* introduces present-day vignettes through incantatory repetition of the refrain "Let me tell

you about slavery," superimposing the past onto current forms of racism such as police harassment. If, in Michael Harper's celebrated poem "American History," the four black girls killed in the 1963 Alabama church bombing "remind" the speaker "of five hundred middle passage blacks," in Mitchell's *Tell Pharaoh* bankers and mortgage lenders in present-day Harlem are not only reminiscent of but are equivalent to slaveholders.[15] The effort to convey the simultaneity of past and present plays out at the level of form, marking the emergence of an experimental theater that breaks with the naturalist conventions that had thus far dominated African American drama. *Tell Pharaoh* and *Ododo* both perform the past as if it were present, but it is Baraka's *Slave Ship* that most radically departs from realist historical drama. In his famous essay, "the last days of the american empire," Baraka marvels at "anyone in realworld America who thinks Slavery Has Been Abolished."[16] *Slave Ship* dramatizes his view of freedom as a "legal fiction" and of racial progress as a "huge fallacy" by simulating a multisensory, affective experience of enslavement.[17] Baraka's extensive stage directions as well as the stage sets of early productions of the play were designed to create an immersive experience of the contemporaneity of slavery. For example, in the 1969 production at the Chelsea Theatre in Brooklyn, the theatrical space was set up to resemble the hold of a slave ship, a structure that rocked back and forth to convey a ship's motion and that enfolded the audience into uncomfortable proximity with the stage. Baraka's opening stage directions evoke a "total atmos-feeling" of the Middle Passage, stifling the theater in darkness and heightening the senses of smell ("dirt/filth smells") and sound (heavy chains rattling, the ship groaning, drums, and terrified moaning).[18] Through this sensory onslaught, the play interpellates the contemporary African American spectator as a slave. Urging its audience to understand slavery viscerally rather than as an object of abstract knowledge, Baraka fashions a theatrical experience in which "history is absolutely meaningful and contemporary," felt in the present as an open wound.[19]

Baraka thus anticipates the efforts of post-1975 writers to convey the affective immediacy of slavery. Novelists such as Octavia Butler and Toni Morrison employ devices such as time travel and reincarnation to force past and present into disorienting simultaneity. Such antirealist devices for breaching historical distance first emerged on the literary scene during the decade of Black Power. Baraka's play creates a sense of simultaneity by superimposing the sounds of the slave ship on to a scene depicting a civil rights preacher's advocacy of nonviolence. Fair's *Many Thousand Gone* creates a counterfactual historical narrative in which the institution has literally survived into the 1960s, maximizing the jarring effect of his speculative history through strategic recourse to

anachronisms (such as using *Ebony* magazine to repurpose the literacy motif of antebellum slave narratives). The time displacements characteristic of the later canonical literature of slavery are most directly prefigured in Williams's novel, where a traumatic injury on the battlefields of the Vietnam War jolts an unconscious Captain Blackman into different eras of U.S. military history. In one of his earlier trips back in time, when Blackman is taken to be a slave, he responds with outrage in the militant lingo of the 1960s. But this initial moment of anachronism, which indicates the difference between slavery and the present, yields to an overwhelming impression of historical impasse, as Blackman's experience in one period after another reinforces the same lesson about the betrayed promise of freedom. Williams incorporates actual documents and details from U.S. military history to build up a sense of veracity, but the truth-telling impetus of his (as well as Fair's) novel demands a narrative form in which counterfactual elements are yoked to historical realism. Derailing the proper workings of historical time, by projecting slavery forward into the mid–twentieth century or catapulting a '60s militant backward into slavery, these novelists literally deform post–civil rights narratives of American history as a process of racial advancement.

A broad spectrum of writers sympathetic to Black Power, including creative artists, political activists, and psychologists, describe the historical remainder of slavery in predominantly psychological terms. When Baraka hails his audience as slaves, he means to index a psychological syndrome of racial inferiority originating in slavery and perpetuated by continuing racial subordination. Baraka identifies "cultural shame" as the "last pure remnant of the slave mentality," echoing Carmichael and Hamilton's call for a new racial consciousness to supplant the "shame" instilled by "White America's School of Slavery and Segregation."[20] Black Power accounts of slave mentality are generally seen as critical interventions in the debates sparked by Stanley Elkins's "Sambo thesis," elaborated in his book *Slavery: A Problem in American Institutional and Intellectual Life*, first published in 1959 and reissued in 1968. To summarize in a nutshell Elkins's most widely circulated claim, North American slavery operated as a closed system of domination, breeding the personality type of Sambo, a "docile but irresponsible, loyal but lazy" figure tied to the master by "utter dependence and childish attachment."[21] Elkins was widely criticized for his absolutist view of the workings of power. Historians contested the Sambo thesis by stressing the importance of slave community in counteracting the psychological dynamics of the master-slave relation. Eugene Genovese, among others, also pointed out that the enslaved became adept at simulating deference in the presence of masters and that Elkins misrecognized the Sambo mask for the reality.[22] In

revisionist historiography as well as in the literary and political writings of this time, the Sambo thesis was discredited by way of a countervailing emphasis on slave resistance, fostered by communal folk practices developed in relative autonomy from the slaveholders' culture.[23]

Black Power writing takes a contradictory approach to the Sambo thesis, challenging it through an emphasis on slave rebellion but also describing the crippling psychological effects of slavery in terms strongly reminiscent of Elkins. Two of the psychiatrists included in the 1968 volume, *The Black Power Revolt*, delineate the psychological burden of slavery in consonance with Elkins, in fact going further in extending the Sambo thesis to apply to the 1960s. Reviewing the historical factors feeding into "the Negro's chronic identity crisis," Alvin Poussaint argues that the "plantation system implanted a subservience . . . in the psyche of the Negro that made him forever dependent upon the good will and paternalism of the white man," and James Comer explicitly cites Elkins to support his argument that the slave's identification with the master hindered the formation of "positive identity."[24] Elkins's image of the emasculated, infantilized Sambo haunts the pages of *Black Rage*, the widely read book by psychologists William Grier and Price Cobbs. Ascribing "a timeless quality to the unconscious which transforms yesterday into today," Grier and Cobbs assert that black men and women in the 1960s exhibit pathological symptoms of self-hatred "that had their genesis in slave experience." Voicing the objectives of psychological liberation prioritized in Black Power discourse, Grier and Cobbs hope that this pathology will be swept away by the tidal wave of rage unleashed by "the new black movements."[25]

Elkins's Sambo also lives on as an emblem of psychological servitude in literary texts inflected by Black Power, but he is invariably polarized against and ultimately destroyed by the resistant slave. An obvious personification of Sambo, "The Slave" in Baraka's *Slave Ship* is portrayed as a "shuffling" figure always "agreeing with massa."[26] His latter-day avatar, Uncle Tom, is beheaded in a climactic scene that marks the transition from slave to militant subjectivity, a transition prefigured by references to Nat Turner's revolt. The militant black subject is therefore modeled on the enslaved black man even as he is positioned as the antithesis of "The Slave." Texts of the Black Arts Movement (BAM) toggle back and forth between these extremes of the abject slave and the rebellious slave. The stark opposition between Sambo and Nat Turner as well as the identification of Turner with the radicalized Black Power subject helps explain the furor surrounding the publication of William Styron's *The Confessions of Nat Turner* in 1968. In *Ten Black Writers Respond*, published the same year, critics lambast Styron for portraying Turner as a self-hating Sambo identified

with the slave-owner's values.[27] Linking Turner's insurrection to the violent urban uprisings of the 1960s, several contributors to the volume indict Styron for falsifying the past but even more so for his willful blindness to the present. Ernest Kaiser faults Styron for writing the novel "just as he would have written it in 1948," utterly "impervious" to the racial ferment of the 1960s.[28] Stressing Turner's import for the present (there are "thousands of Nat Turners in the city streets today"), John Oliver Killens writes: "Just as it was impossible for the slave master to look at slavery from the point of view of the slave, it has proven impossible for the slave master's grandson to look at slavery or at the contemporary black-and-white confrontation from the perspective of Rap Brown and Stokely Carmichael or Floyd McKissick or any other black revolutionary."[29] Styron's misrepresentation of the past thus carries the insidiously pernicious effect of invalidating '60s political militancy.

As Killens's critique suggests, at stake in the Styron and Elkins controversies is the importance of representing slavery from the perspectives of the enslaved. In this respect, debates about the psychological dynamics of slavery bear direct implications for literary characterization. Framed as a confession and narrated in Turner's first-person voice, Styron's novel presents itself as a subjective view of slavery, and on this count it is judged to be an "eloquent forgery."[30] In terms of "getting into the slave's psyche," writes Killens, the novel "is a monumental failure," and Loyle Hairston agrees that the novel "is deficient in that interior quality" needed to take literary character beyond "abstraction."[31] Elkins had been similarly assailed for producing a caricature lacking psychological depth and dynamism. Given such critiques of Elkins's Sambo and Styron's Turner, we would expect contemporaneous literary writers to take a three-dimensional approach to characterization, but they are in fact utterly uninterested in conveying the interiority of slave personality, an intention that would become integral to the canonical literature of slavery.[32]

The plays of Walker, Mitchell, and Baraka, for instance, all feature characters that are deliberately depersonalized. The performers in *Ododo*, designated arbitrarily by letters of the alphabet (Actor A, Actress L, and so forth), assume different roles over the course of the play. Similarly, cast members are identified as Mr. Black, Mrs. Black, Miss Black, and Black Jr. in *Tell Pharaoh* and as 1st Man, 2nd Woman, and so on, in *Slave Ship*. This reliance on flattened abstractions rather than rounded characters is suited to the didactic, consciousness-raising intentions of BAM theater. Eschewing psychological realism, dramatists such as Baraka, Mitchell, and Walker purposefully propagate reductive types and antinomies that must be assessed by different standards of characterization than those applied to Styron's novel. Distilled to the pure essence of the Sambo type,

"The Slave" in Baraka's play is meant to teach a clear-cut lesson about political accommodation rather than to offer a plausible subjective portrait of slave psychology, as we would expect from a realist novel narrated in first-person voice. What the controversies surrounding Styron and Elkins suggest, when viewed in relation to the political aims and generic choices of BAM theater, is that the Sambo stereotype is perfectly acceptable for racial allegories about the psychopathology of slavery but must not be advanced as an accurate representation of slave personality.[33]

The commitment to flattened allegorical modes of characterization is equally visible in novels inspired by Black Power. Captain Blackman, as his name indicates, represents Black Everyman, and the allegorical method exempts Williams from adhering to the realist model of psychologically credible characters that develop over time. As Blackman visits different historical periods, he exhibits a range of behaviors designed more to illustrate political lessons about particular periods than to build up a coherent character portrait. His persona occasionally acts in ways that seem wildly "out of character" but such standards are irrelevant to Williams's allegorical purpose. Other characters as well, such as Colonel Whittman, appear across historical periods narrated in chronological sequence, but Williams has no interest in imbuing them with psychological continuity or consistency. The static nature of characters such as Blackman and Whittman, which are essentially composites of personae from different eras of American history, in fact intensifies Williams's transhistorical allegory of racial confrontation. Killens similarly approaches characters primarily as vehicles for ideological instruction, correcting the Sambo stereotype by devising alternate stereotypes rather than by rendering the complexity of slave psychology. Luke, the protagonist of his novel *Slaves*, undergoes an awakening when his master sells him to pay off a debt, an act of betrayal that shatters his trust in the plantation romance of paternalistic masters. Following his conversion from loyal to resistant slave, Luke's character becomes increasingly flat as he is idealized through the rest of the novel. His enveloping aura of nobility deters emotional involvement on the part of readers, but this accords perfectly with the BAM emphasis on characters that invite emulation more than empathy or identification.[34]

Novelists writing about slavery during the Black Power era are willfully indifferent to the literary goal of exploring the "psychic hold" of slavery in all its affective complexity, a goal that would impel the formal experimentation of later texts such as Gayl Jones's *Corregidora* or Toni Morrison's *Beloved*.[35] Black Power literature of slavery also violates realist precepts, but its formal peculiarities are designed to instruct the reader by provoking strong reactions of

outrage or admiration. As indicated by the prevalence of anonymous or composite characters and choric narrative voices, this didactic mission demands a view of the enslaved as emblems rather than distinctive individuals. This notion of character is consonant with the BAM tenet that art can best serve a politically instrumental purpose by dethroning the individual and instead building communal solidarity. Invoking this BAM principle, Blyden Jackson's *Operation Burning Candle* explores in great depth the question of why individual psychology must be decentralized in any plausible account of political change.

The novel's protagonist, Aaron, is noted for his specialization in the field of "minority psychology."[36] His interest in understanding how racism warps the personality prompts him to question a key tenet of the psychological theory he has been taught: the burden of responsibility it places on the individual as the primary agent of change. In response, Aaron adapts Carl Jung's concept of the collective unconscious to postulate the existence of "one big black mind" containing the affective history of the race, a concept that explains how a psychological syndrome originating in slavery has been transmitted into the present. Because systemic racism stigmatizes the entire group, liberation must hinge on "collective psychotherapy" rather than individual transformation. Inspired by Fanon, Aaron believes that only a calculated act of violence can convulse the racial unconscious of the nation and instate a new psychological framework. The specific act of therapeutic violence that Aaron executes in the novel is the assassination of Southern politicians who embody "the living continuum of slavery."[37]

Aaron's theory, which the novel fully endorses, brings together all the different threads of Black Power discourses on history and futurity, on the psychology of slavery and the politics of change. Slavery sets in motion a historical trajectory that continues unbroken into the present, but, as William Van Deburg observes, Black Power takes a "cathartic approach" to this legacy that "strip[s] history of its fatalism."[38] Political and literary texts informed by Black Power always invoke history from the vantage point of its imminent disruption, aiming to obliterate, in one clean stroke, the political and, more pointedly, the psychological inheritance of slavery. Marking its sharpest point of divergence from post-1975 literature about slavery, Black Power writing narrates historical stagnation in the service of an emancipatory agenda and stakes an urgent claim to futurity. The transition to the future is generally imagined as an immediate, abrupt change, such as when Aaron promises that "this weekend, in the next 72 hours," black people will expunge "four centuries" worth of history. While bristling with a sense of futurity, few literary works published in this period project what the future will look like beyond asserting its clean break from slavery. Aaron's as-

sassination scheme is deemed to be successful because of its "symbolic impact" of eradicating "the long-suffered effects of American slavery."[39] The novel ends a few pages after Aaron's plan is executed, leaving readers to imagine the exact lineaments of this future, as is also the case with the speculative scenario that concludes *Captain Blackman*. In an unspecified near future, Blackman's military force based in Africa wins the race war by usurping U.S. military power. The novel ends shortly thereafter with one of Blackman's officers mockingly singing "Way down upon de Swanee Ribber," a minstrel song of yearning for the old plantation, inaugurating, like *Operation Burning Candle*, a future charted only in terms of its distance from slavery.[40]

As Black Power radicalism began to wane after the mid-1970s, its model of historical transition came under critical fire on several counts: the masculine thrust of its discourse of freedom; its envisioning of change as thoroughgoing rupture; and its dichotomous view of structural determinism and agency. These limitations are already intimated in the literature produced during the Black Power era, particularly so in the novels—possibly because of the genre's greater propensity for in-depth exploration. Deemed to lack the immediacy and accessibility of drama and poetry, the novel was underprivileged by the Black Arts Movement as the genre least amenable to the aims of ideological dissemination.[41] Even novels most closely aligned with Black Power ideology, such as Killens's *Slaves*, end up registering its contradictions, especially in relation to gender and political agency.

Because they are so ubiquitous, there is no need to belabor the gender conventions guiding representations of servitude and liberation in Black Power literature of slavery. Taking its cue from Elkins, this literature generally equates enslavement with emasculation and, as a corollary, freedom with the reclamation of manhood. For instance, in Baraka's view "the ugliest weight" of the black man's enslavement was that he was "expected to function as less than a man," the clearest evidence of this being his powerlessness to protect "his woman" from the slaveholder's rapacity.[42] Accordingly, scenes of enslaved women being sexually violated feature prominently in literary texts of this time, and are often presented from the perspective of enslaved men as triggers for violent resistance or turning points in the quest for freedom.[43] Offsetting the predatory sexuality of slave-owners, the enslaved black man is often desexualized, especially when engaged in violent rebellion. *Ododo* pointedly clarifies that not a single rape occurred during Nat Turner's revolt and then goes on to castigate white audience members for confusing "revolution with rape."[44] Contrary to Styron's depiction of Turner as an oversexed yet emasculated figure—a portrait that emphasized Turner's sexuality in order to discredit his politics—repre-

sentations of manly but desexualized male slaves were meant to secure the principled purity of their acts of rebellion.[45]

Killens was one of the writers who most strongly censured Styron for reducing Turner's rebellion to a matter of unfulfilled sexual desire for white women and for failing to grant him any measure of heroism or manhood.[46] Not surprisingly, then, the protagonist of his own novel, *Slaves*, epitomizes manhood (defined here as self-respect, autonomy, and irreproachable morality) but is markedly impervious to the sexual charms of Cassy, an enslaved woman whom the slaveholder Mackay has taken as his mistress. At first glance, the novel adheres strictly to nationalist gender conventions, showing how the otherwise recalcitrant Cassy is subdued and feminized by Luke's potent masculinity. Gazing at the "firmness of his manhood," Cassy feels his flame "warming the place inside of her where the babies of the world are born," reawakening the womanhood she has suppressed in response to Mackay's sexual exploitation.[47] Yet this scene, which is marked by a sudden shift to rhapsodic language that enshrines Luke and Cassy as avatars of true black manhood and womanhood, seems at odds with Cassy's characterization in the rest of the novel. Contravening the nationalist sanctification of women's wombs evoked in this scene, Cassy has committed infanticide and refuses to play a maternal part toward an enslaved orphan child. The most intriguing scenes in the novel present Cassy assuming and manipulating the African masks that Mackay collects, eroticizing herself as the exotic object of his desire. As if directly responding to Stanley Elkins's misrecognition of the public personae assumed by the enslaved, Killens calls attention to Cassy "creating a grotesque image of herself" through her sexual masking, but because Killens withholds access to her interior life, she comes across as an opaque figure with depths we cannot fathom.[48] Confessing that she often feels like a stranger to herself, Cassy also frankly acknowledges her inability to withstand the moral degradation of slavery. Her unknowability presents a sort of surplus to the novel's didactic purpose, which requires uncomplicated character types that are easily glorified or vilified. Cassy's characterization thus sparks tension between the novel's truth-telling impulse and its emphasis on positive images, subtly undercutting its exaltation of Luke's manhood.

Unlikely as it may seem, one of the most biting indictments of the racialized sexual dynamics of American slavery appears in the Blaxploitation potboiler *Mandingo* (1975) and this is largely due to its total repudiation of any idealizing impetus. The film sets out to debunk the plantation romances of slavery that had continued to dominate American cinema until the 1960s (see Chapter 3 in this volume). *Mandingo* can be—and has been—easily dismissed as sexploitation of black suffering, but the film's luridly pornographic depiction of sex and vio-

lence is precisely what allows it to uncover the extreme brutality of slavery. The film takes its cue from Black Power accounts of slavery, which de-romanticized the institution by highlighting sexuality as a primary vehicle of racial domination. Like Killens's *Slaves* (which was a novelization of a film released in 1969), *Mandingo* sympathetically portrays the white female slave-owner as an active sexual subject, while underplaying the sexuality of the enslaved black woman, thereby inverting the dichotomous construction of black and white womanhood that helped sanction the systematic rape of enslaved women. *Mandingo* goes further than Killens's *Slaves* by extending its analysis of the sexual psychopathology of slavery to enslaved men as well, showing, through its exaggerated opposition between a hypersexualized slave and a symbolically castrated master, that black and white manhood are purely relational categories with no real substance. Because hypersexuality is imposed on enslaved men and because the film restricts itself to this objectifying gaze, viewers are urged to see phallic black masculinity as a phantasm of the racist imagination. The point of *Mandingo* is not to humanize, heroize, or subjectify the slave, but instead to reveal the extent of slavery's dehumanizing power. The atrocity of slavery as a system of violent domination comes across in nearly every scene but showing that it takes barbaric violence to command submission, the film also hints at the instability of the system. The imprint of Black Power on *Mandingo* is most sharply visible at the end, when Mem, an enslaved man who may easily have been mistaken for Sambo, exhibits resistant agency in a sudden act of violence.

That a popular and undeniably trashy film such as *Mandingo* extols violent slave resistance indicates the broad influence of Black Power rhetoric on American popular culture. Yet political agency is among the most vexed issues in Black Power writings on slavery, due in part to the conflict between their demystifying and idealizing aims. The truth-telling imperative entails an emphasis on the crushing weight of the system and is instantiated by negative stereotypes such as Uncle Tom or Sambo. Conversely, heroically rebellious figures such as Nat Turner fulfill the demand for positive images. Representing Sambo and Nat Turner in either/or terms that make it impossible to imagine any traffic between submission and resistance, these texts struggle with the same problem that preoccupies the Elkins debates—the problem of striking a balance between systemic determination and individual agency. Because Elkins conceptualized slavery as a "regime of total power" rather than an internally contradictory system, his model could not accommodate the possibility of Sambo becoming Nat.[49] The whole point of Black Power literature of slavery is to show, in Killens's words, that "every slave is a potential revolutionary, . . . a potential Nat Turner,"[50] but the texts remain fuzzy on the matter of how Sambo can be

transformed into Nat, of which factors are likely to stoke latent revolutionary potential into action.

Fair's *Many Thousand Gone* offers a concrete illustration of this problem. The novel's modern-day slaves are described as Sambo-like people who had been "conditioned to accept without question the world of their white masters," until they encounter an issue of *Ebony* that shows them how well black people live elsewhere in the country. The arrival of the magazine from Chicago is what makes them "aware of themselves as human beings" and fuels "general unrest."[51] Yet we know this is not quite true, because the opening pages of the novel tell us that the enslaved are "proud not to be white," so much so that they specially cherish those among them who "look one hundred percent Negro."[52] Fair thus characterizes the enslaved as being full of race pride yet unable to challenge the slaveholders' ideology without an intervention from the outside world. This unresolved contradiction betrays the difficulty of mediating between the two poles of Black Power discourse on slavery—emphasis on the dehumanizing impact of the system versus affirmation of uncompromised oppositional agency.

The blind spots of Black Power concepts of political agency are more clearly illuminated by a brief contrast with Margaret Walker's *Jubilee* (1966), a novel of slavery that takes its political orientation from civil rights movement ideologies and, as a consequence, takes a gradualist view of political change. In common with the Black Power literature, Walker highlights the continuation of slavery by other means (such as share-cropping and racial terror) long after its formal abolition. The novel's protagonist Vyry is a representative figure more than a discrete individual, but Walker typifies characters within the generic mode of historical realism, rather than didactic racial allegory, in an effort to elucidate the sociopolitical forces that constrain individual agency. Walker's interest in individuals as types embodying the limits of their historical era is clear from her citation of Georg Lukacs as well as from her description of her great-grandmother, whose life inspired *Jubilee*, as a "product of plantation life and culture, . . . shaped by the forces that dominated her life."[53] Accordingly, instead of narrating the novel in Vyry's first-person voice, Walker uses omniscient narration to build up a densely textured world seen from diverse points of view. Constituting the enslaved and slaveholders as categories striated by class, gender, and ideological dissension, Walker anticipates the questioning of homogenous racial community and political allegiance that would gain momentum during the 1970s. The novel shows that the interests of slaveholding and poor whites, or of enslaved and free black people, are not always neatly aligned and therefore cannot be understood in binary racial terms. Within this social totality fraught with internal contradiction, it becomes difficult to maintain dichotomous views of acquies-

cence and resistance, as illustrated in the scenes in which Vyry abandons her attempt at freedom due to concern for her children, and the militant Randall Ware surrenders his land in the face of relentless white supremacist violence. The genre of historical realism thus allows Walker to clarify the compromised nature of political agency without succumbing to fatalism.

Some contemporaneous reviewers faulted *Jubilee* as an anachronistic novel, both because of its realist form that harked back to the 1940s and the conciliatory political vision embodied in Vyry, who was seen as a female version of Uncle Tom.[54] The other realist novel with a civil rights orientation published in this period, Ernest Gaines's *Autobiography of Miss Jane Pittman* (1971), may appear equally anachronistic in its measured view of political change.[55] Although the novel begins with Emancipation, it shows how residues of slavery survive its formal abolition. A composite character representative of her community, Jane Pittman often voices its fatalist worldview, but the novel ends on a note of guarded optimism as the townsfolk make the tough decision to participate in civil rights protest. Like Walker, Gaines emphasizes the difficulty of exercising oppositional agency in the face of economic threat and political intimidation. The lesson these novels hold for 1960s militants is that political change occurs over decades and is subject to innumerable false starts, derailments, interruptions, and obstructions. Black Power literature of slavery is charged with a sense of fierce urgency, as text after text wills change to happen . . . NOW.[56] Casting the present as a moment of convulsive transition, these texts often short-circuit the problem of political agency through cataclysmic endings that annihilate the racial order of the past.

With all its limitations, the Black Power rhetoric of political change had galvanizing effects on American culture. As Carmichael and Hamilton noted, Black Power drew volumes of "hysterical" public commentary fretting over its polarization of the races and misconstruing its call for self-determination as a spur to black supremacy or reverse racism.[57] One reason Black Power provoked such furor was that it reopened racial wounds that were supposedly healed by the end of the civil rights movement, by revoking the national consensus that racial justice had finally been achieved and fashioning the present as a moment of impending upheaval rather than a closed chapter of American history. The threat of racial crisis associated with Black Power was registered in various ways across American popular culture. Among the most telling responses is a cluster of popular science-fiction narratives that rely on various devices of time displacement to transport characters from the present back to slavery or to project slavery into the future. Jumbling up the trajectory of U.S. history, these devices are designed to confront as well as to contain the racial tumult of the period.

The most reactive of these texts, John Jakes's time-travel novel *Black in Time* (1970) seeks to allay the alarm triggered by Black Power by reassuring readers about the ultimately emancipatory direction of U.S. racial history. This cautionary tale features a white supremacist, Roy Whisk, and a black militant, Jomo, who travel back in time in order to modify American history to suit their own ideological ends. Whisk tries to engineer a Southern victory in the Civil War so as to guarantee the continuation of slavery, but because he is so easily written off as a rabid racist, it is Jomo's desire to alter history to reflect black pride that comes across as the greater threat. Although his time travels are spurred by impatience with the slow pace of racial progress, Jomo is cast as a mirror image of the racist Whisk in that his goal is to institute black supremacy. Both extremists are neutralized by the politically moderate protagonist who also travels back in time to ensure that Whisk's and Jomo's counterfactual histories revert back to history as it actually happened. The novel ultimately ratifies the racial order of the 1970s by insisting that although the present seems "pretty rotten," the civil rights movement did bring about "pretty decent progress."[58] Attesting to the disquieting force of the Black Power mission to overhaul triumphalist narratives of U.S. racial history, Jakes uses time travel—in a manner exactly contrary to Williams's *Captain Blackman*—to reinstate and legitimize such narratives.

Jakes's novel bears out Carmichael and Hamilton's observation that the most common way of dismissing Black Power was to associate it with extremist black supremacy and to assert a false equivalence between the threats posed by black and white supremacy. A clearer instance of this can be seen in race-reversal narratives that dramatize the enslavement of white men in the future, such as Robert Heinlein's novel *Farnham's Freehold* (1964) or the film *Planet of the Apes* (1968). In Heinlein's novel, a nuclear blast propels the protagonist Hugh Farnham into a distant future in which Africans enslave white people. The novel overtly echoes antebellum slave narratives in its description of Farnham's quest for freedom. Forging a pass, communicating with other enslaved people through coded messages, and even wearing blackface, Farnham must appropriate the position of the slave in order to embody the principle of freedom (although he is eventually freed by his master rather than through his own agency). Positing symmetry between the races and emphasizing the reversibility of power, this white slave narrative seeks to neutralize the racial polarization marking mid-1960s black militant rhetoric, but the ultimate effect of this move is to depoliticize race altogether. At bottom, narratives of white enslavement are fueled by anxiety about the risk to white male privilege posed by 1960s black militancy. When Eldridge Cleaver writes that the Black liberation movement has shattered the fantasy world of white superiority and that, in response, the white man wants

desperately to reaffirm, "I am still the White Man, . . . and the world is still an empire at my feet," he may well be describing any of the iconic scenes of Charlton Heston, archetypal American hero, railing against his degraded status as a slave in *Planet of the Apes*.[59] Unlike Heinlein's novel, which discounts the political significance of race, this film uses the reverse enslavement narrative to racialize the white man at the moment of his abjection, to make his whiteness visible, thereby stripping him of the ability to personify universal humanity.

What is really striking about race-reversal narratives is that they claim the status of slave for the white man at the very moment that Black Power disavows slave subjectivity for black men and that, notwithstanding their convoluted timelines of future white enslavement, they clearly position slavery as the past of black people. In *Conquest of the Planet of the Apes* (1972), the third film in the series, dealing with human enslavement of apes, a black character, McDonald, plays an ambiguous role that stymies impulses to interpret the film as racial allegory, impulses the film also actively encourages. In the electrifying climax of the film, Caesar, the leader of the apes, justifies their revolt by claiming violence as "the slave's right" and McDonald, who has surreptitiously abetted the apes' freedom movement, responds as the voice of political moderation. The prior history of black enslavement invests McDonald with authority throughout the film, and when he counsels Caesar to refrain from violent vengeance, he does so as "a descendant of slaves." Slavery is designated here as the historical past of the one black character that plays a central part in the film. At the most obvious level, this can be seen as an attempt to consign acute black oppression to history, as does Jakes (who also novelized *Conquest)* in *Black in Time*. But the film evinces a more ambivalent response (of understanding mixed with alarm) to 1960s black insurgency, validating Caesar's rebellion but also underscoring its extremism and futility from the perspective of McDonald, the descendant of slaves who is now incorporated into the higher echelons of slave management. Clearly marking McDonald's distinction from the enslaved apes, the film forgoes the simplicities of racial allegory, instead signaling the difficulty of assessing the exact nature of black inequality—as well as black advancement—in the post–civil rights decade.

In this respect, the film casts into bold relief the crucial importance of slavery to explorations of political agency in this period. The resistant slave embodies the purest form of political agency, one that is irreproachable because directed against a system of domination as extreme as slavery. This is one reason Black Power claims that "the future belongs to today's oppressed" and names this oppression slavery.[60] Race-reversal narratives of white enslavement can then be seen as attempts to reclaim the future, to stave off anxieties about the impend-

Figure 1.1. Screenshot of ape slave revolt from *Conquest of Planet of the Apes* (1972) APJAC Productions.

Figure 1.2. Screenshot of Charlton Heston subjected to slavery by the apes in *Conquest of Planet of the Apes* (1972) APJAC Productions.

ing extinction of white power. These anxieties also fuel the impulse to relegate black enslavement to a remote, finished past, just as Black Power is asserting its afterlife in the present. Because the invocation of slavery simplifies the problem of agency, insofar as the slave's claim to freedom carries unquestionable legitimacy, Black Power emphatically equates '60s urban uprisings with slave revolts, a calculated rhetorical move that indirectly reveals the difficulties confronting black racial politics in the post–civil rights decade. Not by coincidence, *Conquest* makes the same rhetorical move when it pictures the ape slave revolt by visually citing footage of 1960s black urban rebellions. The apes in the film are subjected to an urban and militarized rather than plantation-based form of slavery, a system whose visual signifiers are at once futuristic and crudely primitive. This odd temporal grafting can be seen as an inchoate effort to make sense of the racial dispensation emerging by the beginning of the 1970s. The urban unrest of the previous decade had accentuated the limited efficacy of the civil rights movement in rectifying racial inequality and the consequent need for new political strategies. At the same time, militant racial politics seemed increasingly hard to legitimize in the immediate aftermath of the urban uprisings, as the short-lived national consensus on civil rights dissolved into panic about racial disorder. The contradictory status of the slave—as a foundational yet abjected figure—in Black Power discourse attests to the difficulty of claiming unimpeachable black agency in the wake of the civil rights movement. Not surprisingly, then, with the gathering momentum of colorblind rhetoric in the subsequent decades, slavery would become an even more potent object of investment for African American writers.

Notes

1. In *Neo-Slave Narratives: Studies in the Social Logic of a Literary Form* (New York: Oxford University Press, 1999), Ashraf Rushdy discusses the centrality of Black Power to contemporaneous literary and historiographical debates about slavery, but with the exception of William Styron's *The Confessions of Nat Turner*, he does not deal with literature about slavery produced during the Black Power era.

2. Stokely Carmichael and Charles Hamilton, *Black Power: The Politics of Liberation in America* (New York: Vintage Books, 1967), viii.

3. Eldridge Cleaver, *Soul on Ice* (New York: Dell, 1968), 82.

4. Ibid., 70, 75, 77.

5. Joseph A. Walker, *Ododo*, 1968, reprinted in *Black Drama Anthology*, ed. Woodie King and Ron Milner (New York: New American Library, 1971), 366.

6. Carmichael and Hamilton, *Black Power*, 50.

7. Nathan Wright Jr., "The Crisis Which Bred Black Power," *The Black Power Revolt: A Collection of Essays*, ed. Floyd Barbour (Boston: Porter Sargent, 1968), 111.

8. Ibid., 115.

9. LeRoi Jones, "The Need for a Cultural Base to Civil Rites & Bpower Mooments," in Barbour, *Black Power Revolt*, 119.

10. Walker, *Ododo*, 384.

11. John A. Williams, *Captain Blackman* (New York: Doubleday, 1972), 48.

12. Loften Mitchell, *Tell Pharaoh*, in *The Black Teacher and the Dramatic Arts*, ed. William Reardon and Thomas Pawley (Westport, Conn.: Negro Universities Press, 1970), 266; Walker, *Ododo*, 384.

13. Mitchell, *Tell Pharaoh*, 268, 269.

14. Williams, *Captain Blackman*, 79, 141.

15. Michael Harper, "American History," in *Dear John, Dear Coltrane* (1970; Urbana: University of Illinois Press, 1985), 62.

16. LeRoi Jones, *Home: Social Essays* (New York: William Morrow, 1966), 190.

17. Ibid., 70, 79.

18. Amiri Baraka, *Slave Ship: A Historical Pageant*, 1967, reprinted in *The Motion of History and Other Plays* (New York: William Morrow, 1978), 132–133.

19. LeRoi Jones, "What the Arts Need Now," 1967, reprinted in Amiri Baraka, *Raise Race Rays Raze: Essays since 1965* (New York: Random House, 1971), 34.

20. LeRoi Jones, *Home*, 135; Carmichael and Hamilton, *Black Power*, viii, 31.

21. Stanley Elkins, *Slavery: A Problem in American Institutional and Intellectual Life* (Chicago: University of Chicago Press, 1959), 82.

22. See Ann Lane, ed., *The Debate over Slavery: Stanley Elkins and His Critics* (Urbana: University of Illinois Press, 1971), especially Earl Thorpe, "Chattel Slavery and Concentration Camps," 23–42; Eugene Genovese, "Rebelliousness and Docility in the Negro Slave: A Critique of the Elkins Thesis," 43–74; and Mary Agnes Lewis, "Slavery and Personality," 75–86.

23. For a discussion of Elkins's impact on American literature of slavery, see Tim Ryan, *Calls and Responses: The American Novel of Slavery since Gone with the Wind* (Baton Rouge: Louisiana State University Press, 2008), Ch.2.

24. Alvin Poussaint, "The Negro American: His Self-Image and Integration," in Barbour, *Black Power Revolt*, 95; James Comer, "The Social Power of the Negro," *Black Power Revolt*, 74.

25. William H. Grier and Price M. Cobbs, *Black Rage* (New York: Basic Books, 1968), 34, 60, 54.

26. Baraka, *Slave Ship*, 137.

27. John Henrik Clarke, ed., *William Styron's Nat Turner: Ten Black Writers Respond* (1968; Baltimore: Black Classic Press, 1997), especially Lerone Bennett Jr., "Nat's Last White Man," 7; Ernest Kaiser, "The Failure of William Styron," 54.

28. Kaiser, "The Failure of William Styron," in Clarke, 65, 57–58.

29. John Oliver Killens, "The Confessions of Willie Styron," in Clarke, 43, 36.

30. Loyle Hairston, "William Styron's Nat Turner—Rogue-Nigger," in Clarke, 72.

31. Killens, "Confessions," 43; Hairston, "William Styron's," 68–69.

32. Toni Morrison explicitly writes of her intention to convey the "interior life" of the enslaved in *Beloved*, in "The Site of Memory," in *Out There: Marginalization and Contemporary Cultures*, ed. Russell Ferguson et al. (Cambridge: MIT Press, 1990), 302.

33. See Pinto, Chapter 6 of this book, for an analysis of 1970s African American women writers extending and reinterpreting the BAM legacy through their experimental, nonrealist modes of characterization.

34. For example, see Barbara Ann Teer, "Needed: A New Image," in Barbour, *Black Power Revolt*, 221.

35. The quoted phrase refers to *The Psychic Hold of Slavery*, ed. Soyica Diggs Colbert, Robert J. Patterson, and Aida Levy-Hussen (New Brunswick: Rutgers University Press, 2016), which examines the continuing reverberations of slavery in contemporary American literature and culture.

36. Blyden Jackson, *Operation Burning Candle* (New York: Pyramid Books, 1973), 195.

37. Ibid., 23, 205.

38. William Van Deburg, *New Day in Babylon: The Black Power Movement and American Culture, 1965–1975* (Chicago: University of Chicago Press, 1992), 273–274.

39. Jackson, *Operation Burning Candle*, 149, 250.

40. Williams, *Captain Blackman*, 335.

41. See Rolland Murray, *Our Living Manhood: Literature, Black Power, and Masculine Ideology* (Philadelphia: University of Pennsylvania Press, 2007), 7–8.

42. Jones, *Home*, 221.

43. This Black Power trope continues to resonate into twenty-first-century representations of slavery. In the 2016 film *The Birth of a Nation*, based on the story of Nat Turner's rebellion, director Nate Parker deviates from historical record in depicting the rape of two enslaved women as the catalyst for male rebellion against slavery.

44. Walker, *Ododo*, 364.

45. Although the male slave is desexualized, the contemporary militant is generally invested with virile masculinity in Black Power literature, especially fiction. In this respect, Williams's *Captain Blackman* represents an unusual case. Overtly inspired by Black Power racial politics, the novel nonetheless registers a note of unease with its sexual politics. Blackman is shown to be deeply invested in sexually virile masculinity until the end of the novel, when his war wounds cast doubt on his sexual potency, causing him to feel like a "broken man" (301). But his assertion of militancy endows him with a new sense of wholeness—a political ideal of manhood detached from phallic masculinity. For an analysis of the reclamation of phallic black masculinity in much BAM writing, see Margo Natalie Crawford, *Dilution Anxiety and the Black Phallus* (Columbus: Ohio State University Press, 2008), Ch.3.

46. Killens, "Confessions of Willie Styron," 35–36.

47. John Oliver Killens, *Slaves* (New York: Pyramid Books, 1969), 110.

48. Ibid., 54.

49. Genovese, "Rebelliousness and Docility in the Negro Slave," in Lane, *Debate over Slavery*, 70, 71.

50. Killens, "Confessions of Willie Styron," 37.

51. Ronald L. Fair, *Many Thousand Gone* (New York: Harcourt, Brace, and World, 1965), 68.

52. Ibid., 11.

53. Margaret Walker, *How I Wrote Jubilee* (Chicago: Third World Press, 1972), 27, 25.

54. On reviews of *Jubilee* during the 1960s and 1970s, see Jacqueline Miller Carmichael, *Trumpeting a Fiery Sound: History and Folklore in Margaret Walker's 'Jubilee'* (Athens: University of Georgia Press, 1998), 33–34.

55. While its gradualist view of political change affiliates *The Autobiography of Miss Jane Pittman* with civil rights ideology, the novel is critical of certain aspects of this ideology, as Robert J. Patterson persuasively argues, in "Rethinking Definitions and Expectations: Civil Rights and Civil Rights Leadership in Ernest Gaines's *The Autobiography of Miss Jane Pittman*," *South Atlantic Quarterly* 112.2 (Spring 2013): 341.

56. "NOW" is the last word of Mitchell's *Tell Pharaoh*, echoing the Black Power catchphrase "Freedom Now."

57. Carmichael and Hamilton, *Black Power*, 47–48.

58. John Jakes, *Black in Time* (New York: Paperback Library, 1970), 18, 170.

59. Cleaver, *Soul on Ice*, 80.

60. Robert Williams, "from *Negroes with Guns*," 1962, reprinted in Barbour, *Black Power Revolt*, 160.

Generations

Slavery and the Post–Civil Rights Literary Imagination

LISA WOOLFORK

Black authors writing about slavery post–civil rights sought to expose the false-hoods and deliberate omissions of historical and literary narratives that dis-torted or ignored the experiences of the enslaved. Their narratives negotiated a balance between America's euphemistic vision of itself and a slave past that had been repressed or distorted. These literary imaginings result in a body of African American literature that aims to acknowledge the work and lives of previous generations while forging space for the imagination of future writ-ers and readers. This return to the slave past is critical for a variety of reasons. These works provide a context to explore the paradox at the heart of American democracy while fostering an understanding of the foundational aspects of racial hierarchy. In addition, the works encourage an improved understand-ing of the dual roles of black American life which Salamisha Tillet describes as "simultaneous citizens and 'non citizens,' who experience the feelings of disillusionment and melancholia of non-belonging and a yearning for civic membership."[1] As Madhu Dubey argues in Chapter 1 in this volume, "Slavery is crucial to the task of historical revision urged by a broad spectrum of 1960s militants ranging from the Black Panthers to cultural Nationalists." In this way, a return to slavery helped to reclaim a usable black past and to revise black and American nationalisms.

If a single word could encapsulate the defining message of African American literary works about slavery in the post–civil rights years of 1975 to 1980, that

word might well be *generations*. Lucille Clifton, Alex Haley, and Octavia Butler are among the African American authors whose works focused attention on the slave past. With other writers, they also channeled their historically based energy through a literary preoccupation with generations, encompassing familial lineage, historical legacy, and racial inheritance—including the intergenerational transmission of trauma (including aspects of psychic, material, and cultural traumas). Generations also pertains to how the representation of slavery underwent a dynamic evolution of interpretation. For many writers of this era, to retrospectively examine slavery meant more than archiving the past, even as they archived and revised the extant collection. They narratively reanimated the slave past, textually reinhabited it, and imaginatively pulled forward elements of its overlooked significance. These works became an early repository of memory and inquiry, a "site of slavery," in the words of Salamisha Tillet.[2] These writers foreshadow the words of Toni Morrison's 1988 Melcher Book Award acceptance speech (later known as "A Bench by the Road") where she describes her award-winning novel *Beloved* as a necessary space to consider the slave past: "There is no place you or I can go, to think about or not think about, to summon the presences of, or recollect the absences of slaves; nothing that reminds us of the ones who made the journey and of those who did make it."[3] Morrison's novel acts as a corrective for the erasure of slavery from American memory. Similarly, writers before Morrison use their works to cultivate a space in which to hold the past and the present in tandem, to demand recognition of the perils and particularities of the slave past.

Mid-1970s African American writers sought to shift depictions of slavery away from master narratives and historiographical practices that belittled or erased the full humanity of those enslaved. These stories anticipate what Monica White Ndounou describes as a "focus on black experiences of slavery, to foreground black agency in liberation struggles, and to reject the white savior formula and racial reconciliation narrative" (Chapter 3 in this volume). Rather than privilege a white master's view or archival records that ignored black interiority, such as Margaret Mitchell's *Gone with the Wind* (1936) or William Faulkner's *Absalom, Absalom!* (1936), these texts paid attention, if not homage, to those humans whom authors previously had depicted as little more than props in the larger drama of America's Civil War dissolution and reconciliation. Contextualizing the literature of slavery within the historical and archival work of scholars such as Deborah Gray White and John Blassingame,[4] literary critic Deborah E. McDowell identified congruence between the contemporary history and literature of slavery. She writes, "Contemporary Afro-American writers who tell a story of slavery are increasingly aiming for the same thing: to

reposition the stress points of that story with a heavy accent on particular acts of agency within an oppressive and degrading system."[5] This impetus to find autonomy within a context of dominance and degradation is a critical concern for writers of 1975 to 1980.

Reclaim Generations

In the period of 1975 to 1980, the most significant year, 1976, frames the various narrative strategies, corrective or complementary motivations, and historical interventions that emerged in slavery-themed African American literary and cultural production. The period 1975 to 1980 is noteworthy for the Watergate scandal, the end of U.S. involvement in Vietnam, Nixon's resignation, the rise and fall of President Carter, and the ascent of Ronald Reagan with his disastrous policies for black people. However, the year 1976 also commemorated the 200th anniversary of American independence. The celebrations of this event (on the heels of the humiliating withdrawal from Vietnam in 1975) synergized efforts to re-form the national memory by instilling a sense of domestic unity rooted in a nostalgic past. Any return to a state of American innocence perforce could not include careful or accurate attention to its slave past. As David Ryan notes of the commitment to America's bicentennial nostalgia, "The very processes of the formation and articulation of collective memory necessitates a displacement of certain aspects of the past that no longer comport with the attempts to reconstruct the nation's identity through a selected reading of the past."[6] The challenges of 1975 propelled 1976 into the false comforts of a carefully invented past that denied the ways that slavery built the nation while also minimizing contemporary experiences of black dispossession. In a gesture of national assuagement, "the 1976 Bicentennial enactment reached back to a mythical and monumental reading of the U.S. Declaration of Independence in 1776 and its revolution. It did so through a lens and frame of nostalgia that produced a discourse and evident yearning for home and for a past that no longer existed and never did [. . .]."[7] The 200th celebration of the birth of the nation reflected a larger social fantasy designed to sweep away slavery with the broom of nostalgia. At the same time, the bicentennial's celebratory narrative distracted from and obfuscated the contemporary experiences of black disenfranchisement, as the promises of civil rights legislation went unfulfilled during the economic crisis of the mid-1970s.

African American writers working in this period of national commemoration had no compunction to craft false idyllic visions of America, especially when those romanticized illustrations of America's past would never expose

the paradox at the heart of U.S. democracy. These writers recognized that the predominant nostalgic American narratives could operate only by erasing black people. Poet Lucille Clifton explains this in response to a request she received to write a commemorative poem celebrating the colonial era: "I wrote a poem which goes, 'They ask me to remember, but they want me to remember their memories, and I keep on remembering mine.'"[8]

The notion of incompatible memory is an important aspect of Lucille Clifton's 1976 memoir *Generations*. A slim prose poem that incorporates lines from Walt Whitman's *Song of Myself*, the Book of Job, and recollections of her father, who acts as the book's griot, the work is elegantly crafted in a lyrical, spare but concentrated style. The variety of interpretive modes Clifton uses suggests the capaciousness of her rich family history, implying that the slim volume is the result of deliberate and aesthetic compression. Photographs from each generation preface their respective section of the narrative. An epigraph explains the point of origin, "The woman called Caroline Donald Sale / born free in Afrika in 1822 / died free in American in 1910" (1). Clifton's memories of her father and his stories frame *Generations*. As an elegy of/to both of her parents, *Generations* takes 1822 as its point of origination. That year Clifton's great-great grandmother, Caroline Donald Sale, was born in Dahomey, was then forcibly transported to New Orleans as an eight-year-old and walked to Virginia in a slave coffle. As Hilary Holladay notes, "Though Caroline is long dead, Clifton humanizes her ancestor's plight so that readers cannot help empathizing with the African child who became an American slave and finally evolved into a freed African-American matriarch. Much more than a one-dimensional victim of her times, Caroline is a living presence in the minds of her descendants."[9] Clifton conjures and commemorates this living presence. Not content to indulge in either the American national fantasy or the archival fiction of the white branch of her family tree—which does not recognize her lineage as kin—Clifton crafts her own history and includes her slave ancestor as its foundation. "What I'm writing is also history. And some of it is the history of the inside of us; and some of it is the history of the outside."[10] Like Jones's work in *Corregidora*, these texts open a space in which to grapple with morally complicated histories, even if the protagonists and characters (and readers) resist this process.

In this way, *Generations* dually intervenes: it engages the national story of America's past and it corrects the archival record of her extended family. Clifton placed an advertisement in the Bedford, Virginia, newspaper seeking information about the Sale/Sayles family as part of her genealogical research. The memoir's first chapter recounts a telephone conversation between Clifton and

a white woman who has "compiled and privately printed a history of the Sale/ Sayle family of Bedford County Virginia" (6). The white woman, who is initially "happy and excited" to discuss their shared heritage, is confused when Clifton shares her father's name, "I don't remember that name, she says" (6). When the self-designated keeper of her (white) family's history lacks knowledge of her father, Clifton quickly returns to the slave past and the hierarchy of memory that dominates many archives. "Who remembers the names of the slaves?" she muses, "Only the children of slaves" (6). Clifton reveals the names of her Sales ancestors to the white woman—"Caroline and Lucy and Samuel"—and adds "Slave names" as a point of clarification. The white woman's response is one of dismay, "'Ooooh,' she cries. 'Oh that's just awful.' And there is silence. Then she tells me that the slave cabins are still there at the Sale home where she lives, and the graves of the slaves are there, unmarked. The graves of my family. She remembers the name Caroline, she says, her parents were delivered by the midwife, Mammy Caroline. The midwife Mammy Caroline" (6). Clifton's work corrects the gap in the white family history and personalizes her ancestor. As a result, the memoir serves as an allegory for the larger historiographical processes that typically overlook the intricacies of slave life.

Caroline is *not* only a midwife (or worse, "mammy") occupying a minor supporting role in the white family's history. She is the progenitor of Clifton's family line, who retains aspects of her Dahomey heritage so firmly that a frequent comment Clifton heard growing up was "Get what you want, you from Dahomey women" (1). Clifton associated strength and resiliency with her ancestor who was a mere footnote in this white archive, as slaves lie buried in unmarked graves. The victory ultimately belongs to Clifton and her progenitors. When Clifton receives the family tree compiled by the white woman, she sees that "in it are her family's names. And our family names are thick in her family like an omen" (6–7). She also observes that the white woman is "old and not married, left with a house and a name" while Clifton is married with six children. The comparison notes the way that her ancestors' white family's official history denigrated her ancestors, yet she remains connected: "the Dahomey women gathering in my bones" (7).

Clifton's *Generations* posits her fecundity as a type of victory over the "old" childless white woman who preserves a formal, written family history that excludes its African American and slave heritage. In the same way that this white woman reduced Clifton's Dahomey progenitor to mammy and midwife, Clifton diminishes the woman's role as official family historian to one of an elderly woman "left with a house and a name." Without children to fill the house or

descendants to continue the name, the white woman's family history may possess archival authority, but it is sterile and stagnant, privileging the capacity to *preserve* itself rather than *reproduce* itself.

Like Gayl Jones and Lucille Clifton, Alex Haley examines ancestry and the need to acknowledge the slave heritage of African Americans while recognizing the brutality white people committed against them. The generations theme is critical to Haley's opus, *Roots*, as he traces his family line from Tennessee back to eighteenth-century Gambia. *Roots* marked an unprecedented achievement in the representation of slavery. Much of the book's power links to events that occurred well before and after its 1976 publication date. Though he had long worked as a journalist writing profiles of such renowned figures as Martin Luther King Jr., Miles Davis, and Johnny Carson, Haley received robust popular acclaim for his role as a coauthor of *The Autobiography of Malcolm X*, an "as-told-to narrative that expands the written by himself autobiography tradition in African American letters."

Haley's work as an amanuensis for Malcolm X inspired his research and writing about his own family. According to Arnold Rampersad, Haley believed that the genre of autobiography was "almost by definition a project in fiction."[11] The intersection of fiction and autobiography would result in the hybridized genre of *Roots*, which was based on years of Haley's research around the world (autobiography) but which also reproduced some narratives of plantation literature (fiction). Haley balanced the genres of fiction, autobiography, archival research, and historical inquiry. He described *Roots* as "faction," a neologism to describe the balance of "fact" and "fiction." In this way, Haley participates in (and anticipates) the broader tradition of African American authors who craft a hybridized generic approach to textually resurrect the slave past.

Roots tells the story of Alex Haley's progenitor Kunta Kinte, who was born in Gambia in 1760. Seventeen years later, white slavers kidnap and force him aboard the ship *Lord Ligonier* with 140 other captives (see Chapters 3 and 4 in this volume). After surviving the horrors of the Middle Passage, Kinte is sold to John Waller in Annapolis, Maryland, and assigned the name "Toby." Kunta Kinte's indomitable spirit leads him to flee from Waller's possession four times. Each effort results in recapture and harsh physical abuse. After the fourth and final attempt, Kunta Kinte's owners ask him to choose between genital or foot mutilation. Kinte chooses his foot, which is then severed, leaving him permanently maimed and unable to attempt escape again. Kinte marries Bell, the enslaved woman who nurses him back to health. They have a daughter and Kinte names her "Kizzy," which means, "stay put" in his native language. Kizzy becomes a type of playmate and companion to Anne, the white family's niece who often visits.

Kunta and Bell provide Kizzy with as much love and peace as they can muster and recite to her accounts of her father's history, customs, and language from Africa. Kizzy lives a rather sheltered life with her parents and under the patronage of Anne. At the age of 16, however, she helps her slave lover attempt to escape by forging a pass for him, and he is sold to the brutal Tom Lea as punishment. Lea rapes her continually, and Kizzy gives birth to George who, like his father, develops into a skilled trainer of fighting cocks, which earns him the nickname Chicken George. George marries Matilda, a slave whom Tom Lea purchased when George mentioned his attraction to her. The couple marries and have eight children, including a son named Tom. When Tom Lea loses his fortune, he gives George to an Englishman to whom he is indebted, and who grudgingly promises to free George after they return from a trip to England. When George returns, he is emancipated, the first of Kunta Kinte's descendants to be free in America. He learns that those who have not died during his time abroad have been sold, as a family, to the Murrays, to settle Tom Lea's debt. After the Civil War, George and his family move to Tennessee. His son, now named Tom Murray, continues to pass on the story of Kunta Kinte to his own family, including his daughter Cynthia, who in turn relates the story to her own daughter, Bertha. The first to attend college, Bertha meets Simon Alexander Haley in Ithaca, New York. The two marry and become Alex Haley's parents. Haley grows up hearing stories about "the African Kin-tay" from his grandmother Cynthia. These shards of family history spark his curiosity and imagination. They eventually lead Haley to embark on an international, decades-long genealogical research project, the result of which is the epic tale that is *Roots*.

It seemed crucial to Haley that *Roots* be seen as more than just Alex Haley's origin story, and recounting the details in depth here confirms this point by contextualizing how Kunta Kinte's story establishes him as diasporic African everyman. His narrative of captivity, torment, survival, and finally legacy metonymically stood in for the millions of unnamed (and renamed) African captives who would ultimately comprise black America. In lectures delivered years prior to the book's publication, Haley shared the tale of his genealogical research and discovery in a two-hour speech titled "Saga of a People." Haley imagined *Roots* as more than just *his* story in the same way that Malcolm X was more than a man of *his* time. The book project would be a megaphone, amplifying the larger history of black America.

As Haley explained, "Every black person shares this ancestral story of capture, slavery and obliteration (even in as much as the story counters 'obliteration')."[12] In addition, the work presented a new, corrective mythology to rectify the then still-popular proslavery literature such as Margaret Mitchell's *Gone with*

the Wind (1936), and antiblack historical analyses such as that of Stanley Elkins that claimed that black people had been transformed into "sambos" during the antebellum period. As Haley's biographer Robert J. Norrell notes, "Kunta was the second great hero Haley had created on the page. Kunta and Malcolm X both were examples of fierce, independent, and manly characters, and together they formed a new and cherished archetype for black Americans."[13] Similarly, in a 1977 review of the book that considered some of the interpretive liberties Haley may have taken, David A. Gerber notes, "this embellishment compromises the historical Kunta Kinte in order . . . to explore the larger meanings of the Black-American's African memories . . . of slavery, resistance, and victimization."[14] *Roots* testifies to and counteracts the mythology of the then predominant interpretation of antebellum black life.

The cultural impact of *Roots* in 1976 cannot be underestimated. As Haley notes in the dedication, the bicentennial year fortuitously timed its publication: "It wasn't the plan that *Roots*' researching and writing finally would take twelve years. Just by chance it is being published in the Bicentennial Year of the United States. So I dedicate *Roots* as a birthday offering to my country within which most of *Roots* happened."[15] Critics and scholars challenged the book on many grounds, including, but not limited to, its mixing of fact and fiction; its nonacademic research methods; its stilted "slave" dialect and historical dialogue; its sometimes clunky prose; and its adherence, in parts, to tropes from the plantation literature tradition. Controversies and lawsuits (some settled, another dismissed) involving plagiarism and third-party contributions to the text also emerged. Overall, however, Haley's work represented (however ideally) Africa as black America's origin story and earned commendations. James Baldwin, in his review for the *New York Times*, celebrated Haley's "birthday present to us . . . this election and Bicentennial year." For Baldwin, Haley's work was a "study of continuities, of consequences, of how a people perpetuate themselves, how each generation helps to doom, or helps to liberate, the coming one—the action of love, or the effect of the absence of love, in time. It suggests, with great power, how each of us, however unconsciously, can't but be the vehicle of the history which has produced us."[16] The text also received acclaim for presenting one of the first prose depictions of a captive's view of the treacherous transatlantic journey aboard a slave ship. A contemporary reviewer, David Gerber, noted, "Other than Robert Hayden's chilling poem, I have not read anywhere an account of the cruelty, raw and hideous greed, foulness, death, and despair of the Middle Passage more moving and horrifying than that to be found in *Roots*."[17]

Perhaps because of robust prepublication efforts, which included Haley's popular lectures and frequent interviews about his literal and figurative journey

in magazines and newspapers, *Roots* swiftly became a phenomenon. It debuted on the *New York Times* bestseller list in the number five slot but quickly rose to the top, eventually selling millions of copies. The *New York Post* serialized it. The pedagogical impact of the work resounded. Educators at all levels sought to incorporate elements of the book into their classrooms: instructional packages and lesson plans (some with recordings by Haley) became available for teachers and professors. It received the Pulitzer Prize and the National Book Award. Haley thus renewed popular interest in African American genealogy and created a market for "roots" tourism for black Americans who wished to retrace their family heritage as Haley describes in the book.

Roots continued to wield a powerful influence on American culture beyond the book's bicentennial publication date. The paperback version of the book released in 1977. This date coincided with an ABC television miniseries, which itself became a record-breaking phenomenon: 61 percent of the TV viewing audience watched. Ultimately, the miniseries accumulated a total of 100 million viewers (a record that remains unbroken). The network believed that the twelve-hour series would be too emotionally challenging to retain viewer attention once a week for eight weeks as it was initially scheduled. Instead, the network chose to concentrate all the episodes in a consecutive eight-night viewing period. This arrangement fostered a virtually collective viewing experience across a typically diverse television audience. "It's like millions of people reading the same book simultaneously, instead of privately, making it a shared experience," said an ABC executive.[18] Charlayne Hunter-Gault, reporting on the reception of the series in 1977, notes "Doubters and enthusiasts, whites as well as blacks, young and old, wealthy and poor had reactions they wanted to share." She described the communal atmosphere at Jock's Bar in Harlem, where a group gathered every night to watch: "Joe Kirkpatrick, the owner, said that one night viewers got so angry over the treatment of Kunta Kinte that they would not allow the jukebox to be turned on even after the show had ended. 'They just wanted to talk it out,' he said, 'and it wasn't until they had talked and talked for a very long time that they finally remembered they were in a bar. 'That's when they started drinking up.'"[19]

The timeframe of 1975–1980 provided an ideal context for *Roots* to make a significant impact in American culture. Mainstream television programs such as *Good Times* and *The Jeffersons*, both of which engage the idea of success and what it means for black people in the post–civil rights era, debuted. As historian Matthew F. Delmont notes, "The 1970s saw an explosion in progressive, black-centered television and culture, just as blacks were starting to make real socioeconomic gains as a result of the civil rights revolution of the 1960s."[20] This

comment highlights how the post–civil rights era empowered writers like Gayl Jones, Lucille Clifton, Alex Haley, and others to approach slavery in their works as corrective and disrupting devices. Black literature about slavery published in the mid-1970s made deliberate literary interventions. In the same way that *Roots*, both the text and television program, elbowed aside racist fictions like Margaret Mitchell's *Gone with the Wind* and D. W. Griffith's *Birth of a Nation* to take its place in the story of American history, so too did works like Gayl Jones's *Corregidora* and Lucille Clifton's *Generations* refute the story of America's birth as a wholesome, universally applicable tale about life, liberty, and the pursuit of happiness. This corrective revises the story natal America seeks to tell about itself and ushers in a new and fuller understanding of America's origin story.

Another significant contribution to the development of African American literature of slavery written in the post–civil rights era, Ishmael Reed's novel *Flight to Canada* offers a powerful commentary on nineteenth-century abolitionist fiction, slave narratives, and proslavery ideology. Reed's imaginative variation on the nineteenth-century slave narrative form marks a noteworthy evolution in literature about slavery. Although Reed does not try to rediscover lost or erased slave ancestors, his work shares—with those of Jones, Clifton, Haley, and Butler—a focus on generations. Significantly, however, this novel's generational focus is on literary heritage rather than genealogy, and it rescripts previously dominant literary modes to present something new.

Reed is "engaged in a project of emancipating an artistic heritage from predictable or predetermined forms and norms imposed by those who fail to fully comprehend the depth and complexity of that heritage, including its folkish inventiveness, hilarious undercurrents, and seasoned extravagances. Reed, in short, uses tradition to illuminate and reinvigorate tradition, combining continuity and improvisation in a cultural dynamic that Amiri Baraka has astutely dubbed 'the changing same.'"[21] At the same time, Reed's work challenges "our ideas about the way history usually works in Afro-American literary texts. It shares the postmodern concern with producing previously untold histories and questioning both who has had the power to write history and the assumption of the authenticity of written texts."[22] Reed might be seen as a literary descendant of satirist George Schulyer (*Black No More* 1932) as well as a predecessor of Paul Beatty (*The Sellout* 2015). He also has been described as a unique and inventive writer who "dared to seek the absurd in places one normally finds only tragedy."[23]

A raucous, irreverent revision of the nineteenth-century slave narrative, *Flight to Canada* begins with an acclaimed poem, "Flight to Canada," and a letter from the poet-protagonist and fugitive slave writer, Raven Quickskill. Quickskill writes to his former master and adversary Arthur Swille. Swille, the rich-

est man in America, relentlessly pursues Quickskill despite the abolition of slavery. The absurdist tone of the work establishes itself when readers learn that Quickskill's "flight" to Canada is not a dramatic escape across ice floes as in Harriet Beecher Stowe's *Uncle Tom's Cabin*. Instead, Quickskill flies in an airliner, complete with passengers who cheer and buy him drinks when they learn that he's a fugitive slave writer: "Traveling in style / Beats craning your neck after / The North Star and hiding in / Bushes anytime, Massa."[24] Quickskill has fled with two other fugitives, "40's" and Stray Leechfield (Stowe was born in Litchfield, Connecticut), who becomes a porn star. Leechfield defends his career choice to Quickskill: "Shit, everybody can't do antislavery lectures. I can't. I have to make it the best I can, man. I don't see no difference between what I'm doing and what you're doing" (72). Reed collapses time for satiric effect: Swille's disaffected suffragette wife sits around watching "The Beecher Hour" until she's whipped into shape by Mammy Barracuda. Swille arranges to assassinate Abraham Lincoln in retaliation for abolishing slavery (Lincoln had promised Swille he would keep the institution). The fateful night at the theater is broadcast on national television. Through it all, Quickskill's fellow enslaved remain on Swille's property, among them Mammy Barracuda, Cato ("So faithful, he volunteered for slavery. So dedicated he is to slavery, the slaves voted him all-Slavery"), and Uncle Robin, who attends to Swille's correspondence in Quickskill's absence. The paragon of the faithful retainer, Uncle Robin has no desire to leave Swille, but is the mastermind of the culminating sleight-of-hand coup, carried out by the slaves. Upon Swille's death, Uncle Robin inherits the entire estate. Quickskill returns to write Uncle Robin's narrative.

Reed's experiments with form (through such methods as pastiche, improvisation, and collage) exemplifies his theory of "neohoodooism," which Reed first iterated in a prose poem, "The NeoHoodoo Manifesto," in his 1970 chapbook "catechism of d neoamerican hoodoo church." He had used it previously in his well-regarded novel *Mumbo Jumbo*, but it is integral to the narrative structure of *Flight to Canada*. Neohoodooism is a "philosophy and aesthetic process [Reed] employs to take care of business on behalf of the maligned and the mishandled. Hoodoo—the African American version of voodoo . . .—appeals to Reed because of its 'mystery' and its eclectic nature, thus providing him with an appropriate metaphor for his understanding and realization of art."[25] This aesthetic practice of neohoodooism displays resplendently in *Flight to Canada*, where Reed explicitly revises or signifies on a variety of literary representations and cultural phenomena. For example, Reed collapses time by hilariously eliding nineteenth- and twentieth-century technologies. As Glen Harris notes in "Ishmael Reed and the Postmodern Slave Narrative, "Reed frequently invokes

"bizarre anachronistic historical details: fugitive slaves watch Barbara Walters and Harry Reasoner on television and slaveholders travel by helicopter. His striking revisions to nineteenth-century slave narrative content are certainly not attempts at providing an accurate black story of slavery. Instead, they foreground Reed's 20th-century rewriting of a slave story."[26] Reed's collapse of time, despite its apparent irreverence, gestures significantly: not only does it signal a postmodern sense of play and dissonance, it also critiques what only a "20th-century rewriting of a slave story" can permit. From the benefit of hindsight and foresight, Reed's time-bending narrative brings two disparate time periods together to emphasize how the past resides in the present and the present might be an example of the future's changing same.

What Harris sees as anachronisms, Reed frames firmly with his theory of neohoodooism, as he explained, "According to *vodoun*, the past is contemporary. . . . In *Flight to Canada*, I tried to make novelistic use of the concept, though everybody called it *anachronism*, after digging back into their literary glossaries. I was trying to work with the old *vodoun* theory of time."[27] Reed satirizes a heady mix of targets, demonstrating black aesthetic and postmodernist techniques as well as a bracing sense of iconoclasm. The list of figures lampooned or alluded to in the novel is sizable: King Arthur (Arthur is also Swille's first name), Dracula, Camelot, T. S. Eliot, Sir Walter Scott, Tennyson, Walt Whitman, Dickens, Oscar Wilde, Jefferson Davis, and others. None receives more close scrutiny than Harriet Beecher Stowe and *Uncle Tom's Cabin*. One contemporary reviewer noted that the novel was "Ishmael Reed's bid to take back the story of Uncle Tom from Harriet Beecher Stowe—probably because Reed thinks it too valuable to leave to a white writer."[28] Indeed, the story is sacred in neohoodooism and in this novel. Quickskill calls Stowe's text "a steal," suggesting not so much that the book is inexpensive but that it represents an act of theft and appropriation. Reed perceives Stowe's use of materials from Josiah Henson's narrative, *The Life of Josiah Henson, Formerly a Slave*, as the basis for her own fiction as actually "taking" Henson's "life." As Christian Moraru explains, "That otherwise not unusual act of 'inspiration' appears to Reed as a deadly aggression."[29] Reed's indictment of Stowe for seizing Henson's story reflects a larger aesthetic indictment neohoodooism made: that the power of narrative is supreme. Raven Quickskill notes that Stowe's effect on Henson was debilitating because his story, his *life* story, "was all he had. His story. A man's story is his gris-gris. The thing that is himself. It's like robbing a man of his Etheric Double. People pine away."[30]

By making Raven Quickskill a fugitive slave, poet, and writer, Reed features the craft of writing as central to freedom. Stories are sacred, "gris-gris." At the same time, the publishing industry, which does not share the same reverence for

story, has a tale of its own to answer for when it comes to the telling of stories about the lives of black people. The trajectory of African American experience is mirrored, Quickskill observes, in the pattern of the stories that America tells about itself and its relation to black people: "Books titles tell the story. The original subtitle for *Uncle Tom's Cabin* was 'The Man Who Was a Thing.' In 1910 appeared a book by Mary White Ovington called *Half a Man*. Over one hundred years after the appearance of the Stowe book, *The Man Who Cried I Am*, by John A. Williams, was published. Quickskill thought of all of the changes that would happen to make a 'Thing' into an 'I Am.' Tons of paper. An Atlantic of blood. Repressed energy of anger that would form enough sun to light a solar system."[31] The powerful transformation of black bodies from objects into subjects is facilitated by beings with their own autonomy and agency and reflected in the deliberate expressions of words and idioms. Stowe's revision of "the man who was a thing" into "life among the lowly" as the subtitle for *Uncle Tom's Cabin* does not alter the abject condition of black people on which her story relies for its emotional force. Similarly, the idea that a black man is, for Ovington, "half a man" is also dangerous in its denial of full humanity and capacity to black people. By citing Williams's existential resolve as the culmination of this evolution, Reed reveals the consequence of making black people the subjects of their own stories rather than presenting them as props or symbols in the tales of others.

Embodying Generations

Ishmael Reed's experiments with time, the neohoodoo aesthetic, and the playful but strategic revision of history effectively connect *Flight to Canada* with Octavia Butler's novel on slavery, *Kindred*, published in 1979. A. Timothy Spaulding links these books under the rubric "postmodern slave narrative," and argues that both seek "to thematize its simultaneous occupation of two distinct time periods. Each time period informs the other in a mutual interchange, a mutual commentary."[32] Like Reed's novel, *Kindred* disrupts the chronological sequence of time to highlight the physical and emotional brutality of the slave past, while also calling attention to its lingering effects on the present. *Kindred* is set in two time periods (the nineteenth and twentieth centuries) and two geographic locations (Maryland and California) to create a story that pushes the boundaries of generations and genre and geography.

Kindred tells the story of Dana Franklin, a young black woman, who in 1976 travels from her California home back through time to the nineteenth-century Maryland plantation of her ancestors. On her initial visits, Dana meets Ru-

fus Weylin, a slaveholding white boy, and Alice Greenwood, a free black girl who lives a few miles away from the Weylin property. Dana has only a limited awareness of her family's history, but she recalls reading that the union of Rufus Weylin and Alice Greenwood produced her great grandmother. Meeting the two as children, Dana wonders how they would marry, "or would it be marriage?" Primed by her family genealogy, Dana becomes convinced that her family's survival into the twentieth-century depends on protecting Rufus Weylin, the white ancestor with whom she shares a peculiar and mystical connection.[33] When Rufus fears that his life is endangered, he can unwittingly summon Dana from the twentieth century to save him. For her part, Dana can return to the twentieth century only when she believes herself to be in mortal peril. On various occasions, Dana travels to the past to rescue Rufus from largely self-inflicted childhood mishaps, including a near-drowning, a fire that he started, and a broken arm. She believes that "this child needed special care. If I was to live, if others were to live, he must live. I didn't dare test the paradox" (29). Over time, however, the nature of their relationship changes. When Rufus becomes an adult, Dana's first act is to save him from being beaten to death by Alice's husband after he discovers Rufus raping Alice. Alice attempts to help her husband, a runaway slave from a neighboring plantation, escape but she is captured and enslaved. After forfeiting her freedom as punishment for the "crime" of aiding a runaway slave, Alice is sold to Rufus. He shows no remorse for having sexually assaulted her; as he explains to Dana, "I never wanted it to be like that. But she kept saying no." Rufus's explanation, while plausible from his position as a nineteenth-century slave master, repulses Dana. It is also meant to shock the contemporary reader who recognizes coerced sex as rape, a crime rather than an inconvenience. This is the beginning of Dana's moral crisis and the novel's most dangerous paradox: Alice's sexual coercion and its role in Dana's future. Dana continues to believe that her task is to ensure her twentieth-century existence. Among the services that she provides Rufus, the most vexing is to encourage Alice to submit to Rufus's unwanted sexual advances. As Rufus explains to Dana, "I'll have her whether you help or not. All I want you to do is to fix it so I don't have to beat her. You're no friend of hers if you don't do that much!"[34] Alice reluctantly "succumbs" to Rufus's demands, gives birth to several children (one of whom engenders Dana's family line), and commits suicide. Though her future existence is secure, Dana does not exit unscathed from the past. Rufus seeks to replace Alice with Dana by attempting to rape her, but Dana vigorously resists and fatally stabs him. "I could accept him as my ancestor, my younger brother, my friend, but not as my master, and not as my lover. He had understood that once" (260). In killing Rufus, Dana exposes the unresolved paradox at the heart

of the novel: she has relied on Alice's prolonged sexual abuse to produce her ancestors and preserve her own life. However, Dana retains her own sexual agency, drawing an inviolable perimeter around her own body that Rufus is not permitted to cross even as Dana has encouraged Alice to compromise her sexual integrity. Fearing for her life, Dana begins her departure back to the twentieth century. As she vanishes, Rufus's last act before dying is to seize her arm—which is ripped from her body by the cosmic pull of the past. Her severed arm is part of Butler's larger commentary about the daily terror of black subjectivity in the nineteenth century. "I couldn't let her return to what she was, I couldn't let her come back whole, and that, I think, really symbolizes her not coming back whole. Antebellum *slavery* didn't leave people quite *whole*," Butler explained.[35] In her speculative frame, the wounds of the slave past are worn on Dana's body in the present as a reminder and memento. Dana returns to the twentieth century missing her arm, forever scarred by her perilous encounter with her white ancestor.

Kindred is an inventive culmination of the slavery-themed African American literature preceding it. Like Ursa Corregidora, *Kindred*'s protagonist was "made to touch the past" and has inherited knowledge of and responsibility for the sexual abuse of her ancestors (see the discussion of *Corregidora* in Chapter 8 of this volume). She must wrestle with what to do with that knowledge and the paradox it generates. Analogous to Clifton and Haley's works, *Kindred* shares an urgent need to *flesh out* the slim historical and archival records of the slave past. Butler's deployment of the power of flesh builds upon the Black Power literature of slavery, such as Amiri Baraka's 1967 play, *Slave Ship*. As Madhu Dubey writes in this volume, both Butler and Baraka urge their "audience to understand slavery viscerally rather than as an object of abstract knowledge" (Chapter 1).

Kindred is a compelling tale of generational conflict, personal responsibility, and black progress that, like *Flight to Canada*, relies on chronological disruption, a critique of formal history, and the premise that people in the present are intricately linked to those in the past. Butler's experience as a science fiction writer serves her well in *Kindred*. Despite her claim that the novel is not, in fact, science fiction, Butler's willingness to experiment with the slave past draws a tight connection between the quotidian black experience of the late 1970s and the quotidian black experience of the antebellum era. The novel casts its protagonist as part of a dyad (an interracial marriage in the late 1970s). Dana's white husband, while progressive in the novel's present, exposes the regularized brutality of slavery when transposed upon the nineteenth-century version of interracial coupling (Rufus coercing sex from Alice). As I have suggested else-

where, "Butler's reversal of the linear space-time continuum and of the notion of chronological as well as ideological progress is more than a staple of science fiction. Butler uses the time-travel technique to raise moral dilemmas of inter-racial love and sex, gender equality, and racism. In this way, she elevates a trope of fantasy fiction into a meditation on the means and meanings of traumatic knowledge."[36] Butler renovates both the time-travel and historical fiction genres to speculate about what it means to inherit an erased or unknown slave past. Both Butler and Jones's protagonists share an inherited slave history of trau-matic sexual abuse that they must address using their own bodies, yet Butler requires her protagonist to witness and participate in the sexual exploitation of her foremother. The time travel narrative convention allows Butler to place Dana within what Freud calls the "primal scene"—when a child sees her parents having sex and is then on the scene of her own conception. This primal scene is traumatic and historically distant: Dana's ancestors started the family line that would lead directly to her through rape and coercion. In this way, Dana shares a morally compromised history with Ursa Corregidora and the descendants of Tom Lea and Kizzy. Unlike them, however, she is placed in the historical mo-ment where the protracted sexual abuse is not in the past but unfolding in the present. Dana's choice to sanction her ancestor's sexual abuse to assure her own survival is one of the novel's powerful ethical problems.

Butler's novel inaugurates what I have termed *bodily epistemology*, a theory of literary representation that relies on physical reenactment as a method for acquiring and critiquing knowledge, especially of the past. The bodily epis-temology of *Kindred* drives a critical wedge between the past and the present, between memory and erasure, and between textual representation and lived experience. *Kindred*'s representation of bodily epistemology attempts to "de-center the cognitive," to borrow from Alison Landsberg, and "experience history in a personal, bodily way."[37] The novel then is a paradox: a book that is suspi-cious of textuality and one that imagines a fantastical journey as a means to better understand true captivity. As Nadine Flagel notes, "Butler's novel not only uses the slave narrative to turn the table on the conventional assumptions and rhetorical tropes of speculative fiction but also deploys speculative fiction to critique the conventions of the slave narrative, introducing a significant am-bivalence toward literary representation."[38] Missy Dehn Kubitschek observes of *Kindred* that Dana's embodied experience in the nineteenth century means that she has "acquired understanding of the past, not as some procession of abstracts like 'slavery' and 'westward expansion,' but as a collection of known individuals' experiences."[39]

Kindred entails a more proximate, less detached approach to the slave past. In its pages, slavery is immediate and its consequences are hideously tangible. As Nadine Flagel notes, "Reading slavery, knowing slavery from a distance, enables one to make analogies; experiencing slavery, knowing slavery intimately, makes one wary of analogies."[40] The novel, as Kubitschek claims, "provides a literal paradigm of coming to terms with a history of slavery and oppression, a process that is in other works frequently metaphorical."[41] Madhu Dubey suggests that the strategic value of time travel is to "convey certain truths about slavery that are inaccessible through the discipline of history, but they are also and more importantly calculated to make their readers as well as characters feel ill at ease in the present."[42]

Kindred reminds readers that the racial progress realized by the late 1970s was not inevitable, linear, or permanent. As Madhu Dubey observes, "With the legal termination of Jim Crow and the formal achievement of equal rights for African Americans, the nation supposedly passed into a post-racial era, and in this sense the civil rights movement was believed to mark the end of a very long period of racial inequality spanning from slavery to the 1960s. The suspicion of history in speculative novels of slavery bespeaks a sharp sense of incredulity toward this historical narrative of racial emancipation."[43] *Kindred*, like the other works in this period, pays attention to the dissonance of America's ideals (drafted at the nation's founding) and its practices. As Salamisha Tillet describes "sites of slavery" (neoslave narratives), "post–civil rights African American writers and artists claim and reconstruct pivotal figures, events, memories, locations, and experiences from American slavery in order to provide interiority and agency for enslaved African Americans and write them into the national narrative."[44] The precarious nature of progress was evident during America's bicentennial year, signified by widespread nostalgia and a whitewashing of unsavory aspects of the nation's past. To underscore its importance, Butler chose July 4, 1976 (Independence Day and the 200th anniversary of Thomas Jefferson's death) as the date of Dana's ultimate journey to the past.

Conclusions

The period from 1975 to 1980 proved a fecund time for African American literature devoted to the representation of slavery. The post–civil rights context—which included the belief that full racial equity had been achieved with the demise of Jim Crow and increased legislation for voting and other civil rights—brought into stark relief the practical reality that antiblack racism and

bigotry remained a dominant feature of the American social landscape. In the same way that some critics define the Black Arts Movement of the late 1960s as a counterpart of the Black Power Movement based on a shared commitment of advocating for black communities but through aesthetic formations rather than physical conflict, so too are the black authors who write about the slave past in the latter half of the 1970s engaged in a form of advocacy, revision, and black empowerment. An encroaching backlash against the gains of the civil rights legislation begins to stir during this time. Consider the 1976 inaugural edition of the National Urban League's "State of Black America," which concluded that no recent year "has been more destructive to the progress of blacks than 1975."[45] The report, crafted by Vernon E. Jordan Jr. in his role as National Urban League Director and offered as a corrective to the president's State of the Union address, featured statistical research about "the economy, employment, housing, health, education, legislation, crime, and social welfare" specific to black people.[46] Jordan notes "many of the gains blacks made over the past decade were either wiped out or badly eroded in 1975, and the portents for the future are not encouraging."[47]

In this context, the works published between 1975 and 1980 pay serious attention to American slavery to correct sets of interpretations and to generate new possibilities for black life to flourish. These books imaginatively re-center the story of slavery on the enslaved, focalizing their complex interiority. The works demand that care and attention be paid to the depth of the experience and the impact that the institution of American slavery had on black lives in the moments of bondage, throughout subsequent generations, and on all facets of America's history and its infrastructure. The novels revise prevailing modes of interpretation that sought to diminish slavery as a formative and traumatic historical period. These authors also create sites for critical engagement, bringing a new dimension to Faulkner's claim that the past is never dead—it isn't even past.

African American literature about slavery is so capacious that Ashraf Rushdy has classified four types of "neoslave narratives." Between the years of 1975 and 1980, African American authors wrote in each of the four generic styles: historical fiction, palimpsest narratives, genealogical narrative, and imitations of the nineteenth-century slave narrative. Whereas historical novels use factually documented people or events as the basis for fiction set in the past, palimpsest narratives collapse the past and the present to explore how contemporary black subjects connect current sociopolitical relations to slavery's legacies. The genealogical narrative traces a family's lineage, and the generic mode reimagines the nineteenth-century slave narrative and uses the perspective of a fugitive or manumitted slave character as the center of the work.[48]

Between 1975 and 1980, all four of Rushdy's neoslave narrative forms appear: Barbara Chase-Riboud's *Sally Hemings: A Novel* (1979) and Frank Yerby's *A Darkness at Ingram's Crest* (1979) are historical fiction. Gayl Jones's *Corregidora* (1975) and Octavia Butler's *Kindred* (1979) are palimpsest narratives. Lucille Clifton's *Generations* (1976), Alex Haley's *Roots* (1976) and Leon Forrest's *The Bloodworth Orphans* (1977) are genealogical ones. *Flight to Canada* (1976) and *Kindred* (1979) imitate and revise conventions of the nineteenth-century slave narrative. The depth and breadth of the work produced by the writers in the latter half of the 1970s laid the groundwork for future approaches. One can draw an imaginative line from *Kindred* to Tananarive Due's *My Soul to Keep* (1997) and Stephen Barnes's *Lions Blood* (2002), as both of these authors combine an interest in slavery with the techniques of speculative fiction. In addition, a 2017 graphic novel adaptation of *Kindred* by Damian Duffy and John Jennings demonstrates the continued resilience of Butler's work in a new age and different genre. The haunting power and traumatic legacy of female ancestry described in the works of Gayl Jones and Lucille Clifton later resonate in novels by Toni Morrison, who edited Clifton and Jones's books. *Flight to Canada* (1976), with its sharp and poignant view of American slavery as not just a phenomenon of the past seems to have inspired Paul Beatty's satire, *The Sellout* (2015),[49] and Colson Whitehead's *The Underground Railroad* (2016).

African American writers who focused their literary imagination on slavery labored to strike a balance between the past and the present. Inspired by historiography that encompasses slave testimony, the works of these writers amplify the stories of those who had been overlooked or appropriated. Thus more than a century after its abolition, the devastating impact of American slavery reverberated.

Notes

1. Salamishah Tillet, *Sites of Slavery: Citizenship and Racial Democracy in the Post–Civil Rights Imagination* (Durham: Duke University Press, 2012), 3.

2. Ibid, 4.

3. Toni Morrison and Robert Richardson, "A Bench by the Road: Beloved," *World* 3 (January–February 1989): 4.

4. John Blassingame's *Slave Testimony: Two Centuries of Letters, Speeches, Interviews, and Autobiographies* (Baton Rouge: Louisiana State University Press, 1977) exemplifies the growing interest in perceiving slavery from a nondominant narrative position during this time. The term *testimony* suggests that voices of the enslaved are being called upon to declare their experience in their own words, intervening in a history that has been written *for* or *about* them but not *by* them.

5. Deborah McDowell, "Negotiating between Tenses: Witnessing Slavery after Freedom *Dessa Rose*," *Slavery and the Literary Imagination*. Deborah E. McDowell and Arnold Rampersad, eds. (Baltimore: Johns Hopkins University Press, 1989).

6. David Ryan, "Re-enacting Independence through Nostalgia—The 1976 U.S. Bicentennial after the Vietnam War." *FIAR: Journal for the International Association of Inter-American Studies* 5.3. http://interamericaonline.org/volume-5-3/ryan/.

7. Ibid.

8. Charles Rowell, "An Interview with Lucille Clifton," *Callaloo* 22.1 (Winter 1999): 58–71.

9. Hilary Holladay, "'Our Lives Are Our Line and We Go On': Concentric Circles of History in Lucille Clifton's *Generations*," *Xavier Review* 19.2 (1999): 18–29. Rpt. in *Poetry Criticism*, ed. Lawrence J. Trudeau. Vol. 148 (Detroit: Gale, 2004).

10. Rowell, "Interview," 58.

11. Arnold Rampersad, "The Color of His Eyes," in Joe Wood, ed. *Malcolm X: In Our Own Image* (1st ed.) (New York: St Martin's Press, 1992), 119.

12. Angela Terrell, "Tracing His Past," *Washington Post, Times Herald (1959–1973)*, December 8, 1971, ProQuest Historical Newspapers: *The Washington Post*, B6.

13. Robert J. Norrell, *Alex Haley and the Books That Changed a Nation* (New York: St. Martin's Press 2015), 142.

14. David Gerber, "Haley's Roots and Our Own: An Inquiry into the Nature of a Popular Phenomenon," *Journal of Ethnic Studies* 5.3 (Fall 1977): 98.

15. Alex Haley, *Roots* (Garden City, N.Y.: Doubleday, 1976), v.

16. James Baldwin, "How One Black Man Came to Be an American: A Review of 'Roots,'" *New York Times*, September 1976. https://www.nytimes.com/books/98/03/29/specials/baldwin-roots.html.

17. Gerber, "Haley's Roots and Our Own,"101.

18. Les Brown, "ABC Took a Gamble with 'Roots' and Is Hitting Paydirt," *New York Times*, January 28, 1977. http://query.nytimes.com/mem/archive-free/pdf?res=9505E2DA1539E334BC4051DFB766838C669EDE.

19. Charlayne Hunter-Gault, "'Roots' Getting a Grip on People Everywhere," *New York Times*, January 28, 1977. http://timesmachine.nytimes.com/timesmachine/1977/01/28/75035444.html?pageNumber=38.

20. Matthew F. Delmont, "Why America Forgot about 'Roots,'" *New York Times*, May 27, 2016. http://www.nytimes.com/2016/05/28/opinion/why-america-forgot-about-roots.html.

21. William L. Andrews, Frances Smith Foster, and Trudier Harris, eds. *The Oxford Companion to African American Literature* (New York: Oxford University Press, 1997), 626.

22. Glen Anthony Harris, "Ishmael Reed and the Postmodern Slave Narrative," *Comparative American Studies* 5.4 (2007): 461.

23. Andrews, Foster, Harris, *Oxford Companion*, 672.

24. Ishmael Reed, *Flight to Canada* (New York: Random House, 1976), 4.

25. Andrews, Foster, Harris, *Oxford Companion*, 625.

26. Harris, "Ishmael," 460.

27. John Domini, "Ishmael Reed: A Conversation with John Domini," 1977, *American Poetry Review* 7.1 (1978), reprinted in *Conversations with Ishmael Reed*. Ishmael Reed, Bruce Dick, Amritjit Singh, eds. (Jackson: University Press of Mississippi, 1995), 139.

28. Greil Marcus, "Uncle Tom Redux," *Village Voice*, November 15, 1976, 47.

29. Christian Moraru, "'Dancing to the Typewriter': Rewriting and Cultural Appropriation in *Flight to Canada*," *Critique*, 00111619 41.2 (Winter 2000).

30. Reed, *Flight to Canada*, 8.

31. Ibid., 82.

32. A. Timothy Spalding, *Re-forming the Past: History, the Fantastic, and the Postmodern Slave Narrative* (Columbus: Ohio State University Press, 2005), 27.

33. For an alternate interpretation, see Linh U. Hua's "Reproducing Time, Reproducing History: Love and Black Feminist Sentimentality in Octavia Butler's Kindred," *African American Review* 44.3 (Fall 2011): 391–407. Hua challenges scholars to examine fissures in the text (393).

34. Octavia Butler, *Kindred*. 1979 (Boston: Beacon Press, 2004), 164.

35. Randall Kenan, "An Interview with Octavia E. Butler," *Callaloo* 14.2 (1991): 498.

36. Lisa Woolfork, *Embodying American Slavery in Contemporary Culture* (Urbana: University of Illinois Press, 2007).

37. Alison Landsberg, "America, the Holocaust, and the Mass Culture of Memory: Towards a Radical Politics of Empathy," *New German Critique* 71 (1997): 76.

38. Nadine Flagel, "'It's Almost like Being There': Speculative Fiction, Slave Narrative, and the Crisis of Representation in Octavia Butler's *Kindred*," *Canadian Review of American Studies* 42.2 (2012): 228.

39. Missy Dehn Kubitschek, *Claiming the Heritage: African-American Women Novelists and History* (Jackson: Mississippi University Press, 1991), 26.

40. Flagel, "Speculative Fiction," 234.

41. Kubitschek, *Claiming the Heritage*, 51.

42. Madhu Dubey, "Speculative Fictions of Slavery," *American Literature* 82.4 (2010): 791.

43. Ibid., 793.

44. Tillet, *Sites of Slavery*, 5.

45. "Distress Signal," *New York Times*, Monday, February 2, 1976, 22. http://timesmachine.nytimes.com/timesmachine/1976/02/02/issue.html.

46. Vernon Jordan Jr., *The State of Black America* (New York: The National Urban League, 1976), 1

47. Ibid.

48. Rushdy, in *Oxford Companion*, 535.

49. Paul Beatty's *The Sellout* (New York: Farrar, Straus, and Giroux, 2015) is the first American novel to win the prestigious Man Booker Prize, an award given to the best novel written in English and published in the United Kingdom.

Slavery Now

1970s Influence Post–20th-Century Films on American Slavery

MONICA WHITE NDOUNOU

On May 30, 2016, social media erupted as enslaved Africans on a Virginia plantation were forced to watch the horrific beating of Kunta Kinte (Malachi Kirby) in the 2016 remake of *Roots*, the iconic 1977 television miniseries adaptation of Alex Haley's historical novel.[1] At the end of the first of four two-hour episodes, the sadistic, white overseer sneers before beating Kinte within an inch of his life, "Anyone looks away takes a turn." The black captives on screen witness the horror with varying expressions of silent anguish as Kinte's screams punctuate each lash of the whip. Throughout the ordeal, the home viewing audience shared sad or angry emoji faces on social media, tweeting prominent lines from the film or typing Kinte's name and lineage even as he eventually submits to the name, Toby, which his white mistress forced upon him.

In spite of the psychic pain such scenes cause, many black audiences feel compelled to watch the growing number of American motion pictures about slavery, including but not limited to feature-length films *Nightjohn* (2005), *Django Unchained* (2012), *12 Years a Slave* (2013), *Belle* (2013), *Free State of Jones* (2016); the television miniseries *The Book of Negroes* (2015) and *Roots* (2016); and the television show *Underground* (2016). Nate Parker's *The Birth of a Nation* (2016), a direct response to D. W. Griffith's 1915 film of the same name, also reinvigorated debates by scholars and general audiences concerning the necessity of slavery films and their potential for representing slavery.[2]

Reactions to the *Roots* remake and the famous scene I recall epitomize the ambivalence contemporary black audiences experience with each Hollywood representation of slavery.[3] The overwhelmingly positive, real-time audience response to the *Roots* remake starkly contrasts with rapper and actor Snoop Dogg's social media campaign against the miniseries. Snoop Dogg urged his 12 million Instagram followers to boycott the program, lamenting the ongoing representation of black people as slaves rather than focusing on contemporary black success stories.[4] In a tweet to his 5 million twitter followers, actor and television personality Nick Cannon called for more films about ancient African civilizations that predate the European trans-Atlantic slave trade.[5] Data scientist Umesh Rao Hodgehatta suggests tracking such sentiments on social media can shed light on market behavior and improve customer experience.[6] These varied responses to *Roots* and other twenty-first-century films about slavery will drive subsequent production and distribution of slavery films just as much as the current social climate, which is informed by the Black Lives Matter movement.[7]

As a network of advocacy designed to rebuild the black liberation movements of the 1960s and 1970s through intersectionality, Black Lives Matter affects the production and reception of twenty-first-century films about slavery.[8] Ed Guerrero explains that the black political struggles of the late 1960s influenced a "sharp reversal in perspective in the plantation genre"; whereas earlier films tended to depict slavery as a benign enterprise with happy slaves—for example, D. W. Griffith's *Birth of a Nation* (1915) and *Gone with the Wind* (1939)—softer supremacist notions about slavery appeared by the late 1950s.[9] This sharp reversal represented in *Mandingo* (1975) and *Drum* (1976) and arguably *Roots* (1977) most effectively emerges in Haile Gerima's *Sankofa* (1993), which began filming during the 1970s but was not released until 1993. The 2016 *Roots* remake, *The Book of Negroes*, and *The Birth of a Nation* evolve out of this tradition of representing slavery and rebellion from black perspectives.[10] These counter-narratives undermine stories about white vigilantism against blacks and viral videos of police killing black people. Stories of slavery and rebellion that affirm the humanity of enslaved Africans can help fill a gap in the general public's understanding of past and present racial injustice and black responses to it. Since the most effective projects document the survival and resistance strategies of the enslaved, the dangers of neglecting to represent the history of slavery far outweigh the threat of reinforcing white supremacist ideology.

Even though they have not always been included, black perspectives matter in the telling of American slavery stories. Gerima's *Sankofa* failed to receive

U.S. financial backing and broad theatrical release after Hollywood executives labeled it as being "too black," thereby suggesting such films lack a sizable audience.[11] Hollywood prefers to represent white heroes and black people forgiving white people for racial injustice; these master narratives have more crossover appeal than those that try to dismantle racism.[12] Critics of Quentin Tarantino's *Django Unchained* (2012),[13] Steve McQueen's *12 Years a Slave* (2013),[14] and Gary Ross's *Free State of Jones* (2016)[15] recognize the limits of Hollywood's white savior complex and the tendency to focus more on individual rather than collective resistance in films about slavery.[16] Such patterns negate the revolutionary potential of these films to raise public awareness or serve as a call to action against the current conditions sparking debates between Black Lives Matter supporters and detractors.

Responses to recent films like the 2016 *Roots* remake align with Richard Iton's assertion that audiences can engage with such films so long as the film is not saturated with psychically and emotionally paralyzing violence.[17] Contemporary social media and social movements enable audiences to look and talk back; actions that enslaved Africans were denied. My analysis compares patterns in 1970s films like *Mandingo*, *Drum*, *Roots*, and *Sankofa*, and their influence on twenty-first-century ones like *Roots*, *The Book of Negroes*, and *The Birth of a Nation* to argue that films centering black perspectives of slavery can help reconcile the cultural trauma informing American identity across the color line.[18]

From Black Liberation to Black Lives Matter:
Historical Context Informs Revolutionary Films about Slavery

Black Lives Matter rebuilds black liberation movements that followed the *classical* civil rights era (1954–1968). While black resistance has been an ongoing practice through uprisings and various forms of rebellion since slavery, Black Lives Matter represents a significant development in the history of black liberation. BLM's emergence during President Barack Obama's presidency, the first known black president of the United States, has forced the nation and the world to interrogate the racial disparities black Americans have encountered throughout American history. Despite the nation's continued disregard of the racial disparities of police brutality, mass incarceration, and other forms of institutionalized racial bias, in 2016 the United Nations charged the United States with "racial terrorism," thereby arguing for reparations for the nation's black population.[19]

The murders of black and brown people and the acquittals of the white perpetrators and police sparked the rise of this grassroots movement. From the

murders of Trayvon Martin and Rekia Boyd in 2012 to Philando Castille and Korryn Gaines in 2016, and countless others, BLM has gained momentum.[20] The call for social justice and recognition of the value of black lives continues to intensify.[21] In August 2016, BLM announced its first political platform, which includes six core issues: reparations for slavery, criminal justice, economic justice, political power, community control, investment and divestment, and political power.[22] The movement's call for reparations continues to illuminate the critical role of slavery in the degradation and devaluation of black lives in the past and present. As a quintessential historical moment under which black expendability underwrites nation building, slavery underscores that black lives and humanity do not matter—or matter only as much as their value to their white enslavers. During Reconstruction and Jim Crow, the value of black bodies was further diminished once they were no longer the property of whites.

Revolutionary films about slavery tend to focus on black experiences of slavery, to foreground black agency in liberation struggles, and to reject the white savior formula and racial reconciliation narrative.[23] White savior films like *Django Unchained*, *12 Years a Slave*, and *Free State of Jones* tend to feature a white hero who saves black people from oppressive circumstances. The repetition of this hegemonic narrative ignores white complicity in the racial oppression of people of African descent and reinforces the belief that only white people can liberate people marginalized by race.[24] The formulaic conventions of racial reconciliation narratives feature people of color forgiving the transgressions of white individuals but leave intact the racial/racist ideologies and structures that necessitate forgiveness. The frequent repetition of the white savior and racial reconciliation narratives leads crossover audiences to feel good about themselves but tend to be harmful to black people as the onscreen misrepresentation affects social relations.[25] The Black Lives Matter movement and the various individual and collective responses to police brutality rewrite the historical narrative of black resistance in ways that coincide with revolutionary films about slavery.

Revolutionary films about slavery starkly contrast with the white savior and racial reconciliation narratives. These films center black experiences, social justice, and institutional reform rather than accentuate white characters who eventually overcome their racial prejudice in their one-on-one interactions with black people. It is no wonder the black struggles of the 1960s and 1970s resulted in feature films like *Mandingo*, *Drum*, and *Sankofa*, which call for bloody revolt, and the television miniseries *Roots*. As Madhu Dubey notes, many of the texts of the Black Power era are "marked by rich formal experimentation that lends complexity to their explorations of the inheritance of slavery" (Chapter 1 of

this volume). Each of these films is revolutionary in its own way, with *Sankofa* being the most productive model for emulation influencing the revolutionary slavery films produced during the Black Lives Matter era.[26] Rewriting the historiography of black life is an ongoing trend of cultural production in both historical moments.

The following discussion of adaptation elements in *Mandingo*, *Drum*, and *Roots* illuminate these 1970s films as revolutionary, in comparison to the plantation genre, yet nonthreatening enough for broad distribution in theaters or on television. My subsequent examination of *Sankofa* analyzes the subversive features that likely contributed to Hollywood's censoring it by not distributing it. In forcing the filmmaker to film and release the project after a twenty-year struggle, Hollywood also inadvertently inspired a new, empowering model of distribution that has since become magnified through new technology. Finally, I discuss the elements of rebellion twenty-first-century revolutionary films about slavery draw on from their predecessors. These projects cement a formidable tradition of depicting slavery while taking advantage of new technology and social media. I argue that the most productive roots of today's cinematic slavery grow out of these revolutionary films, which should heretofore serve as adaptable models for emulation to advance the production of historical films about a range of black experiences. Revolutionary historical films embrace the various modes of resistance and survival strategies that have enabled people of African descent to maintain their humanity in spite of the constant fight to proclaim it.

Revolutionary Potential Meets Crossover Appeal: *Mandingo*, *Drum*, and *Roots*

Mandingo and *Drum* are reminiscent of Melvin Van Peeble's *Sweet, Sweetback's Baadasssss Song* (1971) in their portrayal of revolutionary ideology and sexuality, although *Sweetback* takes place in a contemporary setting. The filmmaker, Melvin Van Peebles, and Huey P. Newton, the cofounder of the Black Panther Party for Self-Defense, identify *Sweetback* as "the first revolutionary black film" by drawing parallels to Black Power philosophies.[27] *Sweetback*, which inspired the Blaxploitation genre, features Sweetback, a black male sex worker who becomes a revolutionary. After witnessing police brutality against a local black activist, Sweetback attacks the white cops. While on the run, he has various sexcapades that not only demonstrate his prowess and dominance over women but also exploits fetishes of interracial sex between black men and white women. Similarly, *Mandingo* and *Drum* exploit interracial sex themes but they are historical

films adapted from white author Kyle Onstott's Falconhurst novels, a series focusing on slavery in the south.

Sweetback's merging of revolution and interracial sex is contradictory. The film's erotic subject matter historically references the racialized, sexual dynamics of slavery wherein procreative sex between black men and women profited white enslavers. White men's unrestricted access to black bodies, especially black women, starkly contrasts with the reverse. In *Mandingo* and *Drum*, society regarded consensual sex between black men and white women as rape and maintained that black women could never be raped.[28] The contemporary revision in *Sweetback*'s consensual interracial sex challenges social mores but does not benefit the community. On the contrary, this so-called liberation of black male sexuality comes at the expense of black women and children. Rape scenes involving sexual intercourse between a black woman sex worker and the ten-year-old Sweetback, who later, as an adult, rapes a black woman at knifepoint to avoid capture, undermines the revolutionary potential of the film. For these reasons and others, critic Lerone Bennett argued that *Sweetback* is neither revolutionary nor black.[29] Ed Guerrero, Amy Obugo Ongiri, and Stephane Dunn underscore the complexity of the film's construction, reception, and problematic partnering of revolutionary ideology with sexual politics, which disempowers black communities.[30]

Mandingo, originally published as a novel in 1957, takes place before *Drum*, which was originally published in 1962. In 1961, *Mandingo* was adapted into a Broadway play with a total of eight performances.[31] The film premiered nearly a decade later and ensured the continuous circulation of this story. In *Mandingo*, Hammond Maxwell, the heir of a southern plantation, comes of age and marries his white cousin Blanche, in spite of his preference for black "slaves." Hammond later poisons Blanche after she gives birth to the black child of his prizefighting, enslaved Mandingo, Mede. To retaliate, Hammond also boils Mede to death and forces Lucy (Mede's enslaved mother who has unwittingly procreated with him) to pour Mede's soupy remains on Blanche's grave.[32] The novels primarily portray slavery from the perspective of Hammond and his father while disregarding black humanity and the experiences of the black characters. Although "*Mandingo* can make no claim to historic accuracy," the novel constructs a popular image of the Old South that romanticizes and downplays the horrors of slavery by normalizing racial violence against and sexual assault of enslaved black people.[33]

This pattern of storytelling continues in Onstott's *Drum*, which also narrates an interracial sexual affair that results in a mixed-race baby and the death of

the black father. *Drum* begins in Africa and traces three generations into slavery through the black male protagonists Tamboura, Drum, and Drumson. This framing mischaracterizes African slavery, which was not a permanent condition passed down across generations. As a result, the novel fails to distinguish the particular brutality of the European trans-Atlantic slave trade. Instead, the story caters to the fetishizing of interracial black and white sexual liaisons. It begins with Tamboura in Africa as his brother sells him into slavery and he becomes a breeding slave on a plantation where he eventually couples with his white mistress. Like Mede, Tamboura dies for the transgression but his white lover escapes while pregnant. She allows Drum to believe he is the son of one of her enslaved black women. He becomes a fighter while working in his white mother's whorehouse before she eventually sells Drumson to Hammond Maxwell, the protagonist from *Mandingo*. While Drumson is at Falconhurst, a slave rebellion results from Hammond's lingering hostilities toward his enslaved following his murder of Mede in the prequel.[34] In spite of the rebellion embedded in the narrative, the hypersexuality in the story draws the novel away from its revolutionary potential, which is better realized with the infusion of the Black Power literature of slavery into the film adaptations of Onstott's novels.

Mandingo's 1975 film premier in theaters helped pave the way for revolutionary films about slavery by revealing an audience that desired the subject matter. According to Guerrero, the film "notably, ranked eighteenth among the most lucrative productions of the year" in 1975.[35] The film shifts perspectives to focus on Mede rather than Hammond, makes stark changes in characterization of an enslaved man named Memnon, includes a more nuanced portrayal of the rebellion, and closes with a stronger antislavery message. While *Mandingo* played to mostly mixed reviews, *Drum* was not as well received. As film critic Vincent Canby observed in 1976, "Life on the old plantation was horrendous, I agree, but movies like this are less interested in information than titillation, which, in turn, reflects contemporary obsessions rather more than historical truths. Not since 'Mandingo' have I seen a film so concerned with such methods of humiliation as beating, shooting and castration."[36] In spite of their limitations, both adaptations illustrate the necessity of examining slavery from the perspective of black people without sentimentalizing slavery or including a white savior in order to counteract the damage of the plantation genre's white supremacist viewpoint. By redirecting the gaze, the films explore the possibilities of filming black agency and rebellion.

The films require the reversal because of the sociopolitical climate in which they emerged and to which they responded. The evolution of the classical civil rights era into the Black Power movement spanned the initial writing of *Man-*

dingo in 1957 and the release of the 1975 film adaptation. Stokely Carmichael's induction as the chairman of the Student Nonviolent Coordinating Committee (SNCC) in 1966–1967 marks a dramatic shift from the peaceful demonstrations that morphed into a more militant approach grounded in self-determination for people of African descent. The assassinations of President John F. Kennedy and Medgar Evers (1963), Malcolm X (1965), Dr. Martin Luther King Jr. and Robert F. Kennedy (1968), and Fred Hampton (1969) reflect a volatile period with social unrest expressed through rioting and other forms of protest and revolt. Witnesses of the violence inflicted upon black people and the backlash of every political gain were unlikely to accept another white savior narrative. Together, conflicting critical responses to *Sweetback*, like Newton and Bennett's, reveal a shared rejection of plantation ideology and its generic conventions. The Black Power philosophy and the new mise-en-scène, represented by the Blaxploitation genre infused into *Mandingo*, comment on the original source text's failed representation of black perspectives of slavery and the contemporary circumstances of black people in American society.[37]

It is no surprise that the *Mandingo* and *Drum* film adaptations adopt the most recognizable elements of the Blaxploitation genre—black hero, white villain, along with black and white interracial sex—because these tropes had already proven their appeal with the economic success of films like *Sweetback* and *Shaft* (1971). But *Mandingo* and *Drum* fall into the same trap that *Sweetback* does by overemphasizing hypersexuality and expressing sex as a radical act without adequately conveying the revolutionary ideology driving the rebellion impulse.[38] As Bennett explains, "If fucking freed, black people would have celebrated the millennium 400 years ago."[39] Bennett's additional critiques recognize the individualism embedded in the narrative's focus on Sweetback in spite of Van Peebles's attempts to situate the black community as the star of the film in the opening credits and various sequences throughout. Van Peebles's efforts acknowledge the importance of collective resistance in contrast to the individualism supported by a central hero. His strategy is not as effective due to *Sweetback's* treatment of black women, who are as important to the black community as black men, despite narratives of Black Power that privilege black men's importance. The sexual exploitation of black women, in particular, positions black men as active agents without considering the revolutionary potential of black women in as much detail as in later films (see the discussion of militancy in Chapter 5 of this volume). As later discussed, *Sankofa* corrects this myopia in the initial revolutionary slavery film formula by having a black female character as part of a collective protagonist of enslaved Africans in order to show how the humiliation and dehumanization of one affects all.

Roots also centers the story of a black man during slavery. Even though the narrative tells the story of some of the women in Alex Haley's family, like Kizzy, the story begins with Kinte and ends with Haley essentially guiding the narrative through the lens of a man's perspective (see Chapter 2 in this volume). Like Onstott's Falcolnhurst series, Haley's *Roots* was also a lucrative enterprise as the book sold 1.5 million copies in hardcover and more than 4 million in the paperback edition.[40] The television miniseries aired to 130 million viewers when it premiered in 1977, winning a Golden Globe for the Best Television series along with 15 other awards and 35 nominations.[41] Yet the series was also heavily criticized by scholars like American Studies professor Leslie Fishbein for its attempts to appeal to white middle-class viewers and values through assimilation.[42] Filmmaker Haile Gerima also describes *Roots* as being "political" rather than artistic. He explains:

> *Roots* was about creating harmony between Black and white people. But to me, harmony comes from facts, not delusions. And so while *Roots* did portray certain aspects of slavery, there's this false human union between white plantation owners and Black people. And to me, that's not what history testifies. I think politics usually is an art of lying. When art becomes politics it deceives. I think healing can only come out of truth and reality. Stronger people face certain facts; they become stronger nations.[43]

As Gerima indicates, a great deal remains at stake in the telling of the stories of slavery in American film and television. Fabricating a false union between white slave masters and enslaved Africans throughout the plantation genre harms rather than heals race relations.

Despite its limitations, Haley's project succeeds where *Mandingo* and *Drum* fail in terms of focus and format. The television miniseries follows the novel as closely as possible and is able to do so due to the breadth and depth that can be covered in a weeklong series compared to a two-hour feature film. The potential for more detailed characterization and story development allows for exploration of the subtle nuances of black experiences with slavery in a television miniseries format. Additionally, viewing complex subject matter like revolutionary films about slavery in private, over time with potential breaks, can also enable audiences to more effectively engage with the story. Slavery films viewed in the home may offer a more sympathetic viewing experience because television is more intimate, allowing the characters into one's home. It may also offer a private opportunity to express one's emotional response to the material without fear of judgment or scrutiny. As this chapter's opening indicates, social

media is allowing audiences, especially black ones, to experience the best of both worlds by sharing on social media while watching live at home.[44]

Roots is more likely to empower black audiences because it avoids centralizing interracial hypersexuality, and the television broadcast can reach a broader audience, including children. As recently as 2015, parents have exposed textbooks that misrepresent American slavery.[45] These educational materials refer to the European trans-Atlantic slave trade as "immigration" and enslaved Africans as "workers" or refuse to acknowledge the links between the civil rights movement and slavery.[46] As a result, children encounter narratives about slavery in school but in ways that downplay the complicity of whites, the horrors of the institution, and its ongoing significance. Film and television can help inform audiences about slavery and counteract the false narratives students encounter in school. *Roots* exemplifies the necessity of developing creative ways to convey the horror of slavery as well as rebellion and survival strategies so that various age groups can share in the viewing experience.

Roots' appeal on broadcast television, across the color line and generations, made it revolutionary in 1977. As Lisa Woolfork explains in Chapter 2 of this volume, African American authors of this period "channeled their historically based energy through a literary preoccupation with generations, encompassing familial lineage, historical legacy, and racial inheritance—including the intergenerational transmission of trauma (including the aspects of psychic, material, and cultural trauma)." As part of this continuum, Haley and his contemporaries, in Woolfork's words, "more than archive the past, even as they were archiving and revising the extant archive. They narratively reanimated the slave past, textually reinhabited it, and imaginatively pulled forward elements of its overlooked significance" (Chapter 2). Overall, the international reputation of the original *Roots* miniseries attests to its popularity. It is a groundbreaking model for emulation, embellished upon by twenty-first-century films like *The Book of Negroes* and the *Roots* remake, both of which have the technical gloss and sophistication necessary to appeal to younger audiences of the Black Lives Matter era.

Sankofa: A Revolution That Was Not Televised but Still Found Its Audience

Sankofa is also an epic saga in terms of its content and impact but without the benefit of a long miniseries format on broadcast television. Unlike *Roots, Sankofa* does not promote assimilation. On the contrary, the film encourages the remembrance of slavery and its direct links to daily, lived experiences along with

survival and resistance strategies. *Sankofa* follows the story of fashion model Mona, who travels back in time and becomes Shola, an enslaved black woman on the fictional Lafayette plantation. Shola and the other enslaved Africans that serve as the collective protagonist of the film experience the same degradations of chattel that appears in *Mandingo*, *Drum*, and *Roots*. The film dramatizes sexual exploitation during slavery but does not romanticize or fetishize it like the aforementioned texts.

Sankofa stages the artificiality of slave character performances in the plantation genre by placing archetypes and stereotypes in binary opposition in order to expose the lie of the happy slave. According to Cedric J. Robinson, black performers have historically devised various methods for challenging the recurring happy slave trope in American literature and theater, especially blackface minstrel shows.[47] Actress Oyafunmike Ogunlano's portrayal of Mona/Shola gradually mellows into a depiction that humanizes the characters and transforms the representation of an enslaved black woman into archetype as opposed to stereotype. Ogunlano starkly contrasts her characterizations of Mona as a superficial fashion model in the present at the beginning of the film with her varied portrayals of Shola. She initially portrays Shola as a stereotypical slave on the plantation with her speech and movement and interactions with the other characters. For example, when Shola tries to prevent Shango from intervening in the fatal beating of a pregnant runaway named Kuta (Alditz McKenzie), she uses dialect reminiscent of enslaved black people in films like *Gone with the Wind* (1939). Her movement is just as awkward as her speech as she pleads with Shango, warning him that "dey gon' kill ya" as she tries to prevent the machete wielding Shango from reaching the overseers. The visual and vocal contrast between Shola and Shango, who speaks with a thick, English-subtitled, Caribbean patois throughout the film, markedly distinguishes between the plantation genre's docile slave and the rebellious, enslaved Africans represented in revolutionary films about slavery.

The stereotypical "happy slave" performance that introduces Shola is turned on its ear by the end of the film. Shola becomes a field hand after her failed escape attempt, and her distance from the big house puts her in closer touch with black communities on and off the plantation. These emplotments reveal the importance of individual awakening as well as the power of collective resistance.[48] By the end of the film, Ogunlano's performance of Mona and Shola embodies the empowered transformation reflected in the film's major theme and title, Sankofa, which is an Akan proverb that means: "it is not forbidden to go back and reclaim what you have forgotten."[49] Mona's backward time travel and Ogunlano's performance remind audiences of how slavery informs the

present. Gerima's film stresses the importance of individual, internal harmony and collective resistance against oppression. By dramatizing nonstop rebellion as constitutive of slavery, Gerima's film incorporates Black Power philosophy in form and content. Mona/Shola's time travel and transformation document the historical survival strategies of blacks during slavery and articulate the ongoing need to remember and resist. The final images best depict this when Mona sits among the black tourists and local Africans listening to the call of the drums after returning from her spiritual journey. In this way, *Sankofa* attempts to avoid creating a false human union between plantation owners and black people. As a result, *Sankofa's* message of healing and harmony rejects reconciliation without truth or at least a counter-narrative centered by black perspectives. Additionally, the rejection of the white point of entry, described by Gerima as a sympathetic white character designed to create racial harmony through crossover appeal to white audiences, also provides a concrete, adaptable formulaic convention for revolutionary films about slavery.[50]

In comparison, several elements of *Sankofa* appear more revolutionary than *Mandingo*, *Drum*, and the original *Roots*. Gerima successfully links the black political struggles of the 1970s onward with the history of slavery. By refusing to be nation-specific in the location of the fictional Lafayette plantation, Gerima avoids "this ideology of 'specialness' of human exceptionalism in regard to the plantation owner. . . . Everybody's trying to find out who was the more humane plantation owner [English-speaking, Portuguese, and so forth]. I prefer to confuse this kind of localization. I want to say, 'Hmm . . . it could have happened here, but it also happened there.'"[51] This pan-African perception of slavery evokes physical and metaphysical strategies of resistance and rebellion through a decolonizing of the mind. By placing black audiences at the center and telling the story from the perspective of black characters, *Sankofa* encourages everyone to think differently about slavery, regardless of crossover appeal.[52]

Gerima's cinematic language also exposes the inventions of the plantation genre. Gerima juxtaposes the voiceover narration of violence with images of a beautiful sky or landscape rather than focusing exclusively on the violence. This strategy, along with the film's overall pacing, allows for a psychological break from the trauma of slavery through the use of sound, the content of the frame, camera angles, and movement. Gerima's focus on black characters that occupy the center of the frame at times looking into the camera, as if looking back at the audience during violent episodes, avoids reinforcing a white savior or a peaceful reconciliation based on forgiveness. The mirror effect created when the audience perceives the world through the eyes of characters that look into the camera simultaneously exposes and challenges the audience to see them-

selves through the eyes of the characters. Unlike the plantation genre's racial reconciliation narratives, this strategy empowers black audiences by providing multiple points of entry through the ensemble cast of rebellious, enslaved Africans who suffer varying forms of victimization only to rebel again. Without a white point of entry, white audiences must also engage with slavery from varying black perspectives; they cannot retreat into the viewpoint of the sympathetic white character that often masks the realities of structural racism and implicit bias. White viewers cannot escape white complicity when forced to engage with slavery from black perspectives. As a result, *Sankofa* is one of the most dangerous narratives of slavery on film because it not only challenges the status quo, it serves as a call to action for all audiences.

Gerima's response to Hollywood's lack of interest or support for *Sankofa* reflects the revolutionary mindset filmmakers require on- and off-screen to make their projects available to the broadest possible audience. The making of *Sankofa* is just as important as the film in this regard. The film was censored in the United States by lack of mainstream distribution, a common challenge faced by a range of films by and about black people and cultures, unless the master narrative that centers whiteness drives the story.[53] In the spirit of the Black Power philosophy grounded in self-determination, Gerima initially self-distributed by hosting screenings of the film in metropolitan areas and also selling DVDs of the film. *Sankofa* also was screened in foreign countries, winning the African Cinema Festival's grand prize and Best Cinematography at FESPACO Pan-African Film Festival in Italy.

Cinematic Slavery in *The Book of Negroes*, *Roots* 2016 Remake, and *Birth of a Nation*

Academy Award–winning actor Lou Gossett Jr.'s comparison of *The Book of Negroes* television miniseries with the original *Roots* suggests the twenty-first-century venture is much more revolutionary than its predecessor.[54] *The Book of Negroes* takes advantage of the same television miniseries format, yet tells a distinct story about slavery and variations of resistance.[55] An adaptation of Lawrence Hill's novel published under the same name in Canada, it was republished as *Somebody Knows My Name* in the United States and other countries and *Aminata* in France. The original title, *The Book of Negroes*, is taken from the name of a historical ledger used to document the passage of freed black British Loyalists who resettled in Nova Scotia after the Revolutionary War. The novel tells the story of Aminata Diallo, an African girl kidnapped and sold into slavery.[56] Based on historical events, the story uses fictional characters and storylines

to illuminate the various pan-African challenges blacks faced in the United States, Canada, Europe, and continental Africa. Aminata's travels recount the historical trials many blacks faced at this time, even in the move to Nova Scotia, which also failed to live up to its promise of freedom for the black population.

Lou Gossett Jr.'s comments suggest that *The Book of Negroes* builds on the foundation of the revolutionary film about slavery and rebellion. Although it utilizes the sharp reversal of the plantation genre, the reversal originates in Hill's novel rather than the adaptation process. Gossett suggests that this television miniseries is better than the original *Roots* because *The Book of Negroes* shows how history unfolds through this woman's life story, which she tells from a first-person perspective. The story frames the history of slavery, the experiences of the enslaved, and the migration of blacks from a black perspective. Like *Sankofa*, it also depicts a black woman protagonist who narrates her experiences and emphasizes collective resistance, greater depth, and attention to black agency in liberation struggles, and acknowledges sexual exploitation.

Aminata, the protagonist in the novel and miniseries, remains the central focus throughout the story. This black woman–centered narrative about slavery provides a nuanced perspective by demonstrating the civilization of African cultures and the restrictions placed upon women even as they were empowered in other ways. Beginning the story in West Africa, the film reveals the role tribal conflicts played throughout the slave trade. But unlike Onstott's novel, Hill carefully crafts the humanity of the characters by including the subtle nuances of familial relationships, daily routines, religion, education, and social structure within Aminata's village. Hill's rendering of Aminata and various other characters offers perceptions of a civilized Africa, a depiction that tends to be absent from the plantation genre.

The trajectory of the narrative helps reconcile cultural trauma without hypersexualizing black people. The series traces Aminata's kidnapping, voyage across the Middle Passage, and her sale on a plantation. The threat of sexual violence stalks her throughout her journey, even in childhood. Fortunately, the miniseries avoids depicting the sexual violence Aminata suffers as a child in the novel. In the miniseries, the rape does not occur until the adult actor, Aunjanue Ellis, steps into the role of Aminata as she comes of age. In this way, the television film psychologically protects the viewer from witnessing the pedophiliac rape during slavery. This project deviates from the patterns that fetishize interracial sex and rape between whites and blacks and consequently emphasizes the humanity of enslaved Africans in spite of the inhumane conditions of slavery.

Critical historical events punctuate the unfolding of Aminata's life story. As Aminata comes of age, she falls in love with Chekura, the young boy who initially

helped the kidnappers who sold her into slavery. Chekura joins her in slavery but after the Middle Passage they separate. They eventually find one another, marry, and have a child before being split apart. But Aminata and Chekura's response to their bondage is filled with agency. Chekura fights for the British Loyalists during the Revolutionary War in hopes of obtaining freedom. Aminata helps teach other blacks how to read when she cleverly escapes slavery during a skirmish between the colonists and the British in New York while traveling with her white owner. The series illuminates the active participation of blacks during the Revolutionary War and the failed promises on both sides as neither the British nor the colonialists granted the true freedom and autonomy they promised for the loyalty of black soldiers and supporters. In keeping with pan-African resistance, Hill's novel traces the diasporic steps from Africa to the Americas, back to Africa, and to Europe, showing how and why black people migrated in response to slavery and racism, which the film intricately connects.

The Book of Negroes promotes reparation and transformation by avoiding the white savior complex and racial reconciliation narrative. Even though Aminata's former white owner reunites her with her daughter, May, who was kidnapped and sold away from her when she was an infant, Aminata holds him accountable for his original crime. She does not forgive him and forget but instead confronts him and continues to fight for structural changes that will lead to the enslaved's freedom. When she returns to Sierra Leone, the miniseries' ending is similar to that of *Sankofa*. Both films emphasize the importance of remembering the crimes of the past as well as the survival strategies of enslaved Africans. Yet the ending of *The Book of Negroes* promotes the importance of also building a future as Aminata and her daughter return to the growing settlement after Aminata's story influences the abolition of slavery in England. Aminata's role in the abolitionist movement and subsequent return to Africa acknowledge the necessity of not only remembering the past but also using the knowledge of that memory to transform the present in order to build a future. *The Book of Negroes* uses the television miniseries format to expand and advance the message *Sankofa* initiated.

The 2016 *Roots* remake makes similar innovations while engaging scholarly debates concerning reparations and African collusion in the European trans-Atlantic slave trade. The remake's first episode begins with the voice-over narration of Laurence Fishburne as author Alex Haley distinguishing chattel slavery in Europe and the Americas from all other forms of slavery throughout world history, especially African slavery. Without directly addressing arguments of slavery as a joint venture between continental Africans and Europeans, Fishburne explains that the practice of slavery and servitude in Africa did not doom

people to subhuman status.[57] Africans participating in the European slave trade operated within their local context of slavery throughout Africa where enslaved Africans retained their humanity and could work their way out of bondage or even marry into families. This information clarifies and contextualizes slavery and its complex history for the viewer.

The *Roots* remake also documents and informs audiences about other little known black history facts. For instance, Kinte's parents object to his desire to study at an international university in Timbuktu due to a generational divide of tradition versus modernity. This addition of education as an African and eventual African American cultural value upends perceptions of Africa as a dark continent filled with uncivilized people who needed the salvation of Europeans in order to function. Additionally, the inclusion of Islam as an important religion outside of traditional African religions accomplishes several things. First, it redefines expectations that ground African American religious practices exclusively in traditional African religions often considered in binary opposition with Christianity. Second, it establishes precolonial African connections to Islam and exposes the forced conversion to Christianity and the role religion played in European and American involvement in the European trans-Atlantic slave trade. Third, this storyline aligns the historical experiences of African Americans with the current plight of Muslims, many of whom are also of African descent.

The critical role of black women in black liberation struggles demonstrated in *Sankofa* and *The Book of Negroes* emerges in *Roots*—albeit in a different way. These films reposition black women not as the conquests and objects they appear to be in *Sweetback*, *Mandingo*, and *Drum*. Instead, they resituate black women and children as vital to the past, present, and future of black communities. While *Sankofa* and *The Book of Negroes* follow black women protagonists throughout, *Roots* women are continuously represented as a force to be reckoned with throughout the miniseries, even though the story begins and ends with Kinte and Haley. From the scenes on the slave ship through the very end of the miniseries, black women fight for freedom just as hard as the men and use a range of strategies to do it. The women on the slave ship provide the background intelligence regarding the areas of the ship the men cannot access in order to enable a revolt on the ship. Just as many women die as a result of the failed rebellion on the ship, thereby showing the shared sacrifice across gender lines in black liberation struggles. As a result, Paula J. Giddings's assessment of the historical, overt, and covert racism and sexism black women continue to face is dramatized throughout the miniseries.[58] In contrast, *The Birth of a Nation* focuses primarily on black male rebellion. In spite of the amplified black male voices of

the 1970s, the unique perspective of the black women who sparked the Black Lives Matter movement can also serve as inspiration for a range of narratives about historical black experiences.

As is the case in *Sankofa* and *The Book of Negroes*, the women characters that stand out are those who use a range of strategies to resist how the institution of slavery attempts to thwart their agency completely and upend the myth of the inherently dysfunctional black family. By attacking the stereotypes of the castrating black matriarch (Sapphire), the deadbeat black father (Sambo), and the unruly black children (Topsy) so prevalent in the plantation genre, the movie exposes the roots of slavery in pathologies associated with black families. In this version of *Roots*, Kinte trains Kizzy to become a Mandinka warrior rather than just teaching her the language as he does in the original. Grounded in Kinte's Mandinka warrior training, Kizzy's lessons illuminate the vital necessity of a warrior spirit. Kinte provides Kizzy the education she needs to protect her mind, body, and spirit, as much as possible under the conditions in which they live. This new version provides an alternative way of thinking about fighting slavery and degradation through mental and physical resistance.

Focusing on an uprising led by Nat Turner in the 1830s that led to the deaths of over fifty white people in Southampton, Virginia, Nate Parker and Jean McGianni Celestin's *The Birth of a Nation* demonstrates the importance of portraying rebellion in films about slavery.[59] Its outcome reflects the ongoing challenges of evolving the genre of revolutionary films about slavery, especially in relation to the role of black women and children in black liberation movements. Nate Parker's *The Birth of a Nation* attempts to follow the tradition of revolutionary films about slavery but is limited by its male-centered perspective. Scathing reviews like Vinson Cunningham's find few redeeming qualities in the film, suggesting it fails as art and propaganda.[60] Other reviews focus on the limited portrayals of the women.[61] The victimization of black women featured throughout the film, including Turner's mother, Nancy (Aunjanue Ellis), grandmother (Esther Scott), and wife, Cherry (Aja Naomi King), along with his friend's mute wife, Esther (Gabrielle Union), help inspire Turner's rebellion. When white men rape Cherry and Esther, their enslaved, black husbands despair because of their inability to protect them. The two-hour feature-length film does not fully incorporate the nuance and depth apparent in *Sankofa*, *The Book of Negroes*, or the *Roots* remake, yet several reviews still recognize the film's "dramatic power, political insight, psychological compassion, and historical resonance."[62]

Following its broad theatrical release on October 7, 2016, *The Birth of a Nation* grossed $15 million, nearly doubling its estimated $8.5 million budget (not counting the nearly $18.5 million spent on marketing).[63] The film failed to meet

economic expectations after being plagued by controversy.[64] Audiences were divided on whether or not to support the film due to Parker's remarks concerning past rape allegations.[65] Black actors in the film including Ellis, Union, and Colman Domingo also spoke out on behalf of the importance of the film.[66] On social media and elsewhere, commentary concerning Parker's offscreen predicament began to overshadow the content of the film, and the project never fully recovered.

On and off screen, *The Birth of a Nation* was unable to advance many of the gains of revolutionary films about slavery. By reinforcing black women and children as victims rather than active agents of rebellion and mostly focusing on roving bands of black men stabbing, butchering, and bludgeoning white people, the film misses an opportunity to explore variations of revolt. Toward the end of the film, the lone adolescent boy included in the rebellion regrets exposing the plan to whites as he witnesses Turner's execution and morphs into a future Union soldier in the Civil War. This scene suggests the struggle for freedom is ongoing and evolving. Yet by redirecting the focus to black men, without portraying black women as active agents in their own liberation, the film adapts Hollywood patterns of slavery films to privilege black men in lieu of the usual sympathetic white hero. This approach undermines other potentially revolutionary messages. For example, the film's recognition of the intrinsic value and beauty of black women—albeit depicted in a misguided sense as the property of their husbands—starkly contrasts with the historical negative portrayals of black women. In this way, the film's portrayal of black women as desired, loved, and worthy of protection stands out.

Initially, the film's cachet as a theatrical release with mainstream distribution and critical acclaim that began at its Sundance premier may have added luster to African American films as a whole and revolutionary films about slavery in particular. *The Birth of a Nation*'s broad theatrical release broke a barrier *Sankofa* was unable to break. Theoretically, this should make it easier for the next revolutionary film about slavery. However, the onscreen narrative as well as the offscreen controversies will likely follow the filmmakers and any subsequent ventures into slavery on film due to the way that established precedent drives the film industry. Unfortunately, Parker's personal life and the ambivalence of audiences of slavery films may discourage filmmakers from continuing to explore the various possibilities for filming slavery.

Future studies may consider the limitations and possibilities of a greater range of films that distinguish resistance and rebellion as key features of slavery and also avoid white saviors, racial reconciliation, and hypersexuality or fetishizing interracial sex. Audiences can effectively engage in such projects.

Films that emphasize the intrinsic value of black women and children, while incorporating a range of intersectional identities, will indicate a positive trend that truly reflects the potential of revolutionary films about slavery and various other stories about black experiences throughout history.

Notes

1. "Part 1." *Roots*, History Channel, A&E, and Lifetime, May 30, 2016. Alex Haley, James Lee, William Blinn, Ernest Kinoy, M. Charles Cohen, creators. *Roots.* David L. Wolper Productions and Warner Bros. Television, 1977. Alex Haley, *Roots: The Saga of an American Family* (New York: Doubleday, 1976).

2. Cory Barker, "Why Would the History Channel Remake Roots?" *Complex* (June 2016); Demetria Lucas D'Oyley, "Why We Need More Films about Slavery," *The Root* (January 2016). Robert J. Patterson, "12 Years a What? Slavery, Representation, and Black Cultural Politics in *12 Years a Slave*," *The Psychic Hold of Slavery*, Soyica Diggs Colbert, Robert J. Patterson, Aida Levy-Hussen, eds. (New Brunswick: Rutgers University Press, 2016), 17–38.

3. Kara Brown, "I'm So Damned Tired of Slave Movies," *Jezebel* (January 2016), http://jezebel.com/im-so-damn-tired-of-slave-movies-175250873.

4. Bryan Alexander, "Snoop Dogg Rails against 'Roots' in Expletive-filled Video," *USA Today*, May, 2016.

5. @NickCannon, "Why Don't They Make Movies about Our African Kings and Queens? #OurHistory." *Twitter* (November 2013), https://twitter.com/nickcannon/status/399373562818994176.

6. Umesh Rao Hodgehatta, "Sentiment Analysis of Hollywood Films on Twitter," *Proceedings of the 2013 IEEE/ACM International Conference on Advances in Social Networks Analysis and Mining* (New York: ACM, 2013), 1401–1404.

7. Sue Bradford Edwards and Duchess Harris, *Black Lives Matter* (Minneapolis: Abdo Publishing, 2015). George Yancy and Judith Butler, "What's Wrong with 'All Lives Matter'?" *New York Times*, January 12, 2015.

8. *Black Lives Matter*, http://blacklivesmatter.com/.

9. Ed Guerrero, *Framing Blackness: The African American Image in Film* (Philadelphia: Temple University Press, 1993), 10.

10. *The Birth of a Nation.* Directed by Nate Parker. Los Angeles: Fox Searchlight Pictures, 2016. IMDB.

11. Haki Madhubuti, "*Sankofa*: Film as Cultural Memory," *Claiming Earth: Race, Rage, Rape, Redemption; Blacks Seeking a Culture of Enlightened Empowerment* (Chicago: Third World Press, 1994), 259–265.

12. Monica White Ndounou, *Shaping the Future of African American Film: Color-Coded Economics and the Story behind the Numbers* (New Brunswick: Rutgers University Press, 2014), 40.

13. Glenda R. Carpio, "I Like the Way You Die, Boy," *Transition* 112 (2013), iv–12.

14. Noah Berlatsky, "12 Years a Slave: Yet Another Oscar-Nominated 'White Savior' Story," *The Atlantic* (January 2014).

15. Vann R. Newkirk II, "The Faux-Enlightened *Free State of Jones*," *The Atlantic* (June 2016).

16. Matthew W. Hughey, *The White Savior Film: Content, Critics, and Consumption* (Philadelphia: Temple University Press, 2014).

17. Richard Iton, *In Search of the Black Fantastic: Politics and Popular Culture in the Post–Civil Rights Era* (New York: Oxford University Press, 2008).

18. Cultural trauma refers to the collective memories and forms of remembrance informed by slavery, which play a major role in African American identity formation. Ron Eyerman, *Cultural Trauma: Slavery and the Formation of African American Identity* (Cambridge: Cambridge University Press, 2001). The formation of white American identity relies heavily upon its binary opposition to blackness, making stories about slavery a thorny site for constructing an inclusive national narrative of American identity that also considers the multicultural demographics that make up the United States. See Toni Morrison, *Playing in the Dark: Whiteness and the Literary Imagination* (New York: Vintage Books, 1993).

19. Ishaan Tharoor, "U.S. Owes Black People Reparations for History of 'Racial Terrorism' Says U.N. Panel," *Washington Post*, September, 2016.

20. Sue Bradford Edwards and Duchess Harris, *Black Lives Matter* (Minneapolis: Abdo Publishing, 2016).

21. Arienne Thompson, "Celebs' Link to Black Lives Matter Can Be Risky," *USA Today*, August, 2015.

22. Vann R. Newkirk II, "The Permanence of Black Lives Matter," *The Atlantic*, August, 2016.

23. Hughey, *The White Savior Film*; Ndounou, *Shaping the Future of African American Film*, 52–53.

24. David Sirota, "Oscar Loves a White Savior," *Salon* (February 2013).

25. Erin Michelle Ash, *Emotional Responses to Savior Films: Concealing Privilege or Appealing to Our Better Selves?* https://etda.libraries.psu.edu/catalog/18966. Matthew W. Hughey, "Cinethetic Racism: White Redemption and Black Stereotypes in 'Magical Negro' Films," *Social Problems* 56.3 (2009), 543–577.

26. Ndounou, *Shaping the Future of African American Film*, 222–225.

27. Huey P. Newton, "He Won't Bleed Me: A Revolutionary Analysis of *Sweet Sweetback's Baadasssss Song*," *Black Panther* 6 (January 19, 1971), A-L, and Melvin Van Peebles, *Sweet Sweetback*, 36; *Life* 71 (August 13, 1971), 61.

28. Linda Williams, "Skin Flicks on the Racial Border: Pornography, Exploitation and Interracial Lust," *Media Studies: A Reader*, eds. Sue Thomham, Caroline Bassett, and Paul Marris (New York: New York University Press, 2010), 285.

29. Lerone Bennett Jr., "The Emancipation Orgasm: Sweetback in Wonderland," *Ebony* (September 1971), 106–116.

30. Amy Obugo Ongiri. *Spectacular Blackness: The Cultural Politics of the Black Power*

Movement and the Search for a Black Aesthetic (Charlottesville: University of Virginia Press, 2010), 175. Stephane Dunn, *"Baad Bitches" and Sassy Supermamas: Black Power Action Films* (Urbana: University of Illinois Press, 2008), 58–59. Guerrero, *Framing Blackness*, 86–91.

31. "Mandingo," https://www.ibdb.com/broadway-production/mandingo-2309.

32. Kyle Onstott, *Mandingo* (New York: Fawcett Crest, 1957).

33. Charles Reagan Wilson, *The New Encyclopedia of Southern Culture: Volume 9: Literature*. ed. M. Thomas Inge (Raleigh: University of North Carolina Press, 2008), 119–120.

34. Kyle Onstott, *Drum* (New York: Fawcett Crest, 1962).

35. Guerrero, *Framing Blackness*, 31.

36. Vincent Canby, "Movie: 'Drum' Opens at Loews State 1," *New York Times*, July, 1976.

37. Julie Sanders, *Adaptation and Appropriation* (New York: Routledge, 2006).

38. Stephane Dunn, "The Politics Speak: Performing Race from Sweetback to Foxy Brown," *Film Dialogue*, ed. Jeff Jaeckle (New York: Columbia University Press, 2013), 192–205.

39. Bennett, "Emancipation Orgasm," 106–116.

40. Eric Pace, "Alex Haley, 70, Author of 'Roots' Dies," *New York Times*, February, 1992.

41. Lisa de Moraes, " 'Roots' Premiere Crowd on A+E Networks Grows to 6.9 Million Live +3 Stats—Update," *Deadline*, June, 2016.

42. Leslie Fishbein, "*Roots*: Docudrama and the Interpretation of History," *Why Docudrama? Fact-Fiction on Film and TV*, ed. Alan Rosenthal (Carbondale: Southern Illinois University Press, 1999), 279.

43. Pamela Woolford, "Filming Slavery: A Conversation with Haile Gerima," *Transition* 64 (1994), 92.

44. Jhih-Syuan Lin, Yongjun Sung, Kuan-Ju Chen, "Social Television: Examining the Antecedents and Consequences of Connected TV Viewing," *Computers in Human Behavior* 58 (May 2016), 171–178.

45. Stephen A. Crockett Jr., "Texas Mom Calls Out Textbook Company for Calling Slavery 'Immigration' and Slaves 'Workers,'" *The Root* (October 2015).

46. Alia Wong, "History Class and the Fictions about Race in America," *The Atlantic* (October 2015).

47. Cedric J. Robinson, *Forgeries of Memory & Meaning: Blacks & the Regimes of Race in American Theater & Film before World War II* (Chapel Hill: University of North Carolina Press, 2007), 272.

48. Sylviane A. Diouf, *Slavery's Exiles: The Story of the American Maroons* (New York: New York University Press, 2014).

49. Madhubuti, "*Sankofa*," 260.

50. Woolford, "Filming Slavery," 103.

51. Ibid., 91.

52. Ibid., 90–104.

53. Ibid., 103.

54. *CBC News*, "*The Book of Negroes* Is Better than *Roots* and *12 Years a Slave*," CBC (November 2014).

55. The miniseries was produced on a $10 million budget and debuted to 1.7 million viewers. Katie Bailey, "*The Book of Negroes* Debuts to 1.7 million viewers," *Playback Online* (January 2015).

56. Tambay A. Obenson, "What Critics Are Saying about *The Book of Negroes*, miniseries, which Airs Tonight on BET," *Indiewire* (February 2015).

57. Henry Louis Gates Jr., "Ending the Slavery Blame-Game," *New York Times*, April, 2010, and Charles Johnson, Patricia Smith, and the WGBH Series Research Team, *Africans in America: America's Journey through Slavery* (New York: Harcourt Brace, 1998), 7.

58. Paula J. Giddings, *When and Where I Enter: The Impact of Black Women on Race and Sex in America* (New York: Harper Collins, 2009).

59. Parker and Celestin are the authors of the screenplay. Various texts have been written about the insurrection including but not limited to Thomas R. Gray, *The Confessions of Nat Turner* (Baltimore: Lucas and Devear, 1831) and William Styron, *The Confessions of Nat Turner* (New York: Random House, 1967).

60. Vinson Cunningham, "'The Birth of a Nation' Isn't Worth Defending," *New York Times*, October, 2016.

61. Dee Lockett, "Nate Parker Failed the Women of *Birth of a Nation*," *Vulture* (October 2016).

62. Richard Brody, "The Cinematic Merits and Flaws of Nate Parkers 'The Birth of a Nation,'" *The New Yorker* (October 2016).

63. Nat Turner, "The Birth of a Nation," *IMDB* (December 2016).

64. Pamela McClintock, "Nate Parker's 'The Birth of a Nation' Could Lose $10M for Fox Searchlight," *Hollywood Reporter*, October, 2016.

65. Owen Glieberman, "How Nate Parker's 'Birth of a Nation' Got Swallowed Up—and Defined—by Everything outside of It," *Variety* (October 2016).

66. Gabrielle Union, "'Birth of a Nation' Actress Gabrielle Union: I Cannot Take Nate Parker's Rape Allegations Lightly," *LA Times*, September, 2016; Aunjanue Ellis, "Exclusive: Aunjanue Ellis on Nate Parker & the 'Birth of a Nation' Controversy," *Ebony* (October 2016); Cara Buckley, "A Casualty of the 'Birth of a Nation' Controversy Speaks Out," *New York Times*, December 2016.

Movin' on Up—and Out

Remapping 1970s African
American Visual Culture

COURTNEY R. BAKER

The literary and visual arts of the 1970s reenvisioned the terrains on and for which African American subjectivity should be fought. The focus on desegregation during the civil rights movements of the 1950s and '60s largely emphasized movement in spatial terms and constructed freedom of movement as an index of black achievement. While this equation of black liberation with black mobility echoed prior struggles to expand the terrains that African Americans could legally occupy, the movement's application to policy transformation reinforced juridical means as the privileged form of redress. But it was not only physical spaces and geographic locations that were occupied differently by black Americans after the victories of the civil rights movement. Zones of representation such as television, film, and art as well as historiography and memory were terrains of contestation for black artists. In light of more recalcitrant forms of antiblack discrimination following desegregation, the notion of liberation as freedom of movement was called into question by activists, artists, and thinkers in the 1970s. Floyd Barbour foregrounds the significance of movement in the introduction to his anthology, *The Black Seventies*: "In the black seventies we will not allow ourselves to be led about like puppets. *We* shall be in control. We shall not be persuaded by rhetoric or Afro or militant-stance. We want more. We want, simply, reality. Reality to move and to be ourselves."[1] Responding to the ways that legalized desegregation came up short in its goal of fully freeing African Americans from the structures of white supremacy, and articulating a

sense of self-determination, the black visual culture of the 1970s expanded the representations of space and race to include visual, temporal, and other territories. With this more elastic notion of location, African American visual culture addressed itself to the decolonization of memory, the body, gender, sexuality, ritual, the future, and representation itself to envision not only new spaces but also new black subjects who would inhabit these spaces.

African American authors have often described black existence in the United States in part by attending to the spaces that black folks occupy and how we inhabit them. From autobiographical narratives about slavery, such as Harriet Jacob's *Incidents in the Life of a Slave Girl* (1861) and *The Narrative of Sojourner Truth* (1850), to speculative fiction, such as Octavia Butler's *Parable of the Sower* (1993) and Nnedi Okorafor's *Lagoon* (2014) and realist novels like Toni Morrison's *Home* (2012), African American literature has supplied images of subjectivity and liberation through the portrayal of physical, spiritual, and metaphorical journeys. In this literature, institutions of enslavement and segregation often rendered an idealized North that was *freer* of exploitation and abuse. But the literature includes visions of multiple utopian spaces filled with black desires for safety and nurture as well as spaces characterized by freedoms of expression and exploration.

The popular representation of the spaces that African Americans occupy took on new significance in the decade following the civil rights movements of the 1960s. With a rise in visual mass media, the written word negotiated with visual forms to debate, invent, and recall what the occupation of space meant in the wake of Jim Crow. The fight for representational policies and desegregation marked by the *Brown v. Board of Education* ruling in 1954, the passing of the Voting Rights of 1965, the Employment Act of 1967, and the Fair Housing acts of 1968 meant that a majority of African Americans could—at least theoretically—occupy spaces from which they had previously been barred. In this new political landscape, African Americans literally envisioned themselves as boundary breakers. These rulings "emboldened African American families to assert their rights with new vigor."[2] Though these legal achievements were vociferously challenged through both legal and extralegal means, including redlining and cross-burnings, African Americans persistently represented their spatial positioning in the terms of equality, achievement, and justice that had been forged during the 1950s and '60s. This radical shift is enshrined in Lorraine Hansberry's 1959 play, *A Raisin in the Sun*, and bears upon current debates about gentrification—a topic addressed in Bruce Norris's 2010 *Clybourne Park*—a dramatic reflection upon Hansberry's play.

The ability to move did not always signify victory for African Americans in the post–civil rights era. The deleterious effects of desegregation upon black

Figure 4.1. Paratrooper from the 101st Airborne Brigade applying mouth-to-mouth resuscitation to an injured soldier who was airlifted by helicopter to the medical clearing station near Kontum, Vietnam. Schomburg Center for Research in Black Culture, Photographs and Prints Division, The New York Public Library, *The New York Public Library Digital Collections.*

businesses was presaged earlier in some industries, such as commerce and sports. Jackie Robinson's 1945 departure from the Negro league's Kansas City Monarchs for the Dodgers "appeared to be a harbinger of black progress. But 'progress' in the abstract ran headlong into the reality of the accounting ledgers of black businesses"—a sentiment that could be extended to other enterprises such as black insurance companies, which, according to business historian Robert E. Weems, began to decline in the early 1960s.[3]

In the 1970s, desegregation proved again to be a double-edged sword as the post–World War II desegregation of the military corps, combined with the draft lottery, resulted in scores of African American men finding themselves on the front lines of battle during the Vietnam War.[4] The war and the draft, in addition to the aforementioned redlining and harassment, provided sad reminders that an investment in liberal democratic values could not necessarily protect black people from racial inequity. Black movement in the 1970s must therefore be viewed for all of its complexities and contradictions as the ability to move

did not necessarily register as a freedom. The new spaces in which African Americans now found themselves were not necessarily an improvement over their prior situations.

The arts of this period responded to these newly complex conditions by redrawing the lines of the homefront, invoking a real and imagined motherland, and crossing into new frontiers. Whereas the image of the black man on the run, epitomized by Richard Wright's character Bigger Thomas in *Native Son* (1941) and Ralph Ellison's eponymous *Invisible Man* (1952), dominated the midcentury literary landscape, the image of the entrenched black man ready to defend his territory emerged in the post–civil rights period. The murders of Medger Evers in 1963 and Fred Hampton in 1969 on their property, as well as police standoffs with the black liberationist organizations MOVE and the Black Panthers of Los Angeles (1972 and 1969) illustrated the reality of African American *domestic* insecurity. In their poetry and plays, writers Haki Madhubuti (formerly Don L. Lee) and Amiri Baraka (formerly LeRoi Jones) responded to these circumstances by criticizing the false promises of desegregation and rededicating their work to a project of black self-defense. Aggressive, weaponized language signaled a demand for protection of black self-determination that turned upon African American's equal access to the U.S. Constitution, including its Second Amendment guaranteeing the right of all citizens to bear arms (see the discussion in Chapter 5 of this volume).

While liberation was a political watchword for both the 1960s and 1970s, it was in the 1970s that something like a recognizable "liberation aesthetics" was adapted to the visual styles of mainstream black culture. The three female discussants of Toni Cade (Bambara)'s anthology *The Black Woman* (1970) acknowledge the implications of this shift as they consider the popular rise—literal and figurative—of black women's hairstyles. In the chapter "Ebony Minds, Black Voices," group convener Adele Jones begins the conversation with a directive to *look*, asking the assembled women, "What do you see when you look around at the Black woman?"[5] Although the women see the signs of black empowerment, symbolized most powerfully by the Afro, they also perceive that it has been loosened from an indexical relationship to the liberationist politics whence this "style" grew. The women's attention to the unmooring of the image from a political or even a racial formation motivates the current essay's particular attention to popular forms of visual culture.

As the conversation in *The Black Woman* indicates, black visual culture of the 1970s was marked by the often competing aims of commercial entertainment and ideologically interventionist fare. The contest over black visual representation during this period played out between media formats that pitted mass cul-

ture formats like popular television and cinema against independently produced enterprises like photography and fine art. However, even this boundary proved nebulous if not explicitly false as ruptures, revelations, and disappointments in representation and practice could be located in all sites of African American visual culture, suggesting that black visual expressions were always being negotiated.

Television is one of these ambivalent mediums. Todd Gitlin's 1979 essay, "Prime Time Ideology: The Hegemonic Process in Television Entertainment," discusses a number of programs of the era, including the television series *The Jeffersons*—a sitcom that follows a black couple that has, as the title song goes, "moved on up to [a deluxe apartment on] the East Side"—and the miniseries adaptation of Alex Haley's *Roots*, both of which have come to represent, at various occasions in the African American imaginary, the highlights and lowlights of black popular entertainment. It is not that these commercial programs *accurately* reflected black life. Often to the contrary, Donald Bogle explains, "Most of Black America [was aware] of a fundamental racism or a misinterpretation of African American life that underlay much of what appeared on the tube."[6] This fact, however, did not stop Bogle and others from consuming—often implicitly critically—the image of the black subject on the tube and on screen. Indeed, the tube and screen—as well as the canvas and gallery wall, to name but two more sites—were and remain important terrains of contest for black subjectivity and expression.

Even in objects disparaged or disregarded by scholarly enterprise one finds a revealing interest in movement and space. The supposed division between high and low culture plays out somewhat differently in African American visual culture where the boundary—albeit a constantly negotiated boundary—is framed as a division between righteous and even ideologically radical fare versus popular, retrograde entertainment that can be characterized by "too much clowning" and "too many exaggerations."[7] Investigating these popular images tells us something about the zeitgeist, offering us not quite a historical tract on events, per se, but a sense of the ideological terms that come to the fore and are circulated with great frequency at a particular historical moment.

The late scholar Richard Iton (2008) puts the matter even more simply and in terms that foreground the agency of black arts practitioners: "In trying to map out the most effective strategies for emancipation, African Americans have had to try to understand the precise nature of the linkage between popular culture and this thing we call politics. . . . In particular, the negotiation, representation, and reimagination of black interests through cultural symbols has continued to be a major component in the making of black politics."[8] James Baldwin at-

Figure 4.2. Members of the Black Panther Party demonstrate on the steps of the Alameda County Courthouse in Oakland, California. They are calling for the release of their leader, Huey Newton, who was on trial for allegedly killing an Oakland police officer during a gun battle. Bettmann/Contributor (Getty Images).

tempted just such an investigation in his 1976 essay anthology, *The Devil Finds Work*, which expounds upon African Americans' uneasy but essential relationship to popular cinema. Art is politics, certainly, but for Iton, Baldwin, and also Kara Keeling (2007), the precise contours of this aesthetic political practice register as no less than cultural identity. Keeling goes so far as to declare the identity of the Black Power Movement after 1968 as having been scripted in fundamentally cinematic terms, drawing its rhetorical power from disrupting an easy historical narrative that resolves with African Americans's seamless integration into the American polity. Keeling outlines the limitations and the bigotries endemic to this conceptualization of the revolutionary black subject (variously called "armed Negroes" and "blacks with guns"), in particular for the ways that it forecloses specific gender and sexual expressions as radical postures.[9] Indeed, as Iton explains, "politics in this mode must constantly delegitimize its competitors and mark them as other and outside the realm."[10] Although an analysis of Keeling's insights on the revolutionary black lesbian emerges later in this book, here it is worthwhile to bring her comments into conversation with those made by African American literary critic Larry Neal whose contribution to the volume *The Black Seventies* framed black revolutionary desire in spatial terms:

> As we move into the seventies, many of the things that concerned us in the early sixties are no longer as important as we once thought they were. We fought for the right to eat a meal in some cracker restaurant in the deep South, but now that that right has been assured by the Federal Government, black people are no longer interested in such things. . . . If we could get it, we wanted the land that the restaurant was built on. We wanted reparations. We wanted power. We wanted Nationhood.[11]

Neal's reading of the cultural moment identifies a need for a political and aesthetic project that supersedes the failures of the 1960s movements' ambitions in order to sufficiently envision the terrains for which black people should rally to occupy. The insufficiency of the gains of the 1960s was shown up in the late '60s and early '70s by the more stringent demands Neal articulates: reparations, power, and Nationhood. This more insistent posture of African Americans was, according to Keeling, fundamentally visualized by the Black Panther Party's disruption of historical images of black acquiescence. The Panther's self-presentation as "blacks with guns" and Afros, signs of their awakened consciousness, disqualified "the State's insistence that the post–civil rights present was the culmination of the Black's teleological progress toward national belonging, [as] the Panthers made visible a present, irreconcilable with that posited by the

State."[12] Just as the donning of the military uniform by Black soldiers during the Civil War and the World Wars disrupted notions of citizenship and bravery as the exclusive domain of white American men, the Panther's practice of sartorial display interrupted the nation's image of African Americans as passive or complacent.[13]

In attending to these popular artifacts, however, one must be mindful of the work that such images conduct to manage African American identity in the post–civil rights movement state. As Keeling explains, it is through a national celebration of the civil rights movement's successful appeals to the state that the American nation is able to reassert its power over subjects and to "assert itself as the 'representative' of 'black people.'"[14] In this regard, the visual representation of black movement often proves to be duplicitous, portraying social and economic advancement at the expense of truly unfettered self-determination and self-expression.

Homefront

A prime example of these tensions appears in the popular televisual and cinematic representations of the black home. Through her 1934 satirical essay, "Characteristics of Negro Expression," Zora Neale Hurston destabilized a unified definition of African American home spaces. Nevertheless, Hurston's identification of the home as a site of expression, recognized later by Alice Walker in her celebration of African American women's work in the domestic sphere ("In Search of Our Mother's Gardens" [1974]), recommended an appreciation of the home as a precious and precarious zone where black life and culture could be developed and explored. In addition to Walker's work, other aspects of African American literary and visual culture of the 1970s offered various images of the home as a crucial location for black self-knowledge that was nevertheless frequently under threat and in need of protection. The Blaxploitation film movement reinforced the spatial logics by setting the urban inner city—the 'hood—as an integral locus of African American life in need of defense. In this sense, Blaxploitation films served up a campy spin on the militarized defense of black spaces. Blaxploitation films asserted African American agency through the intimacy of the body and by resuscitating the bodily alienation that underwrote the institution of slavery before the Emancipation Proclamation.[15]

Film scholar Ed Guerrero interprets Blaxploitation's emergence as the consequence of "three broad, overdetermining conditions" including "the rising and social consciousness of black people" during the civil rights movements of the 1960s, the consequent desire for black representation on screen, and "an

outspoken, critical dissatisfaction with Hollywood's persistent degradation of African Americans."[16] These films also responded to desires of working class and urban African Americans who were, as the 1960s progressed, "increasingly dissatisfied with the exhausted black bourgeois paradigm of upward mobility through assimilation and started to identify the black experience with the defiant images and culture of the 'ghetto' and its hustling street life."[17] Although there is good reason to criticize these latter films for offering retrograde depictions of urban life, Blaxploitation films nevertheless addressed a desire on the part of black viewers to be distanced from the stereotype of high-minded endurance associated with the civil rights era and characterized by the roles of Sidney Poitier (*Guess Who's Coming to Dinner?* [1967]). The "bourgeois paradigm" of respectability politics seemingly gave way in Blaxploitation and enabled audiences to take up instead images of black assertiveness and effective self-defense emblematized by actors like Richard Roundtree (*Shaft* [1971]) and Pam Grier (*Foxy Brown* [1974]).

In representing the ghetto, Blaxploitation films presented multiple kinds of ghetto defenders. While films like *Shaft* and the independent production *Sweet Sweetback's Baadasssss Song* (1971) depicted virile black masculine characters as heroes, these representations were not the only forms of heroism on offer. In particular, black women and especially the eponymous characters of *Foxy Brown* (1974), *Coffy* (1973), and the *Cleopatra Jones* (1973) franchise depicted black women's aggressive agency in the face of external threats. These threats took the form of a pernicious white supremacy unafraid of recruiting the most vulgar forms of racist aggression (the Sidney Poitier vehicle *They Call Me Mister Tibbs* [1970] and *Coffy* feature lynchings) as well as the more elaborate corporate forms such as drug running in black communities. Female ghetto defenders also faced off against white violence in the form of rape. But Blaxploitation heroines were also on guard against white women who were, as in *Foxy Brown*, figured as self-serving antirevolutionaries thoroughly unhip to the ways that white supremacy partnered with patriarchy in a repressive project. Depictions of strong black women, especially in relation to the domestic sphere, risk being regarded as the aestheticization of Daniel Patrick Moynihan's notorious 1965 Federal report on "The Negro Family: The Case for National Action." As Terrion L. Williamson discusses in Chapter 8 of this volume, these stereotypes were studiously countered in black feminist writing, often using the cinematic and televisual image as its object of critique.

Studies such as Yvonne Sims's *Women of Blaxploitation* and Stephanie Dunn's *"Baad Bitches" and Sassy Supermamas* attend to the fraught political and visual landscape in which African American women in the 1970s appeared.[18] Sims situates Blaxploitation as a reaction to the past and, in so doing, demands a reading of

Figure 4.3. Screenshot of Richard Roundtree in *Shaft* (1971). © Metro Goldwyn Mayer.

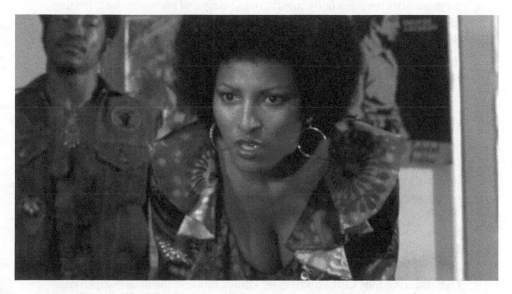

Figure 4.4. Screenshot of Pam Grier in a scene from *Foxy Brown* (1974). © American International Pictures.

visual representation in the 1970s as itself a terrain of contestation for African American women. Both authors recommend that, as we regard the images of the black heroines of the 1970s from our current vantage point, we would do well to cast a critical eye and read these images of black self-determination and protection as evincing the black body as a battleground.

While Blaxploitation films of both the corporate and independent variety do present some radical and inspiring depictions of African Americans righteously occupying and protecting themselves and their own, some of which can be interpreted as elevating the very character that the Moynihan report degrades, the films also traffic in highly regressive notions of gender and sexuality. As seen in films such as *Car Wash* (1976) and *Women in Cages* (1971), African American nonnormative sexuality could be depicted on screen but only if it was contained by humorous performances by men and titillating displays by women. Publicly, black queer and trans*folk played key roles in the 1970s advocacy for LGBTQ rights, with transgender activist Marsha P. Johnson notably taking a leading role in the Stonewall rebellion in 1969 and continuing her advocacy work throughout the decade and beyond. In print and on screen, however, African American queer culture was often cast as an aberration. For Eldridge Cleaver, black nonnormative sexuality fairly constituted a betrayal of blackness itself, leading him to condemn figures such as James Baldwin as traitors to the cause in his book *Soul on Ice* (1968), a work that also saw Cleaver explain how he practiced his retaliatory rape of white women on black women.

Any comprehensive consideration of black sexuality in popular 1970s films must also account for the appearance of black and interracial lesbianism, which was being discussed in groundbreaking intersectional terms by authors Audre Lorde and members of the Combahee River Collective, founded in 1974, and which included the writers June Jordan, Barbara Smith, and Beverly Smith. In popular visual culture, performances of black lesbianism were possible as long as they were contained by a desiring heterosexual male gaze and criminal oversight. Actress Pam Grier's women in prison films (the aforementioned *Women in Cages* and *Black Mama, White Mama* [1973]) make explicit how the setting conspired with visual logics of the cinematic gaze and carceral surveillance culture to make black lesbianism palatable to audiences cued by antigay attitudes. The latter film, a low-budget adaptation of the 1958 film *The Defiant Ones* featuring Tony Curtis and Sidney Poitier, replaced the male escaped convicts with female escapees who are similarly chained together while on the run. Unlike the earlier film, however, *Black Mama, White Mama* utilizes its premise to justify a pornographic gaze upon the female inmates and the titillating spectacle of catfights. While the film features revolutionaries in the form of the island's

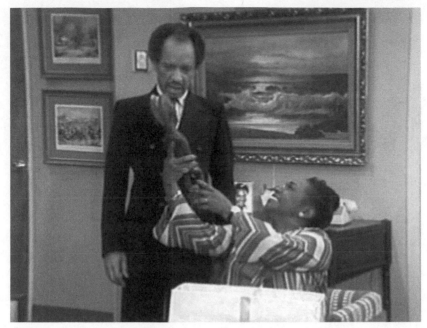

Figure 4.5. Screenshot of Isabel Sanford and Sherman Hemsley in *The Jeffersons* (1975–1985). © Columbia TriStar Home Entertainment.

militia, and explains the white character's imprisonment as a consequence of her involvement in the revolution, these aspects are not themselves seriously engaged and are instead used simply to offer a generalized sense of danger and narrative motivation. Even when revolution is present, the female protagonists are alienated from the cause itself. As Keeling explains, the "common-sense" of black nationalism expressed by the hypermacho attitudes of Cleaver, for example, ruled out femininity and lesbianism as parts of the black liberationist project.[19] *Black Mama, White Mama* dramatizes just this division. At the same time, it is worth noting the agency that these narratives and images (including Betye Saar's *Liberation of Aunt Jemima*, discussed below) attributed to women, and to note that they often do so through the trope of black militancy.

The figuration of the African American body in this period as the space of conflict reflects the necessary shift in discourse that African American conversations about space, movement, and rights had to engage after civil rights movements of the 1960s. With race being, at least in theory, no longer a barrier to movement, some African Americans articulated their new mobility by literally buying into the American Dream and moving into the suburbs. Ac-

Figure 4.6. Screenshot of Gary Coleman and Todd Bridges in *Diff'rent Strokes* (1978–1986).
© Sony Pictures Home Entertainment.

cording to historian Andrew Weise, the migrations enabled by desegregation "emboldened African American families to assert their rights with new vigor, and the passage of protective legislation eased the way for larger numbers to move to suburbs," as " a suburban address symbolized not only the dream of 'a decent house in a decent neighborhood,' but a firm sense of class and race progress."[20] This will to "move on up" was reflected in the television series *The Jeffersons, Diff'rent Strokes*, and, later, *The Cosby Show*. The black sitcoms that appeared during the 1970s depicted African American family units of considerable means negotiating the meaning of African American identity in the presence of class-secured comforts. The relocation and material gains earned by the characters Louise and George Jefferson of *The Jeffersons* and in *Diff'rent Strokes* by Arnold and Willis Jackson, the black children from Harlem adopted into a wealthy white widower's household, did not necessarily translate to the black characters' complete comfort in the programs' narrative arcs, which relegated discussions of racial conflict to humorous diversions in order to preserve a fantasy of seamless integration. In addition to comedic deflations of racial and class conflicts, these programs utilized the trope of the "very special episode"

to entertain serious discussions about the racism that persisted after the civil rights victories, even when the programs were not able to resolve them to any long-lasting satisfaction. "[T]he 'very special episode' . . . problematizes social issues by emphasizing the difficulties of structural inequalities rooted in racial difference," Hollis Griffin explains. "Through 'very special episodes,' television's steady flow of information is ruptured by its own logic," thereby permitting an ostensibly comedic outfit to temporarily but justifiably bracket its typical discursive mode to address subjects deemed more serious.[21]

These often uneasy negotiations of race and class raised the thorny issue of black authenticity as the privileges that social class mobility afforded were undermined by the reality that a majority of African Americans were facing greater, not diminished, ghettoization as white flight to the suburbs continued. Even in the programs, moving up did not involve moving out of the urban center. In fact, for the namesake characters of *The Jeffersons*, improving their status meant moving out of the single-family dwellings of New York's outer borough of Queens and into an upper-Manhattan high-rise penthouse.

Television also offered depictions of African Americans in urban and working-class environments, often with similar problems of stereotyping and defused discussions about race and the failures of the integrationist promise. The primetime series *Sanford and Son* (1972–1977) and *Good Times* (1974–1979) showcased the lives of African Americans in the salvage yard and the housing project, respectively. *Sanford and Son* became the number one television program during its run, but the pleasures that it afforded in "seeing African American performers relating to one another, establishing a semblance of a Black community and an approximation of Black life and culture" were incomplete at best.[22] The show discussed racism, though in hushed tones, utilizing the figure of the clowning curmudgeon portrayed by Redd Foxx to quickly dismiss comments on race as the product of senility.

Good Times, an ensemble production that showcased the talents of multiple cast members, embodied the conflicts of the other programs but also evoked the intergenerational conflict over African American representation and respectability in its casting of serious actors alongside comedic performers. A deep rift appeared in the program's goals to provide serious dramatic work to actors Esther Rolle and John Amos and also to capitalize on the popularity of comedic actor Jimmie Walker. What resulted was a program with an uneven run that involved, on screen and off, a battle for the roles and the representation of African Americans in mass media.

The claiming of black spaces was also an objective of noncommercial or public broadcasting programs such as the variety/talk show *Soul!* (1968–1973). As

Gayle Wald explains in her study of the program, Ellis Haizlip was a pioneering producer and host who brought together important African American artists and leaders for serious conversations and inspiring performances.[23] Haizlip's understanding of the power of a dedicated black performance space to foster "black love, [and] black encouragement" was profound.[24] He extrapolated this political and social imperative for the show to his Lincoln Center, New York, performance series, "Soul at the Center," insisting upon, as Wald says, "the significance of black people's 'occupation' of 'white' spaces."[25]

The 1970s was also a time where work that had previously been conducted out of view was given a public platform and critical language. The growth of African American photography is one such example. Privately, African Americans had been building an archive of their lives, assembled from the numerous photographs taken by professional and amateur Black photographers. The family album, as Deborah Willis has repeatedly illustrated, addressed the essential task of constituting a historical community of black folks, effectively mapping the African American presence across great distances of time and space.[26] African Americans were not mere artifacts of social documentary photography. Though our images appeared in popular formats such as *Life* magazine and even in Langston Hughes and Roy DeCarava's landmark book, *The Sweet Flypaper of Life* (1955), African American photographic images also resided in privately held and lovingly circulated family albums—as important to the transmission of black culture and survival as the legendary family bible. The civil rights movement and the Black Power movement that followed offered opportunities for black people to document a moment of great transformation. Indeed, the Student Nonviolent Coordinating Committee (SNCC) and the Black Panther Party (BPP) both established photographic corps that produced archives that stood in contrast to mass media characterizations of those organizations.

In 1963, DeCarava established the Kamoinge Workshop to enable African American photographers to share information on the craft of photography and to explore, as DeCarava himself did, the art of producing images that emerged from the artist's specific racial location and spoke to the universality of human experience. The Kamoinge photographers worked to overcome the modernist impulse toward "disinterestedness" even as they "aspired to make artistic images."[27] As Erina Duganne explains, it was "the separation between art and life that the members of Kamoinge attempted to resolve in their works."[28]

The diversity of African American photography, from early-twentieth-century salon portraits to more recent work, was formally recognized by *The Black Photographers Annual* (1973–1980). A large format periodical containing high-quality image reproductions and little ancillary text, the *Annual* was no mere

yearbook; it was a clear statement of black photography's longevity and bona fides and a testament to African Americans' important work in the medium. As Carla Williams notes, "Fewer than ten photography books appeared by or about black photographers prior to 1970."[29] While social documentary photography had a reliable outlet in publications such as *Life* magazine, photography began to be classed as a fine art form and made available to viewing publics only in the 1950s.[30] Black photographers were rarely featured in publications and exhibitions (the exception being DeCarava's appearance in *The Family of Man* photographic exhibition and catalog in 1955, and, in 1969, James Van Der Zee's Metropolitan Museum of Art exhibition, *Harlem on My Mind*, and the catalog *The World of James Van Der Zee: A Visual Record of Black Americans*). The inaugural volume of the *Annual* depicted a variety of styles and genres, from documentary to portraiture to abstraction. Variety itself was as much on display as the technical skills of focal length, composition, and lighting—the latter being an important detail as film stock was not calibrated to reproduce the variations of darker skin tones.[31] Significantly, the magazine did not focus exclusively on recent work, "including one of [octogenarian James Van Der Zee's] earliest works, a portrait of his first wife and their daughter."[32] This editorial decision fascinates precisely because it captures the essential power of photography: to preserve, visually, that and those which, over time, will fade from view. *The Black Photographers Annual* understood its project in the present as bringing elements of the past into full view and was part of the broader historiographical project that the 1970s engendered for black life, culture, and history.

Motherland

Indeed, African Americans occupied national and racial memory in new ways during this period, figuring time itself as a terrain in need of fresh mapping. On television, *The Autobiography of Jane Pittman* (1974), a movie adaptation of Ernest J. Gaines's 1971 novel, traced the changes in African American life from the Civil War to the present through the recollections of its 110-year-old protagonist Jane (portrayed by Cicely Tyson). Another television adaptation—the miniseries *Roots*, based on Alex Haley's novel—explored one family's roots in Gambia to their presence in Tennessee. The book and the miniseries adaptation were instant sensations, making *Roots* one of the most significant literary and visual artifacts of the African American 1970s. Though Haley's narrative exists in the shadow of controversy regarding the originality and sources of its historical claims, the story remains important for its depiction of the persistence of black memory. The television adaptation of Haley's text, with "first-rate per-

Figure 4.7. Screenshot of Cicely Tyson in a scene from *The Autobiography of Miss Jane Pittman* (1974). © Tomorrow Entertainment.

Figure 4.8. Screenshot of LeVar Burton in *Roots* (1977). © Warner Brothers.

formances from a gallery of talented African American actors and actresses"[33] including Tyson, LeVar Burton, Leslie Uggams, and Louis Gossett Jr., further impressed the notion that African American history is comprised of individuals, not a nameless black mass lost in the journeys through the middle passage and slavery (see the discussion in Chapter 2 of this volume). *Roots'* turn to the sources unauthorized by Western cultures—the griot, marginalia, oral history— made a case for the mining of archives and the production of counter-archives as key efforts in the larger project of African American historiography. For all of this excavation work, however, both the television series and the book subsumed African Americanness to the dominant American immigrant narrative. As Ella Shohat and Robert Stam explain, "The series' subtitle—'The Saga of an American Family'—signals an emphasis on the European-style nuclear family (retrospectively projected onto [protagonist] Kinte's life in Africa) in a film that casts blacks as just another immigrant group making its way toward freedom and prosperity in democratic America."[34] As the nation prepared to mark its bicentennial in 1976, the appearance of *Roots* put an end to an uncritical and uncomplicated celebration of the United States as a nation composed of voluntary immigrants by asserting both the African American-ness and the American-ness of Kinte's family and descendants.

Black writers and editors also mobilized the visual aspect of books to present a historical map of the black presence in America. Through her work as an editor at Random House, Toni Morrison intervened into the reassembling of African American history by publishing, in 1974, *The Black Book*—a work organized by Middleton Harris, Morris Levitt, Roger Furman, and Ernest Smith—to respond to a black cultural movement that "called upon [African Americans] to make new myths, to forge a new cosmology to live by; the assumption being either that we had no Afro-American myths, or that if we did they were inferior."[35] Morrison's attempt to "put together a thing that got close to the way we really are" resulted in a book that documented the presence, achievements, obstacles, and realities of black life in America. Historical newspaper articles about and by African Americans appear amid black-and-white and full-color reprints of entertainment posters, advertisements, and photographs featuring blackface performers, examples of African American textiles and their African inspirations, and stories about champion black jockeys, voodoo recipes, film stills, and lynching photographs. The effect of this collection, a true assemblage, resonates with Floyd Barbour's insistence: "We shall not give up our past. We want Malcolm and Aunt Sadie and the pimp down the block, because each of these is a celebration of what is human. We want all our black experience: the good, the bitter, the grape-time and the in-between time."[36]

Both books responded to a version of 1970s Afrocentrism that insisted upon the "instant and reactionary myth-making ... [of] the slogan 'Black Is Beautiful,'" and that we "have to go back to Shongo and the University of Timbuktu to find some reason for going on with life."[37] While African American artists have always drawn upon (and sometimes resisted) their ancestral connection to the African continent,[38] the particular contours of 1970s Afrocentrism championed the living (if sometimes mythical) presence of Africa in American culture. In the 1970s, Afrocentrism emerged as a response to the failure of the civil rights movement's integrationist hopes. The project was framed as both a popular and intellectual project by scholars Molefi Asante and Maulauni Karenga, the latter inventing Kwanzaa—a new ritual for African Americans to celebrate their unique heritage in the American context. The rituals of Kwanzaa are grounded in symbols that, according to Karenga, "reflect not only the demands of struggle, but reaffirm and reinforce the best of our cultural values," including "communitarian" values and "first-fruit celebrations."[39] The interest in Africa in this ritualized manifestation stressed the importance of the symbol and therefore influenced the use of both the word and the image.

At the dawn of the 1970s, Larry Neal expressed the acute need for African Americans to cultivate Africanist symbols as a tool for building a black consciousness. For Neal, the political utility of Africa lay not in its function as history and memory, but as a palpable present wherein "our psychic blood lines ... are rooted in the *living* culture."[40] Neal's vision foregrounded the work of symbolism over authenticity and spiritual connection, leading him to remark, in no uncertain terms:

> *What we need to do, however, with African and other Third World references is to shape them into a new cosmological and philosophical framework. We need to shape, on the basis of our own historical imperatives, a life-centered concept of human existence that goes beyond the Western world view.*[41]

This turn to Africanist aesthetics and the deployment of symbols points to the transnational expectations of African American cultural forms during this period. A number of visual artists incorporated objects of black material culture such as cowrie shells, cotton, and quilts to serve as cultural touchstones in their works.

African American visual arts of the period addressed themselves to prior depictions of black people in order to move them out of denigrating stereotypes and into a liberationist vocabulary more consistent with the self-determination of the post–civil rights moment. Betye Saar's assemblage work, *The Liberation of Aunt Jemima* (1972) reenvisions the archetypal mammy in terms that reflect

the new possibilities and freedoms available to African American visual artists. Saar's piece situates a mammy figurine in a vitrine containing two-dimensional pictures of the Aunt Jemima caricature. Saar also includes, as indexes of Aunt Jemima's liberation, models of a Black Power fist and, to offset the broom she holds in her right hand, a rifle in her left. The work utilizes elements of a well-worn iconography, including wads of cotton, to provide quite literally a new view of African American representational politics. Saar's "memory and spirit-conjuring assemblages made from discarded bric-a-brac, family mementoes, and other ephemera" speak to the persistence of memory, the endurance of black people, and the significance of visual objects to African American self-identification.[42] The work functions as both window and shrine, embodying visions of the African American past and its radically new future.

Art historian Richard Powell explains that artists such as Saar and her contemporaries, David Hammons and Faith Ringgold, placed "emphasis on a blackness that was metaphysical and that derived its form not from painted or sculpted humanity but, rather, from a marshaling of symbolic or conceptual strategies in visual communication."[43] Objects and rituals marked out black spaces and distinguished them as being continuous with the spaces that people of African descent in America have inhabited throughout their history.

New Frontiers

The future relevance and representation of the African experience in America was of concern to several artists of the 1970s in part because of the inadequacies of the West to address the needs of black life. Many African Americans perceived in Africa a mode of living more communal and humane than what existed in the United States. Though its seeds may be traced back to Frederick Douglass and other self-liberated enslaved's dependence upon the Northern Star (after which Douglass titled his abolitionist newspaper) and the fantastic stories of the Progressive Era exemplified by George Schuyler's *Black Empire* (1936) and W. E. B. DuBois's *Dark Princess* (1929), the aesthetics of Afrofuturism came into its own during the 1970s. In the foundational 1993 interview essay, "Black to the Future: Interviews with Samuel R. Delany, Greg Tate, and Tricia Rose," Mark Dery defines Afrofuturism as a genre that "treats African American themes and addresses African American concerns in the context of twentieth-century technoculture—and, more generally, African American signification that appropriates images of technology and a prosthetically enhanced future."[44] Although the term is retrospective, its goal is to characterize the constellation of future-oriented, often cosmological and intergalactic visions

of a black-centered world.[45] The post–civil rights movement iteration offered popular depictions of intergalactic travel and the marrying of technological and ideological progress with a deep commitment to a racial history. As was the case for the speculative fiction novels of Samuel Delany (*Dhalgren* [1971], *Equinox* [1973]) and Octavia Butler (*Kindred* [1979], *Patternmaster* [1976]), Afrofuturist visual culture infused representations of alternate worlds with familiar signs of the racial inequity visible in U.S. history.

Science fiction scholar Mark Bould extrapolates from African American author Walter Moseley's assessment of the field by declaring that the "American imagination is overwhelmed by images valorizing whiteness," effectively demanding—and achieving—black narratives "depicting great refusals and demands for a here-and-now home within an unhomely land . . . [which] focuses on the defiant moment when revolution becomes possible, comes to life, promising rupture and new realities."[46] The possibilities for African American representation contained in the science fiction and speculative fiction of authors such as Delaney and Butler were visualized most profoundly in the stylistic and generic codes that some have associated, not uncomplicatedly, with Afrofuturism.

The aesthetic and political imperatives of speculative fiction are often aligned with the style and impulses of Afrofuturism, specifically its project of envisioning a spatial and temporal departure from the limiting logocentrism of the here and now. Bould credits musician Gil Scott-Heron's 1970s song, "Whitey on the Moon," with critiquing America's 1950s and 1960s space race with the Soviet Union and revealing "which race space was for."[47] Through Bould's reading, Scott-Heron's song denotes, through its allusion to a galactic "white flight," a mapping of the racial fissures that characterized the white flight and the redlining of blacks in the wake of desegregation. Here, however, it is space rather than the suburbs to which an anxious white populous flies, presumably leaving African Americans and other racial groups to contend with a degraded and fully exploited earthbound ghetto.

Black speculative fiction authors and Afrofuturist musicians did not envision being left behind, however, and instead crafted notions of the extraterrestrial homeland that supplied not only new resources and new rules but also new spaces wherein black people could express their genius unimpeded. The elemental, intergalactic self-presentations of musicians Earth, Wind & Fire and Sun Ra stand out as the loudest, both visually and sonically, representations of post–Atomic Age black representation. With their space-age lamé costumes and striking album covers and Su Ra's film, *Space Is the Place* (1972/1974), both artists married an African American funk futurity with the symbols of ancient Egypt such as the ankh and the gods Isis and Ra.[48] Just as in the paintings of Jacob Lawrence who, in the earlier part of the twentieth century, envisioned

Egyptian monuments and tools alongside more recent symbols of industrial progress, these musicians depicted the powers of the black past in a continuous line with the contemporary ingenuity of African Americans who harnessed electronic energy (literally, in the form of Moog synthesizers and other electronic instruments) to produce the soundtrack for a new black age.

The new frontiers that opened up onto the funk-inflected new spaces also recalibrated a sense of the black body's abilities and commitments. The obstacles to integration in comics were extremely high. As comics scholar Marc Singer explains,

> Comics rely upon visually codified representations in which characters are continually reduced to their appearances, and this reductionism is especially prevalent in superhero comics, whose characters are wholly externalized into their heroic costumes and aliases. This system of visual typology combines with the superhero genre's long history of excluding, trivializing, or "tokenizing" minorities to create numerous minority super-heroes who are marked purely for their race. . . . The potential for superficiality and stereotyping here is dangerously high.[49]

Consequently, the term *Black Power* took on new meaning in the comic books in this period, where black superheroes such as Black Panther (1966), Falcon (1969), and Luke Cage (1972) worked against the superficial stereotypes and caricatures of earlier graphic formats. Many of these new characters were conceived by white Jewish writer and artist Jack Kirby (Marvel, DC Comics) who recognized not only the striking absence of nonwhite characters in mainstream comics but the natural connection between narratives of justice and conflict and the black American experience. While African Americans had appeared in the comic format as early as 1947 with the single-issue release of the all-black authored and illustrated *All-Negro Comics*, the late sixties and seventies saw black heroes centered (sometimes awkwardly) in narratives that aligned African Americans with the work of maintaining justice.

Much like the heroes of Blaxploitation films, these superheroes negotiated a fragile path through overdetermined gender designations. As Jeffrey Brown observes, "Superhero comics are one of our culture's clearest illustrations of hypermasculinity and male duality premised on the fear of the unmasculine Other."[50] Female characters faced no lesser battles in terms of representation, running up against "exoticized notions of Africa, nature, noble savagery and a variety of Dark Continent themes, including voodoo, mysticism, and animal totemism."[51] Brown's remarks here should remind us to attend to the visual codes of representation and not just to the narrative situations of comics featuring black characters.

The 1970s marked a period in which the dreams and aspirations of African Americans carried them into new spaces, armed with enduring ideas of freedom formed in prior eras and crystallized during the civil rights movement. It also saw them recommit to familiar spaces and fight for new, more honest depictions of their complex lives, passions, and struggles. Visual representation was a crucial terrain upon which old battles were fought and new stakes were claimed. The sentimental politics that shaped earlier efforts at just black representation were only, at best, secondary concerns for African American image creators and consumers who were seeking—and in many spaces found—an image of themselves to carry them into an imperfect but promising future.

Notes

1. Floyd Barbour, Foreword, *The Black Seventies*, ed. Floyd Barbour (Boston: Porter Sargent, 1970), viii, emphasis in original.

2. Andrew Wiese, *Places of Their Own: African American Suburbanization in the Twentieth Century* (Chicago: University of Chicago Press, 2004), 211.

3. Roberta J. Newman and Joel Nathan Rosen, *Black Baseball, Black Business: Race Enterprise and the Fate of the Segregated Dollar* (Jackson: University Press of Mississippi, 2014), 120; Robert E. Weems, "A Crumbling Legacy: The Decline of African American Insurance Companies in Contemporary America," *The Review of Black Political Economy* 23.2 (1994): 25–37.

4. President Harry Truman's Executive Order 9981 formally desegregated the U.S. military in July of 1948. In December of 1969, two "draft lotteries" identifying males potentially fit for military service were held by the U.S. Select Service Committee. The draft arrangement was superseded in 1973 by an order that established an all-volunteer corps.

5. Adele Jones and group, "Ebony Minds, Black Voices," *The Black Woman: An Anthology*, ed. Toni Cade (New York: American Library, 1970), 180.

6. Donald Bogle, *Primetime Blues: African-Americans on Network Television* (New York: Farrar, Strauss, Giroux, 2015), 7.

7. Ibid., 8.

8. Richard Iton, *In Search of the Black Fantastic: Politics and Popular Culture in the Post–Civil Rights Era* (Oxford: Oxford University Press, 2008), 4, 5.

9. Kara Keeling, *The Witch's Flight: The Cinematic, the Black Femme, and the Image of Common Sense* (Durham: Duke University Press, 2007), 68.

10. Iton, 82.

11. Larry Neal, "New Space / The Growth of Black Consciousness in the Sixties," in Barbour, 12.

12. Keeling, 75.

13. On the politics of Black fashion and dress, see Tanisha Ford, *Liberated Threads:*

Black Women, Style, and the Global Politics of Soul (Chapel Hill: University of North Carolina Press, 2015) and Monica L. Miller, *Slaves to Fashion: Black Dandyism and the Styling of Black Diasporic Identity* (Durham: Duke University Press, 2009).

14. Keeling, 76.

15. The Emancipation Proclamation and the Thirteenth Amendment did not, in fact, abolish slavery, but consigned it to a specific sphere: the prison and the regime of punishment. This dislocation of slavery rewrites but does not fully escape the racial determinism of enslavement.

16. Ed Guerrero, *Framing Blackness: The African American Image in Film* (Philadelphia: Temple University Press, 1993), 69–70.

17. Ibid., 89.

18. Yvonne D. Sims, *Women of Blaxploitation: How the Black Action Film Heroine Changed American Popular Culture* (Jefferson, N.C.: McFarland, 2006); Stephane Dunn, *"Baad Bitches" and Sassy Supermamas: Black Power Action Films* (Urbana: University of Illinois Press, 2008).

19. Keeling, 8.

20. Wiese, 211.

21. Hollis Griffin, "Never, Sometimes, Always: The Multiple Temporalities of 'Post-Race' Discourse in Convergence Television Narrative," *Popular Communication* 9.4 (2011): 244.

22. Bogle, 267.

23. Gayle Wald, *It's Been Beautiful: Soul! And Black Power Television* (Durham: Duke University Press, 2015).

24. Haizlip quoted in ibid., 21.

25. Wald, 22.

26. See especially Deborah Willis, *Reflections in Black: A History of Black Photographers, 1840 to the Present* (New York: W. W. Norton and Co., 2002); *Picturing Us: African American Identity in Photography*, ed. Deborah Willis (New York: New Press, 1996); Deborah Willis, *Let Your Motto Be Resistance: African American Portraits* (Washington, D.C.: Smithsonian Institute/Harper Collins, 2007); and Deborah Willis, *Posing Beauty: African American Images from the 1890s to the Present* (New York: W. W. Norton and Co., 2009).

27. Erina Duganne, "Transcending the Fixity of Race: The Kamoinge Workshop and the Question of a 'Black Aesthetic' in Photography," *New Thoughts on the Black Arts Movement*, eds. Lisa G. Collins and Margo N. Crawford (New Brunswick: Rutgers University Press, 2006), 195.

28. Ibid.

29. Carla Williams, "The Black Photographers Annual," *Aperture [Vision & Justice]* 223 (Summer 2016): 31.

30. Ibid.

31. Richard Dyer explains that "photographic media . . . assume[s], privilege[s] and

construct[s] whiteness" as film "[s]tocks, cameras and lighting were developed taking the white face as the touchstone." Dyer, *White* (London: Routledge, 1997), 89, 90.

32. Ibid.

33. Bogle, 345.

34. Ella Shohat and Robert Stam, *Unthinking Eurocentrism: Multiculturalism and the Media* (New York: Routledge, 1994), 204.

35. Toni Morrison, "Behind the Making of *The Black Book*" (1974), *What Moves at the Margins: Selected Nonfiction*, ed. Carolyn C. Denard (Jackson, Miss.: University Press of Mississippi, 2008), 36.

36. Barbour, viii.

37. Morrison, 37, 35.

38. Countee Cullens's poem "Heritage" (1925), which repeats the refrain, "What is Africa to me?" and arrives at ambivalence, is one example.

39. Maulana Karenga, "Making the Past Meaningful: Kwanzaa and the Concept of Sankofa," *Reflections* 1.4 (1995): 41.

40. Neal, 12, emphasis in original.

41. Ibid., 13, emphasis in original.

42. Richard J. Powell, *Black Art and Culture in the 20th Century* (New York: Thames and Hudson, 1997), 152.

43. Ibid.

44. Mark Dery, "Black to the Future: Interviews with Samuel R. Delany, Greg Tate, and Tricia Rose," *South Atlantic Quarterly* 92.4 (1993): 180.

45. According to Mark Bould, "The term 'Afrofuturism' is normally attributed to Mark Dery, coined in an interview with Samuel Delany, Greg Tate, and Tricia Rose that appeared in *South Atlantic Quarterly* in 1993." Bould, "The Ships Landed Long Ago: Afrofuturism and Black SF," *Science Fiction Studies* 34.2 (2007): 180.

46. Bould, "Come Alive by Saying No: An Introduction to Black Power SF," *Science Fiction Studies* 34.2 (2007): 220, 221.

47. Bould, "The Ships Landed Long Ago," 177.

48. The Ancient Egyptian goddess Isis, often depicted in hieroglyphs, paintings, and sculptures with an ankh in hand, presides over magic, healing, women, and life. See Elizabeth A. McCabe, *An Examination of the Isis Cult with Preliminary Exploration into New Testament Studies* (Lanham, Md.: University Press of America, 2008).

49. Marc Singer, "'Black Skins' and White Masks: Comic Books and the Secret of Race," *African American Review* 36.1 (2002): 107.

50. Jeffrey A. Brown, "Comic Book Masculinity and the New Black Superhero," *African American Review* 33.1 (1999): 31.

51. Jeffrey A. Brown, "Panthers and Vixens: Black Superheroines, Sexuality, and Stereotypes in Contemporary Comic Books," *Black Comics: Politics of Race and Representation*, eds. Sheena C. Howard and Ronald L. Jackson III (New York: Bloomsbury, 2013), 134.

"Can You Kill"

Vietnam, Black Power, and Militancy in Black Feminist Literature

NADINE M. KNIGHT

It is hard to think of a single year more significant in the history of black wom-
en's cultural production than 1970. At the midpoint between the span from
1965–1976 that Howard Rambsy calls the "Harlem Renaissance 2.0 and then
some," 1970 alone saw the publication of Toni Cade Bambara's anthology *The
Black Woman*; Toni Morrison's *The Bluest Eye*; Alice Walker's *The Third Life of Grange
Copeland*; Audre Lorde's *Cables to Rage*; and Nikki Giovanni's *Re: Creation*.[1] If we
consider even just the first half of the 1970s, the treasure trove overflows: add
Morrison's *Sula* (1973); the autobiographies of political lightning rods Shirley
Chisholm and Angela Davis; plays and poetry by Sonia Sanchez; experimen-
tal theater by Barbara Ann Teer; novels and poetry by June Jordan; poetry by
Maya Angelou, Lucille Clifton, and Gwendolyn Brooks; Gayl Jones's *Corregidora*
(1975); Ntozake Shange's choreopoem *for colored girls who have considered suicide/
when the rainbow is enuf* (1975); and the wholly unprecedented archive contained
in *The Black Book* (1974). Taken collectively, black women's literary and cultural
production in the 1970s forever reshaped the scope, voice, and representation
of black women's experiences and expression by gaining wide readership and
critical acclaim for their frank disclosure of violence and inequity within black
communities and by championing black feminist agency and sexual liberation
in the post–civil rights era.

Three intersecting sociopolitical forces influenced black women's cultural
production and underscore how these works contributed to broader cultural

conversations at the time: the militarization of the Black Power and Black Arts movements; the growing protests against American involvement in Vietnam, particularly as it intersected with the Black Power movement; and the growth of white second-wave feminism and a separate black feminist movement. These cultural movements catalyzed black women even as the women still strained against the "narrow vision of some aspects of the 1960s protest."[2] As Amanda Davis observes, black women writers, artists, and activists of the 1970s "complicated notions of black unity and revolution by collectively showing that nation-building could not occur without discussing the relationship between black men and women and addressing the specific realities of black women's lives."[3] While the evolution of the Black Power/Arts movements grew from an ongoing dialectical struggle between black and white cultural aesthetics, politics, and economies, black women of the early 1970s championed a greater inward turn when considering the true subjects of "the struggle." Collectively, the women's works examined in this chapter identified injustices and inequalities that oppressed women *within* black communities in order to confront the heteropatriarchal discourse of the civil rights and Black Power movements.[4] The works overturned the long-standing expectations and stereotypes of black "respectability politics" in order to promote sexual freedom in its place and consider the attractions and shortcomings of militancy as a defense against abuse. As Toni Cade Bambara writes in her essay, "On the Issue of Roles," included in her *Black Woman* anthology: "If your house ain't in order, you ain't in order. It is so much easier to be out there than right here. The revolution ain't out there. Yet. But it is here."[5] Black women authors of the 1970s urged audiences to set aside the distraction of battles framed exclusively against white oppression and to instead address problems festering within black communities in order to make them stronger, safer, and more collaborative.

In staking out their positions, the authors expanded and enhanced, with new openness, a proud lineage established by some of their literary foremothers. Zora Neale Hurston's *Their Eyes Were Watching God* (1937) embraced black vernacular, voiced dissatisfaction with black heteropatriarchal constraints against black women's independence, and celebrated a black woman's sexual awakening and pursuit of pleasure. The novel also explored how a black woman could kill both indirectly with her words (Janie's caustic comments to her second husband, Jody) and, resolutely, with a gun (in self-defense against the rabid Tea Cake). No less important is the debt to the groundbreaking antilynching journalist, Ida B. Wells, one of the "pistol-packing mamas" who inspired Toni Cade Bambara.[6] Wells's *Southern Horrors* (1892) advises African Americans to give a Winchester

rifle "a place of honor" in their homes.[7] The Combahee River Collective, a black feminist organization founded in 1974, reflected Wells's influence: "Contemporary black feminism is the outgrowth of countless generations of personal sacrifice, *militancy*, and work by our mothers and sisters."[8] Where Wells saw the Winchester rifle's necessity to defend against external white threats to black safety, Hurston and the women writing in her wake explored how armed resistance may be needed more for self-protection within black people's homes.

An important element in the unprecedented success of the black women's literary renaissance in the 1970s was the women's commitment to collaboration. For example, Toni Morrison worked as Toni Cade Bambara's editor at Random House, while Nikki Giovanni started a publishing collective that promoted other black women poets. Bambara took an editorial role with *The Black Woman* anthology, which republished important recent essays and speeches by black women and debuted new works by a wide-ranging group of authors, scholars, and activists. Bambara saw this project as a means of hosting the necessary conversations that black women needed to have among themselves: it was "a turning toward each other. . . . What typifies the current spirit is an embrace, an embrace of the community and a hardheaded attempt to get basic with each other."[9]

Bambara calls for "basic"—frank and uncensored—discussions of black women's frustrations with their marginalization from both the white feminist movement and the Black Power movement, setting the tone for the 1970s women's renaissance. *The Black Woman* incorporated multiple and hybrid genres, including poetry, rap, literary criticism, history, sociology, and transcriptions of roundtable discussions; thematically, it showcased frank discussions about every facet of public and private life, from the importance of the kitchen in the lives of black women, to the failures of welfare and child-support systems in New York. *The Black Woman* debated abortion, birth control, the perceived castration of black men, and how the Black Power movement and the (white) women's movement have failed black women. In short, it contained multitudes, yet the works in Bambara's anthology commit to giving black women a greater voice in the ongoing equality movements. The works within the anthology unsparingly described the lived realities of violence that affected black women and children, in all its physical and psychological forms. The explorations of (in)equality and violence, delivered in bluntly confrontational language, were hallmarks of the black women's renaissance of the 1970s.

Black Power, Black Arts, and Militancy

Closely intertwined, the Black Power and Black Arts movements of the latter half of the 1960s signaled a sharp generational shift from the civil rights movement that arguably birthed them.[10] The Black Power movement, so named by student activists Willie Ricks and Stokely Carmichael in June of 1966, coalesced from the black nationalist legacy of Malcolm X and the continued—and increasing—violence against black activists in the latter half of the 1960s.[11] The Black Power movement and the Black Panther Party, cofounded by Huey Newton and Bobby Seale in 1966, promoted a militant stance in their defiant rhetoric and in their overt display of weaponry to evoke the necessity of self-defense as well as the possibility of armed insurrection. By returning the image of armed African Americans back into the public consciousness, the Black Power movement recalled the use of self-defense urged by Ida B. Wells at the turn of the 20th century and signaled a breach from the famed nonviolence of the civil rights movement.[12]

Black Power identity centralized militancy, but activists drew a distinction between the militancy necessary for fighting white supremacy and the government-sponsored militancy of the Vietnam war effort. Manning Marable notes that as early as 1964, Malcolm X "urged activists to start 'rifle clubs' to defend the black community against police brutality."[13] The Black Panther Party soon became iconic for their displays of their Second Amendment right to bear arms.[14] At the same time, Kimberley Phillips notes, "Carmichael articulated black militancy in language and action as mass self-defense to determine blacks' destiny and as part of the larger struggle against colonialism. . . . Carmichael insisted black men refuse the draft for an 'immoral' war."[15] How, when, and where to use violence were questions Black Power and antiwar activists grappled with, and the black women writers of the 1970s reflected these same concerns as their cultural works probed the uses and limitations of violence and militancy *within* black communities.

The Black Power and Black Arts movements were closely intertwined. Larry Neal, one of the founding fathers of the Black Arts movement, defines it as "the aesthetic and spiritual sister of the Black Power concept. . . . The Black Arts and the Black Power concept both relate broadly to the Afro-American's desire for self-determination."[16] Howard Rambsy explains that "black arts discourse was characterized by expressions of militant nationalist sensibilities, direct appeals to African American audiences, critiques of antiblack racism, and affirmations of cultural heritage."[17] The Amiri Baraka poem, "Black Art," one of the founding

works of the movement, encapsulates the Black Power/Arts embrace of violence and confrontation as necessary forms of self-expression:

> We want "poems that kill."
> Assassin poems, Poems that shoot
> guns. Poems that wrestle cops into alleys
> and take their weapons leaving them dead[18]

As is clear from a reading of Baraka's poem—or, in a similar vein, Nikki Giovanni's exhortation of "Nigger / Can you Kill / Can you Kill" and "We kill in Viet Nam for them" in "The True Import of Present Dialogue"[19]—the movements "found [their] power in the expression of rage."[20] The question of rage, and how it was best expressed, guided black women of the 1970s as they critiqued the black/white struggle, celebrated the freedom of disruptive rhetoric, and reimagined the deployment of militancy and violence within black families and communities.

Baraka's and Giovanni's poems reveal how the immediacy of war catalyzed creative efforts. An antiwar stance became a fundamental platform of the Black Power movement because black activists saw black soldiers and Vietnamese civilians as mutually "victimized by the white racist government of America."[21] Reflecting a growing discomfort with the military action in Vietnam and its effect on black soldiers, Baraka's "Black Art" includes a litany of violent acts that culminate in the toxic dehumanization of soldiers, who become "beasts" reduced to their signature military head cover: "Poem scream poison gas on beasts in green berets."[22] Similarly, critic Addison Gayle voiced his dismay at the effect that Vietnam had on black soldiers and the enforced hypocrisy of their actions: "What else is one to make of My Lai. . . . How far has the Americanization of black men progressed when a southern black man stands beside white men and shoots down, not the enemies of his people, but the niggers of American construction?"[23] The horrors of the 1968 My Lai massacre, widely publicized in the American media by the start of 1970, epitomized the war's immorality and an all-too-familiar execution of civilians. To turn against the war was to assert, decades before a new movement emerged in reaction to state-sanctioned violence, that black lives, on foreign soil and well as domestic, mattered.

Though black women are often widely overlooked in histories of the black anti-Vietnam movements, they were of course participants in the war, victims of its efforts, and keenly attentive to the ramifications of the war's effects on black communities.[24] One of the most poignant and controversial examples of how the war brought violence into black households is depicted in the "nite with

beau willie brown" section of Ntozake Shange's *for colored girls*, which Soyica
Diggs Colbert points out was originally about a Vietnam vet, suffering from
what today we recognize as PTSD, who returns home and commits infanti-
cide: "The violence that Beau Willie enacts on the battle field seeps into his
domestic space and demonstrates the ongoing costs of war" (see Chapter 10
in this volume). On the domestic front, antiwar protests often became sites of
violence, most infamously in the Kent State massacre in May 1970. Reflecting
the commingling of atrocities against civil rights and antiwar activists, Lucille
Clifton dedicates *Good News about the Earth* (1972) to "*the dead / Of Jackson and /
Orangeburg / and so on and*," summoning an image of countless casualties of the
civil rights movement rivaling those mounting on foreign soil. The first poem is
"after Kent State," in which the epigrammatic brevity of her poetic style belies
the deep condemnation of white violence:

> white ways are
> the way of death
> come into the
> Black.[25]

In her 1974 autobiography, Angela Davis points out that although Vietnam
mobilized protests, it also gave white police forces combat experience that they
could readily turn against black protesters. Davis recalls that in Los Angeles,
"the SWAT Squad was composed primarily of Vietnam veterans. . . . They had
made their public debut with their attack on the Panther office."[26] Davis's promi-
nent role with the Panthers—in particular, her notoriety for purchasing weapons
and related murder charges—became emblematic for black feminist activists
seeking to portray women as revolutionary agents whose capacity for violence
matched men's and could be turned against oppressors both white and black. In
this light, Mary Ann Weathers argues that Vietnam illustrates women's militant
capabilities in her 1970 "Argument for Black Women's Liberation as a Revolu-
tionary Force." She condemns the "disgusting" state of gender relations within
black communities where "Black men are still parroting the master's prattle
about male superiority."[27] Weathers also calls for "real revolution (armed)" and
points out: "Women have fought with men, and we have died with men, in ev-
ery revolution, more timely in Cuba, Algeria, China, and now in Viet Nam."[28]
Similarly, Frances Beale argues in *The Black Woman*: "We need our whole army
out there dealing with the enemy and not half an army."[29] Though militancy
is often conflated with masculinism, these examples demonstrate that black
women saw specific types of militarism as essential to their own causes.

The toll the conflict took on nonwhite bodies influenced the pervasiveness of violence in black women's literature of the 1970s, particularly in the depiction of civilian victims and in the representation of burning bodies. Of all of the examples of violence in the texts of this period, however, Toni Morrison's *Sula* most fully captures the Vietnam zeitgeist of the early 1970s. *Sula*'s epilogue moves to 1965, and though the narrator contends that life was "so much better in 1965," the narrator immediately qualifies the statement with the telling caution, "Or so it seemed" (163). As Katy Ryan points out, "in 1965, the U.S. war in Viet Nam intensified, Malcolm X was assassinated, and the Watts riots began."[30] Thus, the conclusion invites readers to consider how these moments might contribute to "sorrow" being the novel's last word (174).[31] Given *Sula*'s historical placement, the two immolation scenes in this novel evoke some of the most iconic representations of the horrors of the Vietnam war and connect the horrors abroad with shocking reminders of the ongoing horrors at home.

The widespread use of napalm as a weapon of war was forever captured in the American consciousness through the Pulitzer Prize–winning 1972 photograph of Kim Phuc, the naked young woman trying to outrun the napalm covering her body. Fire was central to the protests against the war, as well: the burning of one's draft card became a common form of protest.[32] In 1963, a South Vietnamese Buddhist monk self-immolated to protest the military actions in his country, and in the United States there was widespread and international media coverage of the 1965 antiwar self-immolation of Norman Morrison, a Quaker activist who drove himself to the Pentagon and set himself on fire in front of his unharmed infant daughter.[33] Less than a week later, in New York, another antiwar activist set himself on fire in front of the United Nations.[34] A lament by Robert Hayden places burning at the center of his grief in "Words in the Mourning Time" (1970), a poem which, much like Morrison's novel, reflects on the sorrows of the 1960s:

> Vietnam and I think of the villages
> Mistakenly burning the schoolrooms devouring
> their children and I think of those who/ were my students[35]

In *Sula*, the first character to die by fire is Plum, Eva Peace's son who has returned home from World War I a shell of his former self. Plum's apparent drug addiction invites readers to see him as a stand-in for Vietnam veterans, many of whom developed drug addictions during the war.[36] Plum's addiction and subsequent helplessness are more than Eva can bear, so, in a passage that is exceptionally horrifying in its calmness, she kills Plum by lighting a newspaper

Figure 5.1. Headline from the November 3, 1965 edition of the *Baltimore Sun*. The lede notes the public spectacle as well as the endangerment of the protestor's daughter: "Pacifist releases girl as flames engulf him in front of building." Permission from the *Baltimore Sun*.

wick and tossing "it onto the bed where the kerosene-soaked Plum lay in snug delight" (47). This scene commemorates the atrocities of Vietnam (where accelerated fire is both war crime and protest) and explores the extreme depths of maternal refusal. When asked by her daughter, Hannah, why she did it, Eva explicitly frames her actions through a tension between maternal embodiment and failed masculinity: "I birthed him once . . . Godhavemercy, I couldn't birth him twice . . . so I just thought of a way he could die like a man not all scrunched up inside my womb, but like a man" (71–72). In closing her metaphorical womb and refusing to care for her helpless, re-infantilized veteran son, Eva sets a limit on just how far maternal care can be asked to stretch and demonstrates just how ravaging American wars were for black men—and thus, in turn, for the black women expected to support them as they attempted to return to a civilian life with grievously inadequate (social) services for black veterans.[37] Just as black feminists were fighting to renounce traditional domestic duties as wives or mothers in the 1960s and 1970s, the substantial needs of some veterans required them to again take up the mantle of helpmate.

While the ex-soldier Plum's immolation was deliberate, Hannah's accidental death by her cooking fire reminds of how often women and children become collateral damage. One minute Eva looks out her window and Hannah is fine; the next minute, "she saw Hannah burning. The flames from the yard fire were licking the blue cotton dress, making her dance" (75). Eva throws herself out the window in a doomed attempt at dousing her daughter, and horrified neighbors only make things worse by throwing water on Hannah which "made steam, which seared to sealing all that was left of the beautiful Hannah Peace . . . her face a mask of agony so intense that for years the people who gathered 'round would shake their heads at the recollection" (76). The spectacle of agony recalls the terrible image of Kim Phuc, both in the searing of Hannah's body and in the lasting impression her death made as an historical touchstone for the community. In real life and in the world of Morrison's novel, a defenseless woman of color is sacrificed in order to metonymize the war and catalyze communal mourning.

The protests against Vietnam and the struggle for black women's equality in the 1970s saw black women moving between sorrow and anger. As Shirley Chisholm admits in her autobiography, *Unbought and Unbossed*, "I can feel in myself sometimes an anger that wants only to destroy everything in its path."[38] Terrion L. Williamson argues that the public image of "the angry black woman 'came of age' in the 1970s" (Chapter 8 in this volume). Women's anger, openly expressed, thus became a hallmark of the era's artistic and literary production.[39] Fran Sanders's "Dear Black Man" expresses her anger that "there has always been among Black men in this country a certain amount of hostility in his approach to his woman."[40] Sanders and her contemporaries exposed the violence often aimed against black women who dared to challenge patriarchal norms that insisted that black women be subordinate and receptive to black men's control.

Alice Walker's *Grange Copeland* explores in depth the expansiveness of black heteropatriarchy's propensity to control black women, and how women's refusal to submit to this authority also leads them to repurpose militancy. Walker's novel offers one of the most militant scenes in which a woman finds satisfaction in perpetuating violence against her husband and also materially (though only temporarily) improves her domestic conditions. After years of regular abuse from Brownfield Copeland, his wife, Mem, ambushes him early one morning while he is incapacitated from alcohol. Notably, it is one of the lengthiest sections in a novel made of extremely short chapters; Mem's revenge is drawn out, treasured by the narrator.[41] Mem slams Brownfield in the head with his own shotgun, makes him wallow in his own vomit, and finally announces that there will be a new order to their household:

Now, first off you going to call me Mem, Mrs. Copeland, or *Mrs. Mem R. Copeland*.
. . . Third, if you ever lay a hand on me again I'm going to blow your goddamn
brains out—after I shoots off your balls, which is all the manhood you act like
you *sure* you got. Fourth, you tetch a hair on one of my children's heads and I'm
going to crucify you. . . . Seventh, if you ever use a cuss word in my new house
I'm going to cut out your goddam tongue.[42] (128, original emphasis)

Mem's rules—ten in all, like ten commandments—focus on both self-protection
and the aspirations of traditional respectability politics. And while Brownfield
is cowed, they approach middle-class comfort in a house in town. What Walker
makes truly tragic about this moment is not that Mem was forced to embrace
militancy; rather, it is that she did not remain militant and thus Brownfield
eventually ruins their fortunes, returns them to sharecropping, regains pos-
session of the shotgun, and ultimately murders her. As GerShun Avilez argues,
"Walker establishes a narrative framework in which Black women cannot trust
Black men. . . . This idea resonates with the critiques of Black women activists
during the 1960s and 1970s about Black male sexism and organizational dis-
crimination."[43] Black men may want to arm themselves against white America,
but black women, for Walker, must arm themselves against black men.

Black Feminism and Female Freedom

Black sexual politics of the 1970s was a topic by no means easily divorced from
violence. The Black Power/Arts movements were undeniably masculinist in
origin and openly concerned with strengthening a heterosexual and patriar-
chal order within and for black culture: as Madhu Dubey argues, "The Black
Aesthetic figuratively trapped the black woman in the past, and barred her from
participating in any new emancipatory discourse of blackness or femininity."[44]
In response, black women writers promoted sexual freedom; they dared to voice,
with a breathtaking new forthrightness, dissatisfaction with the restrictions of
marriage and motherhood as they called for an expansion of possibilities for
sexual expression and fulfillment. Trimiko Melancon explains, in her compre-
hensive overview of the tensions surrounding black women's sexuality and
representation in the 20th century, that the early black rights and women's rights
movements emphasized an image of black womanhood as morally unimpeach-
able and sexually unavailable: "black women, mostly from the middle class,
adopted respectability, propriety, and a politics of silence surrounding sexuality
as a means to challenge their stigmatization."[45] This was a reaction to the long-
standing antebellum and Jim Crow stereotype of the black-woman-as-Jezebel,

a hypersexualized object for men's desires, in stark contrast to white feminine purity. Respectability continued as a hallmark of the civil rights movement, from the businesslike attire of many protestors to the positioning of Rosa Parks as the face of the Montgomery Bus Boycott. According to Katharina M. Fackler, the iconic image of Parks sitting on a bus enacts a "visual grammar of respectability."[46] Fackler notes that at least two black women were arrested for failing to yield their seats before Parks, but they were dismissed as potential catalysts by local movement leaders because they "did not fulfill the strict requirements of bourgeois respectability" given rumors of a baby out of wedlock for one and an intemperate home for the other.[47]

By the post–civil rights era, however, in the wake of the burgeoning white and black feminist movements, many black women writers challenged the restrictions of traditional respectability in order to promote greater agency for black women. For these feminists, respectability summoned oppressive white patriarchal values that undermined black equality. Frances Beale's "Double Jeopardy: To Be Black and Female," in *The Black Woman* (and later reprinted in the *Black Woman's Manifesto*, a pamphlet distributed by the Third World Women's Alliance in the mid-1970s) argues forcefully that "Black women who feel that there is no more productive role in life than having and raising children" are following the corrosive "bourgeois white model" of motherhood.[48] Beale further declares that "Black women sitting at home reading bedtime stories to their children are just not going to make it."[49] Refusing the traditional hallmarks of being a "good" mother—much like the Peace women in *Sula*—became an essential part of black feminist platforms in the 1970s. As Eleanor Holmes Norton argues in the *Black Women's Manifesto*, "blacks must remake the family unit, not imitate it. Indeed, this task is central to black liberation."[50]

Motherhood and marriage are, of course, issues of sexual and economic freedom. The relatively recent availability of the birth control pill and the revolutionary *Roe v. Wade* Supreme Court decision of 1973, which protected *some* privacy and abortion rights for women, shed new light on the entanglement of sexual autonomy with economic security and political activism. Many of the voices in Bambara's *The Black Woman* wrestled with these issues; Farah Jasmine Griffin's critique expresses some disappointment that several entries still reflect a pragmatic "politics of protection and respectability."[51] *The Black Woman* nevertheless also offers strong voices condemning the continued relegation of women to a supportive and maternal role in the post–civil rights era. Kay Lindsey encapsulates the dissatisfaction and the generational shift underway at the intersection of the civil rights and women's rights movements:

> But now that the revolution needs numbers
> Motherhood got a new position
> . . .
> And I thought sittin' in the back of the bus
> Went out with Martin Luther King.[52]

In that light, the surprisingly frank opening lines of Joanna Clark's essay in *The Black Woman* are refreshing: "My first words as I came out from under the ether after I had my son were, 'I think I made a mistake.' Unfortunately, since then, and one more child later, I've had very little reason to change my mind."[53] Her unashamed dissatisfaction with motherhood reflects the new confrontational aesthetics nurtured through the Black Power/Arts period.

In a similar vein but with a more experimental form, Sonia Sanchez's 1974 play, *Uh, Uh; But How Do It Free Us?* traces an evolution of black women's resistance to black heteropatriarchy. In the play, two wives of the same man discuss their resentment of his bigamy (and each other) but still somehow feel beholden to him: "And since I love him. I have to abide by his choices, no matter how unwise it may be," Waleesha, the first wife, says with resignation.[54] The end of the play offers a rebuttal, however, in the form of a "Sister" who has read Franz Fanon and who has set off, alone, from her home in New York to explore San Francisco. Sister recalls how her mother taught her that "we Blk/women been fighting a long time just to get Blk/men to take care of us" (2010: 77). However, she finally realizes that in order to be truly free, she must reject the old idea of dependence on a man. She chastises a "Brother," saying, "To you being a Black woman means I should take all the crap you can think of and any extra crap just hanging loose. That ain't right, man, and you know it too" (2010: 93). Sister models how black women need to "call out" black men in order to force them to acknowledge and reject the inequalities of patriarchy.

In the poetry collection, *Re: Creation*, Nikki Giovanni uses playfully resists the stale tropes of black feminine domesticity. In "Housecleaning," her speaker lists a stereotypical joy in keeping the domestic sphere in order before coming to the punchline, presumably to a male interlocutor:

> this habit has
> carried over and i find
> i must remove you
> from my life.[55]

Her "Poem for Aretha" celebrates the singer and dares to point out that domestic life is not always a pleasure or a priority when a career on the road beckons: "the

wondering if your children will be glad to see you and maybe/ the not caring if they are" (17). Though Giovanni's anger is expressed more subtly than some of her peers, still her poems reject patriarchal expectations and place women's individual agency above traditional respectability: she and her contemporaries confronted respectability politics by championing a de-stigmatization of sex and sex work, which in their texts can lead to financial security and independence for women. Giovanni's "Lady of Pleasure Now Retired" is likened to a "semiprecious jewel" admired by "those / who could afford / her recreation" (30). Even the fact that she is deemed a "lady" repudiates the racialized-gendered rhetoric of the civil rights era, which, as Toni Morrison observed, divided women into "White Ladies" and "Colored Women" under segregation.[56] The long, classist, and racist legacy of who was deemed a "lady" in American society is overturned in Giovanni's work.

Though more pragmatic than benedictory in their depictions, the early novels of Morrison and Walker destigmatize sex work by presenting it as a means of economic security. Walker's *Grange Copeland* features the sex worker Josie as the most financially independent woman character in the novel. Josie is defiant in response to anyone from a "damn respectable family" looking down on her: "Never mind I built up a establishment with my own hands and figure out how to git rich with my own brain" (81). She even condemns Grange Copeland's adulterous wife *not* for her multiple infidelities, but because she made no profit from it to alleviate the family's debt: "*she forgot to charge!* Shit" (82, original emphasis). There is a pragmatism and independence to Josie that starkly contrasts the wives in the novel who stand by their men until their men kill them. Marriage, in Walker's view, is far more likely to ruin a woman's prospects than prostitution is.

While sex work is mostly an individual venture in *Grange Copeland*, Morrison's *Sula* disentangles the relationships between marriage, motherhood, sex, and sexual liberation: "It was manlove that Eva bequeathed to her daughters. . . . The Peace women simply loved maleness, for its own sake (41)."[57] Their love of "maleness" separates heteronormative love from the domestic imaginary: the Peace women love men but do not stay married; though mothers, they are not particularly affectionate ones. Thus, their household explicitly rejects the respectability of maternal virtue as an outmoded and oppressive model. The nonconformist households celebrating women's sexual freedom as presented in Morrison, Walker, and Giovanni offer imaginative revisions of how families can operate and gestures toward Norton's assertion that black people must redefine family. Sula's mother, Hannah, is open about taking multiple lovers, and it makes quite an impression on Sula, teaching her:

that sex was pleasant and frequent, but otherwise unremarkable. Outside the house, where children giggle about underwear, the message was different. So she watched her mother's face and the face of the men . . . and *made up her own mind*. (44, emphasis mine)

Though this portion of the novel is set around 1920, the way that sex is framed sounds as if it could be found in the famous guide to women's health, *Our Bodies, Ourselves* (first published by the Boston Women's Health Collective in 1970 and a cultural fixture by 1974). A product of the emergent feminist movement, *Our Bodies* encouraged women to become "better lovers, better people, more self-confident, more autonomous, stronger and more whole [2016: "Preface"]."[58] *Our Bodies, Ourselves* speaks to Hannah's freeing approach, particularly when contrasted to the ignorance and immaturity about sex from Sula's more traditionally raised peers. Regarding the importance of Sula's lesson on the freedom of manlove, Trimiko Melancon astutely writes, "That Hannah's sexual experiences are unencumbered by sexualized violence also speaks to a black feminist politics of pleasure governing black women's sexual intimacies."[59] Sula learns enough from her mother to be firm in her own desire to resist the expectations of black womanhood she feels pressing upon her when she is urged to have children. "I don't want to make somebody else. I want to make myself," she tells her grandmother (92). Here, too, Morrison celebrates black women who choose to put their energies toward self-fashioning rather than child-rearing.

Conclusion: "Into the Revolution"

Kay Lindsey's call for black women to "project [them]selves into the revolution," encapsulates the emphasis on agency, militancy, and self-assertion affirmed by the cultural workers of the 1970s.[60] As a final example, June Jordan's *His Own Where* (1971) imagines more sustainable models of equality and mutually constitutive support within black communities. *His Own Where* presents—without shame or censoriousness—the sexually active romance between Buddy and Angela, two teens left to fend for themselves as a result of absent or abusive parenting. Their relationship is romantic, mutually supportive, and far more stable than any adult interaction in their lives. The novel celebrates black vernacular and emphasizes the importance of self-empowerment even as it also participates in the larger cultural conversations about domestic abuse within black families, methods of black activism, and the limits of militancy. Militancy infuses even their playful navigation of the city, as Buddy "seem[s] like a commando on the corner. . . . Arms like a rifle in rotation."[61] But, damningly,

militancy does Angela no good when she is at home and her father beats her: "Angela struggle her hand under the pillow where to protect herself she hide a kitchen knife not to be beaten like she is. Seize the handle, ship the knife into his view and tell him 'Leave me alone'" (28). Nevertheless, her father quickly disarms her and abuses her so terribly that she is hospitalized. Though Angela is admirable for her attempted self-defense, her inability to single-handedly combat patriarchal force convinces her to develop a cooperative and nonviolent bond with Buddy.

Buddy is a role model for a new, progressive, and cooperative black male partner. He takes Angela to the hospital after her father's beating and helps her to obtain legal protection. At school, he organizes a protest to demand sex education. His platform—"Want to learn anatomy . . . contraceptives . . . sex free and healthy"—could come from the women's sexual liberation movement (37). In the dining hall, he organizes another protest against the poor food and dehumanizing conditions: "You pack us in like animals, and then you say, they act like nothing more than animals. To hell with your control" (41). Here Buddy is thoroughly disruptive, yet brilliantly nonviolent: he organizes a dance between 700 students and the four matronly lunch ladies, who have the time of their lives. The police, called to rush the lunch room, are loathe to end the women's fun and refuse to find fault in the situation. In short, Buddy models a black activism that is more attentive to black women's endangerment and respectful of black women's pleasures—social as well as sexual—as a corrective to the misogyny and regressive patriarchal demands of much Black Power discourse about gender relations.

Simultaneously charmingly immature and adult beyond his years, Buddy devotes himself to Angela and espouses the importance of respecting—and loving—women, in stark contrast to the "hostility" in black men's approach toward black women that Fran Sanders excoriated in "Dear Black Man." As part of his ability to forge a black activism that honors its predecessors even as it advances the cause of gender equality, Buddy masters the militancy of the Black Power movement even as he also adapts the nonviolent practices of the civil rights generation to serve current needs (though it is hard to imagine Martin Luther King chanting "two-four-six-eight—why don't you coeducate?" (38–39) as Buddy and his classmates do. When Buddy breaks Angela out of the shelter where she has been sent after her parents lose custody, he scandalizes the nuns in charge with a speech both hilarious and sincere: "I tell you, Jesus was a one hundred percent, hip to the living, female-loving dude. A loving dude" (59). Such lessons retreat from traditional biblical justifications for women's subservience to the male head of their household and offer hope for a more egalitarian Black Power

movement. The novel begins and ends with a celebration of the home Buddy and Angela have made for themselves in a cemetery. In the "new day of the new life in the cemetery" (92), which is their "own place for loving made for making love" (1), Jordan urges readers to take similar empowering leaps of claiming and redefining spaces in which to form a freer and more egalitarian black community.

The revolutionary 1970s were unparalleled in the diversity and significance of black women's cultural production. Notably, this period also marks the first sustained mainstream honoring of black women's writings in poetry, fiction, nonfiction, and young adult fiction: Jordan's *His Own Where*, Giovanni's *Gemini*, Audre Lorde's *From a Land Where Other People Live*, Alice Walker's *Revolutionary Petunias and Other Poems*, Morrison's *Sula*, Carolyn Rodgers's *How I Got Ovah*, Sherley Anne Williams's *The Peacock Poems*, and Mildred Taylor's *Roll of Thunder, Hear My Cry* were all National Book Award Finalists in this decade.[62] Many of these women, notably Morrison, Giovanni, and Walker, continue their prolific artistic output in the twenty-first century; all of the women left lasting influences on the Black Arts movement and in the subsequent decades. The cultural work African American women produced in the 1970s crafted a relationship with the Black Power/Black Arts movements that placed women's experiences at the center of black representation, provided unflinching explorations of the benefits and shortcomings of militancy, and opened new possibilities for reconciliation, recognition, and resilience between black constituencies. These women's works offered "Revolutionary Dreams" that propelled African American literature and culture into new arenas of popularity and influence by the end of the 1970s.[63]

Notes

1. Howard Ramsby, *The Black Arts Enterprise and the Production of African American Poetry* (Ann Arbor: The University of Michigan Press, 2011), vii.

2. Stephen Tuck, "'We Are Taking Up Where the Movement of the 1960s Left Off': The Proliferation and Power of African American Protest during the 1970s." *Journal of Contemporary History* 43.3 (2008), 642.

3. Amanda Davis, "To Build a Nation: Black Women Writers, Black Nationalism, and the Violent Reduction of Wholeness." *Frontiers* 26.3 (2005), 24–25.

4. This is perhaps most succinctly illustrated in Stokely Carmichael's widely quoted statement from a 1964 SNCC meeting: "The position of the black woman should be prone" (qtd. in Guy-Sheftall); See Beverly Guy-Sheftall, ed., *Words of Fire: An Anthology of African-American Feminist Thought* (New York: The New Press, 1995), 190. Though some defend this as a mere joke, Pauli Murray and other black feminists believed the remark illuminated the oppressive masculinity embedded in the Black Power movement in the 1960s and '70s. For Murray, Carmichael's quip expressed "a distinctly conservative and backward-looking view in much of what black males write today

about black women, and many black women have been led to believe that the restoration of black male to his lost manhood must take precedence over the claims to black women to equalitarian status." See Pauli Murray, "The Liberation of Black Women," in Guy-Sheftall, *Words of Fire*, 190.

5. Toni Cade Bambara, *The Black Woman: An Anthology* (New York: Washington Square Press, 2005), 135.

6. Zala Chandler, "An Interview with Toni Cade Bambara" in Thabiti Lewis, ed., *Conversations with Toni Cade Bambara* (Jackson: University Press of Mississippi, 2012), 89.

7. Ida B. Wells, *Southern Horrors and Other Writings: The Anti-Lynching Campaign of Ida B. Wells, 1892–1900*, ed. Jaqueline Jones Royster (Boston: Bedford/St. Martin's, 1997), 70.

8. Combahee River Collective, "A Black Feminist Statement." *WSQ: Women's Studies Quarterly* 42.3–4 (2014), 272.

9. Bambara, *Black Woman*, 1.

10. For a concise explanation of both the confusion about what Black Power meant even during the 1960s as well as the growing black cultural embrace of Black Power over the objections of Martin Luther King Jr. and other veteran members of the civil rights movement, see Manning Marable, *Race, Reform, and Rebellion: The Second Reconstruction in Black America, 1945–1990* (Jackson: University Press of Mississippi, 2007), 90–97), and James Smethurst, *The Black Arts Movement Literary Nationalism in the 1960s and 1970s* (Chapel Hill: University of North Carolina Press, 2005), 14–15.

11. Marable, *Race, Reform, and Rebellion*, 92–99.

12. Black film, especially "Blaxploitation" films in the 1970s, also explored the uses of militancy and anger; see Terrion L. Williamson's Chapter 8, in this volume, on Blaxploitation and women's rage and violent revenge, particularly in Pam Grier's roles in this period.

13. Marable, *Race, Reform, and Rebellion*, 88.

14. Ibid., 107.

15. Kimberley Phillips, *War! What Is It Good For? Black Freedom Struggles and the U.S. Military from World War II to Iraq* (Chapel Hill: University of North Carolina Press, 2012), 253.

16. Larry Neal, "The Black Arts Movement." In *Black Aesthetic*, ed. Addison Gagle (New York: Doubleday, 1971), 272.

17. Ramsby, *Black Arts*, 11.

18. Amiria Baraka, "Black Art." *S O S: Poems 1961–2013* (New York: Grove Press, 2014), 149.

19. In Marable, *Race, Reform, and Rebellion*, 104.

20. Eddie S. Glaude Jr., *Is It Nation Time? Contemporary Essays on Black Power and Black Nationalism* (Chicago: University of Chicago Press, 2001), 8.

21. Quoted in Hall, 154. As Marable, Daniel Lucks, and Katy Ryan note, African American casualties in the war were disproportionately high when compared to white casualties. In 1966 alone, according to Marable, though African Americans only made

up about 15 percent of the army force in Vietnam, they suffered almost 23 percent of the casualties. See Marable, *Race, Reform, and Rebellion*, 98. In short, as Ryan puts it, "The black community was also sacrificed in the U.S. American war in Vietnam." See Katy Ryan, "Revolutionary Suicide in Toni Morrison's Fiction." *African American Review* 34.3 (2000), 401. These devastating losses were all the more unbearable in the face of the poor welcome that black vets faced at home: Lucks cites one Black Panther member who pointed out: "Most of the Panthers then were veterans. We figured if we had been in Vietnam fighting for our own country, which at that point wasn't serving us properly, it was only proper that we had to go out and fight for our own cause" (130). See Daniel Lucks, *Selma to Saigon: The Civil Rights Movement and the Vietnam War* (Lexington: University Press of Kentucky, 2014), 134–136. For Black Panther Party Six Point, see Simon Hall, *Peace and Freedom: The Civil Rights and Antiwar Movements in the 1960s* (Philadelphia: University of Pennsylvania Press, 2005).

22. Baraka, "Black Art," 150.

23. Addison Gayle, *The Black Aesthetic* (New York: Doubleday, 1971), xxii–xxiii.

24. Recent histories of the African American anti-Vietnam movements focus on the male soldiers' experience of war and the (largely male) leadership within the civil rights and Black Power movements as they came to protest the war. Hall and Lucks both open with anecdotes about Muhammed Ali's famous refusal to be drafted to frame their studies. Martin Luther King, Bayard Rustin, John Lewis, and Stokely Carmichael, as well as the rest of the male leadership loom large in accounts by Hall, Lucks, Marable, and Eldridge, while women's contributions are significantly under-examined.

25. Lucille Clifton, *Good News about the Earth: New Poems* (New York: Random House, 1972), 2.

26. Angela Davis, *Angela Davis: An Autobiography* (New York: International Publishers, 2016), 236.

27. Mary Ann Weathers, "An Argument for Black Women's Liberation as a Revolutionary Force," in Guy-Sheftall, *Words of Fire*, 158.

28. Ibid., 158–159.

29. Frances Beale, "Double Jeopardy: To Be Black and Female," in Bambara, *Black Woman*, 113.

30. Ryan, "Revolutionary," 401.

31. See also Philip Novak, "'Circles and Circles of Sorrow': In the Wake of Morrison's *Sula*." *PMLA* 114.2 (1999), for more on how Morrison is "promulgating a specifically African American historical understanding" in this moment (190).

32. Lawrence Eldridge notes that "The *Chicago Daily Defender* reported . . . that John Lewis, chair of SNCC, had urged members to avoid the draft, and in a gesture of protest, to burn draft cards 'if that is their desire.'" See Eldridge, *Chronicles of a Two-Front War: Civil Rights and Vietnam in the African American Press* (Columbia: University of Missouri Press, 2011), 46.

33. Taylor Branch, *At Canaan's Edge: America in the King Years, 1965–1968* (New York: Simon and Schuster, 2006), 358–359.

34. Ibid., 360–362.

35. In Marable, *Race, Reform, and Rebellion*, 107.

36. See Eldridge, *Chronicles*, 202–203, on the concerns about "the spread of drug addiction among the troops in Vietnam" and fears that "black veterans would be singled out as scapegoats" for inner-city crime.

37. Lucks cites a study from the House Committee on Veterans Affairs from 1981 in which "75 percent of white soldiers and marines claimed their combat experience had been positive, only 20 percent of African Americans shared this sentiment," *Selma*, 251.

38. Shirley Chisholm, *Unbought and Unbossed*, Expanded 40th Anniversary Edition (Washington, D.C.: Take Root Media, 2010), 157.

39. See also Colbert's Chapter 10, in this volume, and her exploration of how *for colored girls* confronts its audiences with the legacy of black male violence, which was now depicted as public and collective rather than private and individualized.

40. Fran Sanders, "Dear Black Man," in Bambara, *Black Woman*, 90–91.

41. Davis notes that "it is her appropriation of a traditionally male weapon, a gun, which offers Mem the power to control not only Brownfield's use of language, but also his movement" (39). Davis acknowledges that this is a "triumphant" scene, though for her it fails to signal a meaningful change of affairs. In contrast, I think that the scene is important precisely because it is fleeting—the tragedy is that Mem relaxes her militancy and allows Brownfield to plot his revenge.

42. Alice Walker, *The Third Life of Grange Copeland* (New York: Harvest Books, 1988), 128.

43. GerShun Avilez, *Radical Aesthetics and Modern Black Nationalism* (Urbana: University of Illinois Press, 2016), 79.

44. Madhu Dubey, *Black Women Novelists and the Nationalist Aesthetic* (Bloomington: Indiana University Press, 1994), 20. Although most scholars agree about the overwhelmingly masculinist underpinnings of the Black Power/Arts movements, Smethurst offers a nuanced contextualization of the eventual evolution of the gender and sexual politics of the movements. See Smethurst, *Black Arts*, 84–89.

45. Trimiko Melancon, *Unbought and Unbossed: Transgressive Black Women, Sexuality, and Representation* (Philadelphia: Temple University Press, 2014), 22.

46. Katharina Fackler, "Ambivalent Frames: Rosa Parks and the Visual Grammar of Respectability," *Souls: A Critical Journal of Black Politics, Culture, and Society* 18:2–4 (2016), 271–282.

47. Ibid., 273.

48. Beale, "Double Jeopardy," 113. See also Third World Women's Alliance, *Black Woman's Manifesto* (Chapel Hill: Duke University Digital Collections). http://library.duke.edu/digitalcollections/wlmpc_wlmms01009/.

49. Ibid., 114.

50. Eleanor Holmes Norton, "For Sadie and Maude." *Black Woman's Manifesto*, (n.d.), 4.

51. Farah Jasmine Griffin, "Conflict and Chorus: Reconsidering Toni Cade Bambara's *The Black Woman: An Anthology*," in Glaude, *Is It Nation Time?* 120.

52. Kay Lindsey, "Poem," in Bambara, *Black Woman*, 13.

53. Joanna Clark, "Motherhood," in Bambara, *Black Woman*, 75.

54. Sonia Sanchez, *I'm Black When I'm Singing, I'm Blue When I Ain't and Other Plays*, ed. Jacqueline Wood (Durham: Duke University Press, 2010), 63.

55. Nikki Giovanni, *Re: Creation* (Detroit: Broadside Press, 1970), 16.

56. In Dubey, *Black Women Novelists*, 15.

57. Toni Morrison, *Sula* (New York: Vintage Books, 2004). All citations for this text come from this edition.

58. "Preface to the 1973 edition of Our Bodies, Ourselves." Ourbodiesourselves.org. https://www.ourbodiesourselves.org/our-story/history/preface-to-the-1973-edition-of-our-bodies-ourselves/.

59. Melancon, *Unbought and Unbossed*, 58.

60. Lindsey, "Poem," in Bambara, *Black Woman*, 108.

61. June Jordan, *His Own Where* (New York: The Feminist Press, 2010), 4.

62. See http://www.nationalbook.org/nba_winners_finalists_1950_present.pdf.

63. Giovanni, *Re: Creation*, 20.

The Future in Black and White

Fran Ross, Adrienne Kennedy, and Post–Civil Rights Black Feminist Thought

SAMANTHA PINTO

> *Oreo* came to me in this context like a strange uncanny
> dream about the future that was really the past. That is it
> read like a novel not from 1974 but from the near future—
> a book whose appearance I was still waiting for.
>
> —Danzy Senna, Introduction to *Oreo* by Fran Ross, xii

At first glance, Adrienne Kennedy and Fran Ross seem like writers whose only connection is that they wrote in the same decade. Kennedy's surrealist plays seems to take place out of time as we know it, afflicted with a surplus of meaning that seem intent to overwhelm the readers/spectators.[1] Ross's only novel is a satirical romp that contrastingly seems to deny firm attempts at meaning-making at every turn, and fits squarely into the 21st-century postmodern literary landscape. But they are brought together by their commitment to innovative form in a post–civil rights era that was moving toward novel-length literary realism for black women writers. In this way, Adrienne Kennedy's 1976 drama *A Movie Star Has to Star in Black and White* and Fran Ross's 1974 novel *Oreo* each represent a radical reinterpretation of civil rights and Black Arts cultural and political legacies. Kennedy found short-lived public success with her surrealist one act play *Funnyhouse of a Negro* in 1964 (which won an Obie), and Fran Ross was a writer for *The Richard Pryor Show*[2]—marking both authors as "successful" writers for their time. Yet neither remains central to the Black Arts Movement

era in contemporary academic and historical narratives of the moment. This
essay re-narrates this historical-cultural moment in African American literary
historiography with these two authors at its center, marking the era as a time of
transition for black literature and black women's literature in particular—after
the civil rights period at its peak. Heavily relying on genre-experimentation
and capacious references to popular culture, each text employs a postmodern-
ist aesthetic in order to renegotiate the positionality of black women in their
contemporary 1970s political, cultural, and literary scenes. Kennedy and Ross
locate possibility—both painful and pleasurable[3]—in the consumption of popu-
lar performances of sexuality, gender, and race that they draw on to constitute
an emergent black feminist literacy that does not rely solely on literary realism.
By literacy here, I mean knowledge of specialized cultural practices of both
reading and writing—consumption and production. In looking back at these
innovative texts, we can chart a narrative for post–civil rights African American
literature that centers black women as writers *and* as cultural consumers, even
as it breaks with recognizable iterations of what constitutes paradigmatic black
artistic practice of the time.

This essay re-designates Ross and Kennedy as part of the conceptual foun-
dation of a new identifiable "class" of African American readers and writers
in the 1970s, those whose cultural literacy emerged in various ways under the
influence of the civil rights movement culture and Black Arts, Black Power, and
Black Nationalism, and who are pushing against the marginalization of women
in the rhetoric and representations of those movements, as well as the invisibil-
ity of black women within the mainstream feminist movement. Both *Oreo* and
A Movie Star are consistently critically reviewed as out of sync with or ahead of
their times, but I suggest here that they are recognizable today in their simulta-
neous emergence with a wave of black feminist thought—and a black feminist
aesthetic—in the post–civil rights era. Steeped in a wide breadth of American
cultural influence, both texts can lay claim to belonging to the trajectory of the
black aesthetic as much as they can trace their origin to the visual, cinematic,
and literary explosion of the post–civil rights era. But *Oreo* and *A Movie Star* are
also uneven inheritors of such histories and uneasy representatives of their own
historical moments. Much of that is because of the way cultural critics have nar-
rated the arc of African American literary and cultural production and its core
modes of representation. Critics and writers of the past forty years have mapped
this complicated terrain, pushing on the question of what constitutes a "black"
text.[4] *Oreo* and *A Movie Star* continue this push in several interconnected ways:
both stage difficult writing and difficult subjects as the core of a literary period
that sees the ascendancy of black women writers in the marketplace and in the

world's eye; both trouble visions of what we might think of as a usable past for African American authors, not engaging in obvious histories of slavery and only glancingly referencing a history of segregation; *Oreo* and *A Movie Star* both controversially reimagine and reinterpret whiteness, alongside blackness, as the province of African American subjects; and in giving complexity to popular cultural texts and their consumers, both reimagine the role of black women as subjects of, not just subject to, American culture writ large.

Rewriting Post–Civil Rights Literary History

In a project that foregrounds the transition to the post–civil rights era, Ross and Kennedy are key figures to think about how and why we might have formed certain trajectories that write such innovative black women authors out of these arcs, and what it might look like to think about their aesthetic and political projects as, instead, foundational texts of this historical moment of African American literature and politics.[5] If, like Robert J. Patterson, we take seriously Jacquelyn Dowd Hall's call for a conception of the long civil rights movement,[6] we must follow Patterson in his reformulation of "post" civil rights literature as a field in need of redefinition and expansion.[7] 1970s black women's literature emerges in the immediate and ongoing wake of the failings of civil rights, black power, and feminist movements to contend with race and gender simultaneously in sustained and meaningful ways for political change, though there were many moments that complicate that generalist narrative of the period. Writers like Ross and Kennedy who lived mostly outside of these documented schools of activism and aesthetics nonetheless took up the shifts in racial discourse and representation that the post–civil rights period brought. The 1970s was in many ways the depressing aftermath of the peak of what is now known as the *classical* civil rights movement era: the re-entrenchment of Jim Crow and segregation by economic and other means; the use of the law, government, sociological research, and the financial system to coerce black lives into certain segregated spaces and scripts; and globally, the ongoing conflict in Vietnam and the rise and collapse of idealism around independence movements in Africa.[8] Alongside and in conjunction with these political movements, the post–civil rights era also marks a shift in representation of African Americans—away from Southern poverty on the one hand and respectability politics on the other. Instead [and presaged by Ann Petry's *The Street* (1940)], the 1970s brings gritty urban spaces into focus as the locus of black life, experience, and culture, marking a proliferation of black culture in the semi-mainstream: television and cinema that features black, working class families, as well as novels by black authors

published by major publishing houses (see the discussion in Chapter 4 of this volume). This era ushers in a "new" urban realism which African America will be pushed into the shape of and then judged against—including by evolving intraracial definitions of authenticity.

Against this historical backdrop of political, economic, and geographic change, Madhu Dubey projects a "crisis in representation for black literature and culture."[9] Addison Gayle's succinct characterization of his "The Black Aesthetic" in a 1972 interview that "form is of less importance than the content. . . . The form is the delivery system while the message is the thing delivered,"[10] was giving way to various fractures in what, exactly, that message entailed—and who, exactly that message was for.[11] Of course, the Black Arts Movement produced many innovative works and authors that complicate an easy narrative of formal and gendered homogeneity, but it remains that this historical moment emphasized the tension between form and content in African American literary production. The 1970s saw the rise of not just public critiques of black nationalism from black feminists within the movement but the rise of the novel as the form par excellence for black women to write through this particular tension within black communities. Toni Morrison, Alice Walker, Gayl Jones, Ntozake Shange, and Toni Cade Bambara were all actively publishing their novel-length work (alongside other genres) in this decade, with a stream of black women writers finding publishing success by publishing fiction that moved from "stereotype" to character as a mark of black feminist progress and visibility,[12] with, as Dubey characterizes it, a "strong political investment . . . in the notion of a whole self."[13] The rise of these novelists, and ostensibly the audience for their work, represents how complex and diverse versions of black cultural representation were wending themselves around the American marketplace, in many ways as a response to their exclusions from Black Nationalist and feminist movements; As Nadine Knight argues in Chapter 5 of this volume, the aesthetic and political renaissance of this era comes from these elisions, but also from the collective and collaborative labor of these writers and black feminist thinkers of the era.

If Ross and Kennedy are an uneasy fit with this group of black women novelists, they may feel closer to a subset of writers whom Gene Jarrett might deem the "truants" of the time period—the "anomalies" balance out the "deans" of "realism" who have dominated the African American literary landscape.[14] As Robin Kelley argues in *Freedom Dreams*, the Black Radical Aesthetic is also connected to surrealist expression, nonrealist manifestations of what one might conceive of as freedom in a material world that denies the possibility and imagining of that concept on so many grounds.[15] The post–civil rights era is a moment where some of those realist possibilities crumble in execution for the

state-sponsored reasons listed earlier. It is a moment of political and aesthetic reflection, which both Ross and Kennedy engage in through their repurposing of African American and white western civilization's cultural touchstones as part of a black literary genealogy—as part of the experience of blackness—but not only in antagonistic or oppositional terms. If we think of the history of black literacy itself as historically "a risky political achievement,"[16] then perhaps we can see, formally, in Ross and Kennedy's texts what Dubey and Elizabeth Swanson Goldberg, in their "New Frontiers, Cross-Currents, and Convergences" essay surveying trends in post–civil rights African American literature,[17] draw from Paul Gilroy's *The Black Atlantic*: a literary double consciousness not as "a marker of racial inauthenticity," but as "the very condition of possibility rather than a debilitating dilemma"[18] for black literary production. Ross and Kennedy are then early authors of a practice of black feminist literacy that locates itself in this space of possibility uniquely situated in the post–civil rights frame.

Oreo Finds the Future of Black Feminism

Novelist Danzy Senna's futuristic description of encountering Ross's satire that begins this essay comes out of a more material source: Harryette Mullen's 1999 Northeastern Library reissue of the out-of-print book. Still, the reissue received little mainstream attention until its second reissue in 2015, led by Senna's *New Yorker* piece on the book, Paul Beatty's inclusion of an excerpt of *Oreo* in his collection of African American humor, and word of mouth by Mat Johnson on his book tour, all of whom had gotten a copy of Mullen's reissue, vouching for its timeliness.[19] In Dwight Garner's review of the 2015 reissue, he maps out perhaps the flip side of Senna's dream encounter with the novel when he ponders: "It's interesting to imagine an alternative history of African American fiction in which this wild, satirical and pathbreaking feminist picaresque caught the ride it deserved in the culture."[20] This essay takes its cue from Garner's thought experiment of re-centering *Oreo* in the genealogy of black literary production and, in particular, black feminist thought.

 Oreo appears in 1974, in the middle of a decade that was inaugurated in 1970 with the publication of Toni Cade Bambara's *The Black Woman* anthology and Toni Morrison's debut novel, *The Bluest Eye*. These landmarks were followed by many texts from black women writers as well as novels by writers such as Ishmael Reed and John Edgar Wideman that mark the two publishing turns in black writing in the 1970s: to the novel, and to black women novelists in particular. The turn to fiction in the aftermath of 1960s political movements marks not so much of a break as a transformation—a "bridge," in Patterson's terms,[21] to

explore those political and cultural intensities (largely marked by theater and poetry in the 1960s, with some notable exceptions) in narrative form. Literary, narrative, mimetic—these novels both show the newfound black consumer culture power of the post-protest era, but also a turn to realist representation as the key to plotting politics in black literature. As Richard Iton compellingly argues, this turn to culture results from the realization of the lack of access to political power after the 1964 Civil Rights and 1965 Voting Rights Acts.[22] This legal "success" story and a story of the failure of what Iton calls "formal" political inclusion[23] that followed ushered in an era of contested aesthetic protocols. And as some critics have argued, though BAM-era aesthetics created a heavy bent toward what was to be defined as "authentic" African American culture and identity, it also created, "unprecedented opportunities"[24] for black artists to publish, and to innovate in the 1970s and beyond.[25]

Oreo, a text that features a glossary of terms to help the reader map the myth of Theseus[26] onto the picaresque adventures of a 16-year-old African American and Jewish girl named Christine Clark (nicknamed Oreo, but not for the diegetic reason you think—more on this later) on a quest to learn about the mystery of her birth. This quest entails finding her deadbeat Jewish father, necessitating travel from Philadelphia to New York City. The book is filled with non sequiturs, untranslated Yiddish, arcane historical and cultural references, as well as bawdy, brash sexual scenarios (which the virgin Oreo verbally but not physically engages in—sometimes a feat which requires great physical and mental performances of self-defense). It is viscerally funny—about race, about feminism, about sexuality—as nearly all reviewers seem to agree. It is not, in other words, what we think of when we think about Morrison's oeuvre,[27] with her deep attention to black women's self-making through interiority and character. Ross's text more closely mirrors what we think of as Ishmael Reed's irreverent but high-literary aesthetic—in its speed, and its nimble use of all available cultural references.[28]

If, as Garner ends his 2015 review, *Oreo*'s "time is now," it is worth stopping over Garner's first articulation of *Oreo*'s out-of-sync-ness—to imagine an alternative history of black literature that embraces *Oreo*.[29] As his review suggests, *Oreo*'s multigenre format—picaresque, epic, bildungsroman, satire, comedy, quest narrative—did not find its home in the 1970s, or at least success on the literary and literary critical scene.[30] Published by Greyfalcon House Press (which seems to have not left a trace save for this now twice reissued novel) in 1974, *Oreo* never seems to have taken off or taken root until it is re-noticed by poet Harryette Mullen. *Oreo* is, emphatically, a difficult text—for its time and beyond. Its postmodernism leaves many people, at different points, out of the loop of the joke, out of translation.[31] It is not a post–civil rights text, which dwells

in *recognizable* or direct ways on feminism, black feminism, black women, or black community; reviewers dwell on terms like "feminist," "funny," "postmodern," "difficult," and "inaccessible" for a novel that defies recognizable scripts of race.[32] Neither is it obviously mining a traumatic African American past, recent or distant, for its sense of politics. In fact, one of its first and lasting jokes—a chart documenting a 1–10 ranking system for designating the skin color of African Americans—rests on a joke about political identity in the black community: "There is no 'very black.' Only white people use this term. . . . If a black person says, 'John is very black,' he is referring to John's politics, not his skin color."[33] It casts a brilliant African American girl as its protagonist, and politics are found in its vignette plots, which weigh in on American masculinity, women's bodily autonomy and vulnerability, structural racism and anti-Semitism, the limits of formal education, and the value of being able to code-switch in the particular scenarios of American life where race and gender demand it for survival, for information, or for personal, political, or professional gain. Most significantly, Ross's formally innovative practices, on virtuosic display in the text, are at once enabling and alienating. As I noted previously, *Oreo* is virtually impossible for any one reader to fully access in its multiple linguistic and cultural references. This combination of the high and low, of engagement with popular culture and with esoteric and highly culturally specific registers of meaning (like Yiddish), disrupts a readerly sense of full recognition, of knowability.

Oreo also deeply engages 1970s fascination with caricatures of black "urban" culture; there's an extended duel with a pimp that one reviewer notes, "makes Pam Grier's blaxploitation benchmark, the contemporaneous *Foxy Brown*, look like, well, *Laverne & Shirley*,"[34] showing Ross's intersection with Blaxploitation films of the era as well as referencing the one other television show that offered her a writing job post-Pryor. The novel's humor frequently depends upon how much cultural capital is seemingly imbued to black culture and also on how much that capital is a capital illusion—one that doesn't flow to African Americans but away from them. Nowhere is this more keenly satirized than where "the white blue-collar workers who labored so faithfully at the Smith-Jones Afro Wig and Dashiki Co., Inc., were welcome to earn their daily bread in the town, but they were not welcome to bring their low-cholesterol foods, their derivative folk-rock music, and their sentimental craxploitation films to Whitehall."[35] Or, in Ross's construction of Oreo's maternal grandfather, James, who after being denied full-sized pickles at a Jewish deli in his youth, builds a vengeful empire of Jewish cultural and religious paraphernalia in a catalog business that requires his deep investment in Jewish faith and cultural knowledge. Mullen points to these narrative jokes as exposing white appropriation and commodification

of black culture for capital gain through representing its comically impossible photo-negative;[36] Mullen also marks Ross's act of appropriating white culture for herself and her novel—flexing her knowledge, her savvy consumership as one that can repurpose whiteness into unrecognizable forms, thus destabilizing the structural dynamics of race as a stable and knowable commodity altogether.

This show of deep engagement with a range of contemporary cultural and racial forms is not just an oppositional, for or against, model of race. In another chapter, "Helenic Letters,"[37] which are literally letters from Oreo's mother, Helen, while she is singing on the road, Helen wistfully narrates her experience as a child going to what she labels in all caps "THE MOVIES!" at a neighborhood theater called "The Dump."[38] Ross has Helen mockingly extol the cinematic virtues of her own "range" of taste, particularly in white actresses: "I had two movie idols: Jane Powell and Barbara Stanwyck (weep, Yma Sumac, over the range of Helen Clark!). I could be as moved by *Song of the Open Road* as by *The Strange Love of Martha Ivers*; by *Rich, Young, and Pretty*, *A Date with Judy*, *Luxury Liner*, and *Small Town Girl* as by *Double Indemnity* and *Sorry, Wrong Number.*"[39] Beyond having Helen exhibit a cultural literacy that ranges from musicals to film noir to opera (Yma Sumac was an opera singer with a famously huge vocal range), such claims, and the very form and genres of the book itself, push on ideas of black cultural consumers' range, the possibilities for black self-making beyond what in 1974 are hardening into static racial-cultural categories, audiences, and markets for not just music and television and movies, but also literature. While acknowledging where most of this silo-ing flows from—the ubiquity of white cultural forms and the lack of production of black texts—Ross also claims pleasure in consuming and including multiple forms of culture into self-construction, including across generations of black women. If anything, she privileges cultural literacy, and multiple literacies in general, as the key tool(s) in configuring not just survival but affirmative agency in contemporary America.

If a large narrative emerging from this post–civil rights period of black women's fiction is a tension—and in some ways an uneasy reconciling—with a black nationalist definition of black community that left women out of central narratives of meaning, making, and identity, *Oreo* is an anomaly. The text is boldly unconcerned with what we've come to recognize as collective identity formation, instead staging individual self-making as an act that is "contingent" from "one encounter to another."[40] Instead of organizing itself around a consolidated, singular cultural entity or a strategic politics of racial solidarity and community, *Oreo*, the novel and the character, exhibits a "cultural competence"[41] that is, as mentioned before, overwhelming; it is the subject of the novel, the takeaway, even more than the plot. Ross represents generations of black women—Oreo,

her mother Helen, Helen's mother Louise—who are downright entrepreneur-
ial, concerned not just with self-sustainment but self-fulfillment in a text that
would make any second-wave feminist proud—there is no romanticization
of motherhood or labor, even as the barebones descriptions of the characters
seem straight out of central casting.[42] Helen, a quasi-math genius/singer, gets
to strike out on her own and not identify through her children—a rejection of
patriarchal politics of women's roles in black nationalist movements. When
she writes an early letter home claiming that "Mommy would give anything
to just stay at home and take care of her precious babies,"[43] a precocious Oreo
writes back, backward, telling her "dear mom cut the crap."[44] Louise, likewise,
supports the family through her virtuoso cooking—her menus as polyglot and
multinational/cultural as the novel itself—when her husband James has what
they think of as a stroke upon learning of the pending marriage between Helen
and Oreo's father, white and Jewish Samuel, and Louise also takes on a new
boyfriend during this years-long era before James's reboot toward the end of
the novel. The novel writes outside of a literary realist mode, and none of the
narrative characterization relies on representing or exposing black women's
interiority—their affective, complicated cores.[45]

As such, Ross both winks knowingly at the African American woman reader,
who must constantly locate herself within a larger culture that erases and willfully
misrepresents her, and teases out the complexities of a white reading public eager
to consume black culture as a way to affirm both stereotypical representations
of black life and their own liberal politics. What Ross does have the narrative
ruminate on, in plot and non sequiturs and formal challenges alike, is a semi-
utopic black feminist epistemology, one that emphasizes knowledge production
and consumption as the base of bodily sovereignty and cultural literacy in a world
that routinely and materially strips black women of the former and denies them
access or the assumption of competence in the latter. The Battle Royale between
Oreo and a pimp in New York City displays this point, where Oreo's vulnerability
is denied by both witty strategy and the physical maneuvers and props that Oreo
knows to arm herself with in a world that assumes that she is always already a
victim—of racism, of sexism, of sexual violence. While demonstrating no strong
affinity or urge to save the prostitutes she encounters with Parnell (her made-up
name for the pimp)—mercifully, in most cases, willing to recognize the agency
and desires of other black women, though some critics might find her lack of
solidarity alarming—*Oreo* makes an example out of the romanticization of pimp
culture in the 1970s American imaginary and strongly rests on a platform of
bodily and intellectual autonomy—and not collective interdependence, even as
it recognizes the uncontrollable limits of culture and power.

Literary postmodernism and formal innovation, as too many critics to document here have argued, have for too long been associated with "whiteness."[46] If we can understand the harsh line some enthusiastic critics draw between *Oreo* and The Black Aesthetic as such—reducing the latter to a caricature, as well as the boom in black women's fiction that proceeds the era—we can also appreciate that Ross is not wholly engaged in an untimely endeavor here. Comparisons to Ishmael Reed,[47] while making nervous any feminist critics in the room (myself included), are certainly apt, but at the same time one can see Ross using her immediate available material to make something new. Mullen attributes this to her "anticipat[ion]" of techniques like sampling and remixing,"[48] but we might also look to the ways that Ross is already working on bringing the "micro-level"[49] of an emergent pattern of black women's writing—concern with women's sexuality, corporeal vulnerability, even the domestic sphere itself, however satirized—into the fold of something more like Reed's *Flight to Canada* and his high literary success. This success is followed by Senna's generation of mixed-race and African American writers like Johnson, Paul Beatty, Colson Whitehead, Suzan Lori-Parks, Sharon Bridgeforth, and others, as well as playwrights from the generation in between, like George Wolfe and Anna Deavere Smith. Still others have claimed Ross as the precursor to Michelle Wallace's early black feminist critical work and even the Combahee River Collective's 1977 declaration of black feminist politics.[50] *Oreo*'s belated claiming by various factions, and her backdated significance, suggest that we, as critics of the African American literary tradition, still have a deep investment in mapping the past, present, and future of African American literature as a progress narrative of more complex and difficult reckonings with race as a history and construct of the U.S. *Oreo*'s malleability, its ability to signify so much to so many, is because of its innovative aesthetics, certainly, but also its confidence that its multiple literacies should be "aesthetically enabling rather than anxiety provoking condition[s]"[51] for black writers and black readers. *Oreo*'s untimeliness is, in fact, exactly of its time—a moment of deep transition between a movement for civil rights, strictly defined in classical terms, and an emergent recognition of the work that culture itself would have to and could do to map out a "post" civil rights version of black feminist thought. Its exuberant, unbounded curiosity about what this literature, and this politics, might look, sound, and read like is, as the following section on Adrienne Kennedy attests, not alone on the scene of African American literature in its complicated reckoning with what it means to consume whiteness, and to be culturally consumed as a black feminist subject as that particular subject position was just emerging into a more coherent post–civil rights view.

Reimagining a Black Feminist Past

Critic Deborah Geis argues that Adrienne Kennedy's 1976 play, *A Movie Star Has to Star in Black and White* is "anachronistic, collagelike, and filled with lacunae or ellipses"[52]—an apt allegory for post–civil rights black life, left with legal victories but a shifting cultural landscape that backslides on economic and social progress. For Kennedy, practices of critical cultural consumption become the primary site for Iton's aforementioned map of (informal) African American political life in the historical period, turning to cultural expression when the formal political sphere has failed to fulfill its promises of inclusion and progressive change. If *Oreo* offers us a seemingly endless future in its vast breadth of knowledge, Kennedy's work is frequently spoken about as the ultimate interiority—not because of its realist characters, but for quite the opposite reading: that her plays, particularly her early career one-acts, take place within the complex minds of their subjects/protagonists, who are often fixated on the cultural past that they are trying to exorcise. Experimental, surrealistic, nonlinear—her work is, like Ross's, not invested in "character" in recognizable forms. And, as the *New York Times* review of the 1995 restagings of *Funnyhouse* and *A Movie Star* at the Public Theatre claims of Kennedy's work, it is, like *Oreo*, frequently seen as inaccessible—in Ben Brantley's words: "esoteric," "celebrated by aficionados of the avant-garde, and studied in universities," but infrequently staged.[53] Looking back on Kennedy's oeuvre, Brantley is already diagnosing (if not aligning himself with) her irrelevance to a public canon of American, particularly African American, theater and culture that is marked by its adherence to realist aesthetics and clear themes of racial trauma and pathology.[54] But he's also marking Kennedy's unique relationship with "the avant-garde" and "academia," which are just as frequently characterized as "white," much like the term *postmodernist*. This placing of Kennedy both marks her "exceptional" status as one of the few African American—and certainly African American women—playwrights produced and lauded by the established theater world of the era and misses some of the connections Kennedy had—and has—to an African American literary and theater world during this period. This section begins by taking up Kennedy as someone placed elsewhere in black literary traditions, (dis)placed to "white" cultural and institutional attention, someone who is difficult to bring into the fold of "blackness" until black postmodernism and revisions of early cultural-nationalist definitions of black literature became more normalized in African American studies.

Like *Oreo*'s critical characterization as ahead of its aesthetic and political moment, Kennedy's dramas are frequently described as untimely: "out of sync

with the emerging black politics of the time";[55] "dramatic harbingers of feminist themes in contemporary Black women's writing";[56] and from a playwright who warps mimetic representational politics in a "syncopated time."[57] Other critics claim a strong break with The Black Aesthetic on familiar grounds: "A feminist in a period of masculinist Black nationalism, she was also a postmodern experimentalist in a period of realist political drama,"[58] or a softer oppositional stance like bell hooks's assertion that "Kennedy's plays always have that ritualized "play". . . . [while] most African American drama remain a drama of the story, it's naturalistic, it's realistic."[59] Still others emphasize the complexity that Mullen attributes to *Oreo* in its historical moment—acknowledging that BAM era drama "sponsored vital innovations in the genre of drama,"[60] inasmuch as it dictated political strategy. Of course, Kennedy's surrealistic plays of the 1960s and 1970s exist in this continuum of black literature and theater—inspired by O'Neil and Albee as much as by Lorraine Hansberry,[61] included as one of only five playwrights in the Norton Anthology of American Literature in 1988/1989 (a mark of her inclusion into a white/traditional canon) and commissioned for a powerful piece on Malcolm X after his assassination in 1968. To set Kennedy completely apart from the Black Aesthetic is to miss the ways that black artists commingled in this heady period of rapid political, not to mention aesthetic, change—as seen in her correspondence with artists like Amiri Baraka and Nikki Giovanni, as well as the casting of future performance artist Robbie McCauley as Clara in the inaugural run of *A Movie Star*.[62]

Hooks's common-sense take—that most of the theater we think of when we think of African American theater, the kind produced and restaged by venues in NYC, tends to steer toward the mimetic and realistic.[63] It reflects most canonical takes on African American literature that view this literary tradition through a lens of recognizable political, thematic, and aesthetic strategies that, in complicated ways, reaffirm a certain sociological view of African America and its cultural production, even as most of this writing is cast as produced under the banner of antiracist labor. As Nicole Fleetwood powerfully asserts about both the larger field of black cultural production and the specific importance of the visual in constituting that field, "the weight placed on black cultural production to produce results, to do something to alter a history and system of racial inequality that is in part constituted through visual discourse . . . is the desire to have the cultural product solve the very problem that it represents."[64] For Fleetwood, this tension belies the complex and uneven work of visual consumers' trained recognition of "blackness" as an identity and experience that is already "knowable through visual and performative codes."[65] Kennedy, in her dramatic forms, works to estrange us from our familiarity with those codes.

Figure 6.1. Photograph of original production call sheet: Harry Ransom Center, Adrienne Kennedy Collection, box 8, folder 12.

Critically situated as a playwright who stages black women's subjectivity in unique, startling, and graphic terms, through her debut play, the Obie-winning *Funnyhouse of a Negro* in 1964, Kennedy also wrote *A Movie Star Has to Star in Black and White*, staged in 1976, also at the Public Theatre. Dubey and Goldberg identify Kennedy (and, not insignificantly, Suzan-Lori Parks) as creators of "a grim theater of misrecognition"[66] that marks itself as opposed to a Black Arts political and aesthetic statement, rather than the (still experimental) work of Shange in *for colored girls* (also 1976) with its aesthetic project of repair from sexual, gendered, and racialized violence (see Chapter 10 of this volume). Al-

most all identify *A Movie Star* as both closing of a circle of work that is thematically and aesthetically linked and as a move toward a "more playful" aesthetic,[67] and marking "a new phase of creative work"[68] for Kennedy where subjects and cultural scripts "are no longer fragmented but decentered . . . [and] the black woman's 'I' is displaced onto a disparate array of personal and cultural simulacra."[69] And while Edward Albee's correspondence with Kennedy about the play worries "how it will seem to someone who doesn't know your other work—who doesn't have the references, for this new play fits so tightly in with the other plays,"[70] *Movie Star* is often written about through its relationship to popular mass culture (like *Oreo*) and cinema—its most recognizable mode of literacy/representation. Like most of Kennedy's work, the play's form and content point toward the endlessly original and yet historically underwritten possibilities for black women's subject formation in the contemporary U.S. political landscape—much as Jermaine Singleton locates the project of Gayl Jones's experimental fiction as a radical reckoning and reformulation of poststructuralist subjectivity in Chapter 7 of this volume.

The precursor to Kennedy's groundbreaking autobiography, *People Who Led to My Plays*, *A Movie Star* visually stages three scenes from the Golden Age of Hollywood cinema alongside an ongoing "narrative"[71] of "Clara," a middle-class black woman, and her stories of marriage, birth, and familial trauma. Only the women speak from *Now Voyager*, *Viva Zapata*, and *A Place in the Sun*, but they do not speak lines from the films; instead, they ventriloquize Clara's own monologues on her life, with Clara (infamously) listed as playing a "bit part" in the initial character list of the play.

While some critics have emphasized Kennedy's obsession/fascination with white culture,[72] Kennedy's relationship to cinema is not cast, by herself or her staging here in *A Movie Star*—or in her numerous other texts that take up Hollywood referents—as exclusively one of racial tragedy. That is, though readings of *A Movie Star* that emphasize the distance between the black protagonist and the white women movie stars and white ideals they offer compelling critique that holds up, surely, at one layer of the play, they often reproduce the terms of oppositionality that define the common narratives of BAM, the black nationalist movements, and the black literary canon (something my own previous work on Kennedy also reproduces, admittedly). While Kennedy's juxtaposition of white stars and narrated black "experience" surely calls attention to the disconnect between the overwhelmingly white mainstream culture's vision of life and the quotidian and endlessly variable narratives of black subjectivity that whiteness disappears, it could also be said that Kennedy interrogates the queer narrative arcs of even white Hollywood narratives—finding tragedy

Figure 6.2. Manuscript draft page with "Bit role played by Clara" handwritten, Harry Ransom Center, Adrienne Kennedy Collection, box 3, folder 14.

(the prescriptive genre perhaps most frequently employed to think through the recognizable arc of black life and death in the United States) at the core of even idealistic romantic whiteness and the culture industry that represents and produces this whiteness. In this sense, Kennedy is an innovative performer of "afro-alienation," Daphne Brooks's compelling formulation of distanced performances of "blackness" that actually bring us closer to a recognition of black subjectivity;[73] one could argue that Kennedy is, in fact, staging afro-alienation as her very subject of interrogation. The rest of this section outlines the inno-

vative uses of cinematic whiteness in Kennedy's play as well as her deft employments and critiques of race, gender, sexuality, and spectatorship. Finally, I examine how the radical work of staging the materiality of the body in the play seeks affinity across embodied racial and gendered experience at the same time that it acknowledges the incommensurability—the out-of-sync-ness—of these bodies across various cultural, social, sexual, and historical contexts.

In "Clara's" first (non-bit part) dramatic appearance, in Kennedy's 1965 play, *The Owl Answers*, she repeats, "I was the only Negro there" throughout the play. In *A Movie Star*, Kennedy dramatizes this line, this state of being and being watched, through the ventriloquizing of Clara's life and thoughts by actors playing classic Hollywood film stars. The levels of distance between Clara's narrative and the stars' narration is jarring in that it shows cinema's refusal of black women's bodies as visible presences and also the lack of nuance granted to Hollywood narrative, period. But to call attention to this is not to level Kennedy's writing as oppositional critique alone. Kennedy's powerful identifications with Hollywood transform her, but she racializes her own plots, in reverse Baldwinian form,[74] demanding, like *Oreo*, a type of authorial or editorial power. Kennedy harnesses iconic whiteness to perform what Fleetwood might call "the visible seam," "the subtlety of a stitch that sutures but leaves visible the wound that it mends . . . to insert a troubling presence in dominant racializing structures"[75] in her presentation of cross-racial identification and its failures.[76] Critics argue that the play then "co-opt[s] the spectacular surface of the cinematic image";[77] "makes Bette Davis into her own character";[78] and "stages an exceptional scene of cross-racial identification . . . [that] makes her audience all the more keenly aware of the conventions that normally confine black performers and playwrights to the niche of racial particularity and precludes them from representing universal humanity."[79] The critical assumptions here are: a) as Diamond says, "mass culture narratives . . . produce our lives,"[80] or have outsized explanatory power to lead our selves off-script, so to speak, if we allow them too much surrogate power, and b) the critical bent of Kennedy studies is to find her winning this oppositional contest—resisting the cultural and visual power of whiteness by having it, innovatively, perform blackness.

As Sollors understates in an undated essay submission to *Callaloo* that was edited to become his introduction to *The Adrienne Kennedy Reader*, published in 2001, "'Hollywood' was part of an imaginary cultural community in which Kennedy matured."[81] Allowing this stretch of Benedict Anderson's usually nationally defined "imagined community,"[82] Sollors unmasks an alternative reading of Kennedy's work and this play in particular. Going further here than claiming Kennedy's play as repetition with a difference, one can start to read the identifi-

catory power of the cinema for Kennedy not as something to be refused whole-sale, but as a critical lens whereby her love of cinema, so well documented in 1992's *People Who Led to My Plays*, is one that always already recognizes classic Hollywood's subgenre of darker, "failed" heterosexual romance narratives—and that this quality is indeed part of the glamour, the ideal, and even the white-ness of its construction. This reading of Kennedy reading Hollywood does not emphasize the play's gaze on cinema as oppositional but intimate, where, as Diamond puts it, "Clara's movie stars are proximate and continuous with her, but in a mimetic relation that creates, rather than elides, difference."[83] To return to the idea of the visible seam, Kennedy's "technique and . . . discursive interven-tion" in employing whiteness here is not necessarily a resistance or an outright refusal of "dominant racializing structures."[84] It is too close for such repudia-tion—instead, Kennedy invests this performance with her own Hollywood-centered fantasies of transformation and metamorphosis, again documented in her autobiography. The desire to be someone else, the desire to be seen and recognized, the desire for drama and change in a life of largely middle-class respectability mapped out before Kennedy and Clara—these affective, intimate relations to Hollywood's cinematic surface suggest the possibility of a nontragic adoption—and adaptation—of a visual regime of whiteness. In other words, Kennedy imagines a black feminist literacy that can read whiteness as includ-ing but not limited to racial injury.

Kennedy's postmodernism does not, however, present radical, boundless choice. *A Movie Star* begins, after a flickering appearance from the Columbia Pictures Lady voicing Clara's first monologue, with a scene from *Now Voyager*, the 1942 movie starring Bette Davis. The arc of the film is that of romantic, heterosexual love lost—or rather, forsaken. Charlotte denies her love for Jerry in exchange for caring for his neglected daughter for the rest of her "spinster" days. Moments of glamour in the film, then, do not coalesce into the expected subjectivity, in other words—the march of progress from desired object to wife and mother; instead, they are translated to other desires—maternal but not bio-logical, with a focus on psychological reparation and repair, albeit represented in a radically different form than literary or performative realism might call upon in traditional narratives of African American literary history. Appended to the *Now Voyager* scene are monologues about Clara and her parents' lives, includ-ing marriage, suicide attempts, miscarriages, gender disparities in writing life, and segregation in the South. Kennedy talks of *Now Voyager* and the cruiseship voyage Davis's character takes as a frontier of possibility and transformation in *People Who Led to My Plays*, and this maps onto this scene, then, in unexpected ways.[85] Possibility isn't endlessly progressive or positive. Instead, the possibili-

ties—of the body, of the racist structure of the United States, of travel, of love, of romance—become just as likely to turn up in failure, what we might think of as negative narrative space, constrained by not just one's own cultural identity and choices but also those surrounding you, in intimate contact with you. Kennedy reads these terms, the basis of black subjectivity—vulnerable bodies, unthought of/unthinkable intimacies, how the act of watching is transformative—into "generative possibility"[86] that assumes black women's subjectivity to be the base of reading, of watching, and of literacy.

As Kennedy lays out in her stage directions at the start of the play regarding the ostensible protagonist, Clara: "Her movie stars speak for her. Clara lets her movie stars star in her life."[87] Kennedy's focus on *lets* here gives spectatorship agency—not new in feminist or other film criticism, but different from the routes we usually think about power and narrative flowing from the overwhelming whiteness of Hollywood cinema to black women as viewers/subjects.[88] Kennedy's very insistence on bodily verisimilitude for the actors playing the actors in their specific roles suggests that, even within a space of "possibility" there are external structures that are immutable and not necessarily liberatory. In the post–civil rights, post–"sexual revolution" era, Kennedy displays bodies for consumption but also those that are already consumed by its plots, and by the plots available to them. Kennedy's spectator/writer is at once "empowered" and bounded, much as black women writers are coming into their own in this time period, but are also hemmed in by markets, and by the post–civil rights plots available to them.

As Clara intimates during the transition from Jean Peters to *A Place in the Sun* on stage, this blurs the line of consumer and "author," of who can ever be the agent of one's life and one's body:

> Eddie says I've become shy and secretive and I can't accept the passage of time, and that my diaries consume me and that my diaries make me a spectator watching my life like watching a black and white movie.
>
> He thinks sometimes . . . to me my life is one of my black and white movies that I love so . . . with me playing a bit part.[89]

Watching, writing, being embodied—these acts align for Kennedy, or, rather, she aligns them for us by representing these acts as material, visceral, omnipresent like the movie stars themselves. Yet she does not plot these acts as such—as teleologies of conflict that either succeed or fail. In fact, Kennedy jettisoned an earlier version of the ending that landed on the dissolution of Clara's marriage, eclipsing the romance plot for the ambiguity of Clara's brother's ongoing injury.[90]

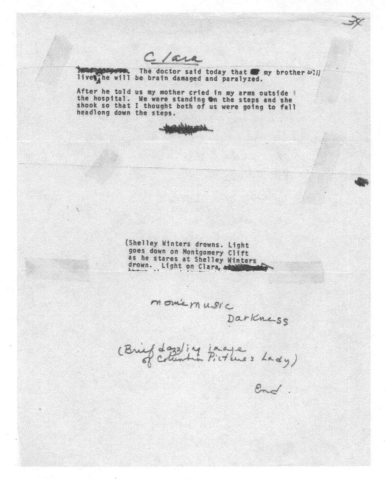

Figure 6.3. Amended ending with stage directions handwritten, Harry Ransom Center, Adrienne Kennedy Collection, box 3, folder 14.

If Kennedy's language is, as Diamond suggests, "the materiality of her consciousness,"[91] Kennedy insists on equivalences between the materiality of writing, of cultural consumption, and of bodies themselves, even as they are out of sync with history,[92] culture, race, gender, sexuality, war, and gestational time. Once in a while, those narratives, bodies, and times converge, as when Kennedy has Clara and one of the movie stars speak the same line simultaneously. Kennedy invests in the mental and cultural state of black life and the impossibility of extracting it from white life and white American cultural landscapes—as well as the surreal nature of that out-of-sync match-up for her assumed audience,

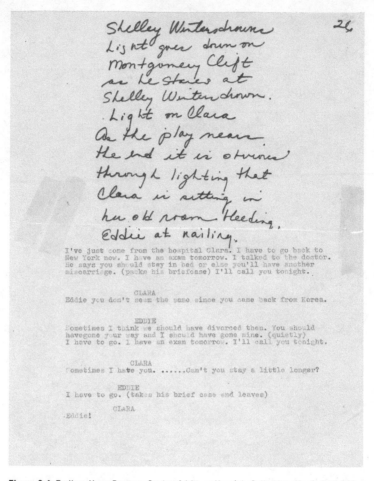

Shelley Winterschrowne
Light goes down on
Montgomery Clift
as he stares at
Shelley Winterchrown.
. Light on Clara
As the play nears
the end it is obvious
through lighting that
Clara is sitting in
her old room Bleeding,
Eddie at nailing.

I've just come from the hospital Clara. I have to go back to
New York now. I have an exam tomorrow. I talked to the doctor.
He says you should stay in bed or else you'll have another
miscarriage. (packs his briefcase) I'll call you tonight.

 CLARA
Eddie you don't seem the same since you came back from Korea.

 EDDIE
Sometimes I think we should have divorced then. You should
havegone your way and I should have gone mine. (quietly)
I have to go. I have an exam tomorrow. I'll call you tonight.

 CLARA
Sometimes I have you.Can't you stay a little longer?

 EDDIE
I have to go. (takes his brief case and leaves)

 CLARA
.Eddie!

Figure 6.4. Ending, Harry Ransom Center, Adrienne Kennedy Collection, box 3, folder 13, labeled Page 26 with earlier ending.

a commentary itself on what white and black audiences might assume black cultural reference can contain.[93]

For Kennedy, "agency" is always circumscribed in/by/through the available and apparent structures that can limit black (women) subjects—like the boundaries of the stage and the theater themselves. But Kennedy does push back against an easy assumption about the overwhelming linear timing of said structural limits for black women in America, wanting to leave room for those "lacunae and ellipses" Geis described, for the slip of identification that does not insist on only alienation between white and black cultural consumptions (and production) but

also desire, pleasure, and a kind of editorial skillset around the specificity and multiplicity of cultural encounters. Like *Oreo*, *A Movie Star* finds joy and power, but also loss and critique, in the multiple and (sadly) surprising cultural literacies that it lays claim to as the province of black women, and as constituting subject formation in the wake of the peak of the civil rights movement.

Black Feminist Thought Out of Time/Right on Time

Although *Oreo* and *A Movie Star Has to Star in Black and White* share many critical terminologies—neglected, feminist, postmodern, innovative—they do not, together, represent a unity of black feminist thought that congeals into a trend in literary subject formation that claims a political identity, perhaps, in the way we might want to extract such a line from them and from this era. Instead, Kennedy and Ross's 1970s texts *begin* a literary revolution that had both arrived and was (and is) belated. The "future" is not just about representing black women as subjects—not just about mimetic representation of an assumed set of experiences. It's also about the aesthetics and politics of writing and reading, performing and viewing, what's lost when we imagine white readers and viewers as the prototype—for black aesthetics, but also for theater and Hollywood cinema. The deep focus is on the reader and the spectator in *Oreo* and *A Movie Star*—on their powerful ability to be understood through others' texts, and also to be obscured or left out—"bewildered" by one critic of *Oreo*'s estimation.[94]

Oreo and *A Movie Star* seem out of sync because of our narrow critical hindsight on what makes black literary history post–civil rights. But they are also inconsumable, unpalatable, even—marking a future of black feminist aesthetics that hasn't fully arrived and may never do so. These works eschew certain pleasures of the text, of narrative cinema and theater and fiction in particular, as consumable aesthetic goods that offer more recognizable paths to spectatorship and audience investment. They also engage in what Sarah Cervenak calls "wandering," a strategy of disorganizing black women's subjectivity away from these now-recognizable freedom scripts. Though both *Oreo* and *A Movie Star* are, undeniably, part of a rich genealogy of African American literature—not totally out of time—their prescient commitment to representing differences in blackness, and blackness as difference, marks them, belatedly, as the start of the future of reading black literature and culture we are living in the contemporary moment—one of proliferation. To extend that generosity and difficulty to the long narrative of African American literary studies is a project that both Ross and Kennedy augur in this post–civil rights period of black literature and culture—one that saw the rise of black women writers and black feminist theory

and critique at the same time that the "promise" of civil equality was transforming to an understanding and deployment of insidious policies and politics of antiblackness. Difficulty need not be resolved, or resistant, much as *Oreo* and *A Movie Star* unequivocally refuse to choose between black vulnerability and pleasure, but instead refuse the very terms that dictate opposition/capitulation as the only forms black culture and black politics should and could take. This is the critical terrain of these two black feminist texts in 1970s America; out of time and outside of certain streams of visibility, they insist on not just unruly representation, but unruly consumption. This consumption is also a practice of unruly reading, and the legacy and the future of African American literary studies—a practice of black feminist literacy that *Oreo* and *A Movie Star* both signal and map.

Notes

1. Danzy Senna, Introduction to *Oreo* (New York: New Directions Publishing Corporation, 2015), xii.

2. Pryor's autobiography suggests a heated interview around the use of a racial epithet that resulted in Ross getting fired. Richard Pryor, *Pryor Convictions: And Other Life Sentences* (New York: Pantheon, 1995).

3. See Hazel Carby, *Cultures in Babylon: Black Britain and African America* (London: Verso, 1999); Jennifer C. Nash, *The Black Body in Ecstasy: Reading Race, Reading Pornography* (London: Duke University Press, 2014).

4. Henry Louis Gates Jr., *The Signifying Monkey: A Theory of African American Literary Criticism* (New York: Oxford University Press, 1988); Claudia Tate, *Psychoanalysis and Black Novels: Desire and the Protocols of Race* (New York: Oxford University Press, 1998); Richard Iton, *In Search of the Black Fantastic* (New York: Oxford University Press, 2008); Gene Jarrett, *Deans and Truants: Race and Realism in African American Literature* (Philadelphia: University of Pennsylvania Press, 2007); Samantha Pinto, *Difficult Diasporas: The Transnational Feminist Aesthetic of the Black Atlantic* (New York: New York University Press, 2013).

5. Mullen says in her 1999 introduction to the novel, "Ross's *Oreo* languished in the purgatory or limbo of innovative works by black writers that have been overlooked in the formation of the African American literary canon" (xvii). Harryette Mullen, Introduction to *Oreo* (Boston: Northeastern University Press, 1999), xvii.

6. Jacquelyn Dowd Hall, "The Long Civil Rights Movement and the Political Uses of the Past," *Journal of American History* 91, no. 4 (2005): 1233–1263.

7. Robert J. Patterson, *Exodus Politics: Civil Rights and Leadership in African American Literature and Culture* (Charlottesville: University of Virginia Press, 2013), 9.

8. Eric Sundquist, *Stranger in the Land: Blacks, Jews, Post-Holocaust America* (Cambridge: Belknap Press of Harvard University Press, 2005), 313; Michael Omi and Howard Wi-

nant, *Racial Formation in the United States: From the 1960s to the 1990s* (New York: Routledge, 1994), 122.

9. Madhu Dubey, *Signs and Cities: Black Literary Postmodernism* (Chicago: University of Chicago Press, 2003), 24–25.

10. Addison Gayle, *The Addison Gayle, Jr. Reader* (Urbana: University of Illinois Press, 2009), 368.

11. Gayle himself does not wholly dismiss form but prioritizes content over it.

12. Madhu Dubey, *Black Women Novelists and the Nationalist Aesthetic* (Bloomington: Indiana University Press, 1989), 2–3.

13. Ibid., 2.

14. Jarrett, *Deans and Truants*, 186.

15. Robin Kelley, *Freedom Dreams: The Black Radical Imagination* (Boston: Beacon Press, 2002).

16. Dubey, *Signs and Cities*, 10.

17. Madhu Dubey and Elizabeth Swanson Goldberg, "New Frontiers, Cross-Currents and Convergences: Emerging Cultural Paradigms," in *The Cambridge History of African American Literature*, eds. Maryemma Graham and Jerry Ward Jr. (Cambridge: Cambridge University Press, 2011), 568.

18. Paul Gilroy, *The Black Atlantic: Modernity and Double Consciousness* (Cambridge: Harvard University Press, 1993).

19. See reviews of the reissued-reissue by contemporary authors Mat Johnson and Paul Beatty, as well as novelist Danzy Senna's *New Yorker* piece. Paul Beatty, "Black Humor," *New York Times*, January 22, 2006; Mat Johnson, "'Oreo': A Satire of Racial Identity, Inside and Out," *NPR: All Things Considered*, March 7, 2011; Danzy Senna, "An Overlooked Classic about the Comedy of Race," *New Yorker*, May 7, 2015.

20. Dwight Garner, "As American as Knishes with Catfish," *New York Times*, July 15, 2015.

21. Patterson, *Exodus Politics*, 11.

22. Iton, *In Search of the Black Fantastic*, 6.

23. Ibid., 4.

24. Mullen, Introduction to *Oreo*, xi–xii.

25. Dubey and Goldberg, "New Frontiers," 579.

26. Theseus, the son of two fathers—one mortal, one God—has to go on a quest to claim his birthright.

27. Senna's glib line on how Oreo fits into the mold of the archetypal black women's novel is: "'Oreo' resists the unwritten conventions that still exist for novels written by black women today." Senna, "An Overlooked Classic," in *Oreo*.

28. Bertram Ashe refers to these contemporary mixed-race narratives as the "blaxploration genre," but Michele Elam notes mixed-raced identity in/as this genre also stands as a commodity ready to be mobilized in service of whiteness (20). Bertram Ashe, "Theorizing the Post-Soul Aesthetic: An Introduction," *African American Review* 41, no. 4 (2007): 609–623; Michele Elam, *The Souls of Mixed Folk: Race, Politics, and Aesthetics in the New Millennium* (Stanford: Stanford University Press, 2011), 20.

29. Garner, "As American as Knishes."

30. Ibid.

31. Many of the text's reviewers also comment on its moments of inaccessibility—the contemporary reviewers largely applauding these moments.

32. Levy Hussen takes on this arc of reading for what we think of as "freedom" narratives in the post–civil rights era. See Aida Levy-Hussen, *How to Read African American Literature: Post–Civil Rights Fiction and the Task of Interpretation* (New York: New York University Press, 2016).

33. Fran Ross, *Oreo* (Boston: Northeastern University Press, 1999 [1974]), 5.

34. Melissa Anderson, "Smart Cookie," *BOOKFORUM*, June/July/August, 2015.

35. Ibid., 74.

36. Mullen, Introduction to *Oreo*, xxiii.

37. Ross, *Oreo*, 23.

38. Ibid., 25.

39. Ibid., 27.

40. Mullen, Introduction to *Oreo*, xxvii.

41. Ibid., xiii.

42. *Oreo* was released the same year as *Rubyfruit Jungle* and *Fear of Flying*.

43. Ross, *Oreo*, 23.

44. Ibid., 24.

45. See "Marlon James: 'Writers of Colour Pander to the White Woman,'" *Guardian* November 30, 2015. See Claire Vaye Watkins, "On Pandering," *Tin House*, November, 2015.

46. Mullen, Introduction to *Oreo*, xxvi.

47. Seth Cosimini, "Oreo—Fran Ross," *Full Stop* (blog), August 17, 2015, http://www.full-stop.net/2015/08/17/reviews/seth-cosimini/oreo-fran-ross/; Dubey and Goldberg, "New Frontiers."

48. Mullen, "Apple Pie with Oreo Crust: Fran Ross' Recipe for an Idiosyncratic American Novel," *MELUS* 27, no. 1 (2002): 121.

49. Cosimini, "Oreo."

50. Tru Leverette, "Traveling Identities: Mixed Race Quests and Fran Ross' 'Oreo.'" *African American Review* 40, no. 1 (Spring 2006): 85.

51. Dubey and Goldberg, "New Frontiers," 574.

52. Deborah Geis, "'A Spectator Watching My Life': Adrienne Kennedy's *A Movie Star Has to Star in Black and White*," in *Intersecting Boundaries: The Theater of Adrienne Kennedy*, ed. Paul K. Bryant-Jackson and Lois More Overbeck (Minneapolis: University of Minnesota Press, 1992), 175.

53. Ben Brantley, "Glimpsing Solitude in Worlds Black and White," *New York Times*, September 25, 1995.

54. For alternate readings of African American performative traditions and genealogies, see Daphne Brooks, *Bodies in Dissent: Spectacular Performances of Race and Freedom, 1850–1910* (Durham: Duke University Press, 2006); Soyica Colbert, *The African American*

Theatrical Body: Reception, Performance, and the Stage (Cambridge: Cambridge University Press, 2011).

55. Robert Scanlan, "Surrealism as Mimesis: A Director's Guide to Adrienne Kennedy's *Funnyhouse of a Negro*," in Bryant-Jackson and More Overbeck, *Intersecting Boundaries*, 108.

56. Werner Sollors, Introduction to *The Adrienne Kennedy Reader* (Minneapolis: University of Minneapolis Press, 2001), vii.

57. Elin Diamond, "Mimesis in Syncopated Time Reading Adrienne Kennedy," in Bryant-Jackson and More Overbeck, *Intersecting Boundaries*, 131.

58. Linda Kintz, "The Sanitized Spectacle: What's Birth Got to Do with It? Adrienne Kennedy's *A Movie Star Has to Star in Black and White*," *Theatre Journal* 44, no. 1 (1992): 70.

59. bell hooks, "Critical Reflections: Adrienne Kennedy, the Writer, the Work," in Bryant-Jackson and More Overbeck, *Intersecting Boundaries*, 180.

60. Dubey and Goldberg, "New Frontiers," 579. See also Kimberly W. Benston, "Locating Adrienne Kennedy: Prefacing the Subject," in Bryant-Jackson and More Overbeck, *Intersecting Boundaries*, 113–130.

61. Scanlan, "Surrealism as Mimesis," 109.

62. Correspondence in Kennedy's papers includes a friendly note between Baraka and Kennedy—undated but certainly written in or after 1972, when Baraka was elected Chairman of the Congress of Afrikan Peoples (the title and letterhead mark both), and well before 1980. Kennedy papers at the Harry Ransom Center, 7.10. Correspondence with Amiri Baraka; Clive Barnes, "'A Rat's Mass Weaves Drama of Poetic Fabric," *New York Times*, November 1, 1969.

63. hooks, "Critical Reflections."

64. Nicole Fleetwood, *Troubling Vision: Performance, Visuality, and Blackness* (Urbana: University of Chicago Press, 2010), 3.

65. Ibid, 5–6.

66. Dubey and Goldberg, "New Frontiers," 580.

67. Ibid.

68. Sollors, Introduction to *The Adrienne Kennedy Reader*, xiii.

69. Diamond, "Mimesis in Syncopated Time," 137.

70. Kennedy papers at the Harry Ransom Center, 7.10. Correspondence with Albee, August 3, 1976.

71. Kimberly Benston, "Kennedy's plays don't usually have any story or plot, in familiar or recognizable ways" (117). Benston, "Locating Adrienne Kennedy," 117.

72. hooks, "Critical Reflections"; Geis, "A Spectator"; Clive Barnes, "Theater: '*Cities in Bezique*' Arrives at the Public," *New York Times*, January 13, 1969.

73. Brooks, *Bodies in Dissent*, 25–26.

74. For a larger critique of adaptations of "white" texts into "black" films/plots, see James Baldwin, "Carmen Jones: The Light is Dark Enough," in *Notes of a Native Son* (Boston: Beacon Press, 1955).

75. Fleetwood, *Troubling Vision*, 9.

76. Kennedy is very clear in her initial stage directions that the actors playing the movie stars should be very serious, not "ironic."

77. Diamond, "Mimesis in Syncopated Time," 137.

78. Sollors, Introduction to *The Adrienne Kennedy Reader*, xiii.

79. Dubey and Goldberg, "New Frontiers," 581.

80. Diamond, "Mimesis in Syncopated Time," 137.

81. Sollors in Adrienne Kennedy papers, box 4, folder 10.

82. Benedict Anderson, *Imagined Communities: Reflections on the Origins and Spread of Nationalism* (London: Verso, 1983).

83. Diamond, "Mimesis in Syncopated Time," 138.

84. Fleetwood, *Troubling Vision*, 9.

85. Adrienne Kennedy, *People Who Led to My Plays* (New York, NY: Theatre Communications Group, 1987), 91. There are several references to *Now Voyager*, and to Kennedy's identification with the film, in *People*.

86. Soyica Colbert, *Black Movements: Performance and Cultural Politics* (New Brunswick: Rutgers University Press, 2017), 14.

87. Adrienne Kennedy, *A Movie Star Has to Star in Black and White* (New York: New York Shakespeare Festival, 1976), 87.

88. Jenny Spencer, "Emancipated Spectatorship in Adrienne Kennedy's Plays," *Modern Drama* 55, no. 1 (2012): 19–39.

89. Kennedy, *A Movie Star*, 99.

90. In draft version of the play. See Harry Ransom Center, Adrienne Kennedy Papers.

91. Diamond, "Mimesis in Syncopated Time," 138.

92. Kennedy's life was, since 1964, inching closer and closer to celebrities, from collaborating in the midsixties with John Lennon to set his poems for the stage to correspondence with Dustin Hoffman, William Marshall, Elizabeth Taylor, and Elia Kazan, among others, in her papers.

93. Kennedy's correspondence with contemporaries as far apart as Ishmael Reed, a large supporter of Kennedy's work, and Fay Weldon show her own influence and the breadth of her aesthetic circles. Think of Margo Jefferson's formulation of her own "terror and love of white culture, between white vulnerability and black invincibility" here. Margo Jefferson, *Negroland: A Memoir* (New York: Pantheon Books, 2015). See the work of Lauren Berlant and Christina Sharpe on the instability and unevenness engendered in the term *intimacies* here.

94. Kathryn Hume, "Narrative Speed in Contemporary Fiction," *Narrative* 13.2 (2005): 105–124.

Renegotiating Racial Discourse

The Blues, Black Feminist Thought, and Post–Civil Rights Literary Renewal in Gayl Jones's *Corregidora*

JERMAINE SINGLETON

Published in 1975 on the eve of what has been called "the true African American Renaissance," Gayl Jones's *Corregidora* takes African American literature "steps forward and a mile deep" at a moment in which black art was measured against an increasingly entrenched politics of black respectability and conservative backlash against post–civil rights African American socioeconomic strides. The significance of *Corregidora* emerges throughout this volume as Woolfork's discussion in Chapter 2 of this volume considers how texts that revisit slavery during the 1970s "hold the past and the present in tandem, to demand recognition of the perils and particularities of the slave past." Nadine M. Knight further situates *Corregidora* in a corpus of Black women's literary and artistic production marked by "frank disclosure of violence and inequity within Black communities and by championing Black feminist agency and sexual liberation in the post–civil rights era" (see Chapter 5 of this volume). Knight and Woolfork's perspectives identify *Corregidora*'s ideological work as advancing critical ethnic thinking during the post–civil rights era.

Corregidora emerged amid the onset of neoliberal ideology and policies that rendered black communities and bodies paradoxically more "public" and "private." This essay posits Jones's novel as a corrective to these ideological and existential binds. Jones's novel embeds and utilizes the productive tensions between past and present, African American resistance and healing, and black-

ness as a public and private claim to destabilize foundational tenets and cultural reverberations of racial ideology. Moreover, Jones's novel aligns with a critical trend of African American cultural production during the post–civil rights era, exploring "music and other cultural forms of vernacular culture as springboards for literary innovation and theoretical analysis."[1] Thinking through psycho-analytic theories of mourning and melancholia and the work of black feminist scholars, this essay explores how Jones draws on the blues aesthetic to fashion a novel that accounts for the process of racial subject formation at the intersec-tions of buried social memory and ongoing practices of racialization, without stabilizing hegemonic discourses of racial ideology.

Hazel Carby describes "classical blues" as a cultural form where buried social memory, racial order, and gender order merge to shape black female identity and survival against the dictates of white supremacist patriarchal order.[2] The incorporation of classical blues themes and tropes into narrative form is what aligns Jones's *Corregidora* with representations found in Nella Larsen's *Plum Bun* (1928), Jessie Fauset's *Quicksand* (1928), and Zora Neale Hurston's *Their Eyes Were Watching God* (1937). All four novels depict black female sexuality and family life within the broader context of historical processes and relations. Jones's treat-ment of classical blues in *Corregidora* advances these conversations, providing a useful paradigm for theoretical reflection on the transgenerational effects of racial slavery and imperialism on black familial relations. *Corregidora* provides an imaginative context for understanding and addressing the psychic claims of racial and gender abuse and invites a reconceptualization of the place of trauma and psychoanalytic insights in advancing critical race and ethnic studies.

The personal narratives of Ursa and the three preceding generations of her matrilineal line fracture *Corregidora* in a way that aestheticizes the interlocking social and emotional injunctions that claim and bind all four women discreetly. Ursa, her mother, and grandmother are the daughters and property of Old Man Corregidora, a Portuguese seaman who immigrated to Brazil. Personal nar-ratives of slavery, rape, incest, and resistance coalesce to lay bare a-present-that-cannot-embrace-the-past and a past-driven-to-confiscate-the-present. These unacknowledged claims of history form a signifying chain of narrative ruptures, evasions, and abrupt transitions.

Readers discover Ursa's inability to fulfill a familial mandate to "make gen-erations" pursuant to bearing witness to her matrilineal line's sexual abuse and exploitation at the hands of Old Man Corregidora shortly after entering the narrative. The fact that Ursa's abortion and hysterectomy are induced at the violent hands of her husband, Mutt, is not without significance. What ap-pears to be postmodern narrative complexity opens a paradigm for linking the

uneven, contradictory, and disavowed claims of buried social memory to the persistence of abuse and trauma in the lives of the Corregidora women. As the collective struggle against racism and sexism evolves from the ritual of "making generations" to Ursa's blues performances, readers learn how the Corregidora women are affectively linked by the trauma of racial and sexual exploitation at the hands of Old Man Corregidora and the abusive suitors that follow his reign.

Refracting the Corregidora women's social history of loss, resistance, and recovery through the prism of ritual and the African American oral tradition, Jones uncovers the complex ways hidden affect works through everyday acts of resistance to shape and link identities across multiple generations. Three of the four generations of the Corregidora women absorb the shock of the psychosocial baggage of their immediate forbearers' oppression in a manner that is colored by their personal experience with Corregidora himself or some other force of gender and sexual oppression. Jones thus showcases a radicalized subject-formation that is at once individualistic and interpersonal while debunking racially conservative and Black Nationalist paradigms that force *one to stand in for the many*.

Jones's choice to depict the transmission of buried social loss across four generations makes *Corregidora* an apt literary and theoretical reflection on Daniel Patrick Moynihan's 1965 report. The report appealed to white guilt and justified social programing designed to support urban black families ravaged by historical and structural oppression (see the discussion of Moynihan in Chapter 8 of this volume). Moynihan's report also attributed the dysfunction it associated with the African American familial structure to its alleged "matrifocal structure." The equation of post–civil rights era African American familial health and patriarchal order also underpinned Black Nationalist efforts to, borrowing the words of Michael Awkward, "reestablish black masculinity as the unchallenged center of black American life."[3] Jones's exploration of the claims of past oppressions on the present of post-emancipation African American communities through the prism of the blues walks a fine ideological line. More specifically, Jones renders black life neither a byproduct of oppressive forces nor an ideologically sealed cultural island. Rather, she portrays it as an ongoing discipline of discernment and choice across variable contexts. Jones does so to rework white conservative and Black Nationalist discourses that frame African American communities and individuals in ways that support their power.

Ursa's matrilineal mandate to "make generations" is both a means of memorializing the family's survival in the face of bondage and sexual exploitation at the hands of Old Man Corregidora and a vehicle for the disavowed time travel of unspeakable social loss. For most critics of the novel, trauma explains the

legacy effects of the familial mandate to bear witness to the atrocities the women suffer at the hands of Old Man Corregidora. For Ashraf Rushdy, the familial mandate to narrate what happened and make generations embalms ghosts of the past as opposed to exorcising them.[4] Joanne Lipson Freed attributes the reproduction of the legacy of slavery's sexual commodification and victimization in the relationships between black men and black women in the middle of the twentieth century to this process of "traumatic repetition."[5] Drawing heavily on the insights of Kai Erickson, noting the way "traumatic experiences work their way so thoroughly into the grain of the affected community that they come to . . . govern the way its members relate to one another," and Ron Eyerman, suggesting that each generation "reinterprets and represents the collective memory around that event according to its needs and means," Freed astutely collapses individual and collective trauma across traumatic events.[6] While these readings, underscoring the self-replicating power of trauma through and across changing circumstances, resonate, there is a question that these perspectives generate yet do not answer: what role do rituals of resistance to ongoing racial and sexual subjugation play in the preservation and reconstitution of buried social memory?

An examination of the psychical underpinnings of the gendered operations and effects of racialization on African American cultures provides insights to answer this question. The examination also situates *Corregidora* as a text that engages the humanistic work of contextualizing Moynihan's diagnosis of black life and countering the heteropatriarchal discourses of black nationalism it buttressed. Indeed, Jones's treatment of the gendered legacy effects of racialization on black life lays bare the complexities of subjugation administered and endured without relegating blackness to the conservative dungeon of ethnographic specificity and limited communal agency. *"They squeezed Corregidora into me and I sung back in return"* (Jones 103; original emphasis). While the blues provides a more viable form of reconciliation with the past than "making generations," Ursa remains stuck between acknowledging and honoring this familial mandate throughout most of the novel. Ursa's existential crisis emblematizes post–civil rights era African America's battle with its own internalization of white supremacist heteropatriarchal order and logic. Jones makes it difficult for readers to determine whether the familial mandate to produce light-skinned offspring stems from internalized racism. At the same time, as Robert J. Patterson argues in *Exodus Politics*, "the Corregidora women's mission to make generations' and Ursa's blues performances function as forms of civil rights activism and leadership that counter masculine and heteronormative civil rights discourses."[7] Indeed, the novel speaks truth to the uneven and contradictory

terrain of African American social progress at the intersections of racial and gender order that animated the progressive and post–civil rights eras.

During the 1970s, women of color began to explore and interrogate the claims of the pernicious nexus of white supremacist discourse and heteropatriarchy on black life. Posing a threat to both the centrality and authority of the white heteropatriarchal familial structure and black masculinist reclamation discourses and projects, the reproductive rights of African American women were subject to control and violation. The policing of black women's reproduction was waged from both outside and within African American communities. Shirley Chisholm's struggle to increase the presence of family-planning clinics in African American communities from her seat in the U.S. Congress during the 1970s aimed to provide more structural and institutional support for "Black women's control over their own procreative decisions."[8] For Chisholm, the pro-choice agenda took priority over Black Nationalism's ideological battle against what was widely recognized as federally funded forms of "African-American extermination." Jones joins Chisholm as ideological bedfellow, pointing to a need to heal the myriad forms of internalized racism that fester in the face of the ongoing fight against white supremacy and racial subjugation. As Dorothy Roberts notes in *Killing the Black Body*, "Condemnation of policies that devalue Black reproduction need not arise from a fear of Black extermination. This opposition can arise from the struggle to eradicate white supremacy."[9] Freud's logic of melancholia cuts to the core of Jones's theoretical engagement with this nexus of oppressive discourses via Ursa's struggle to take up a more proactive and restorative engagement with her past and present.

In his 1917 essay, "Mourning and Melancholia," Sigmund Freud outlines two ways of dealing with loss. While the essay defines "mourning" as the successful integration of loss into consciousness, it also explains the limits of "melancholia." In "melancholia," Freud notes, a loss that is unmourned and barred from recognition is displaced directly onto the subject's ego, enacting an unconscionable loss of self. While mourning is a healthy mode of dealing with loss, melancholia is an unhealthy one. The former is healthy because "we rest assured that after a lapse of time it will be overcome." In contrast, the melancholic suffers an unconscionable loss that claims yet cannot be claimed. In other words, melancholy describes a psychic state wherein losses of self are retained and barred from recognition. In "Mourning and Melancholia," Freud also introduces the concept of the ego, the agent through which identification is produced and negotiated unconsciously. Here, Freud locates melancholia as a psychic state in which the ego is ironically sustained by its own emptiness, filled to the brim with loses that cannot be known:

> An object-choice, an attachment of the libido to a particular person, had at one time existed; then, owing to a real slight or disappointment coming from this lived person, the object-relationship was shattered. The result was not the normal one of a withdrawal of the libido from this object and a displacement of it on to a new one, but something different. . . . [T]he free libido. . . . was withdrawn into the ego . . . to establish an identification of the ego with the abandoned object. . . . Thus the shadow of the object fell upon the ego. . . .
>
> The ego wishes to incorporate this object into itself, and the method by which it would do so, in this oral or cannibalistic state, is by devouring it.[10]

The melancholic consumes the lost object it cannot know about.[11] Extending this observation, Anne Cheng suggests that the shadow of the object that falls on the ego is a metaphor for losses of self that defy yet demand recognition. Thus the melancholic "is stuck—almost choking on—the hateful and loved thing he or she just devoured."[12] For Cheng, melancholia provides a paradigm for viewing the constitution of the human ego—that is, subject-formation—as an ongoing process of legislating or feeding on loss. An overwhelming ambivalence plagues Freud's melancholic subject-formation. The melancholic is always already suspended within the boundary between mourning and melancholia, knowing and not knowing the object or ideal is lost.

The content of Ursa's lost object can be found between the lines of the private memories of the Corregidora women. The Corregidora women are collectively plagued by an impossible mourning that is conditioned, ironically, by the very ritual of resistance to the abuse suffered though colonialism, white supremacy, and/or patriarchy. The familial imperative to "make generations" keeps them moving forward and backward at once. In addition to attributing the propagation of trauma to their inability to exorcise ghosts, Jones suggests that the inability of the Corregidora women *to keep company with* ghosts is what embalms them across time and social space.

Jones situates mourning losses of self as the overlooked prerequisite for neutralizing the impact of white supremacist ideology on African American life and culture. The inability of the Corregidora women to come to terms with the indignities suffered at the hands of their oppressors undergirds their collective failure to build and maintain intimacy between themselves and potential suitors. Moreover, the familial mandate to keep their private memories secure mirrors the behavior of melancholic subject formations rife with disavowed social losses that must be ritually contained and barred from recognition. The loss of self the Corregidora women cannot remember or embrace as their own is a communal intimacy unadulterated by the demands of capital. Intimacy, and the emotional availability it requires, have historically escaped the grasp

of the Corregidora women because of the ongoing abuse and exploitation they have endured. All that remains of this struggle is a set of private memories that isolate the Corregidora women.

The private memories of the Corregidora women occupy what Naomi Shor refers to as the "space of melancholy," a middle ground between the past and the present, the world of the living and the dead.[13] As Ursa moves along her journey of recovery from a miscarriage and hysterectomy caused by domestic abuse at the hands of Mutt, her psychic wounds become indistinguishable from those incurred by her forebears. This inability to establish intimacy is the ghost that claims, yet cannot be claimed, by the Corregidora women. This inability to establish intimacy is a melancholic response that ironically keeps the Corregidora women emotionally stable yet distant.

Jones's depiction of this intimacy trouble aligns *Corregidora* with the black feminist tradition of exploring and addressing the "deeply unsettling" impact of racism on intimate relationships in African American communities that became more public during the 1970s.[14] The precarious state of the familial relations between these women is a chamber of melancholic flux that keeps them tethered to the past. Ursa's resistance to intimacy is a melancholic response to living in a state of perpetual insecurity wrought by the fear of death and desire. One of the private memories told in the voice of Great Gram points to how melancholy works through the lived and remembered threat of death and desire to propagate itself across time and social space:

> There was a woman over on the next plantation. The master shipped her husband out of bed and got in the bed with her and just as soon as he was getting ready to go in there she cut off his thing with a razor she had hid it under her pillow and he bled to death, and then the next day they came and got her and her husband. They cut off her husband's penis and stuffed it in her mouth, and then they hanged her. They let him bleed to death. They made her watch and then they hanged her. (67)

Great Gram's private memory records brutal physical and psychological oppression; however, its disruption of Ursa's everyday existence points to authority's ability to reconstitute melancholic subjection through a mix of memory, familial identification, and the will to survive.

Jones's reordering of the African American literary tradition becomes most palpable to readers through the strained emotional relationship between Ursa and her mother. Just as Ursa's mother unwittingly transforms into a mouthpiece of rememory depicting the sexual injunction placed on her mother and grandmother, a riveting reality lurking beneath her language eclipses the re-

membered social history: The Corregidora women survived death and, thereby, forged community by avoiding social and sexual engagement with those Corregidora called "black bastard[s]" (130). The premise of the institution of slavery hinged on complete control over the reproductive rights of black women and their sexuality. The price for resisting this institutional mandate, as the previous example shows, was death. Ursa's mother explains in the voice of her own mother in retrospect:

> "But he was up there fucking me while they was out chasing *him*. . . . And then somehow it got in my mind that each time he kept going down in me would be that boy's feet running. And then when he come, it meant they caught him." (127–128)

This passage records the trauma of sexual violence wrought by the competing forces of exploitation and survival in a capitalist-driven white supremacist context. As Ursa's mother recalls the regulation of blackness that eventually characterized the bond between the Corregidora women, the melancholic effect of this event becomes rendered unspeakable yet palpable a few passages thereafter:

> I was looking at mama and then looking up at him [Martin, the black male suitor of Ursa's mother], and after he seen me the first time he just kept looking at her. She was acting like she didn't know he was there, but I know she had to know. . . . I'd let him rub me down there. I kept telling him it was because they were in there that I wouldn't. But . . . even if they hadn't been. There she was just sitting there lifting up her breasts. I don't know when it was she decided she'd let him know she seen him, but then all a sudden she set the box of powder down and looked up. Her eyes got real hateful. . . . She kept calling him a nasty black bastard, and he kept calling her a half-white heifer.
>
> "Messing with my girl, you ain't had no right messing with my girl." (130)

The internalized racism negotiated on sexual terms embodies the melancholic effect of the trauma of slavery forged through the crucible of white supremacist heteropatriarchy. In *Post-Traumatic Slave Syndrome*, Joy DeGruy Leary highlights how enslaved Africans and their descendants absorbed the fallacies of racist stock logic that undergirded chattel slavery. DeGruy Leary reminds us, "One of the most insidious and pervasive symptoms of Post Traumatic Slave Syndrome is our adoption of the slave master's value system."[15] As such, the familial mandate to "make generations" by giving birth to girls with light complexions is a ritual of melancholic resistance that disavows and buttresses the inability among the Corregidora women to love and respect themselves, as black women, unconditionally.

Corregidora calls out and indicts what Audre Lorde called a maternity "under patriarchal power" and the tendency to ignore the subtending racism and sexism that framed black life during the post–civil rights era.[16] The trouble Great-Gram has parsing the love and hate she harbors for Old Man Corregidora is conditioned by the paradox of physical survival and abuse she suffers at his hand. This paradox defines the intimacy between the Corregidora women and the men in their lives. While the ritual of "making generations" bolsters the fragile humanity of the Corregidora women in the face of an ongoing history of psychical and emotional abuse, it is an ineffective means of moving beyond this history of psychosocial violence. The ritual is a melancholic effect of the racial and sexual imperialism the family endured for decades. The ritual is a mode of resistance that undermines bonds in vulnerability, interdependence, and strength that black women writers of the 1970s aimed to erect and fortify in the name of universal liberation.

In *Corregidora*, the emotional injunctions against interdependency between women of color and between men and women of color are socially and historically constructed. Jones shows how the fight against the gender and sexual legacies of racial slavery within African American communities is amplified by the very persistence and imbrication of racism and sexism in the everyday lives of the Corregidora women. Ursa's inability to establish intimacy with Tadpole is haunted by the past. The looming threat of physical and emotional abuse at the hands of men in the name of heteropatriarchy secures this haunting that unites the Corregidora women in emotional unavailability across generations. I use the term *haunted* to refer to psychic and material conditions that do not result from circumstances of the past but bear the mark of a discrete inheritance from the past conditioned by the present.[17] As such, the women are psychically bound by the abuse suffered across decades.

Ursa's voice is where readers see how this haunting impacts the Corregidora women uniquely. Ursa's voice intersects and overlaps with that of her great grandmother, grandmother, and mother on the pages of the text to highlight the ways the survival of ongoing sexual exploitation and incest intertwines their psychic lives:

> "What bothers you?"
> "It bothers me because I can't make generations."
> "What bothers you?"
> "It bothers me because I can't."
> "What bothers you, Ursa?"
> "It bothers me because I can't fuck."

"What bothers you, Ursa?"

"It bothers me because I can't feel anything."

"I told you that nigger could do nothing for you."

"You liar. You didn't tell me nothing. You left me when you threw me down those . . ." (90)

This paradigmatic passage, which appears midway into the narrative, highlights the role ongoing sexual and racial oppression plays in interlocking the Corregidora women psychically across generations. Jones relies consistently on word choice, narrative gaps, and situational jumps to draw a parallel between the present and past in order to make this haunting palpable for readers. The inability of Ursa's mother, grandmother, and great grandmother to procreate and forge intimacy on their own terms left a psychic "gap," to borrow Nicholas Abraham and Maria Torok's terminology, that passed on "from the parent's unconscious to the child's."[18] As such, Ursa's emotional injunction is sealed by the present yet conditioned by the unreciprocated claims of a past that are not her own.

This inheritance is stimulated unwittingly by Tadpole as he pleads for Ursa to "get their devils off [her] back" (45). Everyday conversations with Tadpole bear the traces of trauma her forebears suffered:

"Will you tell me sometime?"

"Yes."

I never really told him. I gave him only pieces. A few more pieces than I'd given Tadpole, but still pieces.

"Your pussy's a little gold piece, ain't it, Ursa? My little gold pieces."

"Yes."

"Ursa, I'm worried about you, you so dark under your eyes." (60)

Corregidora's voice of sexual abuse and exploitation ruptures this conversation between Ursa and Tadpole and represents what Cathy Caruth might call a traumatic "collision" between past and present and the "incomprehensibility" of the event.[19] Jones's depiction of the psychically disorganizing effects of chattel slavery across generational lines aligns with established public discourse concerning African Americans in public policy during the 1970s. Under the shadow of "The Moynihan Report," the "Negro Family" and "Negro Culture" of the 1970s were widely received as byproducts of the "damaged black psyche."[20] In contrast, Jones treats the "cultural psychosis" as an effect of capitalism and white supremacist ideology that she enlists the blues milieu to dismantle.

Corregidora extends a meditation on the role black women's blues culture played in disrupting the impact of psychic legacies of trauma on black libera-

tion strategies. Patterson notes how Ursa's blues allows her to lead without reinscribing the trauma her matrilineal line suffered: "By allowing Ursa to make generations through the blues, Jones contextualizes the more general role music had in advancing the civil rights movement and situates Ursa's performances with a broader history of black women's blues performances."[21] In *Blues Legacies and Black Feminism*, Angela Davis describes black women's blues songs as forms of truth-telling that refuse to "romanticize romantic relationships" by expressing "the contradictions of those relationships."[22] Buried social memory and untold truths are more than mere tropes in *Corregidora*; Jones uses them as paradigms for understanding the role blues truth-telling played in forging psychic and ideological transcendence for artists and audiences. As the novel closes, the narrative toggles between past and present less frequently and Ursa's singing promotes this decline.[23] There's a climactic moment of recognition that separates the narrative's rising and falling actions: "I was thinking that now that Mama had gotten it all out, her own memory—at least to me anyway—maybe she had some man. . . . But then, I was thinking, what had I done about my own life? (132).

"My own life": the role singing the blues plays in fostering the self-possession denied Ursa's forebears becomes palpable after this moment in the narrative, lending narrative coherence to the novel's disjunctive form. This passage marks the end of the unreciprocated claims of social history across time and social space, the diminishing power of Old Man Corregidora's haunting. Singing the blues provides an access point for Ursa's psychic liberation in and through the very body that, according to Weheliye, serves as "a vital prop in the World of Man's dramaturgy of Being."[24] The blues stage is where Ursa eventually wields the power of bodily memory and carves out a space of liberation and agency beyond the logic of hegemony and its binary logic. In *Disidentifications*, José Muñoz reminds us that melancholia is an integral part of the everyday lives of people of color, lesbians, and gays who must do battle against oppressive forces. Muñoz defines the status of melancholia as "a mechanism that helps [them] (re)construct identity and take [the] dead with them to the various battles they must wage in their names."[25] For Muñoz, melancholia—in its capacity to mobilize those suffering from abominable oppression and pain on the extreme margins of the social order—is an instrument of agency. Taken together, these insights ground the liberating capacity of the blues in the awareness and discernment the cultural form promotes in the face of the forces of dehumanization and disillusion.

Ursa's blues testimony is a stepping stone beyond the gendered tenets of black nationalism that carried over from the 1960s toward the womanist ideol-

ogy that took center stage during the 1980s.[26] Through the blues, Ursa draws on melancholia to stage mourning, giving veiled expression to the hidden affect buried beneath her matrilineal line. Standing as the tipping point beyond three generations of "stress, self-doubt, and interpersonal relationship problems with family members and others," Ursa's blues furnishes existential liberation beyond the cul-de-sac of traumatic circumstances and effects that ensnared the Corregidora women for generations.[27]

Blues scholars have framed the cultural form as a site of ideological and psychic ambivalences. As a medium of "creativity and commerce," Houston Baker adds that "simple dualities"[28] cannot frame the blues. For Baker, the blues promotes cultural understanding that blends the individual and the collective and collapses the line between spheres of ideological entrapment and amorous agency. The blues, according to Angela Davis, "provides an exceptionally rich site for feminist investigations."[29] Female blues singers like Gertrude "Ma" Rainey and Bessie Smith, according to Angela Davis, attracted audiences that rivaled church congregations in size and fervor because the cultural form registered gendered and sexual freedom in "more immediate and accessible terms."[30] Disrupted by her blues, Ursa's impossible mourning eventually gives way to a third existential space that affords the protagonist a witnessing presence of agency in the face of the circumstances that threaten her safety and well-being. "It [the blues] helps me explain what I cannot explain" (56). In one simple reflection, Ursa accounts for the capacity of the blues to promote agency through veiled expression to disavowed losses-of-self.

Ursa's ability to stimulate catharsis is communal in scope: "You know, like callused hands. Strong and hard but gentle underneath. Strong but gentle too. The kind of voice that can hurt you. I can't explain it. Hurt you and make you still want to listen" (96). As Davis reminds us, "Women's blues cannot be understood apart from their role in the molding of an emotional community based on the affirmation of black people's—and in particular black women's—absolute and irreducible humanity. The blues woman challenges in her own way the imposition of gender-based inferiority."[31] Ursa's blues and the communal power she wields discredits and revises the stock logic of patriarchal order by forging the emotional potential for intimate connections based in "egalitarian affection, rather than hierarchy."[32]

Great Gram shares Ursa's ability to sow ideological alterations. What is more, the power Ursa wields is seemingly sourced from dynamics that outstrip her presence on Earth, pointing to the capacity of the blues to make visible an agency that is, to borrow the words of Diana Taylor, "always already there."[33] Great Gram's choice to refrain from detaching Corregidora's penis from his body with her teeth

during fellatio is more than an act of resistance; it's an act of discernment, compassion, and self-discipline. "What is it a woman can do to a man that makes him hate her so bad he want to kill her one minute and keep thinking about her and can't get her out of his mind the next?" (184). Ursa's act of mercy also displays reverence for black humanity and community. In *The Archive and the Repertoire*, Taylor highlights the status of performance as an "episteme and practice," stressing the cultural agency that attends the performative event: "Multiple forms of embodied acts are always present, transmitting communal memories, histories, and values from one group/generation to the next. Embodied and performed acts generate, record, and transmit knowledge."[34] Ursa's blues allow her to tap into the unadulterated space that prefigures language, history, and culture, and the ideological workings of power that curtailed the agency of her matrilineal line for decades. The blues paves a path for Ursa beyond a mere reaction to oppressive forces, demonstrating Ralph Ellison's belief in the ability of African Americans to "create themselves out of the [cultural forms]" they invented.[35]

Readers encounter the resistance properties of Ursa's blues shortly after she returns to singing the blues while recovering from a hysterectomy:

> He reached over and touched me on the shoulder. I tried not to move. Sometimes I found myself not knowing how much men did meant friendly and how much meant something else. Or maybe I was just kidding myself. I wouldn't let myself tell whether it was a fatherly touch, or whether I should take my hand and remove his. . . ."Don't lie, Max. I don't wont no lying," I said, and then I was thinking perhaps he wasn't lying, perhaps he didn't want to make me, just wanted to be hugged and touched. I said nothing else. (94–96)

Ursa's cognitive and behavioral reconstitution of self deconstructs hegemonic patterns of thought and misrecognition.

Before Ursa explores new existential possibilities, she challenges her construction as a sexual object. Anticipating theorizations bell hooks's *Ain't I a Woman: Black Women and Feminism* outlines, Jones situates the objectification and dehumanization of black women as the effect of black men who saw themselves as the "sole representatives of the black race and therefore the victims of racial oppression"[36] For Mutt, the blues stage is a post-emancipation auction block where he reduces Ursa to a "piece of ass" to be bid on "for sale" (140). As Freed explains, "Mutt's refusal of slavery's legacy of commodification leads him to repeat it through relentless objectification of Ursa."[37] While Mutt falls prey to the misogyny that attends traditional conceptions of kinship structure, Ursa's blues provides an escape patch beyond the ideological assumptions that reduce her lifeforce to a reaction against ideological forces.

By the late 1970s, black feminist writers, thinkers, activists, and scholars renegotiated the image of the "damaged black psyche," creating black cultural production that balanced the fine line of promoting social uplift while incorporating the imagery of "black damage." Toni Morrison's *Sula* (1973), Alice Walker's *Meridian* (1976), and Ntozake Shange's *for colored girls who have considered suicide / when the rainbow is enuf* (1976) deconstruct notions of black pathology within the contexts of capitalism, racism, and black nationalism, replacing it with various images of black resilience and agency. Jones collapses motifs of classical blues into a literary aesthetic in order to expand ideas about African American history, survival, and reconstitution.

The blues provides Ursa an ideological force field against the psychic trauma that results from the meeting of the ego and things barred from conscious recognition:

> Mutt wasn't there when the show started, but he came in the middle. I was singing one of Ella Fitzgerald's songs, and as soon as I saw him I kind of gradually increased the volume, hope people wouldn't notice. The piano player, though, must've thought I was crazy, but he played a little louder too. . . . I was scared too, but I was still singing, and calling his bluff. I saw him raise his arm, and just kept it suspended in the air. (160)

Ursa manages to sidestep Mutt's hail and refuses interpolation by modulating her voice, pointing to the inability of social constraints alone to control the oppressed.[38] The blues assists Ursa's ongoing transcendental project. Ursa's blues catalyzes offensive strategies against the effects of dominant ideology, providing a social and emotional field of force against interpellation in the face of being hailed perpetually. The blues provides Ursa a liminal space for praxis where Ursa acknowledges and redresses the conditions of her dispossession.

The ghost of Great Gram eventually emerges to buttress Ursa's psychic life against Mutt's threat of subjection:

> In a split second I knew what it was, in a split second of hate and love I knew what it was, and I think he might have known too. A moment of pleasure and excruciating pain at the same time, a moment of broken skin but not sexlessness, a moment just before sexlessness, a moment that stops before it breaks the skin: "I could kill you." (184)

Ursa's restraint is more than an act of resistance; it invokes the moral authority of an ancestor who chooses agency in the face of trauma's psychic effects. Ursa's capacity to "produce desire out of resistant activity" is a voluntary act

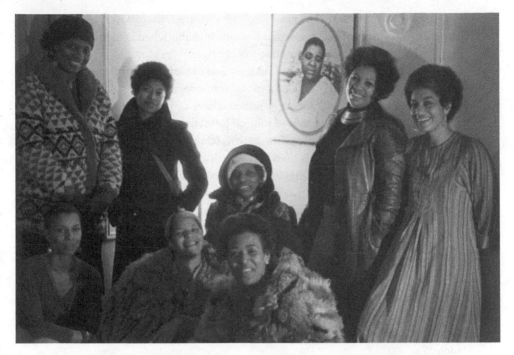

Figure 7.1. The Sisterhood. Vertamae Grosvenor, Alice Walker, Lori Sharp, Toni Morrison, June Jordan, Ntozake Shange, and Audrey Edwards pose in front of a portrait of classical blues legend Bessie Smith in New York during the 1970s. *Schlesinger Library, Radcliffe Institute, Harvard University.*

of melancholic invulnerability as opposed to an involuntary melancholic response.[39] Ursa's blues practice puts her in front of historical trauma as opposed to her earlier position behind the weight of history. Mutt's embrace after fellatio signifies his full acceptance of Ursa's terms of desire tempered by mutual self-respect (185).

"I am Ursa Corregidora. I have tears for eyes. I was made to touch my past at an early age. I found it on my mother's tiddies. In her milk. Let no one pollute my music. I will dig out their temples. I will pluck out their eyes" (77). Jones draws on the blues and a constellation of literary devices to aestheticize a historically, socially, and economically grounded haunting that resists yet does not defy address. Forced to nurture herself in the face of debilitating historical and social circumstances, the blues provides Ursa a means of deflecting the shock of the accumulative weight of historical and social traumas toward productive ends. Functioning as a mediation tool for Ursa's existential crisis, the cultural form

also serves as an aesthetic and epistemological strategy that allows readers to see the novel's theoretical agenda that remains invisible when read in isolation from its historical and discursive contexts of origin.

Jones's exploration of the vexed intersection of racial identity, impossible mourning, and ritual also provides a model for understanding racialized subject-formation that is simultaneously individualistic and interpersonal, refusing to adopt models that force racialized subject-formations to be caught in the bind of being "one" circumscribed by "the many." If, as Nell Irvin Painter reminds us, "What we can see depends on what our culture has trained us to look for," *Corregidora* offers a nuanced lens for a complex reading and renegotiation of racialized identity formation.[40] Indeed, the text captures the effects the legacies of slavery have on African American communities with a measure of sensitivity that makes it possible to renegotiate the psychical effect of racial discourse in the flesh.

Notes

1. Henry Louis Gates Jr. and Nellie Y. McKay, Eds. *African American Literature*, 2nd ed. (New York: W. W. Norton and Company, 2004), 914.

2. Hazel Carby, *Cultures in Babylon: Black Britain and African America* (London: Verso, 1999), 8.

3. Michael Awkward, *Philadelphia Freedoms: Black American Trauma, Memory, and Culture after King* (Philadelphia: Temple University Press, 2013), 85.

4. Ashraf Rushdy, "'Relate Sexual to Historical': Race, Resistance, and Desire in Gayl Jones's *Corregidora*." *African American Review* 34.2 (2000): 276.

5. Joanne Freed, "Gendered Narratives of Trauma and Revision in Gayl Jones's *Corregidora*." *African American Review* 44.3 (Fall 2011): 409.

6. Ron Eyerman, *Cultural Trauma: Slavery and the Formation of African American Identity* (Cambridge: Cambridge University Press, 2002), 276.

7. Robert J. Patterson, *Exodus Politics: Civil Rights and Leadership in African American Literature and Culture* (Charlottesville: University of Virginia Press, 2013), 31.

8. Dorothy Roberts, *Killing the Black Body: Race, Reproduction, and the Meaning of Liberty* (New York: Vintage, 1998), 102.

9. Ibid., 103.

10. Sigmund Freud, "Mourning and Melancholia." In vol. 14 of *The Standard Edition of the Complete Psychological Works of Sigmund Freud*. Ed. James Strachey (London: Hogarth, 1955), 248–250.

11. As Phillip Novak points out in "Circles and Circles," because "African American culture is still at risk, getting done with grieving might well constitute a surrender to the forces that produced the losses in the first place" (193). See Phillip Novak, "'Circles and Circles of Sorrow': In the Wake of Morrison's *Sula*." *PMLA* 114.2 (1999): 184–193.

12. Anne Anlin Cheng, *The Melancholy of Race: Psychoanalysis, Assimilation and Hidden Grief* (New York: Oxford University Press, 2001), 9.

13. Naomi Schor, *One Hundred Years of Melancholy* (Oxford: Clarendon Press, 1996), 4.

14. Gates and McKay, *African American Literature*, 919.

15. Joy DeGruy Leary, *Post-Traumatic Syndrome: America's Legacy of Enduring Injury and Healing* (Milwaukee: Uptone, 2005), 139.

16. Audre Lorde, "The Master's Tools Will Never Dismantle the Master's House." *This Bridge Called My Back: Writings by Radical Women of Color*, 4th ed. Eds. Cherríe Moraga and Gloria Anzaldúa (New York: University of New York Press, 2015), 95.

17. See Jermaine Singleton, *Cultural Melancholy: Readings of Race, Impossible Mourning, and African American Ritual* (Urbana: University of Illinois Press, 2015), which explores the legacy of unresolved grief produced by ongoing racial oppression and resistance in the United States, demonstrating how rituals of racialization and resistance transfer and transform melancholy discretely across time and social space.

18. Nicolas Abraham and Maria Torok, *The Shell and the Kernel: Renewals of Psychoanalysis*, Trans. Nicholas T. Rand (Chicago: University of Chicago Press, 1994), 173.

19. Cathy Caruth, *Unclaimed Experience: Trauma, Narrative, and History* (Baltimore: Johns Hopkins University Press, 1996), 6.

20. In *Contempt and Pity*, Daryl Michael Scott explores the mutually constitutive relations between social policy between 1880 and 1996 and the image of the damaged black psyche. According to Scott, "Ethnologist documented the backwardness of African peoples. Historians highlighted the folly of Reconstruction, the moment in history in which people of African descent played a prominent role in the nation's political life" (Chapel Hill: University of North Carolina Press, 1997), 2.

21. Patterson, *Exodus*, 108.

22. Angela Davis, *Blues Legacies and Black Feminism: Gertrude "Ma" Rainey, Bessie Smith, and Billie Holiday* (New York: Vintage Books, 1998), 41.

23. Something as normal as sound, according to Jacques Atalli, is far from simple, so intricately woven into the fabric of things quotidian that its power is ubiquitous. Attali's reading of music centers on the mutually constitutive natures of music and societal modes of production. Although Attali catalogs this dynamic during the four stages of music history, noting the way music erases the differences upon which society is structured (5), it fails to adequately address the productive power that psychic ambivalence plays in personal and political transformation. See Jacques Atalli, *Noise: The Political Economy of Music* (Minneapolis: University of Minnesota Press, 1985).

24. Alexander Weheliye, *Habeas Viscus: Racializing Assemblages, Biopolitics, and Black Feminist Theories of the Human* (Durham: Duke University Press, 2014), 44.

25. José Esteban Muñoz, *Disidentifications: Queers of Color and the Performance of Politics* (Minneapolis: University of Minnesota Press, 1999), 74.

26. In "The Secrets of Our Mothers' Gardens," Alice Walker defines womanism against feminism, highlighting the former's investment in the wholeness of both males

and females. See Alice Walker, "In Search of Our Mothers' Gardens," in Gates and McKay, *African American Literature*, 1180–1188.

27. DeGruy Leary, *Post-Traumatic*, 124.

28. Houston Baker, *Blues, Ideology, and Afro-American Literature: A Vernacular Theory* (Chicago: University of Chicago Press, 1984), 9.

29. Davis, *Blues*, xvii.

30. Ibid., 7.

31. Davis, *Blues*, 36.

32. Candice Jenkins, "Queering Black Patriarchy: The Salvific Wish and Masculine Possibility in Alice Walker's *The Color Purple*." *Modern Fiction Studies* 48.4 (2000): 985.

33. Diana Taylor, *The Archive and the Repertoire: Performing Cultural Memory in the Americas* (Durham: Duke University Press, 2003), 142.

34. Ibid., 21.

35. Ralph Ellison, "American Dilemma: A Review," *Shadow and Act* (New York: Vintage Books, 1972), 315.

36. bell hooks, *Ain't I a Woman: Black Women and Feminism* (Boston: South End Press, 1981), 101.

37. Freed, "Gendered," 414.

38. In "Gayl Jones," Dubey grounds Ursa's ability to transform the legacy effects of slavery through her "blues voice." I'm interested in the always already provisional nature of Ursa's agency and aim to highlight the ambivalent role Ursa's blues plays in acknowledging hegemonic force without being interpellated. See Madhu Dubey, "Gayl Jones and the Matrilineal Metaphor of Tradition." *Signs* 20 (1995): 245–267.

39. Rushdy, "Relate," 286.

40. Nell Irvin Painter, *The History of White People* (New York: W. W. Norton and Company, 2011), 16.

From Blaxploitation to *Black Macho*

The Angry Black Woman Comes of Age

TERRION L. WILLIAMSON

> Almost like the ultimate girl. You didn't quite want a girl
> that was that tough. But you did want a girl that was, you
> know, that tall, and had a big 'fro. You didn't want your
> girlfriend to actually be able to kick your ass.
>
> —Samuel L. Jackson

At about the midpoint of Isaac Julien's 2002 documentary film *BaadAsssss Cinema*, the actor Samuel L. Jackson succinctly articulates the appeal that the lead characters Pam Grier played in films such as *Coffy* (1973), *Foxy Brown* (1974), and *Sheba, Baby* (1975) held for him and many other black people of his generation, particularly black men. Statuesque, aggressive, and ostensibly modeled after the revolutionary figure Angela Davis, who was at the height of her notoriety during the blaxploitation era, Grier's characters quickly became *the* prototypical blaxploitation heroines. They employed weapons skillfully and avenged themselves against their racist and sexist oppressors with the same violent aplomb as their male counterparts, while still maintaining the sexual allure and physical attractiveness mandated of most women striving to make it in Hollywood. While Grier contends that she took her film work very seriously and modeled her characters after women in her own family whom she saw as "demonstrative, but yet very feminine," critics typically saw Grier's characters, and blaxploitation more generally, as complicit in championing damaging stereotypes of black people and black communities and as an affront to radical

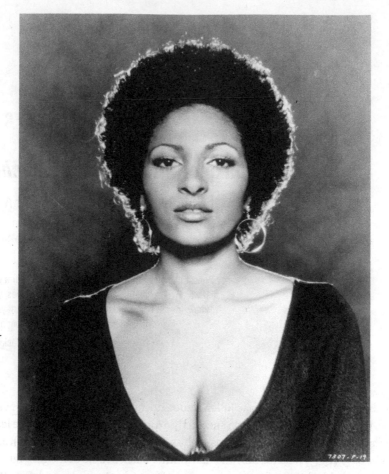

Figure 8.1. A 1974 photo of actress Pam Grier at an unknown location.

black liberation movements.[1] In large part, this characterization explains why the genre was so short-lived, reaching its zenith and then sputtering out within the span of approximately five years in the early 1970s.

Jackson's comment that Grier, via her characters, was "almost like the ultimate girl" indicates the complex representational politics that ensnared Grier and, to varying degrees, other black women actors of the period, including Rosalind Cash, Tamara Dobson, Jeannie Bell, Vonetta McGee, and Teresa Graves. Many black women of the '70s, even some prominent feminists, celebrated characters like Foxy Brown and Dobson's Cleopatra Jones for their strength, independence, and consistent triumphs over their adversaries. These charac-

ters were a marked, and often quite welcome, change from foregoing film images of black women as complacent domestics, tragic mulattos, and brutalized seductresses without recourse to their own capabilities. Still, champions and critics alike recognized that the roles for women in blaxploitation were generally simplistic and repetitive and, at times, degrading caricatures of black women that, as Jackson's comment alludes to, often served as "tantalizing male fantasy come true."[2] According to Cedric Robinson, blaxploitation was a "cinematic deceit" that obfuscated the structural regimes of capitalism implicated in the production of the "urban anarchy" at the heart of the films, and it used black women's bodies to authenticate its "exaggerated unreality." Blaxploitation's deliberate misinterpretation of the image of Angela Davis was thus a mechanism for recasting the black liberation movement as vacuous outlawry and freedom fighters as little more than vigilantes.[3]

Despite the obvious limitations of the genre, scholars Yvonne Sims, Stephane Dunn, and Mia Mask, among others, have done important work in recent years in challenging the academic and industry disregard of blaxploitation films starring women. Though they each orient their work differently, their collective project has been to interrogate blaxploitation as a *cultural asset* with significant implications for how we think about black women's relationships to film specifically and to cultural production more generally. Their varied analyses call attention to the form and content of specific films, argue the necessity of attending to black women as viewers, and explain how blaxploitation films engage elements like camp, fantasy, and action.[4] Consequently, they have also helped to illuminate the sociohistorical contexts out of which the figure I am concerned with addressing here, the angry black woman, emerged.

The correlation between black women and anger in popular culture goes back, at least, to mammy. Deference to white authority aside, the happy disposition of mammy characters was at times undercut by their quick tempers or sharp tongues, as evinced by the consummate filmic mammy portrayed by Hattie McDaniel in *Gone with the Wind* (1939). Indeed, anger or one of its derivatives—sassiness, bitterness, meanness, bitchiness—underlies almost every popular narrative of black women, past and present. I have written elsewhere about the usefulness of contemplating black women's anger as *critical posture*, or a modality through which black women engage with a world that is and always has been largely hostile to their presence.[5] Here, I am not concerned with black women's anger per se but with the trope of the angry black woman—which I see not so much as a misrepresentation of black women as a misappropriation of black women's anger—as it is mobilized within cultural discourse. Rather than attempt to make claims about how well or not black women are represented

within particular media texts, I am interested in the angry black woman as a cultural artifact that, like all such artifacts, can reveal something about the conditions of its existence and those people for whom it is alleged to stand in.[6]

Since the turn of the twenty-first century, the trope of the angry black woman has proliferated most readily on reality television, with the image of the neck-swiveling, punch-throwing, tongue-lashing black woman quickly becoming an unsettling mainstay of the genre. Yet the origins of the contemporary angry black woman lie, I argue, in the 1970s when black women's anger began being commodified into the form of what Robinson has termed the "Bad Black Woman" of blaxploitation. Though there are clear differences in form between blaxploitation and reality television, not the least of which is that the latter explicitly purports to engage with the "real" while the former simply implies it, both mobilize the trope of the angry black woman toward their own, commercial, ends. But as Robinson reveals in his discussion of blaxploitation's barren interpretation of black liberation, the "gain" is not only financial. While blaxploitation cinema may have been a commercial enterprise, it was also an ideological stratagem that "served to rupture the transmission of radical black thought,"[7] and the Bad Black Woman was useful in this endeavor because she reinforced foregoing notions of villainous black womanhood. Building upon the work of art historians and other scholars who have found that "misogynist imagery emerges in reaction to the instability of patriarchy at moments of feminist achievement," Mask suggests that Grier's characters were both a reflection of and a response to larger societal tensions affecting black communities.[8] In what follows, I will take Mask's lead in considering the sociopolitical contexts out of which the trope of the angry black woman emerged in 1970s cultural discourse. While blaxploitation films and television shows featuring "sassy" black women characters like *Sanford and Son*, *The Jeffersons*, and *What's Happening!!* were the sites where the angry black woman most visibly circulated throughout the decade, my focus throughout the remainder of the essay will be how black women were contending with the trope in their writing and public discourse.

Moynihan, Matriarchy, and the Emergence of Black Feminist Thought

In 1970, Toni Cade Bambara (then Toni Cade) published the first anthology of black women's writings of its kind. She claimed to have put the anthology together "out of impatience" with, among other things, "the fact that in the whole bibliography of feminist literature, literature immediately and directly

relevant to [black women] wouldn't fill a page." *The Black Woman*, which would eventually become a bestseller, brought together the essays, poetry, and short stories of writers who were, or, would soon become, key figures in black literary studies such as Audre Lorde, Nikki Giovanni, and Alice Walker, as well as women like Bambara's own mother, Helen Cade Brehon, who had little to no previous publishing experience but who defined themselves as mothers, activists, and artists. Theirs was a common cause: to speak "impatiently" into the void of black women's writing about their own lives. One of the many ambitions Bambara had for the text was to establish a space for black women to "explore ourselves and set the record straight on the matriarch and the evil black bitch."[9]

As Bambara herself noted, *The Black Woman* is a heterogeneous text with "distinct placements of stress." Not all of the contributors identified as feminists or with the women's liberation movement and some of them considered their concerns as women to be secondary to their concerns as black people.[10] Still, many of the contributors clearly shared Bambara's interest in "setting the record straight" on the prevailing image of black women as evil and emasculating. For example, the jazz vocalist and actor Abbey Lincoln argued that "I've heard it echoed by too many Black full-grown males that Black womanhood is the downfall of the Black man in that she (the Black woman) is 'evil,' 'hard to get along with,' 'domineering' 'suspicious,' and 'narrow-minded.' In short, a black, ugly, evil, you-know-what."[11] Likewise, freelance artist Fran Sanders contended that "there has been, on the part of most writers, be they historians, novelists, present-day documentarians, or statisticians, the tendency to vilify the Black woman as castrating matriarch. Whether she went about this task with a velvet glove or a steel gauntlet, she produced the same effect—she de-balled the Black man."[12] And in one of the most well-known essays from the collection, activist Frances Beale lamented that too many black men within the movement seemed to be taking their activist cues from the *Ladies' Home Journal*, with its purported investment in confining the roles of women to sexual objects and conspicuous consumers, opining that "certain Black men are maintaining that they have been castrated by society but that Black women somehow escaped this persecution and even contributed to this emasculation."[13]

The Black Woman helped to initiate a resurgence, or what some commentators have called a "renaissance," of black women's literature in the 1970s that subsequently led to the development of black feminist literary criticism as an identifiable scholarly tradition. At the same time, an unprecedented number of black feminist organizations were formed, including the National Black Feminist Organization, the Combahee River Collective, and the National Alliance of Black

Feminists, that were hugely influential to the burgeoning field of black feminist theory and helped lay the groundwork for future liberation movements.[14] The surge in black feminist writing and organizing in the 1970s was, as Farah Jasmine Griffin has found, "a direct response to the masculinist bias of the civil rights and especially the black power and black arts movements."[15] This bias was perhaps nowhere more visible than in the production of and response to a government report published in 1965 as *The Negro Family: The Case for National Action*, but known colloquially as the Moynihan Report.

Named for its lead author Daniel Patrick Moynihan, an academic and future U.S. senator who was then the assistant secretary of labor and head of the Office of Planning and Research in President Lyndon Johnson's administration, the report made heavy use of social science and statistics to bolster its claim that significant government intervention was necessary to eradicate economic racial disparities and help pull black people out of poverty. Other than advocating military service as a viable mechanism for reinforcing black manhood, however, the report was largely ambivalent about specific policy proposals, contending that its purpose was to "define a problem, rather than propose solutions to it."[16] While the report did find that the "cycle of poverty and disadvantage" attendant to most black communities is rooted in chattel slavery and continued structural inequality, it did so primarily in order to emphasize the idea that the black family was "the nation's oldest, and most intransient, and now its most dangerous social problem."[17]

Either despite of or because of the fact that Moynihan and his family were abandoned by his father in his childhood and supported primarily by the work of his single mother, Moynihan was deeply committed to the heteropatriarchal male-breadwinner nuclear-family ideal.[18] He consequently saw the resistance to this structure on the behalf of large numbers of impoverished black people as densely correlated to their "desperate and deteriorating circumstances."[19] The report thus emphasized the need for the "increasingly disorganized and disadvantaged lower-class group" to adhere to the protocols of middle-class black family life, which purportedly put "a higher premium on family stability and the conserving of family resources" than even middle-class white families.[20] Among the leading causes for the "tangle of pathology" that most black youth, even those who were middle class, were said to be in danger of being ensnared was the matriarchal structure of the black family:

> In essence, the Negro community has been forced into a matriarchal structure which, because it is so out of line with the rest of American society, seriously

retards the progress of the group as a whole, and imposes a crushing burden on the Negro male and, in consequence, on a great many Negro women as well.[21]

According to Moynihan, this "crushing burden" resulted from "the often reversed roles of husband and wife" in black families and the attendant lack of male breadwinners, which ultimately affected every aspect of black life and resulted in educational disparities among black youth, societal alienation, declines in IQ capacity, decreased church attendance among black men, increased crime and juvenile delinquency, and increased drug use. While the primary impetus of the report was ostensibly to encourage the government to commit resources to the elimination of poverty among black people, it simultaneously implied that black women, who were said to benefit from greater levels of education and more access to skilled employment than black men, needed to essentially "stand down" in order that their men might take their rightful places as the heads of their households, thereby thwarting the "aberrant, inadequate, or anti-social behavior" that perpetuated "the cycle of poverty and deprivation" among poor black communities.[22]

As historian Daniel Geary has shown, the Moynihan Report was a contradictory document replete with multiple and conflicting meanings which allowed it to be interpreted variously by a range of groups from liberals and civil rights advocates to conservatives and segregationists.[23] Indeed, despite the report's language of black pathology and black familial dysfunction, it was initially praised by numerous black leaders and civil rights organizations, including Martin Luther King Jr. and the National Urban League. It also received favorable coverage in a number of major black newspapers upon its release. Much of the support for the report was focused on the potential it was thought to offer for expanding the dialogue about social and economic opportunities for black people, while some support also emerged out of the belief that Moynihan was correct in his assessment that black families should adhere to normative middle-class standards and eschew the supposed matriarchal black family structure. Still, many black people, including *Invisible Man* author Ralph Ellison, saw the report as yet another instance of white "experts" presuming the superiority of prototypically white socioeconomic norms and attempting to displace them onto black people whose real lives they knew little to nothing about. Stokely Carmichael and other activists within the black power movement contended that the report confirmed the necessity of black self-representation.[24] At the same time, leaders such as Bayard Rustin, a prominent figure within various civil rights organizations, and James Farmer, one of the cofounders of the Congress

of Racial Equality (CORE), openly criticized the report for its reliance on and extension of racial stereotypes and its vulnerability to appropriation by those who opposed the expansion of initiatives meant to combat racial inequalities—a concern that was realized when some press accounts and conservatives started using the report as evidence of the "defective culture" of black people and as the basis for advocating the use of racial "self-help" strategies rather than holding the government accountable for its role in the fomentation of structural and institutional racism.[25]

Despite the substantial criticisms levied at the Moynihan Report by black leaders, activists, and lay people, one of its key provisions—that the black family suffered from a matriarchal structure and a lack of male breadwinners—appealed to the desire for black male familial authority among many of those who were otherwise Moynihan's staunchest critics.[26] For example, the black sociologist Robert Staples, whose reputation as an expert on the African American family was cemented in the wake of the controversy surrounding the Moynihan Report, wrote an article in the journal *The Black Scholar* in 1970 that decried "the myth of the black matriarchy." He cited the socioeconomic exploitation of black women in multiple arenas as evidence that Moynihan had largely overstated their dominance within the family structure, arguing that "referring to black women as matriarchs is not only in contradistinction to the empirical reality of their status but also is replete with historical and semantic inaccuracies." Yet by contending that the pre-slavery black family of African civilization "was patriarchal in character and was a stable and secure institution," and that slavery had stripped the black men of "the responsibilities and privileges of fatherhood," Staples ultimately affirmed Moynihan's central thesis about the crumbling black family infrastructure. Rather than address the particular needs of black women attendant to the intersecting forms of exploitation they faced as outlined in his argument, Staples named black women's oppression as but a subset of the oppression experienced by black men in "America's racist empire" and reinforced the notion that the uplift of black people necessitated the restoration of the black male patriarch in the heteronormative family structure.[27]

The most penetrating critiques of the Moynihan Report were ultimately offered up by black feminist thinkers. The same year that Staples's essay appeared in *The Black Scholar*, Pauli Murray, an attorney and activist who four years earlier had helped found the National Organization for Women, published an essay that worked to disprove some of the statistically based holdings the report used in suggesting that the needs of black men should take precedence over those of black women. She argued, for instance, that the complaint Moynihan and others made that black women were better educated and had more and better job

opportunities than black men ignored the fact that there are more black women in the general population than black men, that by 1966 the percentage of black women and men with college degrees was roughly equivalent and, perhaps most importantly, that black women are typically relegated to the "bottom rung of the employment ladder" while maintaining heavier economic responsibilities than their white counterparts, thus further justifying their need for equal opportunities in education and employment.[28] She also refuted the idea that slavery had somehow done greater harm to black men than it had black women, contending that "if black males suffered from real and psychological castration, black females bore the burden of real or psychological rape."[29] In this way, Murray, like Staples, sought to demythologize the black matriarchy thesis, but where Staples's discussion was primarily confined to an analysis of how the myth further prevented black men from becoming "the kings of their castles,"[30] Murray discussed how it worked to further stigmatize black women. She also presented a more comprehensive analysis of the effects of racism, sexism, and economic exploitation on black communities writ large.

The year following the publication of the essays by Murray and Staples, *The Black Scholar* published an issue titled "The Black Woman" that featured Angela Davis's now classic essay, "Reflections on the Black Woman's Role in the Community of Slaves," which she wrote during the time she was imprisoned on charges of murder, kidnapping, and conspiracy for which she would later be acquitted. Using only the secondary sources that were available to her during her confinement, Davis sought to "debunk the myth of the matriarchate" at its "presumed historical inception."[31] She argued that the conditions of black slave women's labor stripped them "of the palliative feminine veneer" and occasioned a "profound consciousness of resistance" that was on par with that of their male counterparts.[32] Suggesting that the history of black women's resistance during slavery evinced "egalitarian tendencies" among black women and men that mitigated against the notion of black women's dominance, Davis named the matriarch an "open weapon of ideological warfare" that was meant to make black men misdirect their animus toward black women and to convince black women to suppress their will toward rebellion.[33] That same issue of *The Black Scholar* featured an essay by sociologist Jacquelyne Jackson who argued that a more careful look at the data regarding black women's education and employment practices revealed that black women were actually *dis*advantaged in those areas relative to other groups, including black men.[34] And in yet another essay, congresswoman Shirley Chisholm, who at the time of publication was running as a candidate in the U.S. presidential campaign, argued that the black revolution could not be separated from other movements for liberation, including the

women's movement, without risking the maintenance of black people's "own peculiar form of slavery."[35]

The foregoing examples from *The Black Woman* and *The Black Scholar* attest to the profound affect the Moynihan Report had on black women—so much so that it helped generate some of the most important writings by black women of the era. Yet, the report also helped to position Moynihan, who had very little experience with either black people or black culture prior to the publication of his report, as the "Head Commissioner of Negro Affairs in America" which, in turn, spawned a cadre of academics committed to the growth of "Black Sociology" and helped spur research on African American families.[36] The Moynihan Report ignited widespread debate among scholars, policy makers, community leaders, feminists, activists, and lay people that eventually "sank deeply into American consciousness"[37] and continues to play out nationally in conversations about the needs and responsibilities of black Americans. And though black women fought valiantly against Moynihan's matriarchy thesis, the trope of the domineering and emasculating black woman had found fertile ground.

The Return of Black Macho

By the end of the 1970s, the black feminist movement, which had been induced by the heteropatriarchy of black liberation groups and rampant racism within the women's liberation movement, had generated a significant cultural and political discourse.[38] Although most of the major black feminist organizations would be defunct by 1980, their work throughout the 1970s helped lay the critical infrastructure upon which black feminist consciousness continued to develop throughout the ensuing years. Indeed, it was in 1977 that the Combahee River Collective, a Boston-based group of radical black feminists that had broken off from the National Black Feminist Organization, penned a statement that has come to be widely regarded as the black feminist "manifesto." In it, Combahee outlines the complexities of black women's various oppressed subject positions and opines that freedom for everyone necessitates the freedom of black women because it "necessitate[s] the destruction of all the systems of oppression," and they note further how the "pejorative stereotypes attributed to black women" reveal what little value had been placed on black women's lives historically.[39]

The advance in black feminist scholarship, literature, and organizational activity was essential in cultivating spaces for black women to reckon with their lives and their depictions within public culture and helped provide them a critical language for demanding accountability for the distinct oppressions they experienced as black women. At the same time, black feminism was seen as a

potent threat by some black people, particularly black men who were concerned about feminists' public airing of grievances. This was no more evident than in the fallout from the publication of Michele Wallace's *Black Macho and the Myth of the Superwoman* in 1978. The daughter of visual artist Faith Ringgold, Wallace had been intimately involved with the black feminist movement, including serving as one of the founders of the National Black Feminist Organization. She would eventually become a professor at the City College of New York, but at the time *Black Macho* was published she was a twenty-something-year-old journalist cutting her teeth writing for the likes of *Newsweek* and *Ms.* magazine. Three years prior to the publication of *Black Macho*, Wallace had written an article for the *Village Voice* where she had discussed her experiences as a young girl coming of age in Harlem in the 1960s, as well as her time spent as a student at Howard University and then at City College, and how those experiences led her to become a feminist and to her organizing efforts with the NBFO.[40] The article, which details the racism and sexism she experienced as a child, her burgeoning consciousness as a young woman, and the disappointment she felt in various engagements with individuals involved in the black liberation and black feminist movements, provides important context for the arguments Wallace would go on to make in the polemical *Black Macho*, a discussion of which illuminates how black women's anger was being negotiated intramurally, within and among black people, during the final years of the 1970s.

Black Macho is split into two parts. Both Part I, which is titled "Black Macho," and Part II, titled "The Myth of the Superwoman," are framed by way of the Moynihan Report, which Wallace argues did not *create* hostility between black women and black men but "merely helped to bring the hostility to the surface."[41] A primary contention of the book is that black women and men are in virtual warfare, that there is "a growing distrust, even hatred, between them" and that this internal divisiveness was largely responsible for eroding the political effectiveness of both the civil rights and black power movements.[42] Told that it was not so much institutional racism as an abnormal family structure helmed by black women that victimized them, the Moynihan Report helped fuel black men's reliance on superficial masculine characteristics such as overt sexuality and physical dominance (Black Macho) and black women's desire to define their femininity in opposition to these same superficial masculine characteristics that had come to define them (the Superwoman).

Although black women were complicit in the emergence of Black Macho, they had also been emotionally devastated by it, Wallace claimed. She further argued that black men, particularly those within the black power movement, had come to think of themselves as martyrs whose manhood was of primary

importance, and that said manhood came in the form of sexual access to white women—she spends a significant amount of time detailing and attacking in-terracial relationships—and other trappings of the white power structure, as well as the "systematic subjugation and suppression of black women."[43] For their part, black women had no awareness of how they had been "duped" by the myth of the Superwoman. According to Wallace, black women were the only group in the country that had not "asserted its identity," and rather than work toward their own liberation they had largely "become angry with black men, black people, blackness" and come to "think of [their] history and condition as a wound which makes [them] different and therefore special and therefore exempt from human responsibility."[44]

Shortly after the publication of *Black Macho*, Wallace landed on the cover of the January 1979 issue of *Ms.* magazine whose editor at the time, Gloria Steinem, designated *Black Macho* the book that would "shape the 1980s." Steinem's im-primatur notwithstanding, the book was met with heavy criticism by academ-ics, prominent feminists, and other commentators, including the author's own mother, and within a number of major newspapers and journals, including the *New York Times* and the *Village Voice*.[45] The backlash against *Black Macho* culmi-nated in an article written by Robert Staples for *The Black Scholar* in early 1979 entitled "The Myth of Black Macho: A Response to Angry Black Feminists." Though he had defended black women against Moynihan's matriarchy thesis less than ten years earlier, Staples's response, which took issue not only with Wallace but also with Ntozake Shange whose choreopoem, *for colored girls who have considered suicide/when the rainbow is enuf*, had been published in 1975, echoed some of the same complaints black women had worked to debunk in *The Black Woman* and elsewhere (see the discussion of Shange and Staples in Chapter 10 of this volume). Staples argued that Wallace and Shange were launching an unwarranted "attack on black men." This was especially troubling for him given what he argued was the relatively privileged position of black women in relationship to black men in education, income, and occupation. Moreover, the behavior Wallace was "angry" about and labeling as sexist was "nothing more than men acting in ways they had been socialized to behave." Black men who deserted their families, for instance, were simply "exercising [their] mas-culine perquisite" and acting on their "curious rage" at being unable to fulfill their ascribed roles, while the appeal to self-love and self-determination on the behalf of Wallace and Shange was a troubling "extension of the culture of Narcissism" that ultimately made black women incapable of loving their men, children, families, or communities.[46]

As Nikol Alexander-Floyd has noted, many critics of *Black Macho* "opted to destroy the creditability of the book through attacking Wallace's character, scholarly ability, and priorities and/or by raising questions about the severity of sexism in black communities and the priority it should receive in consider-ations of black liberation strategies."[47] This was evinced in Staples's essay and in several contributions to a special issue of *The Black Scholar* published in 1979 entitled "The Black Sexism Debate" that was dedicated to responses to *The Black Macho* and Staples's critique of it. Maulana Karenga, for instance, contended that Wallace's arguments were "reductive" and that she had "made a political choice to elevate sexual questions above social ones and to elevate the personal over the collective," while Askia Touré labeled Wallace and Shange treasonous "artistic agent-provocateurs" whose work was "utilized by our oppressor as weapons against our overall liberation effort," providing as an example experi-ences he'd had with black women who had spoken to him negatively or yelled at him while he was attempting to "engage in healing, mutual dialogue" and likening those experiences to rape.[48] Fortunately, these contentions were chal-lenged by women like Audre Lorde, who argued that black women should not have to bear in silence the "curious rage" Staples contended was the domain of black men and that black men's rage was no more legitimate than that of black women, and Julianne Malveaux, who took issue with much of *Black Macho* but recognized that Shange's advocacy of self-love in *for colored girls* was not antimale but a healthy and necessary position for black women who "are too often defined in other people's terms, as 'bitch,' as 'matriarch,' as domineering/dominant."[49]

In "How I See It Then, How I See It Now," an introductory essay that Wallace penned in 1990 for inclusion in a new edition of *Black Macho*, the author reflected on the controversy with which *Black Macho* was met and critiqued elements of her own analyses. She noted, in particular, that the problem she was attempting to detail in 1978 was actually "one of representation." Whereas in *Black Macho* she had articulated a view of the failures of the black liberation movement that she had gleaned primarily from mainstream media accounts and had ultimately grounded in "an extension and reversal of the white stereotypes about black inferiority," she later turned her attention to a "politics of interpretation" that took into account the limitations of the media and some of her other source material, including linear historical narratives. She also began to consider more deeply history as it was told from the perspective of black women themselves, and upon returning to graduate school she found that black women often re-vealed their histories most meaningfully within their literature.[50]

Indeed, in the second half of *Black Macho,* which, given its focus on black women, received considerably less attention from commentators than the first half did, Wallace's reliance upon foregoing tropes of black women's anger effectively undercut her own argument. Although she purported to be concerned with exposing the fiction of the emasculating matriarch as established by Moynihan, she ultimately affirmed what she was otherwise intent on discrediting by arguing that large numbers of black women had naively accepted that fiction and turned their anger in on themselves and just about everyone else around them. And so it turned out that, at least where the articulation of black women's anger was concerned, Wallace and Staples were engaged in a similar project. Yet while *Black Macho*, coming as it did early in Wallace's career and before the rapid growth in black women's studies that was to come, has shortcomings that the author herself acknowledges, the book was a significant intervention when it appeared and black feminism has "benefitted tremendously from Wallace's ability to say that black patriarchy is a thing, a real, measurable thing, and black women have been harmed by it."[51]

Conclusion: Black Women's Literary Production and the Way toward Freedom

It is telling that Wallace links the limitations of *Black Macho* to her reliance on mainstream media narratives. Though she does not explicitly mention the blaxploitation films or sitcoms where black actors were so highly visible throughout the 1970s, instead citing evening newscasts, political documentaries such as *Eyes on the Prize*, and the writings of prominent black men—all of which underplayed the contributions of black women—there is clearly a corollary between the ways the black liberation movement was addressed in both the fiction and the (ostensibly) nonfiction media of the time. In either case, the movement was portrayed as belonging to the men, and the specific needs and experiences of black women went largely unacknowledged. When revisiting *Black Macho*, Wallace recognized that altering this reality required that black women write their own stories, claiming that "perhaps if we can begin to claim our own words and our own feelings within the public sphere, we will seize the means of reproducing our own history, and freedom will become a possibility in a sense that it never has been before."[52]

The 1970s were a critical moment in the black women's literary tradition. Although Barbara Christian lamented in 1977 that "all segments of the literary world—whether establishment, progressive, black, female, or lesbian—do not know, or at least they do not act like they know, that black women writers and

black lesbian writers exist,"[53] a number of important texts were published by black women authors throughout the decade that would help black feminist literary studies become "one of the most intellectually exciting and fruitful developments in American literary criticism" by the mid-1990s.[54] In addition to poetry collections by the likes of Audre Lorde, Gwendolyn Brooks, and Sonia Sanchez and short story collections by Toni Cade Bambara and Ann Petry, these works also included Maya Angelou's acclaimed autobiography *I Know Why the Caged Bird Sings* (1970), and novels by Toni Morrison (*The Bluest Eye*, 1970; *Sula*, 1973; *Song of Solomon*, 1977), Alice Walker (*The Third Life of Grange Copeland*, 1970; *Meridian*, 1976), Gayl Jones (*Corregidora*, 1975; *Eva's Man*, 1976), and Octavia Butler (*Kindred*, 1979) (see the discussion in Chapter 5 of this volume).

In her seminal study of black women writers, Christian contends that between 1861 and 1945 a disproportionate number of novels that featured black women as primary characters, including Frances Harper's *Iola Leroy, or, Shadows Uplifted*, which, when it was published in 1892 was one of the first to be written by a black woman, "adhered to the literary convention of the mulatta heroine." Noting the correspondence between social and literary conventions, Christian argues that "the social philosophy that denied the beauty of black women and the economic policy of slavery that relegated black people to the bottom of the economic ladder made it very difficult for anyone to write a novel in which a credible black woman could be the major focus of attention."[55] These early texts were primarily directed toward and consumed by white audiences and thus largely divorced from the oppressive conditions under which the masses of black women labored. Harper, who was already a well-known abolitionist and advocate for women's rights when she published her novel, was fully aware of these conditions but, as Christian notes, she and other writers of her time were constrained by the then-prevalent form of the novel and were consequently consumed with refuting negative imagery of black people.[56]

By the latter half of the twentieth century, black women novelists were firmly eschewing the strictures placed on earlier authors and were "beginning to project their own definitions of themselves as a means of transforming the content of their own communities' views on the nature of women and therefore on the nature of life."[57] Among the most critical literary interventions during this period was Morrison's second novel, *Sula*. In what literary critic Hortense Spillers calls "the single most important irruption of black women's writing in our era," the eponymous protagonist of *Sula* is concerned, almost solely, with her own self-making.[58] In the words of the text, "Sula was distinctly different. . . . She lived out her days exploring her own thoughts and emotions, giving them full reign, feeling no obligation to please anybody unless their pleasure pleased her. As

willing to feel pain as to give pain, to feel pleasure as to give pleasure, hers was an experimental life."[59] Even beyond the notable particulars of Sula's life—she never married or had children, which in and of itself was radical for a black female character in literature or elsewhere at the time—Sula's "experimental life" was a significant articulation of black women's emergent self-expression in the 1970s. The contention, to be clear, is not that Sula is "representative" of black women in the 1970s, but that she fundamentally repudiates the constraints of representative constructs:

> Sula is neither tragic nor pathetic; she does not amuse or accommodate. For black audiences, she is not consciousness of the black race personified, nor "tragic mulatta," nor, for white ones, is she "mammie," "Negress," "coon," or maid. She is herself, and Morrison, quite rightly, seems little concerned if any of us, at this late date of Sula's appearance in the "house of fiction," minds her heroine or not.
>
> We view Morrison's decision with interest because it departs dramatically from both the iconography of virtue and endurance and from the ideology of the infamous ogre/bitch complex, alternately poised as the dominant traits of black female personality when the black female personality exists at all in the vocabulary of public symbols.[60]

In deliberately thwarting the dichotomy between "virtue and endurance" and "ogre/bitch" that Spillers delineates, Morrison enables an altogether novel form of black female possibility in literature. The critical intervention of *Sula* is that with the introduction of the Peace women—Sula, her mother Hannah, and her grandmother Eva—we get black women characters who are neither negative caricatures nor their inverse but who are, to use Christian's word, "undefinable."[61] The final point, then, is that Morrison's *Sula* and so much of black women's literature gives us an alternative for reckoning with the angry black woman that does not mandate particular protocols of behavior but acknowledges that "out of the profound desolation of her reality" and with "nothing to fall back on: not maleness, not whiteness, not ladyhood, not anything," the black woman "may very well have invented herself."[62]

Notes

1. Isaac Julien, *BaadAsssss Cinema: A Bold Look at 70's Blaxploitation Films* (New York: Independent Film Channel, 2002), DVD.

2. Donald Bogle, *Brown Sugar: Over One Hundred Years of America's Black Female Superstars* (New York: Continuum, 2007), 194.

3. Cedric J. Robinson, "Blaxploitation and the Misrepresentation of Liberation," *Race & Class* 40, no. 1 (1998): 1–12.

4. Yvonne D. Sims, *Women of Blaxploitation: How the Black Action Film Heroine Changed American Popular Culture* (Jefferson, N.C.: McFarland and Company, 2006); Stephane Dunn, *"Baad Bitches" and Sassy Supermamas: Black Power Action Films* (Urbana: University of Illinois Press, 2008); Mia Mask, *Divas on Screen: Black Women in American Film* (Urbana: University of Illinois Press, 2009).

5. Terrion L. Williamson, "On Anger," in *Scandalize My Name: Black Feminist Practice and the Making of Black Social Life* (New York: Fordham University Press, 2017), 23–39.

6. See, for example, James Baldwin's discussion of Aunt Jemima and Uncle Tom in "Many Thousands Gone," in *Notes of a Native Son* (Boston: Beacon Press, 1955), 27–29.

7. Robinson, "Blaxploitation and the Misrepresentation of Liberation," 11.

8. Mask, *Divas on Screen*, 72–75.

9. *The Black Woman: An Anthology*, ed. Toni Cade Bambara (1970; New York: Washington Square Press, 2005), 5–6.

10. Ibid., 5.

11. Abbey Lincoln, "To Whom Will She Cry Rape?" in *The Black Woman*, 97.

12. Fran Sanders, "Dear Black Man," in *The Black Woman*, 88.

13. Frances Beale, "Double Jeopardy: To Be Black and Female," in *The Black Woman*, 112.

14. Kimberly Springer, *Living for the Revolution: Black Feminist Organizations, 1968–1980* (Durham: Duke University Press, 2005).

15. Farah Jasmine Griffin, "That the Mothers May Soar and the Daughters May Know Their Names: A Retrospective of Black Feminist Literary Criticism," *Signs* 32, no. 2 (2007): 485.

16. *The Negro Family: The Case for National Action* (Washington, D.C.: Office of Policy Planning and Research, U.S. Department of Labor, 1965), 46.

17. Ibid., n.p.

18. Daniel Geary, *Beyond Civil Rights: The Moynihan Report and Its Legacy* (Philadelphia: University of Pennsylvania Press, 2015), 2–15. For further related discussions of the Moynihan Report and its impact, see Lee Rainwater and William L. Yancey, *The Moynihan Report and the Politics of Controversy* (Cambridge: MIT Press, 1967); James T. Patterson, *Freedom Is Not Enough: The Moynihan Report and Black Family Life from LBJ to Obama* (New York: Basic Books, 2010); Ta-Nehisi Coates, "The Black Family in the Age of Mass Incarceration," *The Atlantic* (October 2015), http://www.theatlantic.com/magazine/archive/2015/10/the-black-family-in-the-age-of-mass-incarceration/403246/.

19. *The Negro Family*, 29.

20. Ibid., 5–6.

21. Ibid., 28.

22. Ibid., 29–45.

23. Geary, *Beyond Civil Rights*, 3.

24. Ibid., 110, 119–124.

25. Ibid., 83–103.

26. Ibid., 140.

27. Robert Staples, "The Myth of the Black Matriarchy," *The Black Scholar* 1, no. 3–4 (January–February 1970): 8–16.

28. Pauli Murray, "The Liberation of Black Women," in *Words of Fire: An Anthology of African-American Feminist Thought*, ed. Beverly Guy-Sheftall (New York: The New Press, 1995), 192–195.

29. Ibid., 187.

30. Staples, "The Myth of the Black Matriarchy," 12.

31. Angela Davis, "Reflections on the Black Woman's Role in the Community of Slaves," *The Black Scholar* 3, no.4 (December 1971): 3–15.

32. Ibid., 8.

33. Ibid., 15.

34. Jacquelyne J. Jackson, "But Where Are the Men?" *The Black Scholar* 3, no. 4 (December 1971): 30–41.

35. Shirley Chisholm, "Race, Revolution and Women," *The Black Scholar* 3, no. 4 (December 1971): 18.

36. Geary, *Beyond Civil Rights*, 110–111, 131.

37. Ibid., 103.

38. Springer contends that the ongoing black feminist movement "encompasses the political and cultural realms of black feminists' activism including organizations, prose, essays, fiction, scholarly studies, films, visual arts, and dance that are the voice of black feminism in the United States." *Living for the Revolution*, 4.

39. Combahee River Collective, "The Combahee River Collective Statement," in *Ain't Gonna Let Nobody Turn Me Around: Forty Years of Movement Building with Barbara Smith*, ed. Alethia Jones and Virginia Eubanks with Barbara Smith (Albany: State University of New York Press, 2014), 50, 47.

40. Michele Wallace, "Anger in Isolation: A Black Feminist's Search for Sisterhood," in Guy-Sheftall, *Words of Fire*, 220–227.

41. Michele Wallace, *Black Macho and the Myth of the Superwoman* (1978; London: Verso, 2015), 12.

42. Ibid., 13.

43. Ibid., 55.

44. Ibid., 174–176.

45. Nikol G. Alexander-Floyd, "'We Shall Have Our Manhood': *Black Macho*, Black Nationalism, and the Million Man March," *Meridians* 3, no. 2 (2003): 171–172.

46. Robert Staples, "The Myth of Black Macho: A Response to Angry Black Feminists," *The Black Scholar* 10 (March–April 1979): 25–28.

47. Alexander-Floyd, "We Shall Have Our Manhood," 172.

48. M. Ron Karenga, "On Wallace's Myths: Wading thru Troubled Waters," *The Black Scholar* 10, no. 8–9 (May–June 1979): 37; Askia M. Touré, "Black Male/Female Relations: A Political Overview of the 1970s," *The Black Scholar* 10, no. 8–9 (May–June 1979): 46.

49. Audre Lorde, "The Great American Disease," *The Black Scholar* 10, no. 8–9 (May–June 1979): 17; Julianne Malveaux, "The Sexual Politics of Black People: Angry Black Women, Angry Black Men," *The Black Scholar* 10, no. 8–9 (May–June 1979): 33.

50. Wallace, *Black Macho*, xxiii–xxxi.

51. Jamilah Lemieux, foreword to Wallace, *Black Macho*, xiii.

52. Wallace, *Black Macho*, xlii.

53. Barbara Christian, "Toward a Black Feminist Criticism," *The Radical Teacher* 7 (March 1978): 20.

54. Griffin, "That the Mothers May Soar," 484.

55. Barbara Christian, *Black Women Novelists: The Development of a Tradition, 1892–1976* (Westport, Conn: Greenwood Press, 1980), 22.

56. Ibid., 3–5.

57. *Ibid.*, 252.

58. Hortense J. Spillers, "A Hateful Passion, A Love Lost: Three Women's Fiction," in *Black, White, and in Color: Essays on American Literature and Culture* (Chicago: University of Chicago Press, 2003), 93.

59. Toni Morrison, *Sula* (New York: Vintage, 1973), 118.

60. Spillers, "A Hateful Passion, A Love Lost," 96–97.

61. Christian, *Black Women Novelists*, 157.

62. Toni Morrison, "What the Black Woman Thinks about Women's Lib," *New York Times Magazine* (August 1971): 63.

From the Ground Up

Readers and Publishers in the Making of a Literary Public

KINOHI NISHIKAWA

Before the 1960s, African American writers navigated a difficult path to publication—one that rarely fed (back) into a black reading public. At every stage of production, from editorial to marketing, the publishing establishment oriented black-authored books toward a white readership, thereby limiting what could be thought and said of them. The mainstream press followed suit, with reviews that measured the form and function of African American literature according to a yardstick not of its own making. This system of literary production and circulation bestowed accolades on certain writers, and it even turned some books into bestsellers, but its overall effect was to stifle and constrain black literary expression. The paradox, then, according to sociologist Robert E. Washington, was that "the liberal-left white American intelligentsia both fostered and culturally subjugated the dominant black literary schools" of the twentieth century.[1]

Black-owned publishing operations sought to reverse that trend in the late 1960s and early 1970s. The social and political unrest of those years called for a new kind of writing—works that defied the liberal consensus to illuminate the persistence of racism and racial inequality in America. Mainstream presses could not be relied on to support this mission, or they stood ready to subvert it, so it fell to artists and activists themselves to seize the means of literary production. Their objective was to publish books *by* black authors *for* black readers and to foster a discourse around those books *through* black critics. Though not typically described in such terms, the Black Arts movement was coextensive with

this push to create an alternative system of literary production and circulation. Indeed, in addition to a commitment to textual radicalism, a "profound sense of entrapment" within mainstream publishing "led Black Arts intellectuals to establish black institutions specifically intended to promote the kind of artistic expression so commonly controlled by whites."[2] From this perspective, the Black Arts movement might be thought of as a revolution in print twice over: not only in terms of what was sayable or imaginable but also in terms of how literature was made available to black readers at all.

The time was ripe for this kind of shift. Publishing historian Donald Franklin Joyce notes that the black literacy rate reached a high-water mark of 96 percent in 1969. This key component of a reading public was complemented by other demographic facts: by 1970 over 18 million, or 81 percent, of African Americans lived in urban areas; over 350,000 were enrolled in institutions of higher education; and over 600,000 worked in professional settings. These interlocking forms of mobility and achievement powered African Americans' "growing self-awareness of their present and past culture," which in turn fueled their "increased demand for books about Black history and culture."[3] No longer content to consume books written for whites, black readers were, in the late 1960s, asserting their right to have a literature of their own.

This essay surveys the publishing operations that coalesced around the project of setting up and sustaining a Black Arts system of literary production and circulation. It examines the publishers that produced books by black authors for black readers, and it identifies the periodicals whose discourse reflected those readers' preferences and tastes. These material activities signaled the building of a *black literary public* from the ground up—that is, through institutional and entrepreneurial ventures that were embedded in and (held) accountable to the black community. As distinct from the general reading public or the concept of the public sphere, a literary public is one that values the specific qualities of imaginative writing to constitute and engage a social body. What made the Black Arts system stand out was its unwavering commitment to a black literary public, and to the power of books to create social change (see Chapter 1 of this volume).

More than previous studies of Black Arts, this essay emphasizes how institutional and commercial publishing operations complemented each other during the movement. The better-known fact is that institution-building was a core principle of the Black Arts movement. In order to counteract the influence of the white literary establishment, Black Arts theorists believed it was necessary to found and run their own cultural institutions. "We must build black institutions," Amiri Baraka wrote in 1969, "based on a value system that is beneficial

to black people." In this cultural nationalist phase of his career, Baraka advocated Maulana Karenga's doctrine of Kawaida as one such system. Against the "practiced morality of Euro-American civilization," Kawaida aimed to establish institutions centered around Africanist principles like Kuumba (creativity) and Imani (faith).[4] For Baraka, cultural nationalism advanced a worldview that could revive the bonds of racial solidarity precisely through the work done by black-operated institutions. Fittingly, he declared his support in the debut issue of the Sausalito, California–based Black Studies journal *The Black Scholar*, itself a product of a nonprofit educational organization, the Black World Foundation.

A less recognized but no less important aspect of the Black Arts movement was its reliance on black-owned commercial enterprises to reach as expansive a readership as possible. In fact, the same year he published in *The Black Scholar*, Baraka announced his conversion to cultural nationalism, and his name change from LeRoi Jones to Imamu Ameer Baraka, in *Ebony*, the lifestyle magazine that was the crown jewel of Chicago businessman John H. Johnson's periodical holdings. Championed as the "newest cultural hero in the black community,"[5] Baraka was given the star treatment in the magazine. Having returned to his hometown of Newark, New Jersey, he was now the leader of Black Community Development and Defense, an activist group modeled on Karenga's US Organization. Accompanying the story were color photographs showing the group in action, from Baraka presiding over a marriage ceremony to women congregating outside the affiliated structure Spirit House. There was even a Baraka family portrait, featuring wife Amini and four children.

Ebony may have been a commercial publication, but it shed light on Baraka's cultural nationalist commitments in a manner that complemented what he wrote for *The Black Scholar*. The former helped make Baraka intelligible to an upwardly mobile black middle class, while the latter inserted Baraka into activist agendas for social and political change. Taken together, the periodicals allowed Baraka to address different segments of the reading public while underscoring the social cohesion of that public.

This was far from the only time when a Black Arts practitioner moved between commercial and institutional organs. Indeed, as this essay aims to demonstrate, the Black Arts system of literary production and circulation was facilitated through a wide variety of black-owned publishing operations—nonprofit and commercial, local and national, avant-garde and mainstream. By accounting for the range of such operations, the essay not only expands the conceptual bounds of the Black Arts movement but also highlights the diversity of interests that made up this literary public.

* * *

With roots going back to the early 1940s, Johnson Publishing Company's periodicals had long facilitated a thriving black book market. *Ebony, Jet,* and *Negro Digest* each had its own book notices section, which ran the gamut from brief synopses to longer reviews. As a group, they served interrelated functions: to generate buzz around the latest releases and to stress the importance of imaginative writing in readers' lives. Black newspapers had done similar things in their book coverage, but Johnson's magazines—slick and smartly put together—were able to turn literary awareness into a way of life. The December 1970 issue of *Jet,* for example, observed:

> Author Chester Himes (*Cotton Comes to Harlem*) was a recent guest on the French TV show, Dossier Souvenirs. Looking every bit the distinguished gentleman that he is, he said that he was not too optimistic about the "solution to the Black problem" at home ending nonviolently. He now lives in Alicante, Spain, where he recently built a new home.[6]

Exemplary of *Jet's* gossipy house style, this notice accorded Himes the kind of celebrity status one would usually associate with an athlete or movie star. That novelists were deemed worthy of such attention went a long way toward making African American letters a subject of general interest to readers.

Johnson's goal in all of his ventures was to target black consumers where white companies had traditionally ignored or overlooked them. He considered himself a businessman first. Yet the market-driven strategies he embraced often proved useful to the expansion of the black literary public. Inspired by the success of the Book-of-the-Month Club, for example, Johnson started the Ebony Book Club, a subscription service for discounted titles that could be sent by mail. Unlike the original, however, the Ebony Book Club offered a choice of titles from "a treasury of Afro-American literature: fiction, history, art, philosophy, poetry—the full range of black culture."[7] In other words, these were books that appealed directly, not incidentally, to black readers. On its debut, the selections included Sam Greenlee's espionage thriller *The Spook Who Sat by the Door,* Sarah E. Wright's social-realist novel *This Child's Gonna Live,* H. Rap Brown's political memoir *Die Nigger Die!* and John A. Williams's hard-boiled fiction *Sons of Darkness, Sons of Light* (all 1969). To be sure, the Ebony Book Club helped Johnson market titles from his own Book Division, notably editor Lerone Bennett Jr.'s popular histories *Before the Mayflower* (1962) and *Black Power U.S.A.* (1967). Ultimately, though, the club's genre diversity was its standout feature, expanding what leisure reading looked like for an upwardly mobile black middle class.

Johnson's capacious view of black consumerism even convinced him to fund what many consider to be the de facto mouthpiece of the Black Arts movement. *Negro Digest* was an unlikely candidate for that platform. In its early years, the magazine had struck a moderate tone on racial issues, aligning itself with white liberals calling for gradual integration and social adjustment. Underwhelming sales led to the magazine's shuttering in 1951. But when Johnson resurrected *Negro Digest* a decade later, he installed an editor who took his editorial cue not from white opinion but from black writers, artists, and activists themselves. Hoyt W. Fuller often butted heads with Johnson, but over the 1960s, he transformed *Negro Digest* into an esteemed review of literature, culture, and politics in the United States and abroad. The reconceived periodical not only reported on Black Arts, Black Power, and decolonization in Africa; it actively shaped these movements by circulating news within and across literary publics. Fuller used his extensive network of contacts to keep the content fresh, and he invited an array of poets, authors, playwrights, and intellectuals to contribute to the magazine. His transformation of the magazine was completed in May 1970 when it came out under a new name: *Black World*.

According to literary historian Howard Rambsy II, *Negro Digest/Black World*'s "wide circulation, its inclusion of so many leading poets, and its prominent role initiating and showcasing particular concerns related to black writers made it a defining outlet in the transmission of black literary art" in the post–civil rights era.[8] Indeed, the national reach and reception of the Black Arts movement may have been impossible without it. By Clovis E. Semmes's tally, under Fuller's editorship the magazine published 791 individual poems or single-issue clusters of poetry,[9] 243 short stories, 169 examples of literary criticism, and 1,237 reviews of books, records, theatrical productions, and film.[10] Every major Black Arts figure published in the magazine at least once, and many elected to contribute writing in more than one genre. Fellow Chicagoan Carolyn M. Rodgers, for example, published literary theory, cultural criticism, poetry, short stories, and reviews in nearly a decade of working with Fuller. This genre flexibility not only showcased the heterogeneity of Black Arts; it broadened the movement's appeal to readers with different preferences and tastes.

As Fuller settled into a rhythm in the early 1970s, he became more daring, melding *Black World*'s accessible middlebrow format with content drawn from the black and pan-African avant-garde. He published full-length plays by Alice Childress, Don Evans, and Kalamu Ya Salaam. He featured radical women's poetry by Johari Amini (Jewel C. Latimore),[11] Angela Jackson, and Brenda M. Torres. And he introduced readers to challenging diasporic poetry by Edward (Kamau) Braithwaite (Barbados), Keorapetse Kgositsile (South Africa), and

Djibril Sall (Mauritania). In keeping with his cosmopolitan inclinations, Fuller and select correspondents reported on the proceedings of poetry festivals, writers' symposia, and arts conferences across the country and around the world. These reports illustrated how the revolution in black art—the move away from white approval and toward what Fuller himself called a Black Aesthetic[12]—was a truly global phenomenon. Finally, Fuller helped shape modern African American literary criticism by publishing important early pieces by the very first generation of Black Studies–informed scholars, including Houston A. Baker Jr., Bernard W. Bell, and Mary Helen Washington.

While *Negro Digest/Black World* was a key component of the Black Arts system of literary production and circulation, the magazine's commercial status did not sit well with some of the movement's practitioners. In a 1971 issue of the *Journal of Black Poetry*, Ahmed Akinwole Ato Alhamisi penned a scathing critique of Johnson's holdings. "Let us ask ourselves the following questions," he stated:

> Is *Black World* (formerly Negro Digest) still a carbon copy of the *Reader's Digest*? Is Ebony an imitation of both *Life* and *Playboy* magazines? . . . What about the images, the symbols, the total format of all our magazines? What effect does it have on our African children? Where are they to go for positive images and not an exploitation of images? Many of our magazines are highly profitable in these militant times of supposedly black rage. All villains are European now. Fine. But we need more than European villains. We need, among other things, to stop supporting the European system on all levels under which we as an African people suffer.[13]

Alhamisi worried that the very format of Johnson's magazines risked upholding the "European system . . . under which . . . African people suffer." The problem was not about privileging whiteness in representational terms. After all, Johnson seemed to have dispatched with Eurocentric role models. Instead, the problem, for Alhamisi, was how the political economy of white supremacy, or racial capitalism, could accommodate "black rage." When "images" and "symbols" of blackness could be exploited like any other commodity, it did not matter whether the owners were black or white: "African people" would still be the ones suffering.

Something like Alhamisi's critique lay behind the flourishing of black "little" magazines in the late 1960s and early 1970s. Little magazines are literary journals that forgo commercial appeal in order to provide a forum in which radical, experimental, and generally nonmainstream writing may be read. Their subscriptions are exponentially lower than those of commercial magazines. While the black little magazine tradition reached as far back as the turn of the

twentieth century, individual periodicals "proliferated as they never had before" in the 1960s.[14] The founding years of these periodicals track the rise of the Black Arts movement: New York's *Liberator* in 1961, *Umbra* in 1963, and *Black Creation* in 1970; the Bay Area's *Soulbook* in 1964, *Black Dialogue* in 1965,[15] and *Journal of Black Poetry* in 1966; and Chicago's *Nommo* in 1969. Several periodicals were connected to writers' groups. *Umbra*, for example, published work by the Umbra collective, whose members included Tom Dent, Rosa Guy, and Harold Cruse, while *Nommo* came out of the Organization of Black American Culture (OBAC), whose members included Don L. Lee (later Haki R. Madhubuti), Sonia Sanchez, and Fuller himself. Whatever their origin, these little magazines fashioned themselves as race-conscious alternatives not only to the white literary establishment but also to black middle-class sensibilities. They constituted the Black Art movement's avant-garde (Figure 9.1).

Yet what made this avant-garde print format distinctive was, paradoxically, its inclusiveness. Unlike white modernist little magazines, which had tended to be bastions of exclusive coteries, black little magazines took up an expansive charge: to connect with ordinary people in the community. *Nommo* was exemplary of this practice insofar as it regularly showcased work that had been produced under OBAC's auspices. Its third issue, for example, featured poetry by the group's young writers' workshop. In one poem, fourteen-year-old Denise Phipps wrote about Chicago's long-serving mayor as he "walk[ed] down some white neighborhood" in his "Sunday best":

He was elected Mayor you know
But
Most of the people who voted for him
Were Black[16]

The long pause in this stanza pointed up the irony of Richard J. Daley appealing to his white constituents while ignoring his black electoral base. In the next stanza, Phipps mapped out the contradiction at a macro level. Contrasting the presumably clean "white neighborhood" to a vermin-infested black one, she intuited that the former's prosperity was made possible by the latter's perpetually ignored blight. For *Nommo*, it mattered little that Phipps was not a professional poet. More important was how she tapped into her everyday observations to make a poetic statement on behalf of the people.

Tellingly, Fuller edited this very little magazine. Johnson Publishing Company's offices were only a short train ride away from the South Side neighborhood that OBAC called home. And so, in the early 1970s, Fuller was able to work on *Black World* and *Nommo* simultaneously. A nimble and pragmatic editor, he

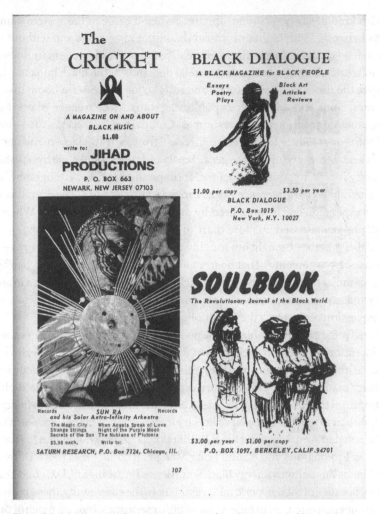

Figure 9.1. Advertisements for various little magazines, from *Journal of Black Poetry* 1, no. 14 (1970–1971).

saw complementarity at scale where Alhamisi could only see contradiction in motive or intention. While doing as much as possible to turn a capitalist venture into a mouthpiece for radical aesthetics, Fuller found the time to promote the arts in his own neighborhood and community for nary a profit. The ability to negotiate the commercial demands and institutional responsibilities of publishing was a distinguishing trait of the Black Arts system of literary production and circulation.[17]

This kind of savvy was more apparent when it came to the system's small press network. With higher overhead than little magazines and without the guaranteed income of subscriptions, small presses, in order to remain solvent, had to keep a close eye on the commercial demands of the black book market. Despite the pressure, the late 1960s and early 1970s witnessed a boom in such ventures. Donald Franklin Joyce's publishing statistics help us see where these companies concentrated their resources. Comparing the periods 1900–1960 and 1961–1974, Joyce identifies an increase from 9 to 16 black-owned book publishers. More revealing is the genre breakdown of this spike, with publishers of poetry increasing from 2 to 9, long-form nonfiction 6 to 15, biography and autobiography 3 to 5, reference works 2 to 6, and novels 2 to 4. The overall effect of this expansion can be measured by publishers' total title output. Whereas small presses released no more than 30 titles between 1965 and 1969, Joyce calculates that they brought out roughly 165 titles between 1970 and 1974—an increase of 550 percent.[18] That poetry and nonfiction account for much of this upsurge indicates the importance of Black Arts—known for its focus on immediacy and expressivity, and for its support of poetic and polemical genres—to the expansion of the black literary public.

Small presses were established by poets and writers themselves, often with the intention of publishing their own work. Far from a vanity undertaking, however, these artists conceived their mission as communicating directly with ordinary readers. If the white literary establishment had long alienated black writing from the wellspring of its inspiration, the new publishers sought nothing less than to repatriate the black literary imagination. Notable presses in this mold included Amiri Baraka's Jihad Productions (Newark), Agadem L. Diara's Agascha Productions and Naomi Long Madgett's Lotus Press (both Detroit), and Ahmos Zu-Bolton's Energy BlackSouth Press (Washington, D.C., and Louisiana). Because of their hyperlocal investment in the community, these presses' scale of operation tended to reflect that of little magazines. Indeed, much of their output (pamphlets, chapbooks, and the like) circulated like ephemera. That was a boon for regional literary publics, but it also meant that small presses only infrequently made an impression at a national level.

But two houses bucked that trend by dint of their editors' commercial savvy. The first was Dudley Randall's Broadside Press, based in Detroit. Established in 1965, the press took its name from the individual poems that Randall had printed on 8½" x 11" broadsides. The format was a cheap and convenient way for him to post and circulate politically minded poetry in public. The first six broadsides, consisting of two poems by Randall and one each by Robert Hayden, Margaret Walker, Melvin B. Tolson, and Gwendolyn Brooks, were known as the "Poems of

the Negro Revolt." The phrase signified a turn away from the civil rights strategy of nonviolent resistance and toward a more militant confrontation with racism and, indeed, racial terror.[19] The broadsides' popularity with readers, in Detroit and across the country, persuaded Randall to expand his homegrown operation. By the late 1960s, he had published broadsides for up-and-coming poets, including LeRoi Jones, Sarah E. Webster Fabio, and Etheridge Knight, as well as chapbooks that were about as affordable as the one-page sheets, including James A. Emanuel's *The Treehouse and Other Poems* (1968), Don Lee's *Don't Cry, Scream!* (1969), and Sonia Sanchez's *Homecoming* (1969).

Broadside became the Black Arts movement's small press of note between 1970 and 1975. Randall's company contributed the most individual publications to the black literary public during this five-year period. Historian Julius E. Thompson breaks down the numbers accordingly: 59 new broadsides by 81 different poets (with multiple poems appearing on several); 5 oversized posters; 36 individual volumes of poetry, 10 of which were by black women; 5 anthologies of poems; and 17 books in 7 other genres, including 5 works of literary criticism, 3 autobiographies, 2 books for children, and a cookbook. As if that were not impressive enough, between 1968 and 1975 Randall published 25 books on tape—that is, recordings of poets reading their own work. Emanuel, Lee, Sanchez, and Brooks each recorded two sessions for Randall; Lance Jeffers, Clarence Major, and Nikki Giovanni were among those who sat down for one.[20] In the aggregate this output says a lot about how Randall approached marketing to a black literary public. Black writing, for him, was not a disembodied phenomenon; it involved sight, sound, and touch, and invited the reader to embody (or body forth) its aesthetic aims.

The other small press to have made a national impression was based in Chicago. In 1966 longtime artist, curator, and activist Margaret Goss Burroughs persuaded Don Lee to self-publish his first collection of poems, *Think Black*. The first run of six hundred copies sold out in no time. According to literary historian James Edward Smethurst, this experience led Lee to believe that "an African American audience for serious, politically engaged literature by black authors not only existed but was hungry for such work."[21] Burroughs then introduced him to Dudley Randall, whose press became an inspiration for Lee's own. In 1967 he and two other members of OBAC, Carolyn Rodgers and Johari Amini, cofounded Third World Press from Lee's apartment. The next year the press brought out Rodgers's *Paper Souls* and Amini's *Black Essence*, collections of poetry, as well as Lee's broadside "For Black People (And Negroes Too): A Poetic Statement on Black Existence in America with a View of Tomorrow." Again, black readers were more than willing to support this program of independent

book publishing. Third World Press expanded, and although Lee lacked Randall's contacts with an older generation of black poets, he made up for it by drawing on a youthful cadre of Chicago writers and artists.

Though Third World did not publish as much as Broadside, it boasted the most robust editorial vision of any small press, promoting the ideology of cultural nationalism. Lee enjoyed continued success with poetry books like *Juju* (1970) by Askia Muhammad Touré (Roland Snellings), *It's Nation Time* (1970) by Amiri Baraka, and *Affirmations* (1971) by Ifeanyi Menkiti. Other poets showed off their genre flexibility by collaborating on illustrated children's books for the press, notably Mari Evans with *I Look at Me!* and Gwendolyn Brooks with *The Tiger Who Wore White Gloves, or, What You Are You Are* (both 1974). But what Third World Press became best known for was its nonfiction, which brought cultural nationalist principles to bear on different prose genres. Prime examples were: George E. Kent's *Blackness and the Adventure of Western Culture* (1972) and Chancellor Williams's *The Destruction of Black Civilization* (1974), revisionist histories (Figure 9.2); Madhubuti's *Kwanzaa* and Baraka's *Kawaida Studies* (both 1972), sociocultural treatises; and Hoyt Fuller's travel memoir *Journey to Africa* (1971). These Third World titles became fixtures at black bookstores and public libraries, and readers' engagement with them sowed the seeds for anti-Eurocentric discourses such as Afrocentrism and multiculturalism.

Cultural nationalist ideology was also popular on college campuses, which brings us to a final key ingredient of the post–civil rights literary public: the black student movement. This nationwide protest action did more than just call for the integration of predominantly white college campuses. Instead, black students sought nothing less than the transformation of higher education in America. How could universities expand their missions to address the needs of underserved communities? What curricular changes did colleges need to make to stem their reproduction of the class structure of racial hierarchy? Who did society deem deserving of higher education, and what good was an education like that for? These questions animated black student activism in the late 1960s. As some of their proposals gained traction and black college enrollment swelled in the early 1970s, students demanded the seemingly impossible: "a role in the definition and production of scholarly knowledge."[22] Allied with black faculty, students' pursuit of this demand led to the creation of Black Studies centers, programs, and departments across the nation.

In addition to supporting the work of small presses, the black student movement spurred the publishing arm of activist nonprofit institutions. *The Black Scholar* is a case in point. Cofounded by academics Nathan Hare and Robert Chrisman in 1969, the journal was an independent political undertaking from

Figure 9.2. Advertisement for Third World Press, from *Black Books Bulletin* 1, no. 4 (1973).

the outset. Hare and Chrisman, both black, had been terminated from their teaching positions at San Francisco State College (now University) after participating in a months-long student-faculty strike against the administration. The prime motive for this action—"one of the longest, if not the longest, in the history of American universities," Chrisman recalls[23]—was to agitate for a Black

Studies academic unit at the college. The administration eventually agreed to set up such a unit, but Hare and Chrisman paid for the victory with their jobs. After their firing, and despite Chrisman's later reinstatement (off the tenure track), the duo identified the need for a Black Studies journal that would not be beholden to white institutional politics.

True to their vision, *The Black Scholar* pioneered interdisciplinary scholarship, particularly in the fields of literature and the arts. The criticism it published abjured a genteel definition of letters and embraced instead an encompassing definition of culture as "not only arts and behaviors, but the collective thrust of a people, as manifest in their tools, their values and their habits."[24] By thus situating literature and the arts within the matrix of black culture, the journal helped scholars understand what motivated black artistic creation beyond the search for white approval. *The Black Scholar* also published what might be thought of as early black cultural studies—that is, critical accounts of the aesthetics of everyday life. Notable articles in this vein included William H. Wiggins Jr. on Jack Johnson's embodiment of the sporting life, Hortense J. Spillers on the rhetoric of the black sermon, and Roland S. Jefferson on the art and politics of graffiti.[25] Encouraged by the student movement's pursuit of autonomous, community-building knowledge, this fresh approach to criticism urged readers to displace white standards of judgment with black modes of cultural understanding. It was a completely different way of evaluating the uses and value of black art.

Another institution to be galvanized by campus activism was the country's sole black university press. Founded in 1972, Howard University Press was not the first of its kind, but it was the first to commence operations in the postwar era. Its executive director was Charles F. Harris, a former editor at Doubleday and Random House. In making the move from New York to Washington, D.C., Harris identified an "opportunity to speak for ourselves—to tell something about our lives." Through his work experience, he had seen how mainstream publishers did not hire the editorial talent necessary to acquire, develop, and publish black-authored books. This lack of support, Harris continued, was belied by the fact that the black reading public was emerging as a distinct demographic:

> A whole new group of readers has been developed by black schools. . . . Black teachers at black colleges have different reading habits. Black students demand reading material that tells them about their past and a lot of this is not available. Our aim is to reach several levels of the reading public—professionals, students, parents.[26]

Attuned to the curricular and cultural changes brought about by campus activism, Harris aimed to make Howard University Press a beacon of black book publishing.

Like many other operations in the Black Arts system, Howard University Press was committed to genre diversity. Whereas previous black university presses had focused on educational and scientific literature, Harris quickly built a catalogue that spanned the black literary public's spectrum of preferences and tastes (Figure 9.3). The first year alone saw the publication of: Larry Neal's *Hoodoo Hollerin' Bebop Ghosts* and Nikki Giovanni and Margaret Walker's *A Poetic Equation*, books of poetry; Lindsay Barrett's *Song of Mumu* and Oliver Jackman's *Saw the House in Half*, Afro-Caribbean fiction; and Arthur P. Davis's *From the Dark Tower* and Houston A. Baker Jr.'s *Singers of Daybreak*, works of African American literary criticism, one by a longtime Howard professor (Davis) and the other by his former undergraduate student, now a professor in his own right (Baker). Three years later, in 1977, Harris reported that the press was holding up even as "other presses were failing."[27] Having published 16 books in 1974 and 14 per year since, Harris was managing an operation that, as far as scale and sales were concerned, only Johnson Publishing Company's Book Division could surpass.

By the early 1970s, the Black Arts system of literary production and circulation had swelled to include avant-garde, commercial, and educational-institutional segments. But how were readers to keep track of developments across these segments? What was the common ground on which the black literary public could be recognized as a socially cohesive entity? In 1971, Don Lee provided an answer in the form of a periodical digest of the black publishing scene: *Black Books Bulletin*. A product of Lee's Chicago nonprofit, the Institute of Positive Education, the quarterly journal assumed the role of clearinghouse for the latest information about black books, pamphlets, journals, and little magazines. The *Bulletin* had two specific departments that spoke to the cohesiveness of the black literary public: "News from the Publishers" and "Biblio One." The first checked in with presses around the United States about their latest titles and forthcoming projects. The second featured what the journal explained was a "continuing bibliography of books published by and about Blacks";[28] on occasion it was ordered by topic or theme and subcategorized by genre. Doubling as a teacher's or librarian's research tool, Biblio One was the historical complement to the news section's emphasis on contemporary publishing. Together, the departments could be said to have highlighted the general abundance of the black literary past, present, and future.

Black Books Bulletin was not a neutral forum, and it hardly pretended to be one. Editorially it hewed to Lee's, later Madhubuti's, cultural nationalist principles. The white literary establishment would have balked at such explicit partisanship, but this turned out to be the *Bulletin*'s virtue. By announcing its politics, the journal identified the conditions for the Black Arts system of literary production and circulation to exist at all. Take, for example, Yakie Yakubu's critical review

Figure 9.3. Advertisement for Howard University Press, from *Black Books Bulletin* 2, no. 1 (1974).

of *Conversation with Eldridge Cleaver* (1970), a white photojournalist's interview with the Black Panther in exile. "Don't buy this book," Yakubu warned, "if you're expecting some clear cut analysis, some detailed, systematic program, giving us, some idea even, of how to take the next step in our struggle . . . to develop The Black Nation."[29] By pointing out the incoherence of Cleaver's aggrandizing pronouncements from Algiers, to which he had fled (by way of Cuba) from U.S.

authorities, Yakubu keenly distinguished black liberation from black notoriety, collective interest from personal fame.

But what made the review exemplary of the Black Arts system was the way Yakubu tied this observation to the workings of the literary marketplace. Cleaver, he wrote, "helps to maintain and nourish the system he speaks so eloquently of destroying by allowing Dell Publishing Company to publish the book." He went further, averring that sales of Cleaver's books, including *Soul on Ice* (1968), had indirectly funded reactionary white supremacy in the form of "the bullets that killed Fred Hampton and Bobby Hutton" as well as "the salaries of the fellows who carry out raids on Panther offices."[30] Yakubu was not mincing words, then, when he advised readers to pass up buying the book. For him, and for the *Bulletin*, what we choose to (buy and) read is itself a political act. Cleaver's status as the darling of the post–civil rights white literary establishment made him an agent of racial capitalism.

Notwithstanding the strident tone taken up by some contributors, the *Bulletin*'s commitment to cultural nationalism fostered a genuine ethos of self-love and community uplift. This fundamentally hopeful outlook characterized the *Bulletin*'s regular feature "Books for the Young" (Figure 9.4). Nominally a survey of recent titles in children's and young adult literature, the feature in fact constituted a space to value black youth. Take, for example, Adisa Kokayi's review of the Broadside book by Gwendolyn Brooks:

> *The Tiger Who Wore White Gloves*—is this our Sister Gwen? Indeed it is—acknowledging her Afrikaness [*sic*] and sending out powerful, positive messages to our children—our future. And, that makes up the other half of the title, *What You Are You Are*. It's really an old bit of wisdom, but the sister from her redefined frame of reference, re-energizes it and brings more meaning of it to our young.[31]

Writing from within a spirit of communal belonging ("our Sister Gwen," "our future," "our young"), Kokayi's mode of address erased the presumed distances between author, critic, and reader. In her account, these three subject positions melded into a unifying concern for "our children." This was a way of talking about books that put community well-being at the very center of its literary discourse. Perhaps more than any other feature in *Black Books Bulletin*, "Books for the Young" articulated the terms by which the black literary public would remain a socially cohesive entity.

The constellation of black-owned publishing operations that made up the Black Arts system of literary production and circulation shined its brightest in the early 1970s. Commercial and institutional interests aligned during these years to overcome the white literary establishment's long-held claim to African

BOOKS FOR THE YOUNG

Figure 9.4. Section break for "Books for the Young," from *Black Books Bulletin* 2, nos. 3–4 (1974).

American letters. The transformation from what had been published previously to what could appear under the banner of Black Arts was undeniable. That went for different types of books and periodicals, but it also applied to how criticism and reviews discussed black literature. Behind it all was the core belief, embraced by publishers and writers, that black readers' diversity of preferences and tastes could sustain an alternative literary marketplace.

* * *

What, then, led to the decline of this system in the middle of the decade? Two articles in the March 1975 issue of *Black World* sought to provide an answer. The first, by novelist John A. Williams, spelled out the predicament in its title, "Black Publisher, Black Writer: An Impasse." Williams was pessimistic about the state of black book publishing. From exploitative contracts and nonexistent advances to editorial hang-ups and production delays, black-owned presses, he charged, had abused their power over the literary public. "When it gets down to bread-time," Williams scoffed, "a lot of Black publishers are out to lunch—and they stay out to lunch." He did offer a possible solution to these alleged abuses: "A consortium of Black publishers could blanket the nation as effectively as any white publisher—and certainly far better in Black communities."[32] Until such a venture could be coordinated, however, the circumstances would remain dire. Williams ended his piece by encouraging writers to join the Authors Guild, on whose council he, Toni Cade Bambara, and Toni Morrison sat. The mainstream professional association, he suggested, would assist writers in reviewing royalty statements and contracts; with such knowledge, they could contest publishers' alleged malfeasance.

Williams did not name any specific wrongdoers, but Dudley Randall's response, "Black Publisher, Black Writer: An Answer," showed that the words had cut deep. The gist of his article was that Williams's criticism had been misplaced. After all, many black publishers were also working writers and thus could identify with Williams's frustrations. The unfavorable circumstances of black publishing, Randall argued, had less to do with poor business practices than with the incredible constraints under which people like him operated. For one, black-owned presses lacked access to capital, whether in the form of business loans or conglomerate investment. No matter how successful, a black system of production and distribution was anathema to white financial interests. As such, the scale of their operations would always be smaller than that of the white literary establishment. Harper's output in 1972, he noted, had been 1,426 titles; Johnson's Book Division, 5. At any rate, small presses "were started by poets, not by businessmen." Hence, "they were not interested in making money, but in publishing what needed to be published."[33] This point was linked to the question of funding insofar as white-controlled capital did not view black literature as a sound investment. Rather than wait around for white banks to finance them, Black Arts publishers seized the opportunity to publish the work that no one else would.

To Williams's proposal for a black publishing consortium, Randall's retort was barbed: "Does Mr. Williams know about the Combined Black Publishers (CBP), formed in 1972 by Amiri Baraka, Don L. Lee, and other author-publishers?"[34] *Black World* had actually reported on CBP's first annual marketing seminar, held in Chicago the previous year. The purpose of the meeting was for the consortium's founding members—among them Broadside Press, Jihad Productions, and Third World Press—to discuss how they could better serve readers by working collaboratively. Marketing director Beni Casselle explained, "The main reason CBP was conceived . . . is because as long as we don't control distribution, we cannot control prices, let alone the type of material our people receive." To that end, CBP had made plans to welcome more presses into its ranks and to expand its operations by distributing not only to bookshops but to "'mom and pop' stores, beauty shops, churches—wherever Black people congregate." According to Casselle, CBP had already gained distribution rights over "60–65 percent of all serious Black literature being published."[35]

Unfortunately, by the time Randall alerted Williams to CBP, the consortium had basically gone defunct. In the very same issue of *Black World*, Carole A. Parks surveyed the state of black publishing and found that the consortium had been whittled down from 15-member presses to a loose agreement between Broadside Press and Third World Press. Complaints about CBP touched on a lack of personnel and resources to make the venture successful. But, as Parks observed, there seemed to be a more fundamental concern that had led to CBP's demise: "lack of trust." Some members "seemed much more willing to share ideas than financial statements and actual money," while others "feared that some publishers' books would be 'pushed' harder than their own."[36] In other words, members had difficulty seeing how CBP would actualize their mutual self-interest. The economics of it ultimately did not make sense for the presses involved.

The consortium's failure augured bad news to come. A number of black-owned small presses were forced to close by the end of the decade, and the few that remained could only limp through the 1980s. Black little magazines experienced an even sharper decline: no periodical dedicated to publishing Black Arts literature survived past the mid-1970s. With academic subscriptions shielding it somewhat from the vagaries of the market, *The Black Scholar* managed to continue apace. But Howard University Press—again, working with higher overhead and without the benefit of subscriptions—dropped off until it closed permanently in 2011. For its part, Johnson Publishing Company stood by *Ebony* and *Jet*, which continued their respective monthly and weekly print runs until the 2010s. *Black World*, however, was discontinued after the April 1976 issue. Hoyt Fuller hoped it would not be the last word on the movement. He moved

back to his hometown of Atlanta and founded *First World*, a little magazine in the mold of the commercial periodical he had built from the ground up. The venture was short-lived.

Was "lack of trust" to blame for the collapse of the Black Arts system of literary production and circulation? With greater hindsight, publishers identified other causes to Donald Franklin Joyce in 1981. Randall put the matter concisely: "Small presses are still not reviewed by the major white reviewing media."[37] Indeed, with the exception of *Negro Digest/Black World*, the reviewing apparatus of commercial periodicals had stayed away from black-owned small presses. That put a cap on how much these presses could grow, for without the promotion that comes along with reviews, it is enormously difficult for a publisher to attract new readers and expand the audience for its books. Doris E. Saunders, former director of the Book Division at Johnson Publishing Company, agreed that major white reviewing media "no longer feel the national imperative to give even lip service to the recognition of Black writers, and certainly not Black publishers."[38] For a time, black-owned publishing operations had successfully contested the white literary establishment's hold on black writing. But now it seemed as though that tiny window of opportunity was being shut. The establishment was reasserting its control over who got published and how their books would be sold.

In truth, racial capitalism had conditioned the shape of the black literary public from the very beginning. Resisting that mode of political economy had given rise to the Black Arts movement. The system of literary production and circulation that flourished under Black Arts constituted what Michael Warner calls a *counterpublic*: an alternative commons in which daring visions are nourished, minority views are given full voice, and visionary experiments may be carried out.[39] In time, though, and as is the case with any counterpublic, the resistance ran its course. Economies of scale overwhelmed publishers, and no matter how many people participated in the black literary public, owners faced the sad reality that, in Haki Madhubuti's words, "Most banks and lending institutions don't think Black people read."[40] This denigration of black readers was but the latest iteration of white efforts to restrict black freedom; it linked up with the suppression of literacy in the slavery era, after Reconstruction, and over the long history of Jim Crow. Centuries-old racism baked into the system itself: that is what rushed Black Arts to its demise.

Yet perhaps it is acceding too much to racial capitalism to suggest that the Black Arts system was defeated by it. Madhubuti, for one, steered Third World Press through troubled waters; it remains in operation today. Black Studies has become an integral part of the academy, and its literary and cultural scholar-

ship a core feature of college curricula and graduate training. And, not least, scores of poets, writers, and critics who were first published in the late 1960s and early 1970s have kept on writing, albeit in more localized venues. In short, the struggle for black self-determination in literature and the arts is ongoing. Perhaps, then, our assessment of the fate of the post–civil rights black literary public ought to take the long view. The question is not so much how many books sold year after year but what black-owned literary production made possible down the road.

From that perspective, we can begin to appreciate the significance of W. Paul Coates starting Black Classic Press out of the basement of his Baltimore home in 1978. Committed to recovering and reprinting works of black intellectual history, Coates initially photocopied book excerpts and turned them into cheap and handy pamphlets. As his business grew, he could afford to publish long out-of-print books in full. J. A. Rogers, Sterling M. Means, John G. Jackson: these names were kept alive and circulating, as their reprints sold particularly well on college campuses and in black bookstores. Compared to the white literary establishment, his was a modest operation—but one that survives as of this writing. More to the point, the intellectually rich, self-determining ethos of Coates's enterprise had a profound effect on his son. It could be argued that, in a meaningful way, Black Classic Press made possible the rise of the most heralded nonfiction writer of the twenty-first century, Ta-Nehisi Coates.

Notes

1. Robert E. Washington, *The Ideologies of African American Literature: From the Harlem Renaissance to the Black Nationalist Revolt* (Lanham, Md.: Rowman and Littlefield, 2001), 330.

2. Erik Nielson, "White Surveillance of the Black Arts," *African American Review* 47, no. 1 (2014): 164.

3. Donald Franklin Joyce, *Gatekeepers of Black Culture: Black-Owned Book Publishing in the United States, 1817–1981* (Westport, Conn.: Greenwood, 1983), 78, 79.

4. Imamu Ameer Baraka, "A Black Value System," *The Black Scholar* 1, no. 1 (1969): 57, 56.

5. David Llorens, "Ameer (LeRoi Jones) Baraka," *Ebony*, August 1969, 83.

6. Art Simmons, "Paris Scratchpad," *Jet*, December 3, 1970, 29.

7. Advertisement for Ebony Book Club, *Ebony*, December 1969, 22.

8. Howard Rambsy II, *The Black Arts Enterprise and the Production of African American Poetry* (Ann Arbor: University of Michigan Press, 2011), 19.

9. If a poet published more than one poem in a single issue, Semmes counted the cluster as a single entry. So, for example, although Philip M. Royster published three

poems in the March 1971 issue of *Black World*, these are counted as a single cluster and make up one entry in Semmes's bibliography.

10. Clovis E. Semmes, *Roots of Afrocentric Thought: A Reference Guide to* Negro Digest/ Black World, *1961–1976* (Westport, Conn.: Greenwood, 1998).

11. Amini's former name is frequently misspelled "Lattimore." This is the correct spelling.

12. Hoyt W. Fuller, "Toward a Black Aesthetic," *The Critic*, April–May 1968, 70–73.

13. Ahmed Akinwole Ato Alhamisi, "On Spiritualism and the Revolutionary Spirit," in *Black Art, Black Culture*, ed. Joe Goncalves (San Francisco: Journal of Black Poetry Press, 1972), 26.

14. Abby Arthur Johnson and Ronald Maberry Johnson, *Propaganda and Aesthetics: The Literary Politics of Afro-American Magazines in the Twentieth Century* (Amherst: University of Massachusetts Press, 1979), 161.

15. *Black Dialogue* relocated to New York in 1969.

16. Denise Phipps, "Here Come Daley," *Nommo* 1, no. 3 (1972): 13.

17. I elaborate on this idea through the prism of Fuller's dual editorial commitments in "Between the World and *Nommo*: Hoyt W. Fuller and Chicago's Black Arts Magazines," *Chicago Review* 60, no. 1 (2016): 143–163.

18. Joyce, 152–153, 147.

19. The first broadside, Randall's "Ballad of Birmingham" (1963), set the tone for the series. It dramatized a scene between mother and daughter on September 15, 1963, the day white supremacists bombed the 16th Street Baptist Church in Birmingham, Alabama, killing four black girls.

20. Julius E. Thompson, "The Growth of Broadside Press, 1970–1975," in *Dudley Randall, Broadside Press, and the Black Arts Movement in Detroit, 1960–1995* (Jefferson, N.C.: McFarland, 1999), 75–132.

21. James Edward Smethurst, *The Black Arts Movement: Literary Nationalism in the 1960s and 1970s* (Chapel Hill: University of North Carolina Press, 2005), 197.

22. Martha Biondi, *The Black Revolution on Campus* (Berkeley: University of California Press, 2012), 2.

23. Quoted in Leo Adam Biga, "Letting 1,000 Flowers Bloom: Robert Chrisman and the Mission of *The Black Scholar*," *The Black Scholar* 36, nos. 2–3 (2006): 5.

24. Robert Chrisman, "The Formation of a Revolutionary Black Culture," *The Black Scholar* 1, no. 8 (1970): 2.

25. See William H. Wiggins Jr., "Jack Johnson as Bad Nigger: The Folklore of His Life," *The Black Scholar* 2, no. 5 (1971): 34–46; Hortense J. Spillers, "Martin Luther King and the Style of the Black Sermon," *The Black Scholar* 3, no. 1 (1971): 14–27; Roland S. Jefferson, "Black Graffiti: Image and Implications," *The Black Scholar* 7, no. 5 (1976): 11–19.

26. Quoted in Hollie I. West, "Toward a Black Press," *Washington Post*, November 4, 1972.

27. Quoted in Anne Chamberlin, "The Academic Type," *Washington Post*, September 4, 1977.

28. Table of Contents, *Black Books Bulletin* 1, no. 1 (1971): 2.

29. Yakie Yakubu, review of *Conversation with Eldridge Cleaver*, by Lee Lockwood, *Black Books Bulletin* 1, no. 1 (1971): 30.

30. Ibid., 31.

31. Adisa Kokayi, review of *The Tiger Who Wore White Gloves*, by Gwendolyn Brooks, *Black Books Bulletin* 2, no. 2 (1974): 63.

32. John A. Williams, "Black Writer, Black Publisher: An Impasse," *Black World*, March 1975, 30, 31.

33. Dudley Randall, "Black Writer, Black Publisher: An Answer," *Black World*, March 1975, 33, 33–34.

34. Ibid., 26.

35. Quoted in Carole A. Parks, "The Combined Black Publishers," *Black World*, January 1974, 95, 96, 97.

36. Carole A. Parks, "An Annotated Directory: The Black Book Publishers," *Black World*, March 1975, 75.

37. Quoted in Joyce, 129.

38. Ibid., 131.

39. See Michael Warner, *Publics and Counterpublics* (New York: Zone, 2002).

40. Quoted in Joyce, 129.

A Woman's Trip

Domestic Violence and Black Feminist Healing in Ntozake Shange's *for colored girls*

SOYICA DIGGS COLBERT

Tyler Perry's multimillion-dollar film business hinges on his ability to "make it plain," to tell stories in a familiar way. Whether drawing from melodrama or the gospel play traditions, Perry produces narratives that his audiences presumably have heard before and yearn to hear again. In *For Colored Girls*, an adaptation of Ntozake Shange's *for colored girls who have considered suicide/when the rainbow is enuf* (1974), Perry takes on another, unfortunately, all too familiar, story about violence against black women. Although the narrative of violence against women, particularly black women, was not commonplace in the mid-1970s when Shange introduced her play to the world, it has now become a more pronounced part of the national narrative. Nevertheless, the everyday reality of violence against women (worldwide, one in three women have experienced either physical and/ or sexual violence in their lifetime) remains less visible in national narratives. The surprise and questions that ensued when women stated that Bill Cosby raped them or claimed that Hollywood producer Harvey Weinstein raped and sexually assaulted them reveal a critical blind spot about the probability that many men physically and sexually assault women.[1] In response to the allegations against Harvey Weinstein, the hashtag #metoo began to circulate on social media to make visible the pervasiveness of sexual harassment and assault in American culture. The high number of victims should create an expectation for testimonies rather than evoke surprise.

Narrative serves a vital purpose in challenging the conscious refusal to ac-
knowledge the violence that structures women's lives. It functions to circulate
experiences of violence that pervade black women's experience and lack leg-
ibility. As Shatema Threadcraft argues in *Intimate Justice: The Black Female Body
and the Body Politic*, "Freedom for black women from such severe violations of
negative liberty as rape will require positive liberty-style support to deconstruct
and then reconstruct the meaning of black womanhood. This might mean sup-
porting black women's representational work—the work of black women and
even black feminist filmmakers, storytellers, visual artists, and even advertis-
ers."[2] Threadcraft goes on to argue that representational work will not alone,
but serves a vital part to, obtain corrective justice.

The representational work that Shange's choreopoem performed emerged
within a context that had heretofore denied black women's bodily autonomy.
In 1974, for the first time, a jury acquitted a woman, Joan Little, for using deadly
force to resist sexual assault. In the mid-1970s, Shange's Tony Award–win-
ning play captivated audiences not only because it revealed the then hidden
story of black domestic violence, but also because it introduced the world to
the choreopoem—an avant-garde form that mixes spoken word poetry and
dance. Shange's dramatic work depicts the coming of age of seven black women
whose names are the colors of the rainbow: lady in brown, yellow, orange, red,
purple, blue, and green. In the play, women experience violence, loss, betrayal,
laughter, and love. Quotidian joy shapes their lives and sustains them through
the regular experience of violence. Most importantly, they learn how to come
together as women to create a supportive community. As Terrion L. William-
son argues in this volume, women writers of the 1970s theorized the specific
constraints and capacities of black women, but, as Williamson also notes, black
women writers dating back to the nineteenth century have expressed how so-
cial, economic, and cultural specificity shapes black womanhood (see Chapter
8 of this volume). Coming together, or what the play describes as "a layin on
of hands," concludes the play. The ritual of coming together at the end of the
play recurs in Perry's adaptation and draws attention to how feminist collec-
tivity remains an important mechanism to address communal violence in the
decades between the premiere of Shange's play and the debut of Perry's film.
This chapter argues that the production history, distribution, and reception of
Shange's play extends the black feminist journey central to the narrative. The
ongoingness of Shange's work perpetuates its ability to confront, depict, and
produce strategies and techniques to heal from violence particularized by the
intersectional position of being a woman of color.[3]

In the introduction to the 2010 edition of *for colored girls who have considered suicide/when the rainbow is enuf*, Shange reflects on the history of the work and asserts, "The poems introduce the girls to other kinds of people of color, other worlds. To adventure, and kindness, and cruelty. Cruelty that we usually think we face alone, but we don't. We discover that by sharing with each other we find strength to go on. The poems are the play's first hint of the global misogyny that we women face."[4] Shange's comment explains that the sharing of other worlds among women of color serves as a source of power that disrupts the heterosexual coupling as the privileged form of intimacy. Sharing in the choreopoem takes many forms, including dance, touch, storytelling, and play. The sharing sets the women in motion along a collective journey into each other's worlds and the world of the play that they create together. It is through the journey—an act of recovery and creation—that the women experience hope, healing, and new forms of communal possibility. The world-making the choreopoem produces enables new forms of visibility within the play and to its audience as well, challenging how black women see themselves and each other, and how they are seen.

Shange's choreopoem begins with trauma, what she calls "dark phases of womanhood / of never havin been a girl" (17), to establish violence's centrality to women of color's development. The title of the choreopoem functions as the first act of recuperation, recovering the lost girlhood denied the characters. lady in brown speaks the first poem, which describes the collective experiences of a foreshortened childhood. In response to lady in brown's depiction of demonization and her cry for "somebody / anybody" to "sing a black girl's song" (18), the other women locate themselves saying, "i'm outside chicago," "i'm outside detroit," "i'm outside houston," "i'm outside baltimore," "i'm outside san francisco," "i'm outside manhattan," and "i'm outside st. louis" (19). The cities function as approximate starting points for the worlds that the women will build through the choreopoem. A transgressive choice on Shange's part to send her characters on a journey when "the forces of poverty and sexism in the inner cities of the 1970s, no less than the pull of bourgeois propriety during the 1920s, kept women close to home."[5] The journey challenges the structures governing the lives of women of color, which render them isolated and vulnerable.

The women, "half-notes scattered" from Manhattan to San Francisco, form a constellation of voices at the rise of the choreopoem to establish their diversity and commonality. All of the women are "outside" some major U.S. city but the cities differ. The commonality and difference in location points to the growing understanding in the late twentieth century that women of color's experience as individual and particular *and* similar and collective.[6] The productive tension

Figure 10.1. Actresses (L-R) Paula Moss, Trazana Beverly, Aku Kadogo, Sert Scott, and Rise Collins in a scene from the New York Shakespeare Festival's production *For Colored Girls*, 1976, New York Public Library, Billy Rose Theatre Division. Photographer Martha Swope.

between acknowledging the particularity of an experience and understanding how that experience fits into a set of experiences would form the basis for women of color feminism and place the work of these women in conflict with black nationalist rhetoric that attempted to prioritize racial identity as *the* identity in difference. It would also enable women of color to narrate their journeys through life as a part of a tradition that rendered their experiences legible, recognizable, and coherent; a harmony rather than "half-notes scattered."[7]

A journey entails a geographical and temporal shift that emerges in *for colored girls* through the women's relationship to violence. Shange explains, "*for colored girls* . . . is a women's trip, and the connection we can make through it, with each other and for each other, is to empower us all" (11). Her use of the word *trip* reinforces her categorization of the dramatic work as a journey—a set of movements that occur over time and throughout space and provide the context to address the women's pain. *Trip*, in the colloquial sense, describes an arduous experience or person; Shange's use of the word also signals the nature of the transformation the women experience, including shifting the physical,

emotional, and psychic state that "dark phrases" represent (17). The choreo-poem offers a narrative and physical response to the representation of women of color as "ghouls," "children of horror," and "the joke" to reclaim the discursive terrain for them and their daughters. (18). By examining both the choreopoem as a journey as well as the choreopoem's journey, we can elaborate the way it has participated in decades of black feminism. In addition, the concept of *journey* accounts for how the choreography, central to Shange's work, transforms the body through movement.

I. Circulation

An analysis of the production history of *for colored girls* further explains why Shange describes the dramatic work as a trip. The choreopoem takes theater-makers (playwright, director, and actors) and audience members on a journey to recover the stories that silence women of color and provide room for them to make new worlds. Shange's choreopoem emerged in the midst of a chang-ing aesthetic landscape. As Samantha Pinto argues in Chapter 6 of this vol-ume, contemporary aesthetic movements—postmodernism, which did "not rely solely on literary realism" and the Black Arts Movement (BAM), which sought: "1. To create a true Afro American Art. 2. To create a mass art. 3. To cre-ate a revolutionary art"—influenced and diverged from Shange's project.[8] Due to its episodic nature, the choreopoem does not adhere to the tenets of dramatic realism, which focus on communicating the psychological interiority through a character developed over time. Shange's work also challenged the claims to authenticity at the heart of the BAM, centering attention on the multiple and divergent perspectives of women of color.

The production history of *for colored girls* details a process that shaped the black feminist aesthetic qualities of the work, neither squarely postmodern nor within the mandates of the BAM. Shange describes the transformation of the choreopoem from a set of poems to a play. It began as a spoken word piece that she first performed with dancer Paula Moss in 1975 at the Studio Rivbea's Newport Jazz Festival in New York City. Shange's sister playwright Ifa Bayeza attended the show and reiterated to Shange "to let theatre artists" perform her work: "As a committed solo spoken-word artist, [Shange] was suspect and re-sistant" (2). She did not understand how her work would translate as drama and questioned ceding some of her artistic control to a director. Apprehension aside, Bayeza convinced Shange to consider working with a team that would trans-form her "solo voice . . . to many voices" (3). Shange began collaborating with director Oz Scott and the women that would form the cast: Moss, Aku Kadogo,

Figure 10.2. Actresses (front L-R) Laurie Carlos, Paula Moss, Aku Kadogo, Trazana Beverly; (top L-R) Rise Collins, Janet League, Seret Scott. In scene "For Colored Girls Who Have Considered Suicide/ When the Rainbow Is Enuf," 1976, New York Public Library, Billy Rose Theatre Division. Photographer Martha Swope.

Laurie Carlos, Trazana Beverley, Janet League, and Rise Collins. The development of the play required Shange to relocate (she moved from the Bay Area to New York City) and reimagine the work as drama. Although Shange's aesthetic principles differed significantly from her peers in the Black Arts Movement, her work demonstrated that "black feminism asserts self-determination as essential."[9] Self-determination did not, as Shange learned, necessitate singularity. The feminist process of collaboration that Bayeza set in motion introduced a guiding principle that would inform the shape of Shange's dramatic work and its lasting impact.

By multiplying the voices, Shange's work shifts the focus from an individual to a collective in order to draw attention to a decentralized form of making cultural and political change. The aesthetic of the choreopoem resists the singularity often associated with poetry or a novel and focuses attention on how collectives become central to the political and cultural work at the heart of third-wave feminist practices. As Robert J. Patterson outlines in the introduction to this volume, the impulse toward individualism and individual success

Figure 10.3. Actresses (L-R) Rise Collins and Aku Kadogo in a scene from the New York Shakespeare Festival's production *For Colored Girls*, 1976, New York Public Library, Billy Rose Theatre Division. Photographer Martha Swope.

as a fundamental principle of neoliberalism ascended in America during the Ronald Reagan Administration (1981–1989). It appeared as a response to the economic downturn in the 1970s but actually sought to retract the cultural and social opportunities made available to people of color as a result of social safety nets and modest structural changes through governmental programs such as Affirmative Action (1961, 1965, 1967). Reagan's economic policies of tax cuts,

defense spending, and deregulation functioned to challenge the incursion of "the welfare state" and "roll back the post-war [WWII] 'settlement' and restore the prerogatives of capital."[10] The correlation of freedom with the maximization of profits prioritizes individual gain, competition, and personal success. The policy shifts sought to dismantle the civil rights collectives by correlating success to individual choice, which renders a few black people exceptional citizens (O. J. Simpson, Oprah Winfrey, Bill Cosby) and far more social scapegoats. In the late twentieth century, black women personified the failed social safety net by being stereotyped as lazy welfare queens.[11]

for colored girls offers a strategy of embodied collectivity that challenges neoliberal modes of individualism that perpetuate violence by isolating victims and blaming individuals for the violations they experience. The choreopoem offers a theoretical intervention as well as a practice that fundamentally challenges neoliberalism by focusing on collectivity as an organizing structure of the women's journey. *for colored girls* participates in the collective practice that is fundamental to all theatrical work. But the ways the choreopoem enacts collectivity by voicing the experiences, traumas, and perspectives of women of color through word, song, and dance establishes how this collaborative process functions as a black feminist one.

Shange's dramatic work makes use of the transformative possibilities of the theatrical space. Once in New York, Shange workshopped *for colored girls* at Studio Rivbea, the Old Reliable, and Demonte's before it began to run at the Henry Street Settlement's New Federal Theatre in July 1975. She describes "opening night" at the Settlement House, which "became a divine space, supplicants flocking from everywhere" (7, 8). Shange's description of the space as "divine" acknowledges how the work harnessed the uplifting possibility of collaboration and community to expose the shaping force of racial, sexual, and domestic violence without giving such violence the power *only* to define women of color. The success of the work enabled the choreopoem to move from Henry Street Settlement House to the Joseph Papp Public Theater in June 1976. It also evidenced an audience hungry for women of color artists to tell stories that shifted focus from the racial solidarity at the heart of the Black Arts Movement to the intersectional oppression women face.[12]

The reception of *for colored girls* following its Broadway premiere on September 15, 1976, chronicled in mainstream periodicals and academic journals, demonstrates the nerve the play struck by depicting violence against women of color that men of color perpetrated. A *New York Times* story about Trazana Bradley emphasizes the popularity and punch of Shange's dramatic work. The author notes that, after Bradley performs the poem "a nite with beau willie

Figure 10.4. A Scene from "For Colored Girls Who Have Considered Suicide/When the Rainbow is Enuf," 1976, New York Public Library, Billy Rose Theatre Division.

brown," which occasions Brown dropping his children from the apartment window, "audible sobs" are heard from the audience.[13] "a nite with beau willie brown" punctuates a set of experiences in the choreopoem that depict the "three-fold anguish of being young, black, and a woman."[14] Edwin Wilson for the *Wall Street Journal* says Shange "articulates this anguish with wit and insight."[15] The resounding praise from the mainstream white press did not echo in black periodicals because the latter often focused on how the work issued a challenge to black people's investments in and desires to perpetuate patriarchy.

The criticism of Shange's work evidences the discursive violence that functions to individuate women of color from one another. Shange notes, "not everybody found solace in my work. There was quite a ruckus about the seven ladies in their simple colored dresses. I was truly dumbfounded that I was right then and there deemed the biggest threat to black men since cotton pickin' and not all

women were in my corner either. The uproar about how I portrayed black men was insidious and venal. I was said to hate men, especially black men" (10). The vitriol calls attention to how racial solidarity required women of color to hide the systematic and persistent violence that a patriarchal society produces. The categorization of the choreopoem as a threat to black men in general ratifies the false reasoning of neoliberalism "that in order for the black man to be strong, the black woman has to be weak" because it situates competition as the basis for thriving.[16]

While building a woman-centered world, which does not oppose men, *for colored girls* challenged the implicit mandate of racial coalition that race supersedes any other form of commonality, including gender, sexuality, and class—a claim that too often and too long had governed the organization of cultural and political movements for human and civil rights. An August 27, 1979, *Newsweek* article, "A New Black Struggle," credits Shange's choreopoem and Michele Wallace's feminist text, *Black Macho and the Myth of the Superwoman* (1979), with making a private and ongoing conversation in the black community more public.[17] The article quotes M. Ron Karenga, who "teaches a course on the black family at California State University at Los Angeles," saying, "If there is a competition between black men and women it is not conscious. It is a competition placed there by whites to divide us, and books like 'Black Macho' and plays like 'For Colored Girls' only help to divide us, while flattering the white oppressor."[18] Karenga's critique misplaces blame by implicitly evoking unity among black people without addressing the discursive, physical, and psychic violence black women bear to enable it. The structuring principles of Karenga's unity requires gender hierarchies based on competition. If they did not, black women telling women-centered narratives would multiply the articulation of black experience (and not divide it). Wallace and Shange's work cause a rift only if patriarchy produces the union. In the same article, Harvard University psychiatrist Dr. Alvin Poussaint is quoted saying, "Black women changed the notion of what they wanted and it confused men" (58). The *Newsweek* article focuses on black middle-class women's earning potential as the primary cause of the "new struggle" in the black community. Although Shange's play focuses on women of color creating feminist communities by sharing their stories and engaging with one another, her play does not reinforce the class hierarchies that threaten the cohesion of the middle-class black family ideal predicated on the exceptional achievement of a few individuals. It troubles such distinctions to call attention to how women create community across difference. It is curious then that the article cites the dramatic work as a touchstone for black women's purported domination of black men without considering any of the ways the

play details men violently dominating women, while altogether oblivious to double jeopardy.[19]

Similar to the *Newsweek* article, the May 1979 issue of the journal *The Black Scholar* stages a conversation about black sexism, but it includes feminist voices. The issue followed the journal's publication of sociologist Robert Staples's essay, "The Myth of Black Macho: A Response to Angry Black Feminists," which directly engages the work of Shange and Wallace. In the essay, Staples establishes that Shange and Wallace are middle class, which perhaps implicitly forms the connection that the *Newsweek* article makes between their work and the rise of contention among black middle-class men and women. Staples's essay makes three central points: that the work of Shange and Wallace (1) does not fairly represent a black male point of view, (2) misrepresents the oppression of black women, and (3) does not fully account for the economic and familial structures that inform black people's experiences.

Staples's critique evidences the historiographic intervention of Shange's work. He builds his argument on historical assumptions that the writing of women of color feminists corrects. He claims, "Unlike other minorities who suffered physically at the hands of their oppressor, women were generally a protected group that was revered by men and children alike."[20] His argument requires forgetting how physical domination of women through rape from slavery to the civil rights movement shaped American society, history, and culture.[21] The memory projects of third-wave women of color feminists challenge the impulse to forget by recovering the voices and stories of women of color from the nineteenth to the early twentieth centuries. In addition, Staples claims, "Ms. Shange does not care to tell us the story of why so many black men feel their manhood, more accurately their feeling of self-respect, is threatened by black women."[22] The idea that a single story can or should represent an entire race reinforces the domination of normative identities and social structures that serve to oppress any identity in difference. Furthermore, his depiction of *for colored girls* fundamentally misunderstands the aims of the work. He asserts, "What is curious is the reaction of black women to this play. Watching a performance one sees a collective appetite for black male blood."[23] The violent appetite Staples ascribes to Shange's audience coincides with a denial of violence against black women in the present and historically.

In many ways, Staples's essay exemplifies the failures that he attributes to the work of Shange and Wallace, particularly in his claim that the structures that govern oppression, primarily capitalism, differ in their impact on black people's experiences. He writes, "Because white women are opposed to the sexist behavior of white men in the form of their complete domination of them,

some middle-class black women assume that the analogous counterpart can be found in black culture. But, the structural underpinnings for sexism are not the same in black society."[24] The analysis does not, unfortunately, account for the ways structures of capitalism manifest over time and serve to inform the appearance of race and gender as overlapping categories. Read historically, his argument anticipates the lasting impact of Shange's work because it reveals the fundamental misunderstanding about the experience of women of color that the choreopoem addresses alongside the work of other third-wave feminist texts.

The May/June 1979 issue of *The Black Scholar* presented responses to Staples's essay that detail the history of black feminist activism and debate the primacy of capitalism as a system of oppression.[25] Shange's dramatic work helped to inspire a national conversation about black women's fundamental and historical role in liberation movements that focused on the overlapping systems of racial, gender, and class-based oppression and the "differences in mechanism used to oppress and exploit" black women.[26] Shange and the women writers of the 1970s and '80s, however, focused attention on the ways male and heterosexual privilege contributed to the oppression of black women and women of color.

The literature about violence against women and the reception of it as anti-men raise important questions about the way power circulates and the fundamental need to rethink individual ascent as a marker of freedom. Black men thriving within a heteronormative patriarchal structure comes at the expense of women, because patriarchy-hierarchal structures manifest themselves as systems of domination and violence. The notion that calling attention to such structural violence betrays racial solidary further perpetuates the violation.

II. Representing Violence, Representing the Race

The production history of Shange's work includes two films that struggle to realize the promise of the choreopoem as a form. The reviews of the 1976 production note the sparseness of the set, which enabled the audience to focus on the movement and words of the monochromatically dressed women. The set design and costuming emphasize the world that the characters build on stage. The characters do not enter the world without baggage, scars, or trauma. The play, however, transforms the women and transports them from their individual geographical locations to a sacred space. The American Playhouse made-for-television-movie (1982), similar to the theatrical production, focuses attention on the women but sets the poems in specific environments. Tyler Perry's 2009 adaptation, however, depicts the settings and figures and their interlocutors referenced in the choreopoem.

Perry's film opens to the flowing edges of lady in yellow's skirt as she dances lyrically to a piano and violin duet. The scene shifts to a rehearsal studio featuring the lady in yellow in the background, captured by the sunlight streaming in from the window and the pianist and violist in the foreground. She moves effortlessly to the melodic sound. The camera angle shifts, cropping the musicians out of the shot and zooming in on the movements of the lady in yellow. The sequence ends as it began with a close-up on the actress's flowing skirt. The introductory sequence then shifts to the words of the choreopoem and women from different locations recite the first poem "dark phrases." The opening dance focuses attention on lady in yellow's body and the ways dance plays a central role in the formal innovation that is Shange's choreopoem. It also emphasizes the physical beauty of a black woman in motion. The opening sequence does not, however, end with collective engagement through dance and play that culminates "dark phrases" in the theatrical production. The shift informs the theatrical production's ability to impart healing rather than solely document trauma.

The impact of the shift in dynamic from the women's shared experience depicted in the dramatic work to their separate worlds connected by happenstance as shown in Perry's film informs the impact of the two most violent scenes in *for colored girls*: "latent rapists'" and "a nite with beau willie brown." "Latent rapists'" poems begin with the entire cast on stage and features the voices of three women: the ladies in blue, red, and purple. The scene opens with "a sudden light change, all of the ladies react as if they had been struck in the face" (30). All but the three speakers leave the stage, communicating the collective violation and focusing attention on the stories of the three remaining figures. The poem focuses on intimate partner violence rather than rape by a stranger or an acquaintance. lady in blue asserts, "a friend is hard to press charges against" (31). The line calls attention to an intracommunal dynamic that polices the victim's behavior but issues little consequences for the assailant. lady in red explains, "a rapist is always to be a stranger / to be legitimate / someone you never saw / a man with obvious problems" (31). The three speakers distinguish between legitimate and illegitimate rape narratives. In 1992, Evelyn Brooks Higginbotham published "African-American Women's History and the Metalanguage of Race," which outlines how the discourse of race in the late twentieth century emerges in relationship to specific understandings of sex and gender. She explains, "Violence figured preeminently in racialized constructions of sexuality. From the days of slavery, the social construction and representation of black sexuality reinforced violence, rhetorical and real, against black women and men."[27] The historical context that Higginbotham offers shifts the context for

understanding narrative representations of rape. Understanding how violence figures "preeminently in racialized constructions of sexuality" reinforces the black women's quotidian experience of violence within their communities.

The discursive regimes that govern rape, including that it is between strangers, occurs only when the woman is sober, requires a robust physical *and* verbal refusal, and may occur only during the first sexual encounter, demonstrate the necessity of telling a different story that accounts for the statistical probability that rape will occur between individuals that have a relationship, often does not include fighting back, and occurs in familiar surroundings. Shange's choreopoem continues to resonate not only because it expressed a counter-narrative to the fictive prominence of stranger rape narratives but also because it offered and provided the feminist community as a plausible space of healing from assault. Her dramatic work disrupted the representation of rape and produced a space—physical, psychic, communal—for women to move through the shame and isolation associated with sexual assault.

In Perry's adaptation, lines from Shange's choreopoem are interspersed with dialogue that creates halting uneven conversation. Erica R. Edwards rightfully argues that filmic adaptations of late-twentieth-century black feminists' works are key to the mass distribution and circulation of the material. The repackaging of "insurgent black feminist narratives for mainstream audiences," nonetheless, refocuses the collective uplift at the heart of third-wave feminism to "individual success in private arenas."[28] In a talkback at Barnard College following a screening of the film, Shange revealed that the contract with Perry specified that he could not change any of the lines of the choreopoem.[29] As a result, there is a disjunction between the film's dialogue, which attempts to create a linear and uniform realist film, and the experimental style of Shange's original work. The portion of the film that depicts the "latent rapist" poem takes place in the apartment of the lady in yellow and begins with dialogue between her and her suitor. Her date initiates physical contact, but the lady in yellow redirects him as she continues to prepare dinner. Although uninvited, he begins to undress in her kitchen and grope her. She looks at his flabby body with shock and fear in her eyes and asks him to put his clothes on. He grabs her violently by the arms and the film cuts to an opera scene and the life of the lady in red. The film manages the visual horror of the violent rape scene by cutting back and forth between the composed world of the opera house and the chaotic scene of sexual violence. In addition, the film mediates the violence by overlying both scenes with the sound of the opera music. As the pace and intensity of the opera escalates so does the violence of the rape scene and the feeling of disorder visually

represented by pots boiling over, food burning, clothes being torn, the lady in yellow's face cringing in anguish, and her hands clawing and reaching for the carpet. The scene brutally depicts the rape, and although it allows the viewer some relief from the traumatic event through the interruption of the scene and the use of operatic singing rather than the lady in yellow's pleas for help, the film does not demonstrate the common and collective experience of violation. In the film, each woman's struggle becomes her own. They come together across their experiences of pain, alienation, and physical trauma, but the film does not depict how the regularity of physical assault shapes black womanhood as a collective and therefore does not allow for a relief from the shame associated with such violation for women and girls.

Shange's dramatic work opened up a window into the unspoken worlds of women of color, a window that some critics would have preferred remained shut. As Régine Michelle Jean-Charles notes, the vitriolic responses to Wallace's writing, Shange's choreopoem, and Walker's novel argued each "perform[ed] a disservice to the black community for exposing intraracial sexual and domestic violence."[30] Feminist responses, such as those of Higginbotham, explained the utility of "rape narratives in general" because they "reveal much about how sex, gender, and power are scripted as well as how sex in general is a completely configured point of transfer for power relations."[31] The narrative not only revealed a hidden dynamic; it interceded in the process of crafting the narrative that shapes identity and social relations.

In the choreopoem, the most stunning scene of violence occurs when lady in red recounts "a nite with beau willie brown." In the 1976 version of the work, Shange depicts Beau Willie as a Vietnam veteran that returns from combat suffering from alcoholism and a propensity to perpetrate domestic violence on his wife, Crystal. In the 2010 revised edition, Shange depicts Beau Willie as a veteran of the Iraq War, suffering from PTSD. She explains in the introduction to the revised edition, "I wrote [a nite with beau willie brown] to make an important, and yet unspoken, social comment. The poem articulated post-traumatic stress syndrome long before it was a national issue, and it was one of the first works of modern literature to give spousal abuse its potentially dire consequences a harrowing voice and vision" (12). Unlike Perry's revisions to Shange's narrative, which attempt to focus attention away from the brutal power structures constituted through women's bodies, rhetorically and physically, and on to the choices that women make that purport to place them in harm's way, Shange's addition calls attention to the social and cultural structures that reinforce violence against women. To cope with trauma of combat, Beau Willie self-medicates,

he'd get up to make coffee, cook up his crack, drink wine,
drink water / he wished one of his friends
who knew where he waz wd come by
with some blow or some shit / anything / there waz no air (79)

The claustrophobic feeling that the poem produces in the refrain "there waz no air" communicates how the suffocating force of state violence constricts the domestic sphere. The violence that Beau Willie enacts on the battle field seeps into his domestic space and demonstrates the ongoing costs of war. In the poem, Beau Willie does not receive any professional help to cope with his trauma. The antagonism and violence between him and his family, Crystal and their two children, escalates until he drops the two children out of a window. The horrifying conclusion left some critics charging that Shange hated men "especially black men" (10). Over the history of the work and through the discursive, physical, and social journey it inspires, the rancor over its depiction of men has subsided. Nevertheless, a great deal of work remains to be done about the limits of what Fleetwood calls "recuperative heterosexuality," which predicates a remedy to intimate partner violence on the reinstallation of heterosexual coupling.[32] Shange's play stages collectivity as an embodied practice that other artists engage by depicting women who connect with women. This tradition is informed by collectives that disrupt the "recuperative heterosexuality" that enables the violation, and, in Christina Sharpe's rendering, quotidian unfreedom of women of color.[33]

III. Reshaping the Body

for colored girls participates in a discursive shift theorized in third-wave feminist scholarship and extrapolated in twenty-first-century black sexuality and gender studies from hiding the impact of discursive violence on the bodies of women of color to exposing it. The claim the choreopoem makes on and of the body is less well considered by scholars that focus on the discursive qualities of the work.[34] Yet, according to Threadcraft, "conceptions of freedom and corrective justice are necessary for the embodied black feminine subject."[35] What does it mean historically for black women to claim and control their bodies? The choreopoem engages with discursive and physical expressions of bodily authority that call to mind political, juridical, and philosophical debates about black female autonomy. From the playful-yet-poignant "somebody almost walked off wid alla my stuff" to the heart rending "abortion cycle #1," *for colored girls* offers practices to reclaim black women's bodily authority.

In "somebody almost walked off wid alla my stuff," lady in green describes how lovers, friends, and acquaintances claimed authority over her person and modes of embodied expression. The extraction of body from person became the unique province of blackness through the trans-Atlantic slave trade. As Hortense Spillers explains, "I would make a distinction . . . between 'body' and 'flesh' and impose that distinction as the central one between captive and liberated subject-positions. In that sense, before the 'body' there is the 'flesh,' that zero degree of social conceptualization that does not escape concealment under the brush of discourse, or the reflexes of iconography."[36] Spillers leaves room for the liberation of the body by locating the flesh as a starting point for conceptions of black womanhood that precede the "violence figured preeminently in racialized constructions of sexuality" that Higginbotham describes. The liberation, in Shange's terms, entails not only reshaping the discursive parameters that regulate black women's bodies and the ways they move in the world. The lady in green articulates and possibly could enact the lines:

now give me my stuff / i see ya hidin my laugh / & how i
sit wif my legs open sometimes / to give my crotch
some sunlight / & there goes my love my toes my chewed
up finger nails . . . (64)

The poem lays claim to the body in articulations and gestures of the body, which demonstrates how discourse functions to shape the body. The seemingly static fixture of the body on stage gets set in motion to simultaneously disrupt physical and linguistic categorizations of black womanhood as, in the words of lady in green, objectifiable and for others' use.

The aesthetic practice that the choreopoem requires, similar to the innovation that Pinto explores in Chapter 6 of this volume, harnesses the historical specificity of black female embodiment to perform critical work at the intersection of the body as the representational and symbolic ground for intimacy and polity. Shange's dramatic work opens space to, as Spillers urges, gain "the *insurgent* ground" of "female with the potential to 'name', which her culture imposes in blindness, Sapphire might rewrite after all a radically different text for a female empowerment."[37] Spillers's essay draws attention to the generative space for imagining empowerment within the specific history of black female embodiment. Such musings might entail reframing the desire for intimate bonds. Shange's choreopoem animates, literally and figuratively, a history of violence and violation that requires women-centered forms of sociality to address and, potentially, redress.

Historically, the battleground for women has emerged at the site of the body. Beverly Guy-Sheftall explains, "Covert use of contraceptives, the practice of abortion, and desperate attempts to control the fate of their children, including occasionally infanticide, provided some slave women a measure of control over their bodies and their reproductive capacity."[38] *for colored girls* seeks to transform the materiality of the body and consider acts that do the same. A highly contested issue, which serves as a litmus test in presidential elections and Supreme Court nominations, abortion also functions as a key issue for black feminists because it raises the larger issue of bodily autonomy.[39] "abortion cycle #1" communicates the personal, political, and ethical stakes of abortion. The first stanza reads:

> tubes tables white washed windows
> grime from age wiped over once
> legs spread
> anxious
> eyes crawling up on me
> eyes rollin in my thighs
> metal horses gnawin my mouth
> i really didnt mean to
> i really didnt think i cd
> just one day off . . .
> get offa me alla this blood
> bones shattered like soft ice-cream cones (76)

The sterile environment introduces alienation as a key feature of the speaker's experience. The isolation feeds the feeling of anxiety as foreign objects—"tubes" and "metal horses"—invade the body and leave the speaker vulnerable and violated. Although the opening stanza speaks of temporal efficiency, "just one day off," the ellipsis that follows the line suggests the ongoing unfolding of recovery.

The early days of third-wave feminists' participation in reclaiming their bodies occurred in the context of the black power movement, which also featured, for some, entrenchment of patriarchal values. "[Political activist Frances] Beale . . . voices her disapproval of black nationalist demands that women be subordinate to men and their assumption that women's most important contribution to the revolution is having babies." Beale asserts, "To assign women the role of housekeeper and mother while men go forth into battle is a highly questionable doctrine to maintain."[40] The theme of women's role in liberation movements emerges in Gayl Jones's 1974 novel *Corregidora*, which explores the correlation of black women's participation in liberation struggles with reproduction and the ways such ascriptions reanimate the histories and legacies of

slavery. As Robert J. Patterson argues, "Increased access to reproductive *choice* does not necessarily translate into increased access to reproductive *control*."[41] The loss of control resonates with the imagery in the first stanza of "abortion cycle #1" with eyes let loose to crawl and roll over the speaker's body.

The conflicting impulses of the speaker's measured and deliberate choice with the experiential impact of "alla this blood" and the ease of "bones shattered like soft ice-cream cones," explains why the matter of black women's bodies requires more than discursive address. Shange's dramatic work accounts for the experiential dynamic key to third-wave feminist theory and practices. Attention to experience accounts for the unexpected, unlegislated, unacknowledged position of black women. The multifaceted position often creates legislative blind spots and social, cultural, and political surplus.

The hard work of repossessing what has been demonized shapes the second stanza of "abortion cycle #1."

> i cdnt have people
> lookin at me
> pregnant
> i cdnt have friends see this
> dyin dangling tween my legs
> & I didnt say a thing
> not a sigh
> or a fast scream
> to get
> those eyes offa me
> get them steel rods outta me
> this hurts
> this hurts me
> & nobody came
> cuz nobody knew
> once i waz pregnant & shamed of myself. (36–37)

As I have argued elsewhere, the word *possession* conjures the metaphysical work of black bodily animation and the connection such work has to capitalist economies of domination.[42] Repossessing requires confronting the external forces and intracommunal dynamics that produce isolation and shame. It also demands attending to the way possession communicates a state of being and an owned object that specifies black people's experience in the Americas and that the necessary work to reclaim bodily autonomy must occur in spiritual and physical forms.

The practice of reclamation, central to Shange's work and that of her contemporaries, requires remapping relationships to the past. The most mythical piece in *for colored girls*, "sechita" follows "abortion cycle #1" as a response to the muted call of lady in blue. Sechita is "an Egyptian goddess of creativity and filth" (4). The poem, set in post–Civil War New Orleans, depicts a woman in full control of her erotic power, participating in a sideshow act that positions her as a deity in the midst of the "heavy dust of the delta" that "left a tinge of grit" and "darkness" "on every one of her dresses" (38). The filthy quality contextualizes but did not restrict the force of her movement:

> . . . sechita's legs slashed
> furiously thru the cracker nite / & gold pieces hittin the
> makeshift stage / her thighs /they were aimin coins tween her
> thighs / sechita / egypt / goddess/ harmony / kicked viciously
> thru the nite / catching stars tween her toes. (39)

Compared to the stillness that "abortion cycle #1" describes, "sechita" calls for violent, erotic, and decisive movement categorized by strong kicking legs and dexterous gripping toes. Sechita's choreographed movement offers a disciplinary history for black women's bodies that refutes shame and claims the "fleshy surplus that simultaneously sustains and disfigures" black embodiment. The ordering of *for colored girls* offers a remedy for isolation through understanding one's self as a part of a larger history that disrupts the alienation of black bodies. The call and response of the two poems participates in the healing journey of the dramatic work as a whole by shifting the discourse that silences, the modes of comportment that constrict, and the histories that misrepresent women of color.

The decades-long journey of *for colored girls* participates in the transformative set forth by a generation of women in the late twentieth century to center the experiences of women of color in order to address and heal from the quotidian violence that structures their lives. The work of transforming representation and physical spaces is slow but the production history of the dramatic work evidences the advances that have been made and the work that remains to be done. The choreopoem also signals the necessary work of innovation that third-wave feminists enacted. They formed new aesthetics and socialities that accounted for the particularity of their experiences and the structures necessary to support the worlds of their creation.

Notes

1. As the November 17, 2014, story "Cosby Rape Allegations Surprise, Disgust: Opinionline" in *USA Today* explains, the decades-long allegations against Cosby were public knowledge but reports chose to overlook the allegations out of respect for the entertainer. http://www.usatoday.com/story/opinion/2014/11/16/cosby-rape-allegations-rapist-celebrity-pr-surprise-disgust-column/19144273/.

2. Shatema Threadcraft, *Intimate Justice: The Black Female Body and the Body Politic* (Oxford: Oxford University Press, 2016), 68.

3. In "Black Feminist Collectivity in Ntozake Shange's *for colored girls who have considered suicide/when the rainbow is enuf*," I argue that the gesture that closes the dramatic work, a laying on of hands, helps to produce the collectivity that the choreopoem offers as a response to the violence that each woman experiences. *S&F Online*, June 2015. http://sfonline.barnard.edu/worlds-of-ntozake-shange/.

4. Ntozake Shange, *for colored girls who have considered suicide / when the rainbow is enuf* (New York: Scribner, 2010), 3.

5. Cheryl Wall, *Worrying the Line: Black Women Writers, Lineage, and Literary Tradition* (Chapel Hill: University of North Carolina Press, 2005), 22.

6. Cherríe Moraga and Gloria Anzaldúa's groundbreaking collection, *This Bridge Called My Back: Writings by Radical Women of Color*, originally published in 1981, describes the work required for women of color to meet across the specific experiences that shape them. Moraga writes of going to visit Barbara Smith. Moraga recalls, "By the end of the evening of our first visit together, Barbara comes into the front room where she has made a bed for me. She kisses me. Then grabbing my shoulders she says, very solid-like, 'we're sisters.' I nod, put myself into bed, and roll around with the word, *sisters*, for two hours before sleep takes on. I earned this with Barbara. It is not a given between us—Chicana and Black—to come to see each other as sisters. This is not a given. I keep wanting to repeat over and over again, the pain and shock of difference, the joy of commonness, the exhilaration of meeting through incredible odds against it" (New York: Kitchen Table: Women of Color Press, 1983), xiv.

7. Creating and narrating black women's writerly traditions is at the heart of Wall's *Worrying the Line* and motivates Alice Walker's "In Search of Our Mothers' Gardens" in *In Search of Our Mothers' Gardens* (New York: A Harvest Book, Harcourt Brace and Company, 1983), originally published 1967, 231–243, and Toni Cade Bambara's 1970 collection *Black Woman: An Anthology* (New York: Washington Square Press, 2005).

8. Amiri Baraka, *The Leroi Jones/Amiri Baraka Reader*, William J. Harris, ed (New York: Thunder's Mouth Press, 1991), 503.

9. Deborah King, "Multiple Jeopardy, Multiple Consciousness: The Context of a Black Feminist Ideology." *Signs* 14(1) (1988), 72.

10. Kim F. Hall and Monica L. Miller, "Introduction: Singing a 'Black Girl's Song,' Barnard and Beyond." *Scholar & Feminist Online* 12(3)–13(1) (2011). http://sfonline.barnard.edu/worlds-of-ntozake-shange/introduction-singing-a-black-girls-song-at-barnard-and-beyond/.

11. Evelyn Higginbotham, "African-American Women's History and the Metalanguage of Race." *Signs* 17(2) (1992), 254.

12. See Amiri Baraka's introduction to the 2013 edition of *Black Fire* for analysis of how blackness became an ideology in the Black Arts Movement (Baltimore, Md.: Black Classics Press, 2013).

13. "An Actress Full of Passion, Pain and Energy, Miss Beverly of 'Colored Girls' Won't Let Up," *New York Times*, September 15, 1976, 50.

14. Edwin Wilson, "The Black Experience: Two Approaches," *Wall Street Journal*, September 21, 1976, 24.

15. Ibid.

16. Frances Beale, "Double Jeopardy: To Be Black and Female." In Beverly Guy-Sheftall, ed., *Words of Fire: An Anthology of African-American Feminist Thought* (New York: The New Press, 1995), 148.

17. "A New Black Struggle," *Newsweek*, August 27, 1979, 58.

18. Ibid.

19. See Beale, "Double Jeopardy."

20. Robert Staples, "The Myth of Black Macho: A Response to Angry Black Feminists." *The Black Scholar* 10(6/7) (1979), 27.

21. See Angela Davis, *Women, Race, and Class* (New York: Vintage Books, 1983). See Danielle McGuire's *The Dark End of the Street: Black Women, Rape, and Resistance, a New History of the Civil Rights Movement from Rosa Parks to the Rise of Black Power* (New York: Vintage Books, 2011).

22. Staples, "Myth," 26.

23. Ibid.

24. Ibid., 32.

25. See Mark D. Matthew's "'Our Women and What They Think,' Amy Jacques Garvey and the Negro World." *The Black Scholar* 10(8/9) (May/June 1979), 2–13. See Audre Lorde, "The Great American Disease." *The Black Scholar* 10(8/9) (May/June 1979), 17–20, and S. E. Anderson and Rosemari Mealy, "Who Originated the Crisis? A Historical Perspective." *The Black Scholar* 10(8/9) (May/June 1979), 40–44.

26. Kalamu ya Salaam, "Revolutionary Struggle/Revolutionary Love." *The Black Scholar* 10 (8/9) (1979), 21.

27. Higginbotham, "Metalanguage," 263–264.

28. Erica R. Edwards, "Tuning into Precious: The Black Women's Empowerment Adaptation and the Interruptions of the Absurd." *Black Camera* 4(1) (2012), 279, 283.

29. See "Ntozake Shange on Stage and Screen: A Video Featuring Ntoake Shange, Soyica Diggs Colbert, and Monica Miller." *Scholar & Feminist Online* 12(3)–13(1) (Summer/Fall 2014). http://sfonline.barnard.edu/worlds-of-ntozake-shange/ntozake-shange-on-stage-and-screen/.

30. Régine Michelle Jean-Charles, "'I Think I Was Raped': Black Feminist Readings of Affect and Incest in *Precious*." *Black Camera* 4(1) (2012), 143.

31. Ibid., 154.

32. Nicole Fleetwood, "The Case of Rihanna: Erotic Violence and Black Female Desire." *African American Review* 45(3) (2012), 419–436. Also, in *Private Lives, Proper Relations: Regulating Black Intimacy,* Candice Jenkins describes the black community's desire to regulate its sexual politics to earn respect and secure middle-class status as the "salvific wish" (15) (Minneapolis: University of Minnesota Press, 2007).

33. See Christina Sharpe, *Monstrous Intimacies: Making Post-Slavery Subjects* (Durham: Duke University Press, 2010).

34. In the Ntozake Shange special issue of *Scholar & Feminist Online,* Jennifer DeVere Brody and Mecca Jamilah Sullivan offer useful definitions of the choreopoem as a form that functions as a performative, making Shange's language do something discursively. I would add, the fundamental formal attribute of the choreopoem requires the transformation of the body physically, spatially, and discursively.

35. Threadcraft, *Intimate,* 7.

36. Hortense Spillers, "Mama's Baby, Papa's Maybe: An American Grammar Book." *Diacritics* 17(2) (1987), 67.

37. Ibid., 80.

38. Beverly Guy-Sheftall, (1995). Introduction. In Guy-Sheftall, ed., *Words of Fire: An Anthology of African-American Feminist Thought* (New York: The New Press, 1995), 3.

39. See Threadcraft's *Intimate* and see the introduction to Dorothy Roberts's *Killing the Black Body: Race, Reproduction, and the Meaning of Liberty* (New York: Vintage, 1998), 3–21.

40. Guy-Sheftall, "Introduction," 15.

41. Robert J. Patterson, *Exodus Politics: Civil Rights and Leadership in African American Literature and Culture* (Charlottesville: University of Virginia Press, 2013), 101.

42. Soyica Colbert's "'When I Die, I Won't Stay Dead': The Future of the Human in Suzan-Lori Parks's *The Death of the Last Black Man in the Whole Entire World.*" *Boundary 2* (39.3) (Fall 2012), 191–220.

Afterword

Post-Soul: Post–Civil Rights Considerations in the 21st Century

ROBERT J. PATTERSON

On November 4, 2008, when the United States elected Barack Obama as 44th president, talk of post-racialism skyrocketed among politicians, pundits, scholars, and lay observers alike. According to the pervasive yet faulty logic, the black president stood as evidence of racial *progress* and a settled score; one could admit that the legacies of slavery and Jim Crow segregation had stained America's past, but *that* past officially had passed. Racial antagonism as some knew it died. The election ushered in a future of racial harmony and decisive evidence that equality of opportunity extended even to the highest office in the land. Ten years later, such an analysis of this historical moment appears naive at best. One of the proposition's main flaws hinges on how the claim turns a blind eye to the fundamental progression-regression paradox that this volume argues has framed black experience in the United States. On the one hand, the election reveals how the eradication of Jim Crow created opportunities that positioned Obama to run for and get elected to the nation's highest office. On the other, the election disguises how black inequality persists in the post–civil rights era, under the cover of color-blindness, race neutrality, and post-racialism.

If Obama's election called to mind debates about racial equality and access that emerged during the late 1960s and 1970s, the successive administration, in a Nixonian and Reaganlike fashion, has engaged in explicit assault on civil rights. While Nixon's law-and-order campaign and Reagan's war on drugs *at times* used *more* implicit markers and images of race to undermine the civil rights movement and engender racist hostility toward black people, the 45th

administration has adopted less implicit policies and practices. From housing, to criminal justice, to education, to health care, black people in the United States find themselves in the government's ire; these rollbacks desire to reinstitute a racial hierarchy that confers second-class, if any, citizenship on black people.

Despite these regressions, black people have again proven their commitment to the very democratic ideals and institutions from which they historically have been excluded. As the November 2018 midterms approached, the public was braced for history to be made. The outcome of the votes held much material and symbolic potential, as the nation was on the verge of the possibility of New York's first African American woman attorney general, Letitia James; Florida's first African American man governor, Andrew Gillum; and Georgia's first African American woman governor, Stacey Abrams. In Ferguson, Missouri, citizens had in effect elected Wesley Bell as the St. Louis County prosecuting attorney, ousting the former one who failed to bring charges in Michael Brown's murder. These examples reveal, in my estimation, the multiple ways that black people are actively making and otherwise imagining black freedom dreams, black freedom strategies, and black freedom struggles. These examples also reveal, for better or for worse, how the post-soul, post–civil rights contexts create different modes of entry into politics. One point is clear, the success of these change-makers will depend heavily on how attentive they are to the past and how willing they are to create new paradigms. Whereas James and Bell's victories provide hope for the possibilities of progressive politics, the racist vitriol and racist practices that informed Gillum and Abrams's defeats underscore how the nation has yet to reach a post-racial, colorblind, race-neutral epoch. It likely never will, and perhaps never should; these concepts betray what they purport to signify and, in the process, retrench black inequality.

In *Black Cultural Production*, we have turned attention to how the reimagining of black freedom—dreams, strategies, and struggles—gains new urgency, significance, and importance in the immediate aftermath of the modern civil rights movement. In particular, we have focused on the ways that black cultural production has engaged these issues, recognizing the historical role black arts have played, and continue to play, in black freedom struggles. In many ways, our collective examination of the relationships that the political and aesthetic have during the post–civil rights era calls to mind Mark Antony Neal's *Soul Babies: Black Popular Culture and the Post-Soul Aesthetic*. Here, Neal examines the tectonic shifts that occurred in American society in general, and African American society in particular, in the post–civil rights era. He uses the phrase "*post-soul* to describe the political, social, and cultural experiences of the African American community since the end of the civil rights and Black Power movements."[1] Neal's post-soul turns its eye toward the generation that was born in the 1970s,

matured during the assault on affirmative action (*Regents of the University of California v. Bakke*), and survived Reaganomics. Neal examines how this generation understands blackness, tradition, and its relationship to the past (particularly black freedom struggles).

Neal argues that the post-soul generation experienced a host of changes, including the move "from essential notions of blackness to metanarratives on blackness, without any nostalgia to the past" that allowed "a radical reimagining of the contemporary African American experience."[2] These expanding notions of blackness desired to "liberate contemporary interpretations of the experience from sensibilities that were formalized and institutionalized during earlier paradigms."[3] While the desire for more capacious notions of blackness makes sense, the rejection of the past, the dissociation from earlier social paradigms seems misguided (not by Neal) given the recurrent intrusions of the past. On the one hand, Soyica Colbert rightfully interprets the post-soul aesthetic to suggest "the sensibilities informing earlier aesthetic modes render the formulations themselves ill-fitted for late twentieth and early twenty-first century cultural production."[4] On the other, the volume considers the relationship between the post-soul era, the past, and the future—noting that even if they don't fit absolutely they may not in fact be ill-fitted.

Black Cultural Production recognizes continuities and discontinuities in modes of black cultural expression that emerge in the post–civil rights era, that remain informed by *and* distinct from the civil rights and Black Power discourses. In the era of Black Lives Matter, Neal's thinking about post-soul aesthetics and the relationships between the past, present, and future helps us to consider how, why, and if the past becomes the past. It, too, makes us wonder what animates the desire to reject earlier paradigms and whether the will toward a decisive split from the past unintentionally reinforces an easily coopted narrative of post-racialism, color-blindness, and race neutrality. *Black Cultural Production* insists that black freedom dreams, black freedom strategies, and black freedom struggles enlarge conceptions of blackness and black political agendas and recognize the present-ness of the past as a planning asset for the future.

Notes

1. Mark Anthony Neal, *Soul Babies: Black Popular Culture and the Post-Soul Aesthetic* (New York: Routledge, 2002), 3.

2. Ibid.

3. Ibid.

4. Soyica Diggs Colbert, "Do You Want to Be Well," *The Psychic Hold of Slavery: Legacies in American Expressive Culture*. Eds. Soyica Diggs Colbert, Robert J. Patterson, and Aida Levy-Hussen (New Brunswick: Rutgers University Press, 2016), 4.

Contributors

ROBERT J. PATTERSON is a professor of African American Studies and served as the inaugural chair of the Department of African American Studies at Georgetown University (2016–2019). He is the author of *Destructive Desires: Rhythm and Blues Culture and the Politics of Racial Equality* (Rutgers University Press, 2019) and *Exodus Politics: Civil Rights and Leadership in African American Literature and Culture* (University of Virginia Press, 2013), and coeditor of *The Psychic Hold of Slavery: Legacies in American Expressive Culture* (Rutgers University Press, 2016). Currently he is working on a book tentatively titled *Black Equity, Black Equality: Reparation and Black Communities.*

MADHU DUBEY is a professor of English and African American Studies at the University of Illinois-Chicago. She is the author of *Black Women Novelists and the Nationalist Aesthetic* (Indiana University Press, 1994) and *Signs and Cities: Black Literary Postmodernism* (University of Chicago Press, 2003), as well as essays on 20th-century African American literature and culture, postmodernism, and race and speculative fiction. She is currently working on a study examining the shifts in American literary "racecraft" since the 1970s.

LISA WOOLFORK is an associate professor of English at the University of Virginia, where she specializes in African American literature and culture. She is the author of *Embodying American Slavery in Contemporary Culture* (University of Illinois

Press, 2008). She is a founding member of Black Lives Matter Charlottesville, which resisted white supremacist incursions in 2017. Her essay "'This Class of Persons:' When UVA's White Supremacist Past Meets Its Future" will be published in a collection of essays about the terror events in Charlottesville.

MONICA WHITE NDOUNOU is an associate professor of Theater at Dartmouth College where she teaches interdisciplinary courses and directs productions. Her book, *Shaping the Future of African American Film: Color-coded Economics and the Story behind the Numbers* (Rutgers University Press, 2014), identifies the intersection of race, culture, and economics as the critical site for determining the future of African American film.

COURTNEY R. BAKER is an associate professor of English at the University of California at Riverside. She is the author of *Humane Insight: Looking at Images of African American Suffering and Death* (University of Illinois Press, 2015). Her current project entails a formalist analysis of recent American and British Black films.

NADINE M. KNIGHT is an associate professor of English and an affiliate faculty member in Africana Studies at College of the Holy Cross. Previous publications include articles on Suzan-Lori Parks, Colson Whitehead, and *The Wire*. She is currently working on a project examining agricultural labor and African American poetry.

SAMANTHA PINTO is associate professor of English at the University of Texas at Austin. She received her PhD in English from UCLA. Her book, *Difficult Diasporas: The Transnational Feminist Aesthetic of the Black Atlantic* (New York University Press, 2013), won the 2013 William Sanders Scarborough Prize for African American Literature and Culture from the MLA. Her second book, *Infamous Bodies*, on the relationship between 18th- and 19th-century black celebrity and human rights, is forthcoming in 2020 from Duke University Press. She is currently working on a book-length project on race, science, and form, and another that explores the role of feminist ambivalence in modern political and cultural movements.

JERMAINE SINGLETON is professor of English at Hamline University. He is the author of *Cultural Melancholy: Readings of Race, Impossible Mourning, and Ritual* (University of Illinois Press, 2015).

TERRION L. WILLIAMSON is an associate professor of African American and African Studies at the University of Minnesota. She is the director of The Black Midwest Initiative and author of *Scandalize My Name: Black Feminist Practice and the Making of Black Social Life* (Fordham University Press, 2016).

KINOHI NISHIKAWA is an assistant professor of English and African American Studies at Princeton University. He has written extensively on African American print and popular culture and is the author of *Street Players: Black Pulp Fiction and the Making of a Literary Underground* (University of Chicago Press, 2019).

SOYICA DIGGS COLBERT is a professor of African American Studies and Theater and Performance Studies at Georgetown University. She is the author of *The African American Theatrical Body: Reception, Performance and the Stage* (Cambridge University Press, 2011) and *Black Movements: Performance and Cultural Politics* (Rutgers University Press, 2017). Colbert edited the "Black Performance" special issue of *African American Review* and coedited *The Psychic Hold of Slavery* (Rutgers University Press, 2016). She is currently working on two book projects: a monograph, "Staging Identity: Lorraine Hansberry an Intellectual Biography" (Yale University Press) and a coedited collection, "Time Signatures: Race and Performance after Repetition" (Duke University Press).

Index

The University of Illinois Press
is a founding member of the
Association of University Presses.

———————————————

Composed in 10.25/13 Marat Pro
with Trade Gothic Condensed display
by Jim Proefrock
at the University of Illinois Press
Cover designed by Jennifer S. Fisher
Cover illustration: Cicely Tyson poses with her
Emmy statuettes at the annual Emmy Awards
presentation in Los Angeles, Ca., May 28, 1974.
(AP Photo)

University of Illinois Press
1325 South Oak Street
Champaign, IL 61820-6903
www.press.uillinois.edu